MICHAEL FREEMAN'S
PERFECT EXPOSURE

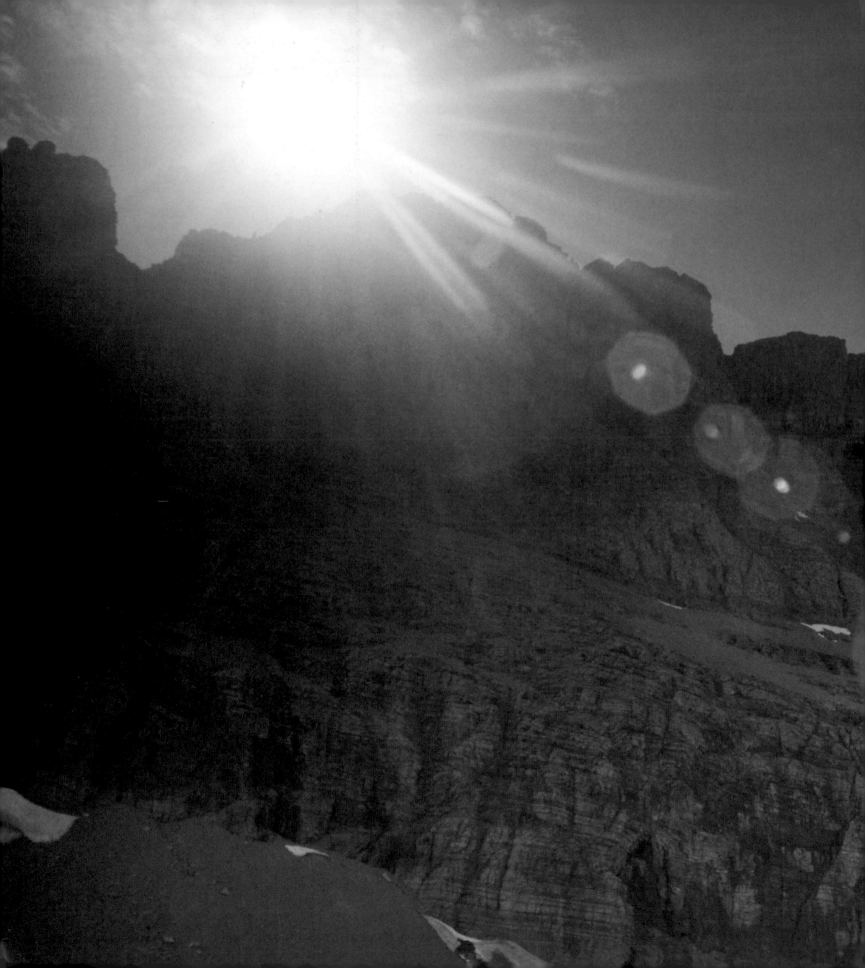

MICHAEL FREEMAN'S
PERFECT EXPOSURE

The professional guide to capturing perfect digital photographs

ELSEVIER

AMSTERDAM • BOSTON • HEIDELBERG • LONDON
NEW YORK • OXFORD • PARIS • SAN DIEGO
SAN FRANCISCO • SINGAPORE • SYDNEY • TOKYO
Focal Press is an imprint of Elsevier

Focal
Press

Focal Press is an imprint of Elsevier
30 Corporate Drive, Suite 400, Burlington, MA 01803, USA
Linacre House, Jordan Hill, Oxford OX2 8DP, UK

Library of Congress Cataloging-in-Publication Data:
A catalog record for this book is available from the Library of Congress.

ISBN-13: 978-0-240-81171-0

For information on all Focal Press publications visit our website at
www.focalpress.com

This book was conceived, designed, and produced by:
The Ilex Press, 210 High street, Lewes, BN7 2NS, UK

Publisher: Alastair Campbell
Creative Director: Peter Bridgewater
Managing Editor: Chris Gatcum
Senior Editor: Adam Juniper
Art Director: Julie Weir
Designer: Simon Goggin
Art Editor: Emily Harbison

Printed and bound in China

CONTENTS

8 **CHAPTER 1: FAST-TRACK AND FOOLPROOF**
10 The basic method
12 The key decisions
14 Decision flow
16 Think brightness, exposure
18 Case study 1
20 Case study 2
22 Case study 3

24 **CHAPTER 2: TECHNICAL**
26 Light on the sensor
28 Exposure terms
30 Exposure and noise
32 Sensor dynamic range
34 Highlight clipping and roll-off
36 Camera performance
38 Scene dynamic range
42 Contrast, high and low
44 Metering modes—basic and weighted
46 Metering modes—smart and predictive
48 Metering adjustments
50 Objectively correct
52 Handheld meter
54 Gray card
56 Key tones, key concept
58 Scene priorities
60 Exposure and color
62 Exposing for color
64 Bracketing

66 **CHAPTER 3: THE TWELVE**
68 First group (the range fits)
70 1 Range fits—average key tones average
74 2 Range fits—bright key tones bright
78 3 Range fits—dark key tones bright
80 Second group (low range)
82 4 Low—average average
86 5 Low—bright bright
88 6 Low—dark dark
90 Third group (high range)
92 7 High—key average key tones average

96 8 High—large brighter large brighter against dark
98 9 High—small brighter small brighter against dark
100 10 High—edge lit edge-lit subject
106 11 High—large darker large darker against bright
110 12 High—small darker small darker against bright

114 **CHAPTER 4: STYLE**
116 Mood, not information
118 Personalized exposure
120 Memory tones
122 Envision
126 The zone system
130 What zones mean
134 Zone thinking
136 Exposing for black-and-white
138 High key
140 Light and bright
142 Flare
144 Highlight glow
146 Low key
148 In praise of shadows
150 Deep shadow choices
152 Another kind of low key
154 Silhouette
156 Irrelevant highlights and shadows
158 Brightness and attention

160 **CHAPTER 5: POST-PROCESSING**
162 Choosing exposure later
164 Exposure, brightness, and lightness
168 Selective exposure
170 Post exposure control
174 HDR imaging
180 Exposure blending
184 Blending by hand

186 Glossary
190 Index
192 Acknowledgments

INTRODUCTION

Choosing the exposure for a photograph is both alarmingly simple and infinitely complex; in fact, it's one of photography's most absorbing paradoxes.

It is simple because there is ultimately only one dosage of light, controlled as it always has been, since the first view cameras carrying wet plates, by a shutter speed, an aperture, and a film speed. There are no qualifications or subsets, just a fraction of a second, an f-stop and an ISO sensitivity. However much agonizing and philosophizing anyone puts into the equation, choosing the exposure still comes back to the same three simple settings—nothing else.

It is also complex because it affects everything about the image and its effect on those who see it. It reaches deep into what the photographer intended and why the photograph was taken in the first place. There are endless subtleties in the brightness, readability, and mood of every part of every scene, as witnessed by the different exposure decisions that different photographers take.

Understanding how and why exposure works as it does is worth a lot of effort, not only because it helps you to get it "right" at will and with total confidence, but also because it helps you decide what "right" is—and that's much more important in photography.

WEBLINK
Some of the pictures shown in this book are clearer on a computer screen, which show a higher dynamic range than the printed page can. For that reason, where it is beneficial, you can log onto the address below to see the images wherever you see this logo.

http://www.web-linked.com/mfexus

CHAPTER 1:
FAST-TRACK AND FOOLPROOF

When it comes to photography, you should beware of any self-proclaimed "system." Systems tend to be invented and promoted either by photographers who have a very particular way of working that might suit themselves perfectly but is not necessarily adaptable, or by people who have little experience of the practicalities of shooting. I write this knowing full well that I'm presenting here what looks suspiciously like just such a creature. The difference is, and my justification also is, that this is a distillation of the ways in which many professionals make exposure decisions. Most professionals, of course, do not use what they would ever themselves call a system, but when you live, breathe, and shoot photography for a living, day in and day out, you develop and hone ways of working that behave very much like a system. Well, I would say that, wouldn't I?

As usual, my model for this book is the way in which professional photographers do things. "Professional" means someone who shoots on assignment regularly for a living, and I believe this is important. Not that professionals have any special dispensation to take better photographs. That kind of talent can rest innately with anyone, and be improved by anyone, though, of course, successful professionals are exploiting that skill. No, what makes the professional approach worth following is that we do photography all the time, and under pressure to deliver the goods every time.

In a slightly unusual departure from most of my books, I've carved out a short and succinct first chapter that is partly a summary of what follows, and partly a way of stressing the decision flow. After this I'll go into much more detail about individual aspects of exposure, all of which will take much longer to read than to do. Here, for the next few pages, I want to be completely practical and acknowledge that when you are shooting there is usually not much time at all for anything. Exposure decisions normally have to be made very quickly indeed, often without consciously thinking them through. But the decision flow is still there, however there is a short amount of time for it. This, then, is how it really is....

THE BASIC METHOD

I'm taking a slightly different approach in this book by trying to explain everything right at the start and as concisely as possible. This may seem almost impossible, but in keeping with the subject—which is both simple and complex at the same time—there's a real need in photography to grasp the essentials in a single perception, followed by gradually absorbing all the implications. Photography is, in any case, always about the moment, and while there is much to learn at leisure there is also the entirely understandable, even necessary, impatience just to shoot.

There are many different aids to exposure, and as many preferences among photographers for choosing camera settings. Camera manufacturers are well aware that this is the crucial issue for most photographers, so they have developed a raft of technical solutions, with each trying to outperform the others. The result is a wonderful choice, but also a chaotic array of methods, many encumbered by jargon for no better reason than to make them seem superior to the competitors' versions.

I plan to cut through this nonsense, and my model is, as always, the way professionals like myself think and work. Being a professional photographer (which is to say, someone who earns their living by getting paid by clients to shoot, not by just teaching or writing about photography or by gaining expertise at messing around with photographs in Photoshop) does *not* mean that the work is any better than that of a dedicated amateur. Actually, often the opposite is the case. What it does mean, though, is constant and realistic attention to shooting on a daily basis.

A professional photographer has the advantage of doing this all the time, building up experience that counts for more than many techniques. Most professionals have little patience with complicated novelties and most choose exposure almost instinctively. I have many friends who will have no sympathy for what I'm about to do, which is to analyze the process and spell it

➤ **DECISION FLOW (STREAMLINED)**

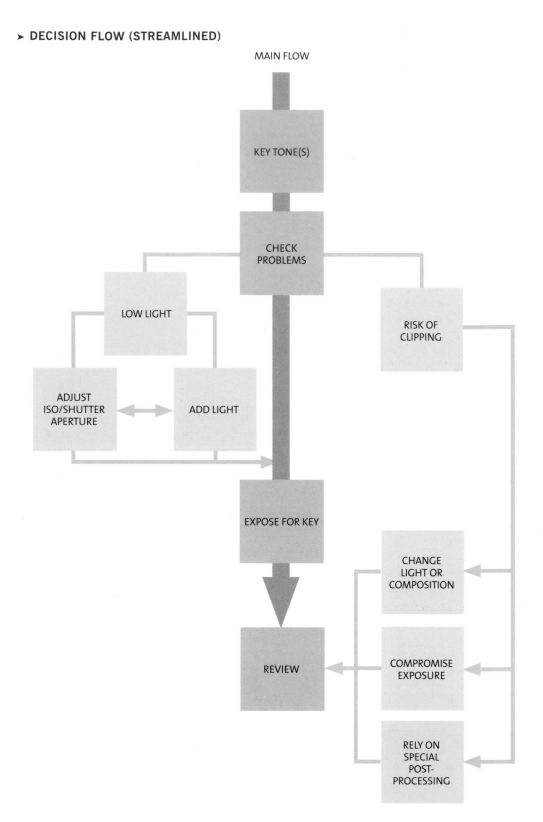

▲ CAMERA PROCESSOR
The camera's onboard electronics can make decisions for you, should you choose, but it will only ever be able to see the scene from the point of view of "averages" or "most people."

▲ IMAGE SENSOR
A Canon 35 mm CMOS image sensor chip, the component of the camera which is ultimately exposed to the light.

out, but that's because they do it as a matter of course. One thing I should warn you about is the unavoidable wordiness of the methods I describe here. Even the short summary that follows will take a minute or so to read and absorb, but putting it to use should take only a second or so. Reflexes in assessing a scene and choosing the exposure can always be improved, and they should be.

Let's start with the absolute summary, as concise as I can make it. Yes, there are all kinds of decisions embedded in each of the steps, but I will explain these later in the book. I've also had to allow for the many ways in which a modern digital camera allows the exposure to be set. An important point here is that it is usually less important *which* method you use than being thoroughly familiar with it. Believe it or not, a significant number of professional photographers set their exposure manually, using a simple, center-weighted averaging mode—and they get it right.

In time sequence, this looks like the Decision Flow chart (opposite), which is a streamlined version of the full flow shown on the following pages. Follow the sequence and you will get the exposure as good as it possibly can be. The only qualifications are these: the first and last are mechanical, while all the rest require judgment and improve with experience... except number three which can take a lifetime.

SUMMARY

1. SETTINGS
Make sure all the relevant camera settings are as you require them.

2. METERING MODE
Set your preferred metering mode and know exactly how it will perform under the lighting conditions.

3. KNOW WHAT YOU WANT
Imagine in advance how you want the brightness distribution of the image to be.

4. SCAN FOR PROBLEMS
Quickly assess what the issues and likely problems will be, particularly the scene's dynamic range relative to the sensor's capability and if the light levels are low.

5. KEY TONES
Identify the areas of the scene that are the most important for brightness, and in order of importance.

6. RISK OF CLIPPING
If the scene's dynamic range exceeds the sensor's performance, decide whether to make changes, or to settle for a compromise exposure and/or rely on special post-processing.

7. METER & EXPOSE
Use the appropriate metering mode, adjusting up or down if necessary.

8. REVIEW
Review the result on the screen. If it needs improving, re-shoot if appropriate.

THE KEY DECISIONS

LET'S EXPAND ON THIS BARE-BONES SUMMARY FROM THE LAST PAGES.

1. SETTINGS

Before you shoot, have all the relevant camera settings exactly as you need them:

- Metering mode: Choose between auto or manual, depending on your preference.
- File format: Raw, TIFF, or JPEG, or a combination such as Raw + JPEG.
- Instant review turned on after each shot (this is just a recommendation).
- Highlight clipping warning: Some people find this distracting, but others value it as a rapid aid to controlling one of digital photography's special exposure problems.
- Histogram readily accessible: With some camera manufacturers this is overlaid on the review image, which is certainly distracting, but it is useful to have available at one click.

2. METERING METHOD

Know exactly how your chosen metering mode behaves. Most cameras offer a choice between, say, average center-weighted, smart predictive, and spot. Some camera models use very smart methods, such as comparing the distribution of tones with a large bank of previously analyzed images. If you choose to rely on an advanced system, make sure that you know how consistently it behaves *for you*. If it over- or under-exposes for certain kinds of composition and lighting that you favor, simply be aware, so that you can adjust with confidence. If you use a simple method, still know how it behaves in different situations. You may need to make adjustments at any time, which is why this is returned to at point 7, below.

➤ DECISION FLOW

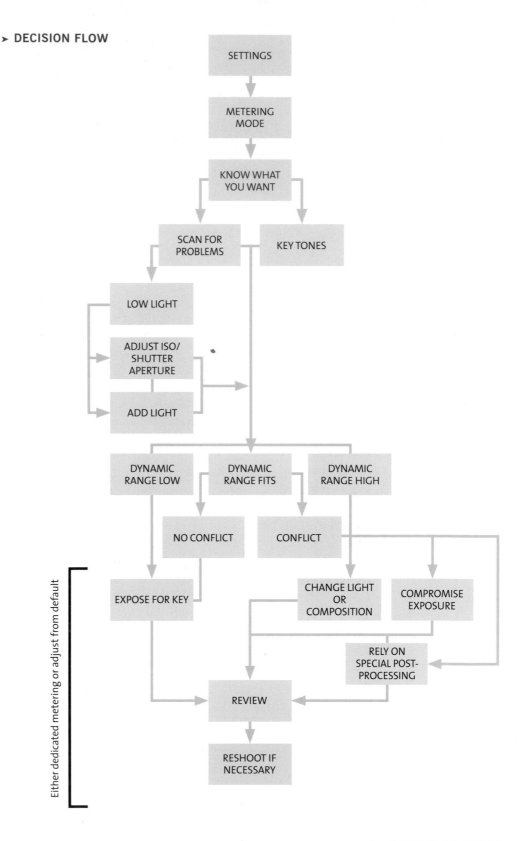

3. WHAT DO YOU WANT?

Know clearly what the photograph is about—what caught your eye, what attracts you about the shot, and what you want to convey. Have in your mind's eye how bright it should be overall, and how the distribution of brightness should look. Naturally, this is the million-dollar question.

4. LIKELY PROBLEMS

Scan the scene for exposure issues. Think about what is in front of the camera before letting the metering system loose on it. For example, is there a major hotspot likely to blow out? Does it matter if it does? Most problems occur because the dynamic range of the scene is greater than the sensor can capture in one exposure.

5. KEY TONES

Decide on the important subject (or subjects) and how bright it (or they) should be. In a portrait, this is likely to be the face, but it ultimately depends on your creative judgment. If it is a face, is it Caucasian, East Asian (which needs to be lighter than mid-tone) or black, (which needs to be darker than mid-tone)? The key tone may be only a part of the key subject, or in some circumstances it may be another part of the scene, such as a background.

6. IS CLIPPING LIKELY? IS THERE A CONFLICT?

If there's a conflict between points 4 and 5, work out how to resolve it. The choice is between changing the light or the composition, or accepting either a compromise in the exposure, relying on special post-processing, or both. For example, if a portrait is backlit and the background has to be heavily clipped for the exposure to be right for the face, you might want to add foreground shadow fill, just accept a clipped background or change the composition. As another example, if there is a small bright hotspot doing nothing special for a shot, you might re-frame to crop it out. A compromise exposure means accepting either shadows that are too dark or over-exposed highlights, which may be perfectly acceptable, depending on the effect you want (see point 3). The third alternative, which can sometimes be combined with a compromise exposure, is to rely on special post-processing techniques, such as exposure blending or even HDR (High Dynamic Range), which might in turn call for multiple exposures that can be digitally blended.

7. APPLY METERING

This depends on your preferred way of working with the camera settings. One method is to use a dedicated metering technique to measure and set the key tones, such as spot-metering, to measure an area precisely. Another is to decide from experience how much more or less exposure from the default is needed and set accordingly, typically by using an exposure compensation button.

8. REVIEW, RESHOOT

Review on the camera screen, adjust and re-shoot if necessary— and if there's time. This is all about the kind of shooting you are doing and the situation you are in. If the action is fast and either continuous or unpredictable, it would be a very bad idea to check the camera screen after each shot. If you are shooting a landscape as the sun slowly sinks and you have plenty of time, you can afford to check everything thoroughly and shoot variations.

DECISION FLOW

In digital photography there are three areas involved in exposure. These are your shooting technique, your personal style, and post-processing, and the main chapters of this book follow this breakdown. The last area, post-processing, may at first seem a little odd, given that the whole subject revolves around the moment of exposure. Yet this very digital stage is linked intimately to the moment of shooting in two important ways. One is the practice of shooting in Raw format, which is always recommended and allows, among other things, for the exposure to be revisited. The second is that many of the newer, more advanced processing techniques affect the immediate exposure decisions, allowing you to shoot at a setting that otherwise you might not think worthwhile.

Nevertheless, the straightforward technique, style, then post-processing route is not necessarily the order in which exposure decisions are made. On the previous pages we looked at all the important exposure decisions you need to make, some of them at leisure earlier and some just a fraction of a second before shooting. Here, I've put together the full Decision Flow in what is usually the most logical sequence. If it looks daunting, that's only because I have broken down the process of making an exposure into steps that, in reality, are close to instantaneous.

It begins with having all the camera settings and the metering mode as you need them, and this may vary according to the overall lighting situation. For instance, if I know that I'm likely to encounter low lighting and I'm shooting handheld, I'll switch the camera's auto ISO on, with an upper-limit shutter speed based on the lens I think I'm going to need. However, if it's a tripod situation, I'll switch it off.

Then comes the all-important decision of knowing what you want from the scene, which is always personal and could be considered an underlying condition as much as a decision.

Next we have the twin scene-critical decisions that establish everything to follow. I've put them side by side because they are of equal importance, and even if one precedes the other by a fraction they are right next to each other in time sequence. One involves deciding on the most important area of tone (or tones) in the scene, the one that should be a certain brightness. The other is damage control, scanning the scene and situation rapidly for likely problems. A neatly separated issue, at least as far as exposure is concerned, is the quantity of light. Once that is dealt with, the other major issues are to do with dynamic range and the danger of clipping.

In the next chapter we'll look at dynamic range, and the three conditions that determine whether there is likely to be a problem. With a low scene dynamic range, there never is a problem; if the scene dynamic range just fits that of the sensor then there may be no issues, but that depends on where you locate the key tone; if the dynamic range is high, there certainly will be a clipping issue.

So, if there's no conflict between choosing the key tone and clipping, you simply expose for the key. If there is a conflict, there are three kinds of solution. One is to accept a compromise in the exposure and settle for the best that's possible. Another is to make changes, which usually means to the light or to the composition. A third, newly digital, is to anticipate special post-processing techniques, many of which lead to a recovery of tones that would ordinarily suffer.

Finally, review the shot if you have time, and if it's less than perfect, adjust and shoot another frame—again, if you have time.

> **DECISION MAKER'S CONTROLS**
> Exposure control largely comes down to three core settings—shutter, aperture, and ISO—all easily accessible on modern digital SLRs like this Canon EOS-5D MkII.

THINK BRIGHTNESS, EXPOSURE

I added this at the last minute, when, after talking at length to a number of readers, I realized that not everyone is completely comfortable switching between brightness, exposure, and ƒ-stops. This is really to do with working method, and yes, it does vary. Photographers have their own idiosyncrasies, their own ways of thinking about light and exposure, and this applies especially to professionals, who have had to work out foolproof methods and have honed these with constant experience. However, whichever way you package the decision-making process, it ultimately rests on knowing what camera settings will get you what results. The simplest, most universally intelligible unit is the stop. You can make life more complicated by talking about EV (Exposure Value) or, worse still in my opinion, Zones. But stops are very, very simple. One step up or down on the aperture or the shutter speed.

Nor is it complicated to relate stops to brightness, and in most circumstances it is not necessary to be obsessively accurate. The chart here is the basic translation, and it does not pretend to be precise. But it is sufficient for most purposes. We are, after all, taking photographs at this point, not tweaking them in Photoshop. The simplest way, it seems to me, to think about brightness is as a percentage. 0% is black, 100% total white, and 50% is in the middle. Mid-tone, average. Later, we'll look at gray cards and why they are 18% reflectance, but all very interesting though this may be if you have the time to think about it, 50% is a lot more intuitive. And it is also how a mid-tone measures on the computer in Photoshop's HSB, or whichever processing software you use.

At its absolute crudest, you could say that a little bit lighter is half a stop, quite a bit lighter is one stop, significantly lighter two stops, and so on. If it seems that I'm promoting sloppy measurement here, yet being almost compulsive in other sections of the book, it's because somewhere here I need to stress the importance of getting things in proportion. If you have the time and the camera is on a tripod, you can measure away to your heart's content, get the readings down to ⅓ of a stop, and have the plan mapped out with total precision. But most photography is not like that, and if you are in the street and have seconds to work it out, then what's clearly needed is a fast and basically accurate decision.

I cannot recommend too strongly the simple ability to look at a scene, see blocks of roughly similar brightness, know intuitively what that brightness is, and how that translates into stops. With practice, it's easy, and maybe you do this already. If not, time to start!

MEASURING BRIGHTNESS

Here and throughout the book, I use brightness as the basic measurement of the amount of light (see page 28, *Exposure terms*). The way of measuring it is the same as in Photoshop's HSB. Total black is 0%, mid-brightness is 50% and total white 100%. This is worth mentioning because there are several light measurements, and it's easy to get bogged down in the minutiae—when the real business at hand is practical photography. The diagram here shows approximately how it relates to ƒ-stops. Most exposure decisions do not need a high degree of precision, but it helps, at least to my mind, to be able to think simultaneously in terms of relative brightness and in the stops needed to achieve it.

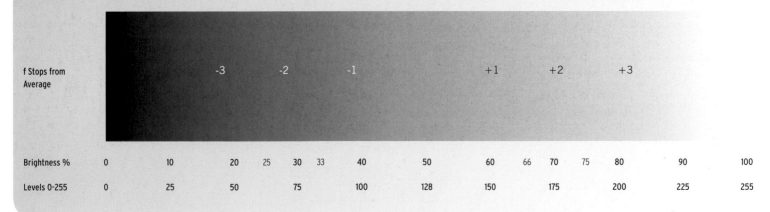

f Stops from Average		-3	-2	-1		+1	+2	+3							
Brightness %	0	10	20	25	30	33	40	50	60	66	70	75	80	90	100
Levels 0-255	0	25	50	75	100	128	150	175	200	225	255				

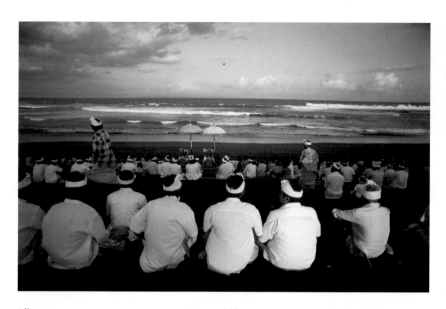

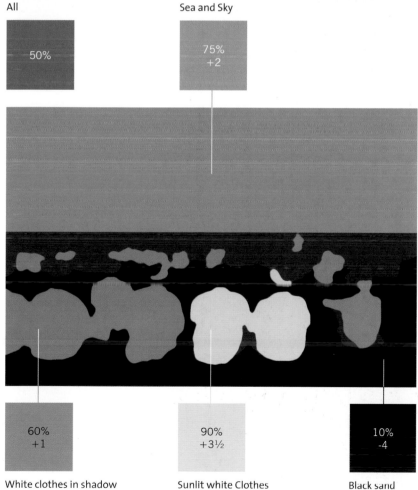

All

50%

Sea and Sky

75%
+2

60%
+1

White clothes in shadow

90%
+3½

Sunlit white Clothes

10%
-4

Black sand

◄ ▲ QUICK DECISIONS

Here is an image that I chose at random, but remembering how I saw it and thought, briefly, about the exposure. Reduced to the essentials, I see the sea and sky as one tone block, the white shirts of the men that are in shadow as another, the two sunlit white shirts as another, and lastly the black sand. To put this in perspective, I probably spent a couple of seconds thinking about the exposure. The schematic shows these tonal blocks and their brightness (in percentages) and the equivalent stops' difference from average.

The quick decision process went as follows:-
1. Watch out for clipping on the bright white shirts; keep bright as possible
2. Sea and sky all more or less the same, need fairly bright
3. Shadowed white shirts not so important; let fall wherever on the brightness scale
4. Black sand not important; will in any event be very dark

I also knew at a glance that the entire mixture of tones should come close to average, and that, using the camera's smart metering mode and with the two bright shirts close to the center of the frame, it would protect them from clipping. This bit was simply familiarity with my camera.

CASE STUDY 1

This is the first of three case studies to show how the Decision Flow works. There are many more examples throughout the book, each focused on a different aspect of exposure. I've chosen this photograph as the first example for simplicity—the dynamic range of the scene is within the capacity of the camera and sensor (in other words, range fits), and there is one clear area of interest that chose itself as the key tone. Nothing complicated, then, and the situation allowed plenty of time to set up the camera, anticipate the right moment, and think in advance about everything, including the exposure.

If you allow yourself the opportunity to think in some detail about the exposure, there is always something of interest in the process. In this case, it was a ruined area of temples in Ayutthaya, Thailand. What caught my eye was the head of a Buddha statue lying in the grass, and having recced the site earlier, I could see that the final rays of the sun might be interesting. The composition and camera viewpoint made the most of the depth in the scene, from the blades of grass surrounding the stone head to the leaning brick stupas beyond. Technically this meant a wide-angle lens stopped well down for good depth of field (20 mm efl and ƒ32).

By this time, in the late afternoon, the contrast in the scene was good, meaning it was strong, but still the dynamic range was perfectly manageable. This was pretty obvious at a glance, but I had time to measure the scene with a handheld meter, and this confirmed it. This meant that so long as I chose a moderately average tone for the key and intended to give it an average exposure, it would all be straightforward. And it was.

The main issue was timing, as the shadows were creeping quite quickly. With trees and more ruins behind the camera, the shadows falling on this patch of ground were not so easy to predict. I chose the moment when the shadow from a distant branch darkened the grass on this side of the head, and there was only a minute or so

➤ **DECISION FLOW**
This is the simplest, most straightforward Decision Flow possible, following the main path with no need to divert to the low-light loop or for clipping solutions.

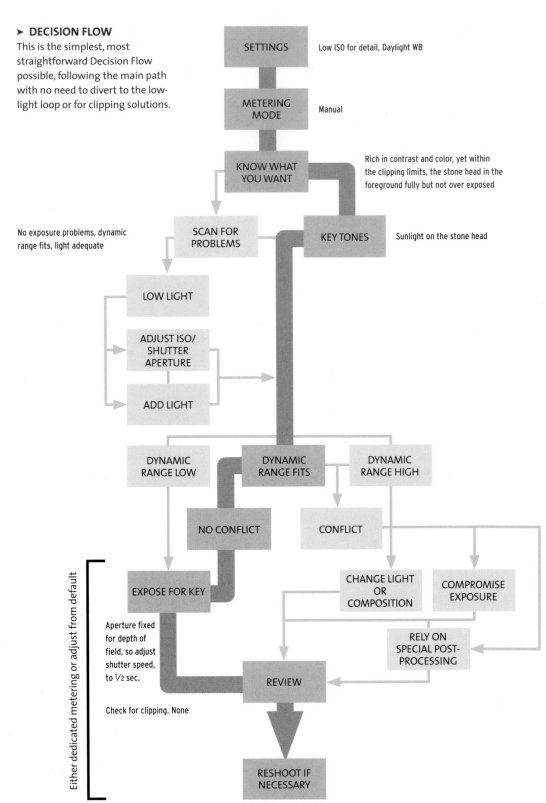

SETTINGS — Low ISO for detail, Daylight WB

METERING MODE — Manual

KNOW WHAT YOU WANT — Rich in contrast and color, yet within the clipping limits, the stone head in the foreground fully but not over exposed

No exposure problems, dynamic range fits, light adequate

SCAN FOR PROBLEMS

KEY TONES — Sunlight on the stone head

LOW LIGHT

ADJUST ISO/ SHUTTER APERTURE

ADD LIGHT

DYNAMIC RANGE LOW

DYNAMIC RANGE FITS

DYNAMIC RANGE HIGH

NO CONFLICT

CONFLICT

EXPOSE FOR KEY

CHANGE LIGHT OR COMPOSITION

COMPROMISE EXPOSURE

RELY ON SPECIAL POST-PROCESSING

Aperture fixed for depth of field, so adjust shutter speed, to ½ sec.

REVIEW

Check for clipping. None

Either dedicated metering or adjust from default

RESHOOT IF NECESSARY

for shooting before that particular shadow crept up the stone head. The key tone is the lit part of the stone head, and the shutter speed was set to render it just a fraction less than average (maybe a ¼ stop), which was ½ sec.

One technique I'll use throughout the book to demonstrate this is to convert the image into a grayscale pixelated matrix. At this scale of pixelation the important tones stand out, but without a proper sense of the content. I find this makes it easier to consider these exposure issues—after the event, obviously. There was time during this shot to look over the scene and find other areas of the same tone as the head. Reassuringly, there were several, including most of the left brick stupa, and the corners of the sky (the "corners" stem from the vignetting of the wide-angle lens).

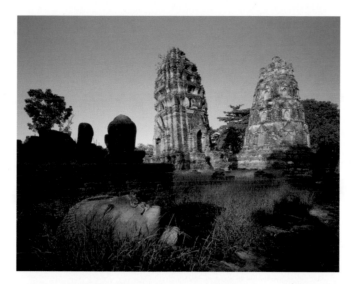

◄ **RESULTING IMAGE**
This picture is the final result of the case study described here. The schematic diagrams below show how, once the head was chosen as the focal point, the other midtones were identified.

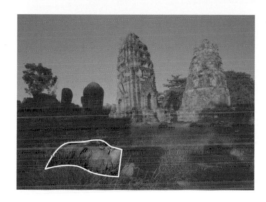

▲ **FOCAL POINT**
The focal point of the picture outlined in white

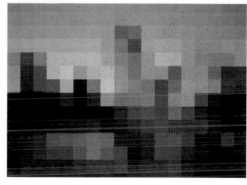

▲ **GRID ANALYSIS**
This schematic shows regional brightness.

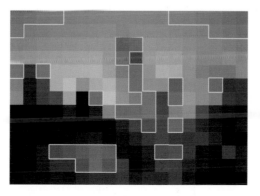

▲ **OTHER MIDTONES**
Other areas of the picture share the same midtones

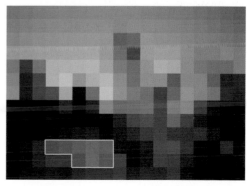

▲ **FOCAL POINT**
The focal point is exposed to be a midtone

CASE STUDY **2**

I've chosen this as the second example because there was almost no time at all to make an exposure decision. A lot depended on the camera settings that were already chosen, and being completely familiar and confident with them—which is exactly the point. Also, I want to show that *almost* no time is still *enough* time to get it right.

The strong chiaroscuro (the high contrast pattern in cast shadow) on this side of the sunlit street caught my eye, and what I was after was a person walking through the scattered pools of sunlight. The lens was a long 300 mm, which gave me some choice to track anyone walking for a short distance without changing the viewpoint. After about a minute of waiting, I saw this woman coming out of a doorway further along the street. Timing was foremost in my mind, and I had about five seconds to anticipate this and the exposure. While waiting, I had already assessed the exposure conditions—dynamic range high, but not important to me so long as I held the highlights, as I wanted contrast. The camera metering mode was what I call smart predictive and what Nikon calls 3D Color Matrix, and I knew from experience that this would almost certainly expose without clipping highlights. In reserve, I also had the fact that I was shooting Raw, which would give me some leeway, perhaps ½ to ⅔ stop in case of error.

➤ DECISION FLOW

The highlighted route covers dealing with high dynamic range through compromise, but the overall light is good so there is no need to follow the low light path.

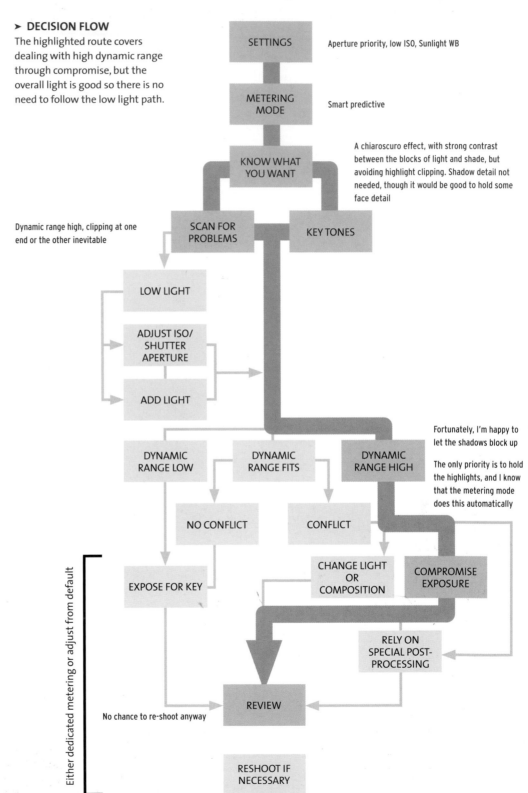

SETTINGS — Aperture priority, low ISO, Sunlight WB

METERING MODE — Smart predictive

KNOW WHAT YOU WANT — A chiaroscuro effect, with strong contrast between the blocks of light and shade, but avoiding highlight clipping. Shadow detail not needed, though it would be good to hold some face detail

Dynamic range high, clipping at one end or the other inevitable

SCAN FOR PROBLEMS — KEY TONES

LOW LIGHT

ADJUST ISO/ SHUTTER APERTURE

ADD LIGHT

DYNAMIC RANGE LOW — DYNAMIC RANGE FITS — DYNAMIC RANGE HIGH

Fortunately, I'm happy to let the shadows block up

The only priority is to hold the highlights, and I know that the metering mode does this automatically

NO CONFLICT — CONFLICT

Either dedicated metering or adjust from default

EXPOSE FOR KEY

CHANGE LIGHT OR COMPOSITION — COMPROMISE EXPOSURE

RELY ON SPECIAL POST-PROCESSING

No chance to re-shoot anyway

REVIEW

RESHOOT IF NECESSARY

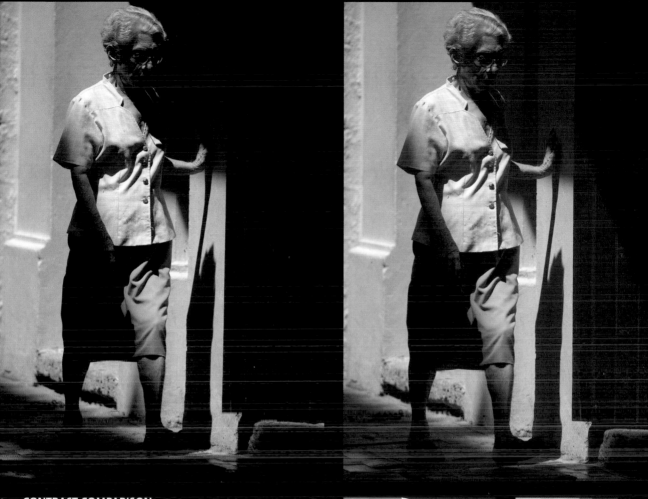

▲ ➤ CONTRAST COMPARISON

These are two alternative versions, but both are valid. For the purposes of this demonstration, they were prepared in ACR (Adobe Camera Raw), using the Exposure slider only. On the left is an exposure half a stop darker, which is the result of making the key tone not the entire sunlit area but instead the more strongly lit upper part of the woman's blouse. This exposure valuably shows the texture of the fabric, but the cost is even denser shadows and a less-readable face. On the right is a fuller exposure, by $^2/_3$ stop, in an attempt to keep some of the shadows open. Here, the cost is clipping in the brighter highlights, especially the blouse.

CASE STUDY 3

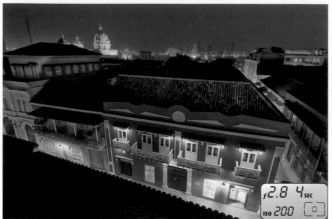

UNPROCESSED SCENE

This is a very different situation from the previous two. As with any planned evening or night overview, it was recced in advance. The camera was set up on a tripod even before sunset, so there was plenty of time to think ahead. Also, as darkness fell (relatively quickly, as this is the city of Cartagena, Colombia, in the tropics) and the streetlights and floodlights were switched on, there was time to anticipate the final pattern of brightness. Experience told me that the dynamic range would increase greatly as light left the sky, but it was a foregone conclusion that I would shoot multiple frames for later exposure blending or HDR. I wanted a full night-time distribution of city lights, but the precise timing would be determined by the sky—I wanted rich blue, so this would probably be about quarter of an hour before total black.

The workflow comments explain all. Note that there were priorities of key tone, with four to consider, which is something quite manageable with the multi-shot technique that I chose. The type of scene lighting or exposure situation, by the way, was type 7: dynamic range high but no single tone dominating.

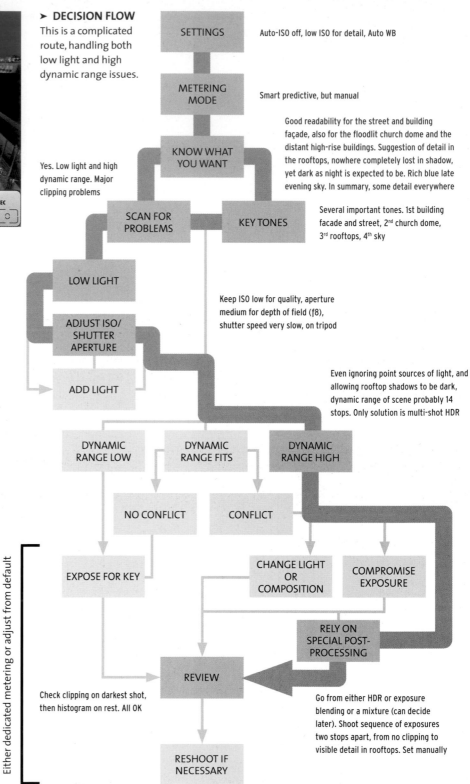

➤ DECISION FLOW
This is a complicated route, handling both low light and high dynamic range issues.

SETTINGS — Auto-ISO off, low ISO for detail, Auto WB

METERING MODE — Smart predictive, but manual

KNOW WHAT YOU WANT — Good readability for the street and building façade, also for the floodlit church dome and the distant high-rise buildings. Suggestion of detail in the rooftops, nowhere completely lost in shadow, yet dark as night is expected to be. Rich blue late evening sky. In summary, some detail everywhere

Yes. Low light and high dynamic range. Major clipping problems

SCAN FOR PROBLEMS

KEY TONES — Several important tones. 1st building facade and street, 2nd church dome, 3rd rooftops, 4th sky

LOW LIGHT

ADJUST ISO/ SHUTTER APERTURE — Keep ISO low for quality, aperture medium for depth of field (f8), shutter speed very slow, on tripod

ADD LIGHT

Even ignoring point sources of light, and allowing rooftop shadows to be dark, dynamic range of scene probably 14 stops. Only solution is multi-shot HDR

DYNAMIC RANGE LOW

DYNAMIC RANGE FITS

DYNAMIC RANGE HIGH

NO CONFLICT

CONFLICT

Either dedicated metering or adjust from default

EXPOSE FOR KEY

CHANGE LIGHT OR COMPOSITION

COMPROMISE EXPOSURE

RELY ON SPECIAL POST-PROCESSING

REVIEW

Check clipping on darkest shot, then histogram on rest. All OK

Go from either HDR or exposure blending or a mixture (can decide later). Shoot sequence of exposures two stops apart, from no clipping to visible detail in rooftops. Set manually

RESHOOT IF NECESSARY

f2.8 4sec ISO 200

PERFECT EXPOSURE

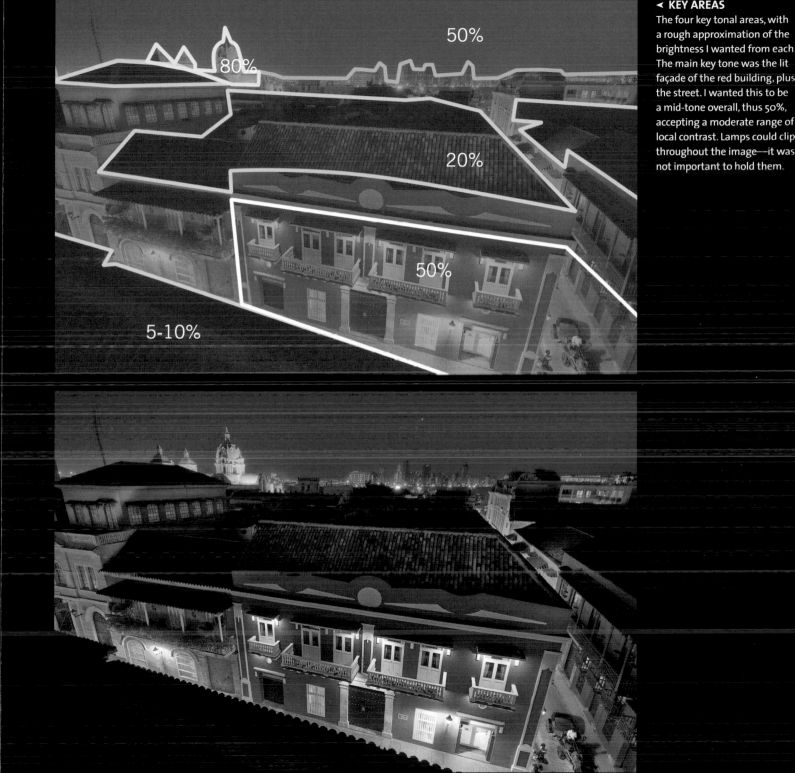

The four key tonal areas, with
a rough approximation of the
brightness I wanted from each.
The main key tone was the lit
façade of the red building, plus
the street. I wanted this to be
a mid-tone overall, thus 50%,
accepting a moderate range of
local contrast. Lamps could clip
throughout the image—it was
not important to hold them.

CHAPTER 2:
TECHNICAL

So simple. So crucial. Getting the exposure right remains the greatest concern for a large majority of photographers. Now, in digital photography, it is more important than ever before: not only because digital sensors are essentially unforgiving in their response to over- and under-exposure, but because digital techniques offer greater opportunities for perfecting exposure. The limitations are more than offset by possibilities, and the two combined make exposure in digital photography a rich and rewarding subject. Perfecting exposure calls on three areas of photography — technical, taste, and post-processing. Here we begin with the technical base. We need to look at how a camera sensor works, the all-important issue of dynamic range (of the sensor and of the scene), and the details of how light and exposure are measured. Underlying all of this is the assumption that there exists a kind of ideal exposure setting for any picture. This is true up to a point, but as we'll see later in this book, it has to be tempered with your own creative decisions as a photographer.

One reason for my writing this book is that with digital photography there is a great deal to consider in the realm of exposure, more so than with film because of the vagaries of digital capture and because of the many settings and adjustments that are possible. With all this potential complexity, the whole subject of exposure seems in need of clear thinking. Another reason, frankly, is that I get bewildered when I look at much of the advice peddled on exposure, especially on-line. Much of it comes from people who are not actually photographers, at least not in the way that I understand professional photography. There is a growing number of experts on imaging software and on camera engineering, but this seems to me to be entirely the wrong direction from which to approach the subject. Surely it's the photography that should come first? Purpose, ideas, vision, the ability to shoot worthwhile subjects in a striking way, these kinds of things. From this point of view — my point of view — exposure is less about twiddling knobs and pressing buttons than about managing light and knowing what you want from an image.

Let me return for a minute to the intriguing paradox of a decision that in the end affects just three simple settings — aperture, shutter speed, and sensitivity — and yet is endlessly complex.

LIGHT ON THE SENSOR

As almost everything to do with exposure is in some way connected to the sensor, it pays to have a good understanding of what goes on inside. The question is, how much do you need to know? Given that we're photographers rather than engineers (well, a few might be both), and that sensor design and manufacture involves complex technology, a full understanding isn't possible. This is a basic issue that affects much of post-film photography—working digitally now means we're dependent on software, firmware, and hardware that is not at all obvious in what it actually does. And apart from the complexity of the engineering, camera manufacturers are justifiably very secretive about what goes on under the hood. They need to protect unique research, and also not draw attention to deficiencies, which there always are. Here I'll attempt to cover just what is needed and relevant, but at the same time posting warnings.

The basic unit of the sensor is the photosite, each one of which collects the light for one pixel. High-end DSLRs these days have 10-12 million pixels, and some models have even more. The density of photosites on a sensor is measured as pixel pitch—the distance between the center of one pixel to its neighbor—and the higher the pitch, the better the resolution. Unfortunately noise, which we'll deal with later, is worse from sensors with small photosites, so image quality involves a compromise between density and the area of each photosite. This makes small camera design particularly difficult.

When light strikes the sensor, it is stored as an electrical charge in each photosite. One photon excites one electron, and this is read as voltage. The next step, involving an analog-to-digital converter (ADC), is to convert the voltage into digital data. As this is all monochrome information, in order to get color a mosaic filter is fitted in front of the sensor, with a pattern of red, green, and blue (there are twice as many green as red or blue because of the eye's greater sensitivity and resolving power in green wavelengths). As two-thirds of the real color information from the scene is lost in this way, the camera's processor has to interpolate it in a procedure called demosaicing.

The different digital values for each pixel, taken all together for the area of the sensor, can then be displayed as an image. A normal computer screen can display 256 distinct tones from black to white. In between taking the basic raw image data and delivering a digital image onto the camera's memory card, there is even more processing. Each camera manufacturer has its own processing methods, all with the aim of correcting errors and producing a generally pleasing result to the customer, which is you and me.

Yet one of the most important things to bear in mind with sensors is that they respond to light in a *linear* way. This simply means they fill up with an electrical charge in perfect proportion to the amount of light. On a graph this looks like a straight line, which is logical, so what's the issue? Well, that our own visual system is much more sophisticated and accommodating, and we don't see bright highlights and deep shadows disappearing abruptly. Our response—and that of film, incidentally—is non-linear, and that helps us see detail in a wider range of tones.

◄ SHADOW AND HIGHLIGHT CLIPPING
Clipping, shown here in the way an image is displayed on the computer when processing the Raw file, happens suddenly, not gradually, with changes of exposure. Each exposure here is one stop apart. Blue shows as completely featureless black, with red as completely featureless white.

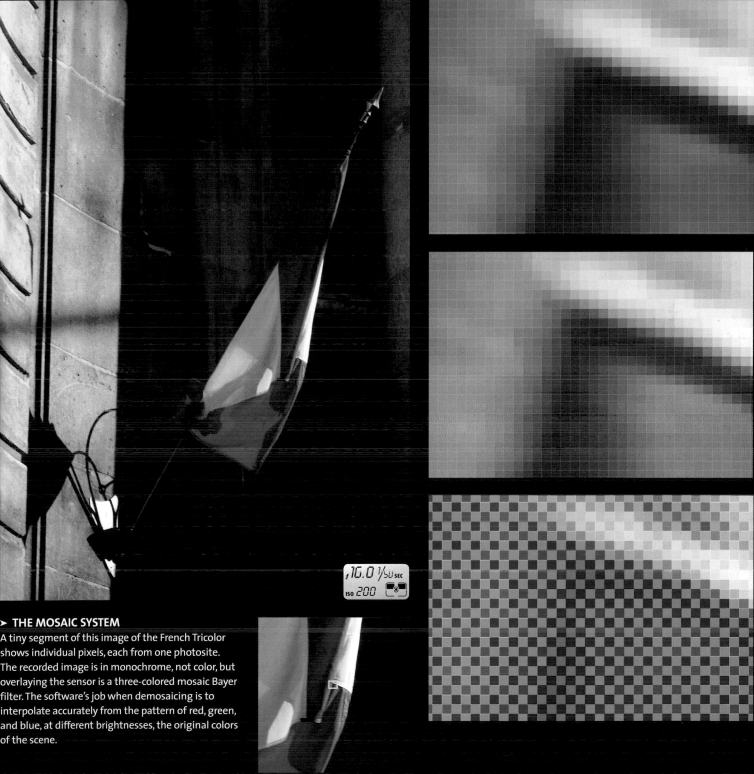

> **THE MOSAIC SYSTEM**
A tiny segment of this image of the French Tricolor
shows individual pixels, each from one photosite.
The recorded image is in monochrome, not color, but
overlaying the sensor is a three-colored mosaic Bayer
filter. The software's job when demosaicing is to
interpolate accurately from the pattern of red, green,
and blue, at different brightnesses, the original colors
of the scene.

EXPOSURE TERMS

At this point, I think it's useful to provide a basic glossary of the most common words and terms used in the business of exposure. In particular, there are several terms used to describe the quantities of light that seem at first glance to be very similar, yet they have important differences.

Beware that on the internet and even in some software interfaces, these terms can be misused. Software manufacturers need to find terms to describe what various sliders and controls do, even though some of these are quite complex. They usually reach for the nearest intelligible word, even if it really means something different. Lightness is one example. It really means the way the eye and brain judge the reflecting qualities of a surface. In other words, a piece of white card is lighter than a piece of gray card. In software processing, however, it usually refers to an adjustment that either adds white or black—a very different matter and a different result.

PSYCHOLOGY OF PERCEPTION

Light falling on the eye or the camera sensor is an essential quantity to understand, but what gets in the way is the psychology of perception. Our eyes and brain process the light information very differently and more intelligently than a camera sensor. So, luminance, which is the amount of light that a sensor faithfully records is a culmination of the physical and the perceived.

Physical, measurable quantity	Perceived, subjective quantity
• Luminance • Reflectance	• Brightness • Lightness

LUMINANCE

This is the amount of light (strictly speaking, luminous intensity) that reaches the eye or sensor from a surface or a light source. Essentially, the measurable quantity that comes closest to brightness, which is measured in candelas per square meter (cd/m^2).

ILLUMINANCE

The luminous power from a light source falling on a surface, per unit area, which is measured in lux.

REFLECTANCE

The proportion of light falling on a surface that is emitted by it. It is a measurable, physical quantity. Another way of looking at it is the effectiveness of a surface to pass on the light falling on it. The difference between a pure white surface and a pure black surface in the same lighting is no more than about 30:1, or 4 stops. If that seems surprisingly little, it merely emphasizes how the *amount* of light falling on different parts of a scene is much more important. 18% reflectance looks like 50% to the eye, due to the non-linear way we perceive, hence the 18% reflectance used for a Gray Card (see pages 54-55).

BRIGHTNESS

This is perceived luminance, so it is therefore subjective and not precisely measurable. It is the most common word we use to describe the amount of light we see.

LIGHTNESS

This is the perceived reflectance. It is subjective, like brightness, and the attempt by the eye and brain to judge how well a surface reflects light.

VALUE

When talking about light measurement, value equals brightness

EXPOSURE

In a camera, this is the amount of light allowed to fall on the sensor.

OVER- AND UNDER-EXPOSURE

These terms are often used vaguely and subjectively to mean more than (over-) and less than (under-) ideal.

HIGHLIGHTS

The upper end of the tonal scale, either in the scene or in the image. There is no precise definition of the cut-off point. Some people understand the term to mean the upper quarter of the range, while others believe it means the top few percent only. Clipped highlights by definition are those at the very top that have been completely over-exposed.

SHADOWS

As with highlights but at the opposite end of the scale. It is a word that varies in use.

CLIPPING

Total loss of information in a pixel because of extreme over- or under-exposure.

BLACK POINT

In a digital image, the point on the lower end of the tonal scale that is completely black—0 on the scale from 0-255. When processing a digital photograph, you can choose where this point should be.

WHITE POINT

In a digital image, the point on the upper end of the tonal scale that is completely white—255 on the scale from 0-255. When processing a digital photograph, you can choose where this point should be.

DYNAMIC RANGE

The ratio between the maximum and minimum luminance values, in a scene or in an image.

CONTRAST AND CONTRASTY

Often used interchangeably with "dynamic range," though it does not necessarily mean the same thing. However, it did in the days of film, hence the confusion. Contrast is the ratio between high and low luminance values, but does not necessarily involve the entire tonal range. Commonly, it refers to the ratio *excluding* top highlights and lowest shadows.

KEY

There are two meanings here. One refers to which part of the brightness range is being used in an image, thus high-key or low-key. The other refers to a tonal area (or zone) of special importance.

EXPOSURE AND NOISE

Noise is the digital equivalent of film grain, but without any redeeming qualities. I make that qualification because grain in a film image can add a structural texture that some people find pleasing. Digital noise, however, only detracts from an image, and it's as well to be cautious when comparing these two very different effects.

As in sound, which is where the word comes from, image noise is a sampling error. The sensor collects photons, but as photons arrive irregularly, the fewer there are the more the sampling error. This is why noise is at its worst in dark tones. And at its worst, it overwhelms image detail. Look at a noisy image at 100% and you will have difficulty in distinguishing real detail from noise. At this point all you can rely on is your perception, using a mixture of knowledge and imagination. However, if you examine areas with evidently little or no detail, like a typical sky or a piece of plain cloth, or indeed any area that is obviously out of focus, any noise will stand out very clearly as there is no detail to compete with. On the other hand, if there is an area full of small detail almost down to pixel level, such as dense vegetation, it may be hard to see the noise above the detail.

The lesson here is that noise appears at its worst in dark tones and smooth areas. Now, so long as the dark tones remain dark, the sheer lack of visibility will keep much of the noise in a noisy image hidden. Problems multiply when you take any action to open up the shadows. If you increase the exposure, you allow the sensor to collect more photons, which is good, but the construction of the sensor itself is never perfect and at long exposures these imperfections become more obvious. This is known as dark current or dark noise, and is consistent for any one sensor at the same temperature. Most of it can be removed by the simple method of making another equal exposure without any light, and subtracting the noise generated from the actual image in the first exposure.

Increasing the sensitivity settings of the sensor, by raising the ISO setting, has the greatest visible effect. New sensor designs and demosaicing methods have concentrated on this area, and some high-end cameras are noticeably more usable in low light than others. Also, improved noise performance is one way to increase the dynamic range of a camera, as we'll now see.

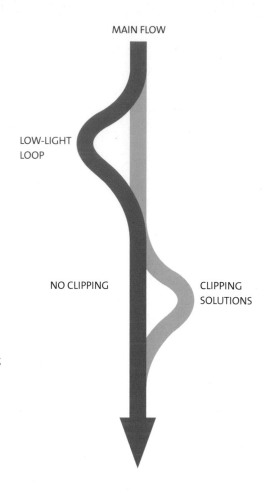

MAIN FLOW

LOW-LIGHT LOOP

NO CLIPPING

CLIPPING SOLUTIONS

▲ LOWLIGHT FLOWPATH
Almost all noise issues are confined to shooting in low light, and this involves a special set of considerations for the exposure—in other words, take the Low-light Loop in the Decision Flow (see pages 14-15).

◄ WITHOUT NOISE CONTROL
Bad dark noise visible at 100% magnification in a camera Raw window. This night exposure, a small detail of which is visible, was at 6 seconds on an older DSLR, a Nikon D100, with the long-exposure noise option turned off. This means that the camera performed no dark-frame subtraction.

◄ **WITH NOISE REDUCTION**

◄ **WITHOUT NOISE REDUCTION**

Here are details from a shot taken at high ISO noise from a camera with excellent noise suppression—a Nikon D3. The ISO setting is a remarkably high 25,600, shown here with no noise removal attempted by the Raw converter, and with a strong 70% removal setting.

31

SENSOR DYNAMIC RANGE

Nothing beats the combination of a camera sensor and scene that are perfectly matched. In this argument, the technical follows the philosophical, because the ideal for any imaging system is that the equipment (the camera in this case) uses 100 percent of its capabilities to record the scene in front of it. Anything else means a loss of quality somewhere and in some way. There are many software techniques for recovering, adjusting, improving, and adding to the captured image, and in Chapter 3 we'll be making full use of them, but it's important to remember that there's always a price to pay. Yes, algorithms that pull back lost highlights from the brink, fill in shadow detail, and expand the range do perform minor miracles, but as we'll see they always involve subtle losses, and sometimes major penalties. The highest image quality in digital photography comes from using the full dynamic range of the sensor to capture the full range in the scene. It's not always possible, but it still remains the ideal.

As a rule of thumb, a good DSLR these days has a dynamic range of around 10 to 11 stops, or between around 1,000:1 and 2,000:1. This means that a single frame can capture brightness levels 10 or 11 stops apart without clipping. Dynamic range for a sensor depends on two things principally—which is to say, two limits. One of these is the capacity of each photosite to hold electrons, called *full well capacity*. The larger the area of the photosite, the better this will be, and modern high-end DSLRs have capacities in the range of 7,000-10,000 electrons. At the other end, the limit is set by noise, and the point at which noise cannot be distinguished from real detail is called the *noise floor*. Modern DSLRs have noise floors of around 4-8 electrons. Divide the full well capacity by the noise floor and you get the dynamic range.

For all die-hard film enthusiasts, I'm afraid this is quite a lot better than the dynamic range of film, mainly because of the loss of shadow detail to grain. Of course, film has other qualities, and this poorer performance on dynamic range

is tempered by two things in particular. One is the more pleasing roll-off in the highlights, which we'll look at over the following pages, and the other is that grain clusters have the potential to be, well, more *likable* than digital noise. This is hugely subjective, but generations of photographers have come to accept that grain can, under certain conditions, be accepted as part of the texture of the image. Noise is unlikely ever to be tolerated in the same way.

▼ DYNAMIC RANGE

The dynamic range of a sensor is the difference between the full well capacity (the maximum number of electrons each photosite can hold) and the noise floor (the point at which noise swamps all subject detail). The noise floor is strictly set by the read noise, but shot noise, which is associated with the random arrival of photons, is related to the signal, and so in practice reduces the dynamic range further.

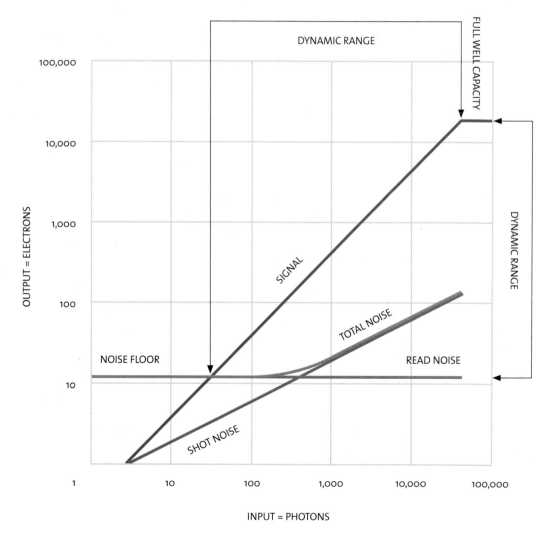

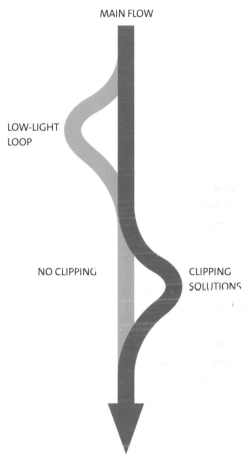

MAIN FLOW

LOW-LIGHT
LOOP

NO CLIPPING

CLIPPING
SOLUTIONS

▲ IDENTIFYING A CAMERA'S DYNAMIC RANGE

A photograph on an African oil rig in bright sunlight with some deep shadows. The scene is a little beyond the range of the camera, a Nikon D100, even though shot in Raw. A detail from the shadows, opened up fully in the Raw converter, shows noise overpowering content. A detail from the highlights, with exposure reduced fully, shows clipping—the edge of this area represents the full well capacity. The dynamic range of the sensor on this older camera model is in the region of 9 stops.

▲ CLIPPING FLOWPATH

When the dynamic range of the scene exceeds that of your sensor, any exposure decision must take the Clipping Solutions Loop in the Decision Flow (see pages 14-15).

HIGHLIGHT CLIPPING AND ROLL-OFF

Losing image detail is the big issue in exposure, and comes before all the subtleties of what happens to the middle tones. Visually, losing detail in the highlights is always more obvious, and looks worse to most people than losing it in the shadows. There is also a higher risk of it occurring. The usual term for it in digital photography is highlight clipping. This is a very apt expression, because one of the worst things about over-exposure with a digital camera is that when the highlights go, they go suddenly, as if they've been cut or clipped. Highlight clipping is worth special attention.

At this very top end of the register, digital highlights can behave in unusual ways that don't fit with the way we see, and which is visually not particularly pleasant. (I realize this is subjective, and under some circumstances it's possible to make creative use of it, but we'll come to that in the next chapter, on pages 106-109). If there is over-exposure, the highlights tend to clip with a fairly sharp and obvious break that is quite different and harsher than the way film would record the same image. It is also harsher than the way we perceive it. The S-curve that used to be familiar to anyone shooting film is a good diagrammatic way of showing the response of not just film, but also the eye and brain, as I touched on earlier (see pages 24-25). This is also the curve that has to be applied in the camera to a Raw linear digital image, in order to make it look acceptable. With film, the top end of the curve that slopes away to become flatter and flatter is called the *shoulder*, while the lower end is the *toe*.

Digitally, it's more common to talk about roll-off, which means essentially the same thing, that in the highlights the tones grade gently away rather than going abruptly to white. In-camera processing does its best to make this happen, and much later, when you process Raw images (if you shoot Raw), there are procedures for applying extra roll-off. However, there are limits to how successful this can be, because when pixels on the sensor have reacted to so much light that they have reached full well capacity, that's it—they are blown and there simply is no visual information there any more. Additionally—because the three color channels of red, green, and blue often clip at different exposure points—there may be odd color fringes.

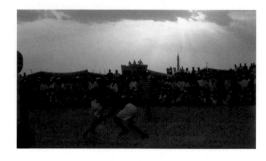

▲ ▼ POST-PROCESSING
Clipping is inevitable when shooting into the sun in a single frame, but the hard edges are a particular and unpleasant feature of digital capture. An unwanted side-effect is the different clipping points for each channel, which gives color banding. In-camera processing can help, but this varies from model to model. Shown here, left to right, is the original, Raw post-processed with 50% highlight recovery, and with 100% highlight recovery.

▲ AS SHOT

▲ 50% RECOVERY

▲ 100% RECOVERY

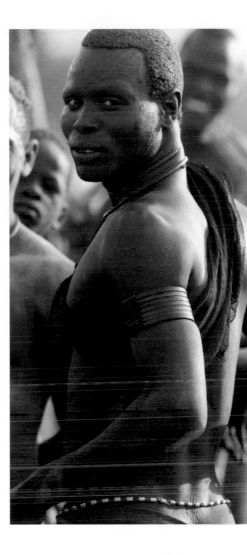

In this image of a Mandari cattle herder in Sudan, the area of interest is the blown highlights in the upper right corner. With Recovery in Photoshop's ACR (Adobe Camera Raw) turned off, there is a distinct edge to the highlights, visible especially on the left temple of the out-of-focus man in the background. Applying Recovery at the 25% set by Auto smooths this transition.

➤ ROLL-OFF

The effect of roll-off is subtle but important, illustrated here by switching off and on the default curve applied by one Raw converter. This is similar to part of the processing applied in-camera to non-Raw files, a curve that lifts the *shoulder* where the *lights* (the high values just below highlights) are. The area in question is a detail of the entire image, a bright white cloud. Note that even though the default curve actually introduces some clipping by lifting some of the highlights, it nevertheless softens the transition from lights into those highlights. Without the curve there is a noticeable edge to the white, with a color cast due to the three channels reacting unequally.

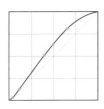 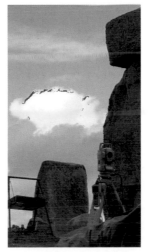 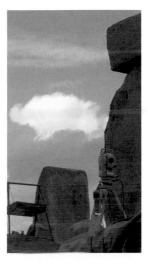

CAMERA PERFORMANCE

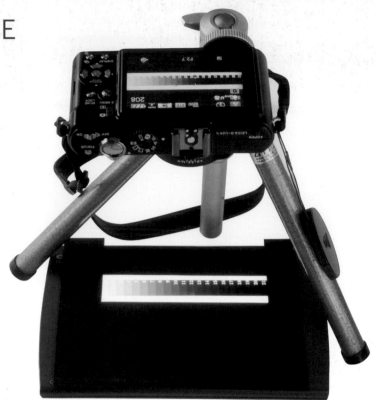

No longer are cameras just mechanical devices. In pre-digital days, engineering, build quality and the availability of good optics were all that mattered. Now, cameras embody sensors and circuitry—and they are all different. Camera makes and models perform better or worse across a range of areas, which include resolution, sensitivity, noise, dynamic range, and color. Not only are they all different, but they are all improving. Nothing stands still in this world. This is a fact of life, that your camera will give better image quality in certain ways than some other cameras, but be worse in some respects than some other cameras.

How do you find out exactly where your camera fits in? By measuring its performance, which you can do by running a series of tests. The most important for most photographers are: noise, dynamic range, geometric distortion, lateral chromatic aberration, color accuracy, and sharpness. The last is subjective, but key measurements are Spatial Frequency Response (SFR) and Modulation Transfer Function (MTF). For our purposes, the two most important are noise and dynamic range which, as we've seen, are intimately linked. Noise sets the lower limit.

Illustrated here are various work screens from the leading lens and camera testing software available retail, Imatest. Not everyone will want to go to this amount of trouble to discover their camera's performance, but there are quick-and-dirty methods that you can run using any processing software. What concerns us most in this book is the dynamic range your camera is capable of, but as we've already seen, this in turn involves sensitivity and noise.

A simple procedure, illustrated here, is to photograph a step wedge. These are available at selected camera stores and online either as printed scales or transmission scales on film. The one here, inexpensive and well-known, is a Stouffer 21-step transmission step wedge. Photographed backlit, it covers a much wider range of tones than a printed scale (reflection step tablet) could.

▲▾ USING A SENSITIVITY GUIDE

A compact camera in position for a close-up shot of a Stoufer 21-step transmission step wedge. The steps cover approximately 1/2 stop differences. Expose and process so that the lightest step (1) is just below clipping (about 250 on the 255 scale), then check the darkest step that is usefully distinguishable. This test is at ISO 80; at high ISO settings, stronger noise will interfere with distinguishing less-dark steps from each other. This is a rough guide only, but dynamic range in any case has a subjective element— someone somewhere has to decide on when noise overwhelms detail, and opinions vary.

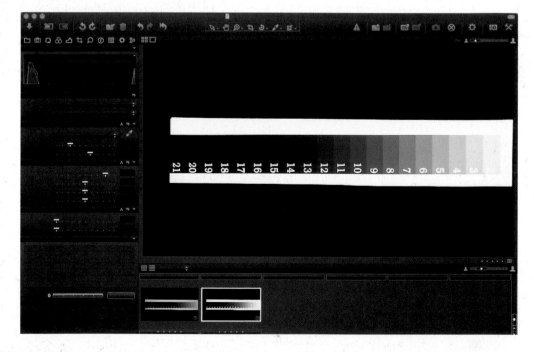

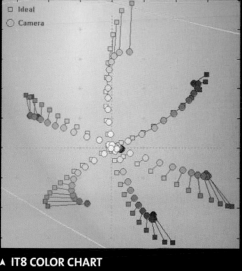

▲ IT8 COLOR CHART

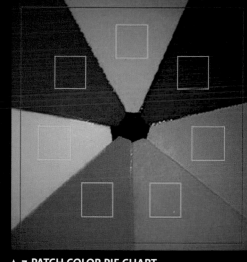

▲ 7-PATCH COLOR PIE CHART

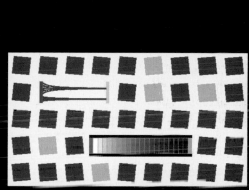

▲ DISTORTION

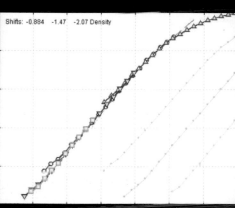

Shifts: -0.884 -1.47 -2.07 Density

▲ DYNAMIC RANGE PLOT

▲ ROI FINE ADJUSTMENT

SVGCHART PREVIEW section:

▲ SVGCHART PREVIEW

◄ ▲ IMATEST TEST SCREENS

Imatest performs its calculations on a range of tests that you perform on selected test charts. The selection shown here include a dynamic range plot for a Canon EOS 20D at ISO 100, Scalable Vector Graphics (SVG) chart for checking lateral chromatic aberration, Log Frequency contrast chart and Star chart for resolution, a distortion grid shown with moderate pincushion distortion overlaid, a two dimensional a*b* display of an IT8 color chart, and a 7-patch pie chart analyzed for vignetting and spatial color-shifts.

SCENE DYNAMIC RANGE

One of the key questions in exposure is this: is the dynamic range of the camera enough for the scene? Put very simply, does it fit? If it does, then life becomes much simpler, and there should be no reason for over-exposing or under-exposing, and there should be no reason for clipping. If, on the other hand, the camera's dynamic range is too small, then you have a potential problem, and in the Perfect Exposure decision flow this means taking the *Clipping Solutions* route.

The dynamic range of a scene is the product of two things—the light falling on it and the light reflected from different surfaces. However, of these two, the light is much more important. The difference in range between a white card and a black card is no more than 30:1, so it contributes relatively little when the dynamic range of some normal scenes can be as high as 10,000:1 or 14 stops. Most of this comes from the lighting. Naked lights create a higher range than diffuse lights because less of their illumination leaks into the shaded parts of a scene, so you can expect the range to be high under an intense sun on a clear day, and lower under clouds or in haze. In the studio, a naked lamp or a spotlamp creates a higher range than a softbox or umbrella. Also, the

more 3D relief there is in a scene, the higher the range, because there is more potential for deeper shadows.

The scene's dynamic range also depends on how you choose to shoot. Shooting towards the light gives a higher dynamic range than shooting away from it. Also, if the light source itself is included in the frame, the dynamic range is *always* high. I've been cautious about putting numbers on all this because the definitions of low and high are largely a matter of judgment, and are, for practical reasons, related to the camera's own range. If the range of the camera's sensor matches that of the scene—say, around ten stops—there's a reasonable case for calling it average or normal. Beyond this, there are degrees of high dynamic range and—because the term HDR (High Dynamic Range) now typically refers to digital imaging techniques that usually involve a series of differently exposed frames, 32-bit per channel processing and tone-mapping software—I prefer to split "high" into medium-high and true high. Of the two, true high dynamic range needs HDRI techniques, while medium-high dynamic range (perhaps two or three stops beyond the camera's ability) can be dealt with using less specialized methods.

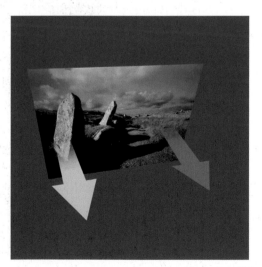

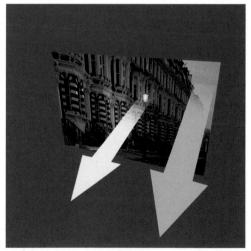

◄ REFLECTANCE VS LUMINANCE
Differences in reflectance contribute much less to the dynamic range than differences in lighting. In the view of the standing stones, both the stone face on the left and the grass are bathed in exactly the same light, so the difference in brightness is due entirely to their different reflectance—which varies only by around 1 stop. In the evening street view, the difference in brightness between the street lamp and the evening sky is due to luminance and is much greater, at around 5 or 6 stops.

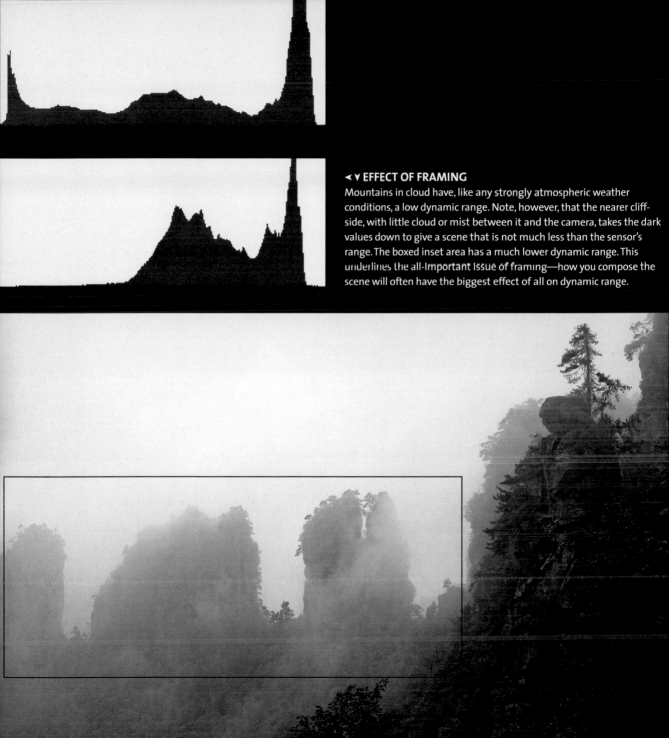

◀ ▾ EFFECT OF FRAMING

Mountains in cloud have, like any strongly atmospheric weather conditions, a low dynamic range. Note, however, that the nearer cliff-side, with little cloud or mist between it and the camera, takes the dark values down to give a scene that is not much less than the sensor's range. The boxed inset area has a much lower dynamic range. This underlines the all-important issue of framing—how you compose the scene will often have the biggest effect of all on dynamic range.

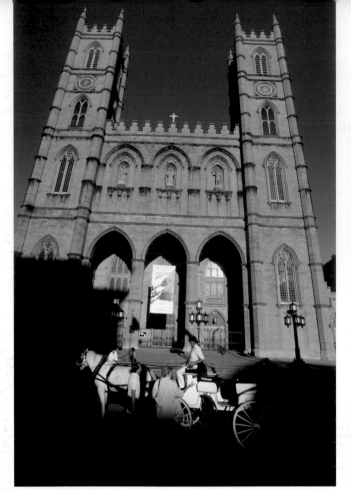

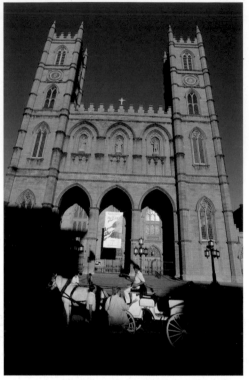

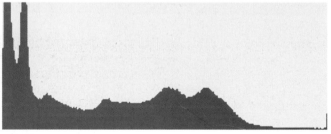

◄ ▲ BRIGHT CONDITIONS
Bright late afternoon sunlight in exceptionally clear, crisp weather, coupled with light surfaces (like the poster and the horse and carriage) and dense shadows give a dynamic range that is predictably higher than the camera sensor. The histogram crushes up against the left and right edges of the scale.

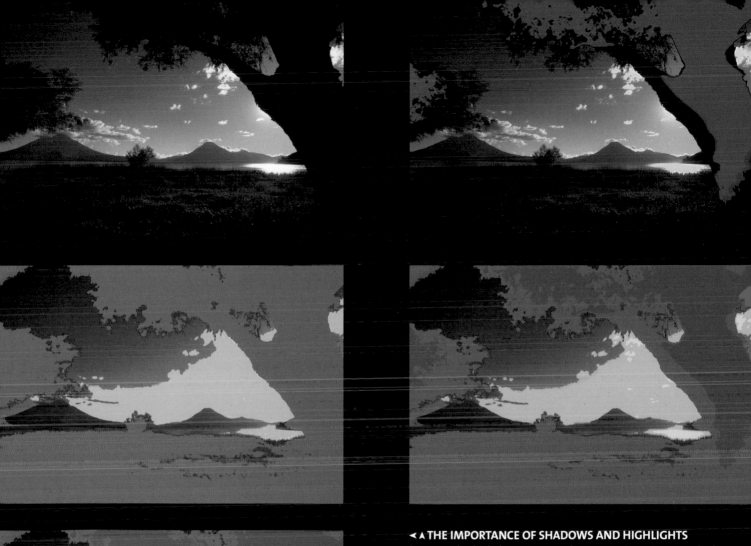

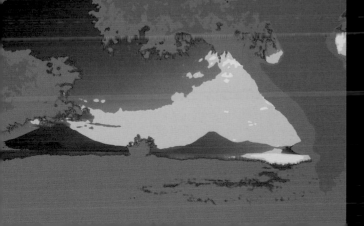

◄ ▲ THE IMPORTANCE OF SHADOWS AND HIGHLIGHTS

Scenes with a high dynamic range place greater importance on shadows and highlights in the sense of how to treat them. This very high-range scene in Guatemala, probably with a dynamic range of about 13 stops (I didn't measure it and it is strongly clipped), has very high values in the sun's reflection in the lake, and there would have been another two stops beyond this had I included the sun in the shot. Hiding the sun behind the tree was obviously one solution to keep the range down. The exceptionally clear air meant little diffusion, and so dense shadows. When shooting, a glance at a situation like this shows that a more or less average exposure will put the reflection in the lake and the bulk of the tree trunk out of range. There is no remedy in a single shot but to let the first go to flare and the second go to a silhouette. The medium shadows and highlights, however, become important areas to consider—that is, the grass and leaves on the one hand, and the white clouds and sky near the sun on the other. How you want to treat them becomes a matter for consideration—and for personal taste. See Chapter 4 Style for more on this.

CONTRAST, HIGH AND LOW

Contrast in photography has come in for some re-definition recently, or at least a closer and more accurate look. This is mainly because of a hangover from the days of film, when *contrast* was used to describe the performance of film and paper emulsions. Here, for example, is a classic description from the 1960s: "The inherent 'emulsion contrast' of a photographic material means in simple terms the range of gray tones it is capable of forming between darkest black and almost complete transparency" (Michael Langford, *Basic Photography*). Used in a general way, as in *a high-contrast scene*, it *is* the equivalent of dynamic range, but sometimes we mean different things. You can increase the contrast of an image, for example, *without* changing the dynamic range.

This calls for a closer explanation. Looking at a typical response curve, the contrast is actually well described by the angle of the slope on the middle section. The steeper it is, the more contrasty the image. This is why the word gamma is often used to describe contrast. If the slope is shallow—less than 45° on a standard log curve diagram—the contrast will look low. If it is steeper, the contrast will be high. The reason we talk about the middle section of the curve is that this is where the mid-tones are, and therefore most of the important information for the eye.

As we'll see in Chapter 4, in processing or post-production you can raise or lower the angle of the slope in order to alter the contrast. However, if you do this in Curves, just changing the shape by moving two points as shown here, you change the contrast but *not* the dynamic range, as the end-points of the scale stay where they are. This is why it becomes a little dangerous to talk about contrast and dynamic range as if they were always the same thing.

Moreover, it's important to be clear about what *area* of the image we're talking about, because contrast can vary *spatially*. This has become an issue since the invention of local tone-mapping—a digital processing technique now widely used, and described in Chapter 4. At one

ORIGINAL

extreme is global contrast, meaning across the entire image. At the other is local contrast, across small segments of the image. On the very smallest scale of all, across one or two pixels only, contrast affects sharpness—digital sharpening, in fact, means increasing the contrast between pixels. The terminology for this is still not quite universal, but it's valid and useful to talk about large-scale, mid-scale, and small-scale contrast. The images here show the differences.

CONTRAST AND GAMMA
Contrast and gamma are related, and even sometimes treated as identical, but offer potential for confusion. Gamma is a difficult concept to grasp because it is used to refer to different things in imagery and electronics. It is a measurement that relates input to output, and so in the language of monitors and color it is a mathematical formula that relates the voltage input to the brightness output on the screen. This seems a long way from what we are discussing here, but it's important to establish that very specific use, as it crops up when you calibrate your display screen. Gamma encoding is necessary when transmitting image signals in order to give a realistic-looking brightness and contrast. For this reason, gamma is often used interchangeably with contrast. The higher the gamma, the steeper the slope, and the more contrasty the image appears.

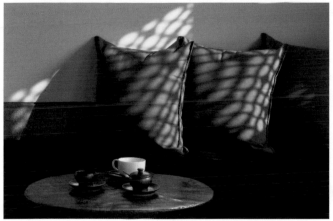

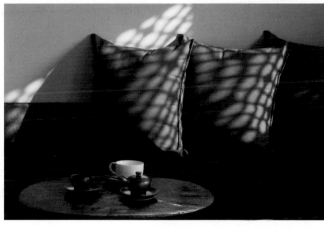

CLARITY

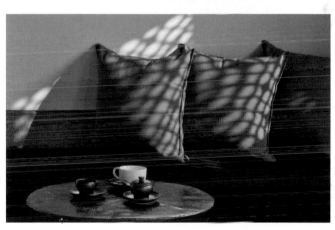

LOCAL CONTRAST

◄ ▲ DIFFERENT SCALES OF CONTRAST

To demonstrate the differences between global and local contrast, here I must step away from exposure and into processing so we can make direct comparisons on a single image. These differences, however, exist everywhere in real life. The dynamic range in this scene remains unchanged. The scene as shot shows a histogram that fills the range, but with the bulk of the tones off-centered towards dark. Applying a standard contrast-increasing S-curve gives deeper shadows and brighter highlights, but without clipping, as you would expect. The effect is more

contrasty, and the histogram shows the bulk of tones being "stretched" outwards. In comparison, look at what happens when a reverse S-curve is applied for a lower contrast, with the histogram showing the bulk of the tones more compressed on the scale. A different kind of contrast— mid-scale, which is increasingly called clarity these days—comes from increasing sharpness slightly over a large radius (there are other techniques to get similar results). A third kind, which is different again and more localized in its effect, is created by using a local-contrast control (Shadows/Highlights in Photoshop).

METERING MODES—BASIC AND WEIGHTED

For camera manufacturers, metering has a high priority, and there is continuous product improvement as they try to satisfy the needs of every photographer as seamlessly as possible. For this reason, all SLRs and high-end cameras offer a choice of metering, and while all the development work goes into the smart modes that we'll look at on the following pages, the original basic modes are there for anyone who wants full control.

Naturally they vary from model to model, but the possible choices are these: average, center-weighted, center-circle, and spot. The essential thing to do with any new camera is to learn exactly how these work and what areas of the image are being measured.

Average metering means measuring the entire frame with no bias at all, and is quite rare nowadays. It tends to be confined to top-end professional cameras as one of several options. Its value is the same as for spot-metering—you don't need to guess what fancy adjustments the camera manufacturer has built into the method, because there aren't any. If there is a sliver of bright sky at the top of the frame, that will not be ignored but simply included in the overall measurement. In Photoshop you can get a perfect simulation of this by taking any image and giving it an average blur (*Filter>Blur>Average*).

Center-weighted metering favors the broad center of the frame, and usually excludes the top (when horizontal) to avoid the occasional bright strip of sky in a common composition from affecting the reading. This was the earliest attempt to anticipate how users take pictures, but it's fairly crude by modern standards. Although useful, it is not always easy to find out exactly what the bias is, and this can sometimes make it tricky when you want to make fine or very accurate adjustments.

Center-circle metering defines itself. The reading is taken from a circle of a particular diameter, and when this circle is engraved on the focusing screen (though not always, by any means), this can be very useful indeed, like a large spot reading. However, cameras with this method may actually be reading a fuzzy version of the circle, with no abrupt cut-off at the edges, and it's important to know this. Some cameras offer different circle diameters, such as 8 mm, 12 mm, 15 mm, or 20 mm. The way to check circle fuzziness is to aim the camera at a scene containing a sharp-edged, high-contrast area, as shown here.

Spot-metering mimics that of a hand-held meter. Only a very small circle, usually between 1% and 2% of the entire area, is measured, which allows you to focus on any detail of the scene. If that happens to be the key detail, you can see how valuable spot-metering can be at times. As with center-circle metering, the limitation is when you cannot see exactly the circle being measured on the focusing screen.

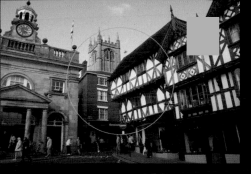

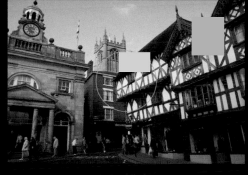

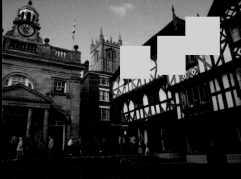

15MM CENTER-CIRCLE

8MM CENTER-CIRCLE

2% SPOT

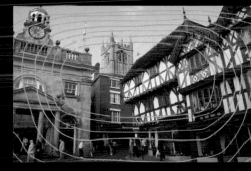

◄ ► USING THE CHOICE OF METERING

Staying for now with the basic, relatively primitive choices that have been available in SLRs for many years, the differences in a fairly undemanding composition and setting are not great. The larger center-circle takes in a little more of the sky than the smaller center-circle, and the result is a difference of not more than 1/4 f-stop with this scene. Center-weighted metering is well suited to this particular image, as it pays less attention to the brighter sky at the top of the frame. With spot-metering (or partial metering), the center spot is not intended to be used dead center, but rather aimed at a tone in the scene that you identify as key or average. This involves aiming off, locking the exposure (usually by keeping the shutter release half-pressed) and re-framing.

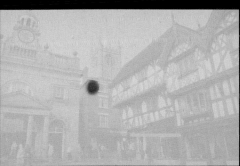

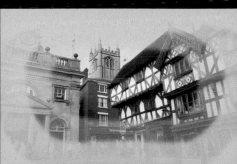

SPOT SELECTED BEFORE RECOMPOSITION

CENTER-WEIGHTED

METERING MODES—SMART AND PREDICTIVE

The real development work in metering has gone into increasingly sophisticated ways of trying to match the reading to what is actually in the frame, and these go under different names according to the camera manufacturer, including *Matrix*, *Multi-zone*, *Multi-pattern*, *Honeycomb*, *Segment* and *Evaluative*. This is a huge challenge. Part of the solution lies in dividing the measurement into various segments. The other part is making some kind of prediction from this pattern of brightness about what is important in the scene.

At present there are two manufacturer approaches to this problem. One method—described in simple terms—involves building a database of all the kinds of photographic composition that people make and working out good exposure settings for each one. Then, the metering pattern in the camera as you shoot can be compared with this database to find the nearest similar pattern, and a precalculated exposure setting to match that pattern is applied. Nikon, who do this, claim a database of tens of thousands of researched photographs.

The second approach, which can be combined with the first, is content recognition—an imaging science still in its infancy. The goal is to recognize subjects in the frame, such as faces and figures. Shape is used, as is focus, on the reasonable assumption that what you choose to

SHOOT

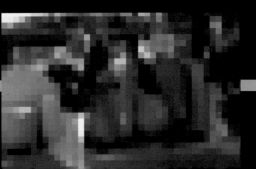

▼ THE SMART, PREDICTIVE WORKFLOW
NIKONMETERING
This is a simplified workflow of the newest Nikon metering system. A high-definition (1005-segment) sensor is dedicated to metering the view. In addition, subject movement in the frame is tracked for priority. This data is analyzed and the results compared with a database of photographs that numbers in the tens of thousands. Exposure compensations have already been worked out for all these possibilities, and the appropriately matching one is used to calculate the exposure for the image.

METERING SENSOR (1005 PIXELS)

TRACK FOCUS POINT

focus on is likely to be the key subject in your picture, and possibly even the key tone.

All of this is admirable, and works more and more of the time. As smart metering gets smarter, you can expect a smaller rate of failure, which is exactly what camera manufacturers are aiming for. The problem is that the very sophistication of the method makes it harder for the photographer to know what decisions are being taken by the camera's processor, and the camera manufacturers are understandably coy about giving away much information on their hard-won inventions. Also, not everyone likes handing over full control to an algorithm invented by a team of engineers. Going back to the basics of exposure, you still have to decide when it's appropriate to use smart metering and when not—and that means thinking about the exposure in all the ways I'm exploring in this book!

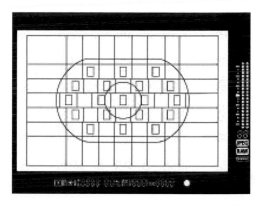

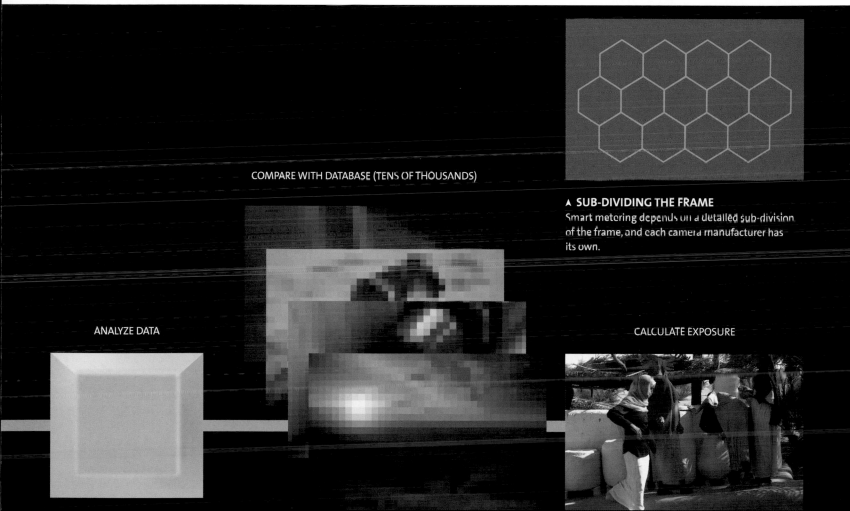

COMPARE WITH DATABASE (TENS OF THOUSANDS)

▲ SUB-DIVIDING THE FRAME
Smart metering depends on a detailed sub-division of the frame, and each camera manufacturer has its own.

ANALYZE DATA

CALCULATE EXPOSURE

METERING ADJUSTMENTS

Getting the perfect exposure means rising above total reliance on the camera's metering mode, whichever that is. As the first and all-important step is to know what you want from an image, you have to evaluate the exposure before committing to a metering mode, whether this takes a fraction of a second or it's something you decide at the beginning of a shoot.

Any lighting situation out of the ordinary calls for some adjustment, and there are various ways of doing this. There are two basic choices with an SLR or any camera that allows manual override and a selection of settings. One choice is between manual and auto. The other choice is between metering modes, one of the basic modes or you camera's smart mode. You can use any permutations of these two choices, and it really is a matter of personal working preference.

Let's look at the choice between manual and auto. Setting the camera to manual exposure is straightforward and leaves little room for error, but it does slow things down if you need to switch back to auto quickly for the next shot. It depends on the kind of shooting you are doing and the situation. Once in manual exposure mode, use whatever means your camera has for altering aperture or shutter, and watch the results in the viewfinder exposure display or on an external screen display. Staying with one of the auto exposure modes (typically shutter priority, aperture priority or programmed), use whatever control your camera has for adjustment/compensation. You may be able to pre-set the exposure compensation to, say, a third of a stop steps or half-stop steps. Check the exposure compensation display in the viewfinder or on one of the external camera screens.

Next, choose between metering modes. The slower, more reliable and predictable way is to use one of the basic un-weighted modes like center-circle or spot, and measure one of the key tones. This is a good choice if you have time on your hands, such as with a tripod-mounted architectural or landscape shot. A key technique here is to aim at an area of the scene that gives you the measurement you want, then (holding that exposure setting) re-frame for the desired composition.

If you're in a fast-response situation *and* if you are thoroughly familiar and at ease with your smart, predictive metering mode, make the adjustments from that. The essential thing here is how well you know the performance of your camera's metering mode, and that's mainly a matter of experience and familiarity. There is more of a risk in this case than with using a basic metering mode, but it tends to be quicker.

➤ ADJUSTING FROM MANUAL OR AUTO

1. With the metering set to auto (in this case, shutter priority), there is no adjustment display by default.

2. Switching to compensation mode displays the exposure scale with an exposure-compensation icon. With this camera, the corresponding button near the shutter release has to remain pressed while the exposure is adjusted with a wheel. The mechanics vary with the camera model.

3. The alternative is to switch from auto to manual mode, at which the exposure scale is displayed and the shutter speed or aperture controls can be adjusted.

1

2

3

FOUR WAYS TO ADJUST
1. Manual plus basic un-weighted metering—the slowest and most deliberate, but most reliable.
2. Auto plus un-weighted metering.
3. Manual plus smart multi-pattern metering.
4. Auto plus smart, multi-pattern metering—the fastest, but there is some risk of getting an inexact result.

This is a basic professional technique, especially with basic metering modes. If the key tone is off-center, or even out of frame, aim quickly at that and set the exposure, then quickly move back to the framing you want. Half-depressing the shutter release on most cameras locks the exposure, but check the manual for your camera to confirm this.

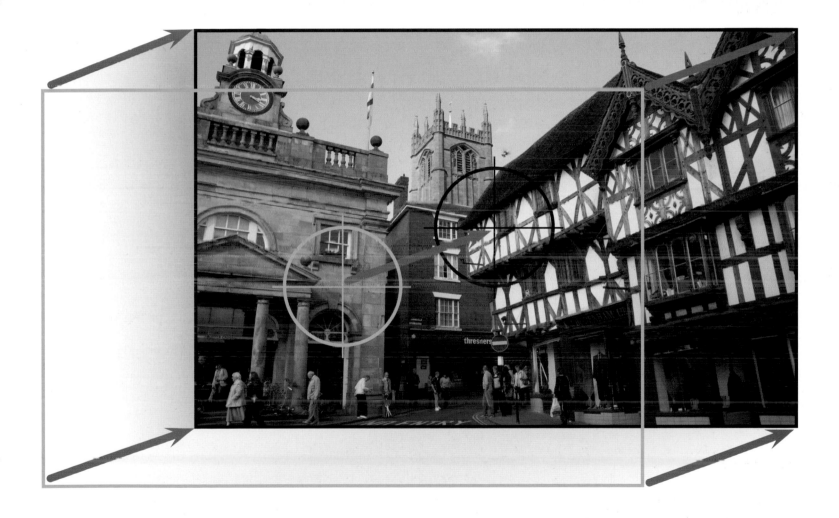

OBJECTIVELY CORRECT

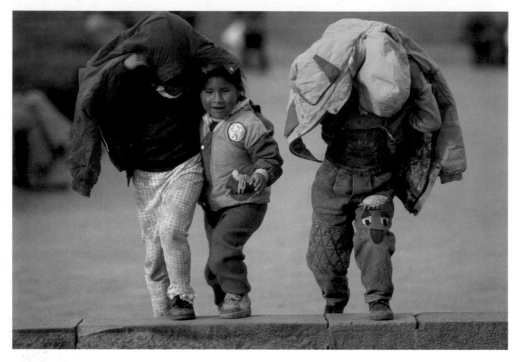

◄ **BALANCED IMAGE**
This picture of three children has no shadow or highlight areas to speak of, so nothing can be considered to be "blown."

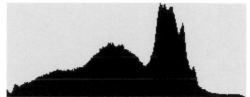

Is there such a thing as a measurably correct exposure? This is a good question, because while there is no dispute that the brightness of a photograph can be chosen to suit personal taste, there are also exposures that most people would say were too bright or too dark—in other words, wrong. The key words here are "most people," and if we're looking for "correctness," we must factor in collective taste. Of course, there needs to be some recognizable image in the first place, which rules out almost total black and almost total white. As it turns out, the best we can say about correctness in exposure and brightness is that there are norms that are accepted, and expected, by most people. This does not prevent anyone from taking off in an unexpected direction and working to an unusual exposure, but that will always be seen as unusual.

The norm in exposure comes from the way we perceive, from what is known of the HVS (Human Visual System). In particular, there are two aspects of exposure that this controls. One is the idea of "average" and the other is the limits of bright and dark. Brightness constancy is one well-known feature of the HVS, in which we see surfaces as keeping the same tone even when the light changes dramatically. A piece of white paper looks the same to us whether we see it in bright sunlight or by candlelight. The HVS adapts automatically to different amounts of light, and this is a form of normalizing. It's not exactly what the camera's metering system does, but it's not far from it in principle.

The limits of bright and dark are handled in a special way by the HVS. The eye adapts rapidly to varying brightness over the small area that it focuses on at any one moment. So, in a scene with a high dynamic range, when our attention flicks from deep shadow to bright highlight, our perception adjusts so that we see the details in each. Our view of the entire scene is built up from flicking over it like this, so we do not have the impression that the highlights and shadows are in any way "blown," blocked-up, or over- or under-exposed. That means that we expect the same from an image, hence the tendency for clipped highlights and pure black shadows to look in a sense "incorrect."

THE "PERFECT" HISTOGRAM
How much use you make of the histogram while shooting depends on time and on whether you actually like the more technical approach to exposure. It can be extremely useful, but also confusing and distracting, and if by nature you like to keep things simple and more intuitive by all means ignore it. On the computer, later, it's a different matter. Controlling the processing of images, particularly Raw format, more or less demands some attention to the histogram. If there's an ideal histogram—and you should be cautious about this—it has the end points of the range right up to, but not pressed up against, the left and right edges of the scale, and the bulk of the tones more or less centered. Like this, most images appear *normally* exposed, although there will often be good creative reasons for wanting it different, as we see in Chapter 4 Style.

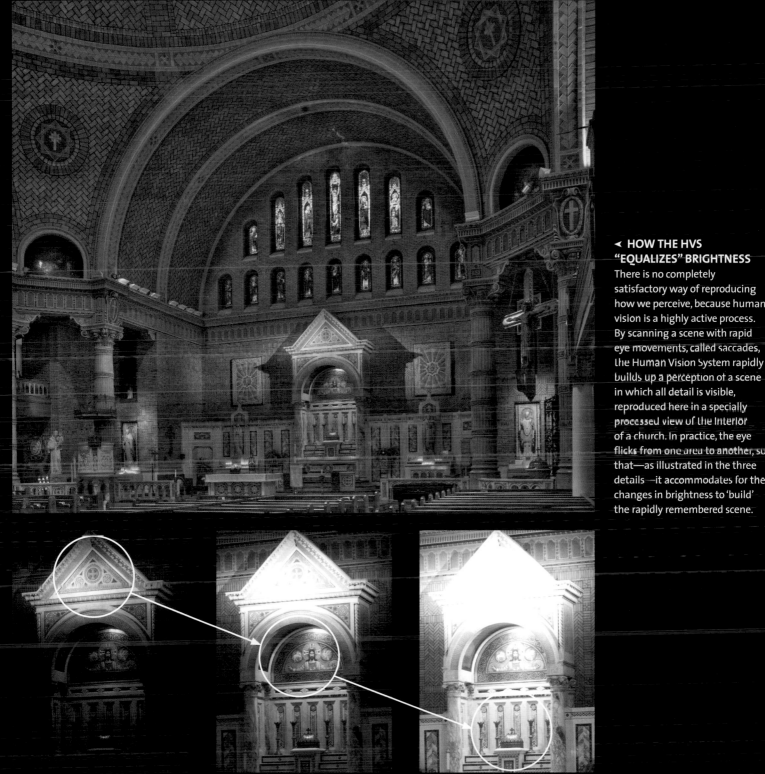

◄ **HOW THE HVS "EQUALIZES" BRIGHTNESS**

There is no completely satisfactory way of reproducing how we perceive, because human vision is a highly active process. By scanning a scene with rapid eye movements, called saccades, the Human Vision System rapidly builds up a perception of a scene in which all detail is visible, reproduced here in a specially processed view of the interior of a church. In practice, the eye flicks from one area to another, so that—as illustrated in the three details—it accommodates for the changes in brightness to 'build' the rapidly remembered scene.

HANDHELD METER

If you're really serious about exposure in difficult situations, and don't have to work at the speed of a news photojournalist, then a handheld meter is a worthwhile investment. With the right attachments, it allows measurements of great precision, calculations dedicated to exposure and luminance, and in particular, the ability to switch from direct to incident light readings. Direct-, or reflected-light, readings are what cameras make, measuring the light entering the camera from the scene. Incident light readings measure the light *falling* on the scene and are completely unaffected by whether the subject is white, red, gray, or whatever. In other words, if the scene is bathed throughout in the same light (by no means always the case), an exposure based on the light rather than the subjects will, in theory, be completely accurate. The attachment that makes incident readings possible is a translucent white dome that fits over the sensor. This basically mimics a three-dimensional subject, such as a face, and the technique is to hold the meter so that the dome faces the camera and is either right next to the subject or in exactly the same light.

Incident readings are the special province of handheld meters, but by no means the only one. These meters are designed to be adaptable and to offer dedicated help in measuring light, making calculations and suggesting the exposure. A different attachment, a flat translucent white disc, is intended to measure illuminance. To do this, you aim the disc receptor at the light source (as opposed to aiming the dome towards the camera for normal use). There are also various reflected-light attachments available. These have different angles of acceptance, such as 10°, 5°, or down to spot readings of around 1°.

➤ **HANDHELD METER**
Hand-held meters can make both incident-light and reflected-light readings, with the attachments to match. Here the incident dome is shown attached.

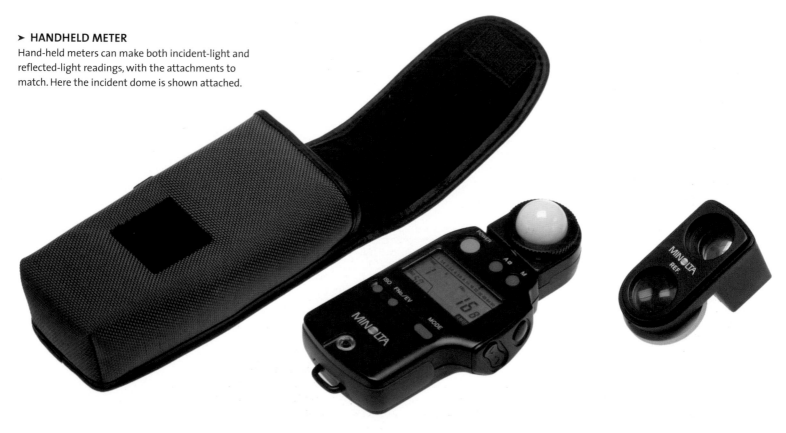

◄ AT-SITE INCIDENT
This late afternoon view of Fisher Towers, Utah, has high contrast, yet a single light source. An incident-light reading will work well here. The sunlight falling on the camera position is exactly the same as on the landscape, making it unnecessary to move closer to take the reading.

◄ ▲ USING A HANDHELD METER
Replacing the incident-light dome with a viewfinder allows reflected-light readings similar to using an SLR's center-circle method, but more precisely because there is no shading of sensitivity at the edges of the circle, which will probably more clearly marked, too.

GRAY CARD

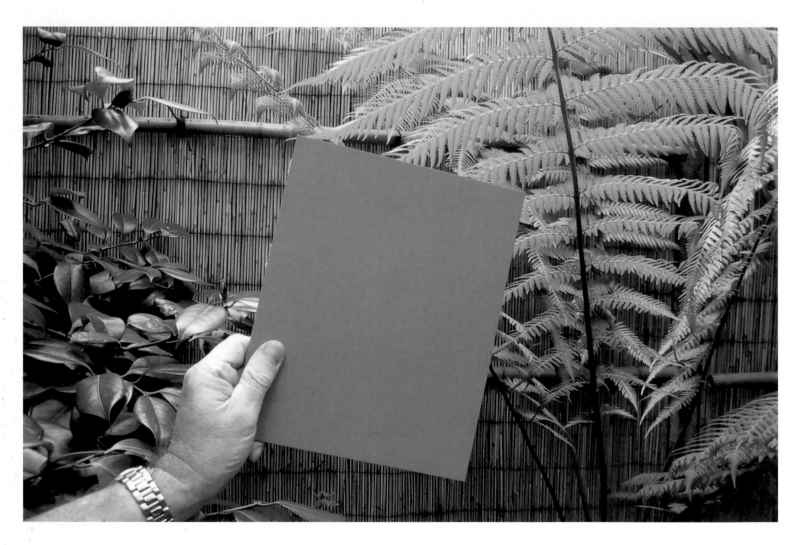

Incident-light readings, as we just saw on the previous pages, are an attractive idea when dealing with a wide range of subject surfaces in a single shot. You measure the light alone, so that the different surfaces fall where they will, just as in looking at the scene in a single glance. Well, there's an equivalent direct reading that you can use with the camera's own meter, and that's a gray card. So long as you buy a card made for photography (there are several manufacturers, including Kodak), you can use it to take the place of a subject for the reading. Gray cards reflect 18% of the light falling on one them, which makes them average, or *mid-tone*. If it puzzles you as to where the 18% figure comes from, this is because our eye and brain perceive in a non-linear way, and 18% reflectance is what *looks like* middle gray. In principle, when you take a reading of the card with the camera's meter, and photograph it, it should appear in the digital image with a brightness (as in Photoshop's HSB measurement) of 50%.

The other valuable property of a gray card is that, if it is made properly, it will reflect the same 18% across the spectrum. In other words, it will be neutral in color, which makes it doubly useful for calibrating the camera or as a reference for adjusting the color balance later on the computer.

However, there is one slight problem. Due to no good known reason—presumably the camera

▲ FOR SHOOTING
Using any localized metering mode, such as a center-circle, hold the card in front of the camera and measure it. It is usually easier to switch to manual rather than fiddle one-handed with exposure compensation. Make sure that the card is held in such a way as to catch the light evenly.

manufacturers follow a different standard for aesthetic reasons—most camera meters average to 12-13%, not 18%. That's not quite as bad as it sounds, and means a difference of ⅓ to ½ a stop, but it is inconvenient, to say the least. If you use the 18% gray card, the results are likely to be slightly darker.

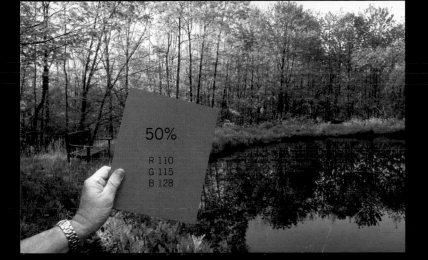

◄ **FOR POST-PRODUCTION**

An alternative way of using the card, and quicker for shooting, is simply to include it in the shot for reference, not necessarily making readings from it. Later, in processing, it is a valuable standard for adjusting both the brightness (exposure if processing Raw) and color balance, as in these examples. When you import the resulting image into your workflow software—for example Adobe Photoshop Lightroom or Apple Aperture—you will be able to make the necessary color adjustments to the gray card image at the beginning of a sequence and then automatically apply the same results to the following images.

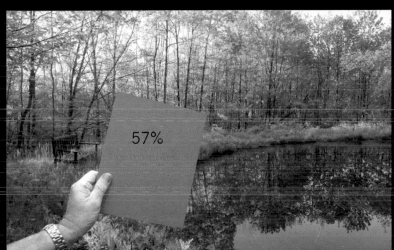

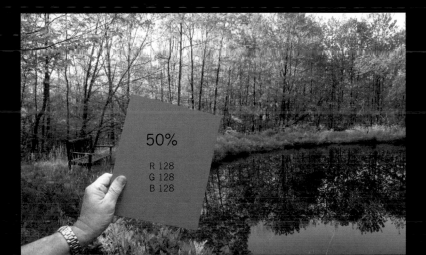

PRECAUTIONS WHEN USING A GRAY CARD

1. Make sure the card is evenly lit and facing the camera.
2. Fill the viewfinder frame with the card.
3. Don't allow a shadow (yours or the camera's, for instance) to fall on the card.

KEY TONES, KEY CONCEPT

This is a simple but absolutely essential concept, and fortunately one that many photographers follow instinctively. In any photograph, at least one part of the scene is more important than the rest. Deciding what makes an area important is an entirely personal choice, even though many scenes will invoke similar reactions from different photographers. For example, in the majority of shots that include a person, the face is what attracts the eye most readily, and the larger the area this occupies in the frame the more likely it is to be the key subject. It's likely, but not guaranteed.

The key subject of interest is usually, though not always, the key tone in the scene—the tone that determines the exposure. In Ansel Adam's Zone System, this is the area that would be "placed" in a particular zone, with any other areas that might suffer because of this being adjusted during processing. The basic logic is hard to escape. You decide what is important in a scene and how bright it should be, and then set the exposure accordingly. The way human perception works, we usually like to see the things that interest us averagely bright, meaning mid-tone, or to put it another way, 18% gray.

Yet this is tempered by what we expect certain things to look like. As we'll see on the following pages, there are certain norms in photographic imagery. Skin tones are expected to look a certain way, as is grass, a blue sky, a white wall, and other things that are so well known that everyone has a rough idea of how bright they should be. As an example, there might be a figure, small in the frame, running across an expanse of grass. The figure's action may be the most important subject, but the key tone is more likely to be the grass itself.

Often there is one clear contender for the key tone, influenced not only by what you intend as the main subject, but also by what is expected. However, there may be competing claims for key tone. Two areas, possibly more, may have to be catered for. The image of the Darfur women here is a case in point. According to my

judgment, there were two key tones, meaning two areas where the exposure had to be right. There's the girl's face, her head half-turned, with her dark skin that had to read as dark yet with all the essential details. The second area was the rest of the image, the mass of colorful *tobes*, as these Sudanese garments are called. I wanted these strong in color, so not over-exposed, while recognizing that orange is inherently a bright color. The question then is, or was, can one exposure satisfy both? The answer is yes, in this case, as the histogram shows.

In summary, it's hard to over-emphasize the importance of thinking in terms of key tones. Even if you choose to call them by another term, or call them nothing at all, they are at the core of choosing the exposure.

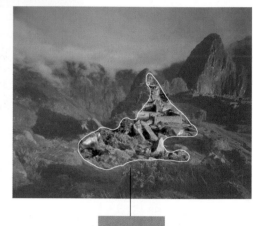

◄ ▼ SIMPLE SCENE
In this view of the Inca ruins of Machu Picchu in Peru, the contrast is full, but within the range of the sensor. The key subject is not in any doubt, as it is the sunlit middle ground close to the center of the frame, and although on a small scale the contrast is high, as a local area it is fairly consistent between stone and vegetation. There is no reason for the exposure to be anything other than conventional, middle brightness (50%). By my classification of scene type, this is the simplest, Fits #1.

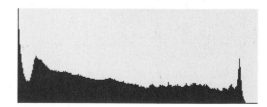

50%

➤ COLORFUL TONES
As explained in the text, the colorful garments were the main key tone (actually concentrating on the orange), but there was also a need to hold shadow detail in the one face turned this way. Fortunately, there was no conflict between the two key tones.

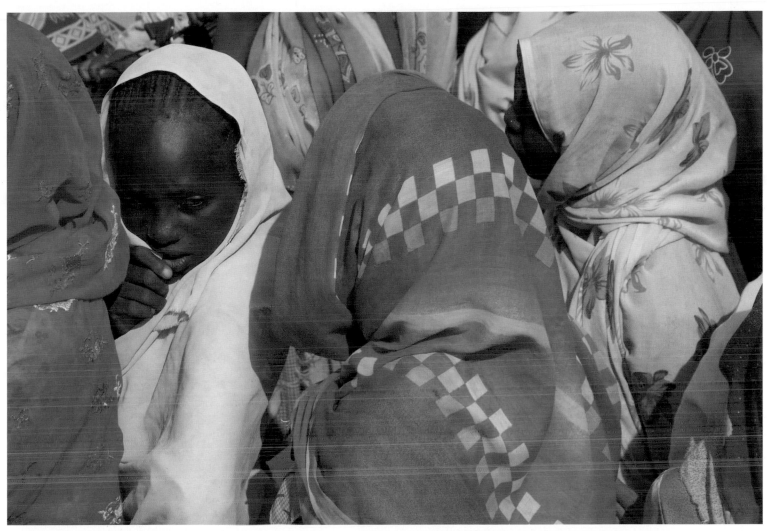

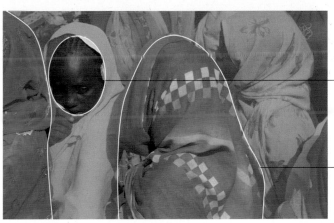

25%

70%

SCENE PRIORITIES

Identifying the key tones in an image is the first step in ensuring that the exposure is right for what you want, and it goes hand in hand with deciding what is *not* important. This becomes especially relevant when you are dealing with a high-contrast scene—that is, with a dynamic range higher than the camera and sensor can cope with. If the dynamic range is higher than the sensor can cope with, you may have to accept a compromise in the exposure, getting it perfect for one area but not quite right for another. When you have this kind of conflict, you have to allocate priorities, and often very quickly.

It's important to get into the habit of thinking about which tonal areas are important in any scene, and you don't even need a camera to do this. Step one is to decide what is the most important area—the key tone. Step two is to see if there are any other areas that ideally should be at a particular brightness. If there are, then you automatically have a first key tone followed by a second and maybe more. Another way of looking at this, which comes more naturally to some

people, is to say, "That's the area I want to set at a particular brightness, *but* I also want this other area to be such-and-such."

If you do have different key tone priorities, the next question is, by setting the first key tone to a particular brightness level, what will happen to the others by default? In other words, how far away will they be from what you wanted?

Perhaps you can get all the different key tones that you want simply through normal Raw conversion processing. This is not quite such a clear-cut proposition, because while Raw converters usually allow very strong adjustments to Exposure, Recovery, Shadow Fill, and so on, the cost may be an unacceptable loss of image quality, such as in noise or in an overall effect that just looks abnormal. On the whole, extreme Raw converter settings are a poor substitute for managing the exposure properly in the first place. And, as the example here shows, it may be better to accept blown highlights and blocked-up shadows than trying to recover both with an unrealistic appearance.

If the answer to the above is that no exposure will be ideal, then the decisions involve either changing the way you take the picture, or accepting a compromise. A third alternative is to use one of the more advanced digital post-processing techniques, which might call for a series of exposures. I'll look at this in more detail in Chapter 4.

▼ A TWO-PRIORITY SCENE
In this scene of a Canadian church mainly in open shadow but with a small yet significant area brightly sunlit, there were clearly two priorities in mind—two key tones. The first was the area surrounding the focus of interest, the two men. That had to be bright enough to read clearly. At the same time, however, I did not want to overexpose the sunlit patch, and this could easily clip because of the light white paint finish. Ordinarily, without the sunlit area, I would have increased exposure for the first key tone by about a stop and a half above average. In this case, to protect the sunlit area, I increased the exposure for the key tone by ⅔ stop only.

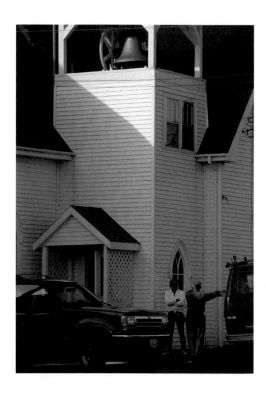

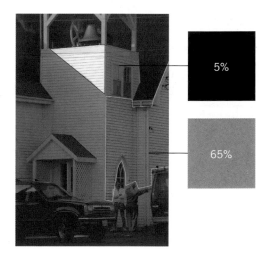

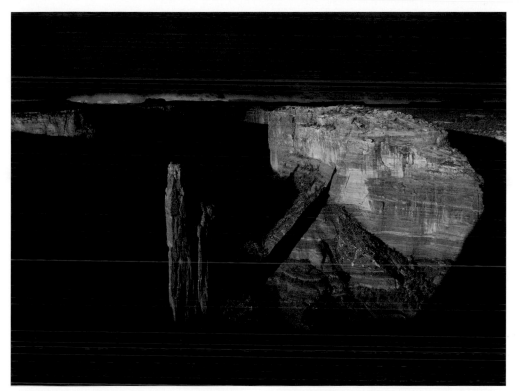

◄ A THREE-PRIORITY SCENE

Spider Rock in Arizona, with a very fortunate break in the clouds late in the afternoon. Dramatic landscape lighting like this works because it combines shafts of light striking the scene at a shallow angle, with resulting strong and often interesting shadows, and also because it contrasts the sunlit areas with a deep, stormy sky. Put bluntly, contrast rules here. For me, the first priority was to hold the major sunlit area of cliff brighter than average but still retaining all detail and good color. Typically I would expose about $^2/_3$ stop higher than the average reading for this area. Second, though, I needed to keep the light on Spider Rock itself close to average. The difference in brightness between the two distinct areas of rock was because of the surface reflectance, not the lighting, which was equal for both. Third, I wanted the sky as dark as possible, for maximum atmospheric contrast. These were the priorities for the scene, and in this case they offered no conflict. I would have preferred the lit parts of Spider Rock to be about $^1/_2$ a stop brighter, closer to the larger areas of cliff-face, but that was the way it was. I can easily adjust this in post-production if I wish, but to stay true to the situation I prefer to leave it as it is.

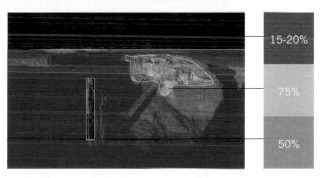

◄ BEWARE OF WANTING TOO MUCH

Knowing that you can pull back so much when processing makes it a temptation, even at the time of shooting, to expect to display all detail in all tonal areas. Here, as you see, it's possible, but the result is dreadful and unrealistic. The key tone, for me, was the rich brown of the woman's face; the background in shadow is irrelevant, and even the lack of separation between her black hair and the background is fairly unimportant.

FACE PRIORITIZED

TOO MUCH DETAIL PULLED BACK

EXPOSURE AND COLOR

The exposure you choose has a special effect on the appearance of colors, and it's not quite as simple an effect as many people imagine. Over-exposure weakens the intensity of any hue, while under-exposure strengthens it—but only to a point, and depending on the particular color.

The most vision-friendly way of defining color is by the three qualities Hue, Saturation, and Brightness (HSB). This pretty well matches the way we think about color—if and when we *do* think about it. Hue is what most people mean when they say "color," the essential quality of being blue or red or green or purple, and so on. Saturation is the purity of the color, and brightness makes up the third parameter. Varying the exposure changes the brightness of a color, but this is complicated by the fact that different colors exist only in different ranges of brightness. Yellow, as the extreme example, can never be dark. If you under-expose significantly it becomes essentially another color—ochre. Blue, in contrast, retains its essential blueness at any exposure. The chart here contrasts the different behavior of colors with changing exposure.

Intentional slight under-exposure was a common practice for photographers using color transparency film, especially among professionals shooting for reproduction in magazines and books, as their aim was to get strong colors. They relied on the ability of the repro house and/or printers to pull back the overall loss of brightness while holding the color. The same, with even more control possible, applies in digital photography. This is, of course, only if you *want* strong, rich colors. It's also important to know the limits for doing this. As a general rule, slight underexposure increases the intensity of hues, while strong underexposure just darkens them towards black. Over-exposure reduces the primary characteristics of hue, creating paler and paler tones.

This kind of color control through exposure may conflict with other image needs. One of the most common conflicts is a colorful sunset. Maximum color intensity is at the expense of

detail on the ground, which often leads people to shooting silhouettes for this kind of landscape photograph. Multi-shot exposure blending is one worthwhile digital solution.

➤ COLORS REACT DIFFERENTLY TO VARYING EXPOSURE

In this color pattern, the spectrum of pure hues varies with exposure, from under-exposure at the bottom to over-exposure at the top. Although it is not easy to relate this to a typical photograph, it shows how some colors, such as yellow, change their basic character (yellow becomes brown), while others, notably blue, remain consistent.

∧ ➤ EXPOSING FOR A SUNSET

This is the classic issue you are presented with when choosing sunset exposure: in order to maximize the intensity of the color, under-exposure helps. As a result, ground features tend to block up, so work best if they make some sort of intelligible silhouette.

◄ COLOR ANOMALIES IN VARYING EXPOSURE

YELLOW: When under-exposed tends towards ochre, saturation peaks when bright.
ORANGE: When under-exposed looks brick red.
PURPLE: When under-exposed becomes a violet; when over-exposed tends towards lavender. Its saturation peaks when dark.

EXPOSING FOR COLOR

L et's take a step beyond the previous pages and consider what it means to adapt the exposure to the needs of particular colors (by which I mean specifically hues). As we just saw, different colors are at their most saturated, or most pure, at different brightnesses. This means that for each color there is one ideal exposure that delivers the combination of brightness and purity. This is easiest and clearest to do with colors that are already fairly pure, but difficult to judge, for instance, with an earth color or a drab green.

There is no reason why this should complicate exposure decisions. Rather, it stresses how important it is, if you are shooting with an eye for good color, to think about how colors respond to exposure. All you have to do is simply factor this in to your basic assessment of the scene. In the Decision Flow at the start of this book, this means deciding how you want a particular color to look in the image, identifying if there's likely to be a problem with it, and making it a key tone.

The time to pay extra attention to the colors in an image is when they are contributing more than usual. Not every image relies on its color content, and not every photographer has the same interest in color. For some scenes and some people, color is simply there by default, and does not have a special role to play. At other times, and quite often for me at least, color can be partly the reason for actually shooting. This adds an extra layer of thought to the shot; so when, as in these examples, some of the colors need to be either strong or accurate, make a point of thinking what varying the exposure might do to them.

◄ ► **STRONG COLORS**

I've chosen this scene for its strong urban colors; to show the effects more easily, even though most natural scenes have nothing like this saturation. It's important to realize that the normal computer/ Photoshop way of describing and measuring color saturation is of no help at all. Instead, we need to look at colors with an artist's eye, subjectively judging the overall color effect on our perception. The exposure differences, created during Raw processing, which is perfectly valid for this exposure range of 2 $\frac{1}{3}$ stops, are in $\frac{1}{3}$-stop steps. From this sequence of exposures, we can see that some are better for certain colors than for others. The yellow, for example, looks purest at a higher exposure, while darker it becomes ochre and drab. The magenta-red reproduces well when somewhat darker, but not as dark as the on-screen Photoshop saturation measurement would suggest (this gives maximum saturation to the darkest shade, although to my eye this becomes a different color). In making such judgments, you need to use your eye, and importantly your perception of the scene as you see it directly. It's for this last reason that I can be confident that this magenta-red looks best at an exposure of ƒ14. Having made this point, though, what practical use can you make of it? The answer is in two ways. One is to consider the purity of certain colors in a scene when assigning the key tone. The other is realizing that you can alter or restore the purity of a hue during processing, particularly with a Raw file.

ORDER OF BRIGHTNESS
In this scale of admittedly pure colors, that are more intense than you're likely to find when out shooting, the hues are arranged from inherently brightest to darkest. Yellow is the brightest hue when fully saturated, and violet the darkest.

*f*9

*f*10

*f*14

*f*16

*f*11

*f*13

*f*18

*f*22

BRACKETING

A long-established technique for dealing with uncertainty in exposure is to range the exposure up and down over a series of frames, from a few to several. In the days of film, this was costly, which put some brake on its use, but now it doesn't cost anything. The choice is between bracketing the aperture or the shutter speed, and there are arguments for both. Many cameras now offer an automated burst of exposure bracketing, accessed from the menu. This speeds up the process and is also useful for any subject containing movement that you intend to treat as an exposure blend or HDR image (see Chapter 5). Bracketing the aperture takes advantage at the darker end of more depth of field from a smaller *f*-stop, and allows the shutter speed to stay constant in situations where that is important, such as movement of branches blowing in the wind. Bracketing the shutter speed keeps the geometry and detail of each frame identical, which is necessary in multi-shot techniques (see the last paragraph). All current DSLR cameras have auto-bracketing, with a choice of the number of steps up and down from average, and of the size of each step.

Be warned that not everyone thinks that bracketing is a good idea, or even approves of it. The argument is that bracketing exposures is counter-skillful, rather like using a shotgun for target practice, *then* deciding which pellet won. Also, many people believe that any photographer who has mastered the craft ought to be able to achieve the perfect exposure in one. These are both true, but it *is* good insurance for those times when the importance of capturing the image outweighs personal performance.

There is a second, more digital reason for bracketing—not for choice but for coverage of the dynamic range. An increasing number of processing techniques make use of a series of frames in order to construct the final image, and two of the most useful are exposure blending and High Dynamic Range Imaging (HDRI). I'll deal with these in the last chapter, but they significantly alter the shooting possibilities. The circumstances need to allow the camera to be steady so that the frames are all in register, and while this ideally means a tripod and a subject that is polite enough not to move, like a landscape, other digital processing techniques can cope with a certain amount of movement, both of camera or subject. These involve alignment based on content, and work by locating the same graphic features in each image and then either re-positioning or warping to match. More about these in Chapter 4.

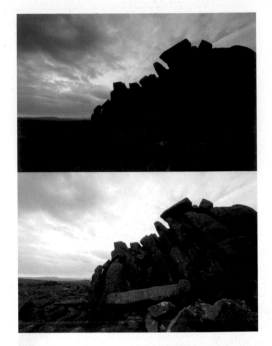

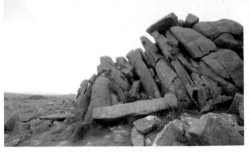

▲ SKY TO GROUND

Bracketing may be the only way to deal with shooting into the light. In this mountain scene in Wales, the steps are large—2 *f*-stops between exposures—and between them encompass most of the scene dynamic range. To render a final version that contains everything, from sky to foreground, some form of blending or even HDR tone-mapping will be necessary. The scene dynamic range is too big even for a carefully recovered Raw processing.

This street scene in Barcelona, Spain, had a high dynamic range due to deep shadows, high sun and very clear air. As an experiment in blending, I shot the nine-frame sequence, in 1 stop steps, handheld—hardly ideal conditions—combining some camera movement and considerable subject movement as people walked towards me. Frame alignment in the blending software (Photomatix), however, coped perfectly with the first issue, and the motion variance managed moderately well with the second. To deal with the inevitable overlaps and ghosting, I later copied the blended version onto the single exposure that was best for the moving people, and selectively erased with a brush.

 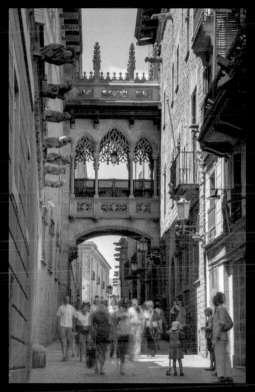

CHAPTER 3:
THE TWELVE

I can certainly be accused of over-simplification in claiming that there are only 12 types of exposure situations, especially as Nikon, for example, uses a database of more than 30,000 images as reference in its metering systems. Yet the vast majority are simply subsets of this essential group, and it means that for the purposes of exposure any scene you shoot can be assigned to one of just 12 types. And each of these calls for a different kind of decision.

How do I arrive at this number? Simply by long experience—my own and that of other professionals I know. Not that any of us thinks consciously of an exposure classification like this. We shoot every day, so the way we assess types of scenes subconsciously has simply been built up over time and is embedded somewhere in our brains. I generally don't have to think too hard about what kind of exposure situation is in front of me, because of long familiarity, yet part of my brain quickly assigns the scene to something I've dealt with before. All I'm doing here, in what I consider to be the key chapter of this book, is to articulate a collective experience. You can give each of the 12 situations any name that you choose, but they are each distinct and real.

Whatever you see through the camera's viewfinder, or on the LCD screen, will match one of these.

Embedded in this breakdown of scene types are two important assumptions, both of which might seem fairly obvious but are worth spelling out. One is the concept of key tones: which is that one or more areas in a scene have a commanding importance. The other is the recognition that most people expect most subjects to be close to average in tone, unless there is a special reason otherwise—for instance, evening scenes are darker because we experience the failing light.

FIRST GROUP (THE RANGE FITS)

This, in a way, is the ideal group. The dynamic range of the scene fits the dynamic range of the sensor—or vice versa. Obviously, there has to be some flexibility in the definition of "fits," but if we let common sense rule, it means no clipping on the one hand, and the histogram within, say, 5-10% of the limits on the other. If you shoot Raw, the extra dynamic range makes some difference, although not as much as is often claimed by its advocates.

Let's start by getting used to looking at images in different ways, making use of simple, accessible digital processing. I've already introduced the pixelated matrix, with its 18 squares on the longer side of the image, as a way of reducing an image to tonal distribution without the content interfering. To do this for yourself in Photoshop, simply make a copy of an image, reduce it in size to 1200 pixels on the longer side, then desaturate it. Finally use a Mosaic filter (in Photoshop this resides in the Pixelate submenu), choosing 67 for the Cell Size. When there is a key tone area to identify, I use a yellow outline. When it comes to mimicking the action of a meter, the area chosen is simply averaged (*Filter>Blur>Average*). Again, this can be a useful exercise to do with your own images, or selected parts of them.

However, processing and looking at the images in these ways is only for analysis, not something to do during shooting. A partial exception is the histogram, and even then it depends on how much time you have to make the shot and, indeed, whether you have time on your hands. If you are shooting anything the least bit active, there probably won't be any time at all. In this case, you might consider making a test shot of the scene before the action starts, or during a lull, to make sure you've judged it correctly.

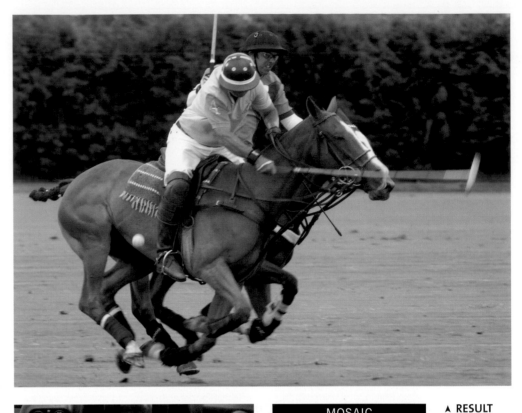

MOSAIC

▲ **RESULT**

◄ **SETTINGS**
VIEW: 100%
CELL SIZE:
67 square.

▲ **CHECK THE SCENE BEFORE THE ACTION**
When there is obviously not going to be time to waste checking the histogram for whether or not the dynamic range fits during the action, as in this polo match, do it before.

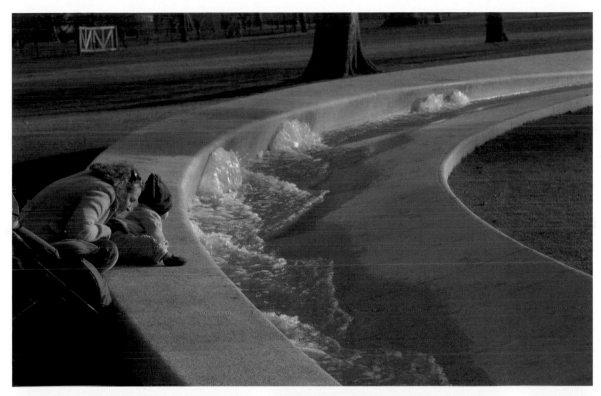

▲ QUICK LOOK ⟳

At a glance, an experienced eye should be able to tell in a scene like this that the dynamic range will fit a typical sensor response. First spot the maximum and minimum (water highlights and shadow below the parapet) and make a judgment. Ignoring the tiny specular highlights in the water, the average brightness for each is within range.

AVERAGE BRIGHTNESS OF AN AREA

To judge the average brightness of any area, make a selection and give it Average Blur, as indicated in the image above, then run the cursor over it and use the Info panel of your image editing program.

The sensor can just cope with the range of the scene, and the scene is sufficiently normal that an average mid-tone rendering does the job. If all photography were like this, exposure would never be a problem and there would be no need for this book. Naturally there are still a few decisions to make, mainly about whether the scene as a whole or the most important part of it should indeed be average in tone, and some finer decisions on whether the exposure should be just a touch darker or lighter according to taste. Lighting situations like the examples here are almost impossible to get wrong.

What is critical, however, is being able confidently to assign the right scenes to this type. The three examples here are chosen to show varieties of "average." The South American cayman (of the alligator family) is an example of a central subject that calls for a mid-tone. The landscape of rice fields is different in that the pattern as a whole should be average (and no significant part of it is out of range). The assortment of objects is a studio shot in which there is total control over the lighting, and whenever I can I'll be including studio or controlled situations, because they usually allow more time to calculate the exposure and the way of working tends to be different.

In theory, if the two dynamic ranges—scene and sensor—match, metered average exposure should result in no clipping at either end. In practice, there are lighting situations that can still throw the meter, which of course is the purpose of the key-tone system promoted in this book. The only significant problem you might have with this is when the key tone that is meant to be average is right at one end of the range. Exposing for this key tone can tip the other end of the range over into clipping, but this is not common.

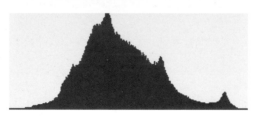

◄ ► CAYMAN SEQUENCE
At a glance, this image of a South American cayman seems to be well within range, although the small highlights and small areas of shadow around the head make it fit rather more closely than you might suspect. This is a straightforward case of exposure, with the cayman, isolated in its pool of water, the obvious subject. There is a slight difference between the subject and the key tone (as there often is) in that the key is the reptile's back. The head, with its shadows, is a little darker, but practically not enough to make a difference. The average brightness for this area, outlined in yellow in the pixelated version, is 48%, which is hardly different from the overall average of 46%. This is a problem-free exposure situation.

46%

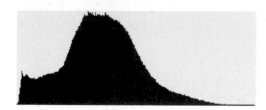

46%

▲ OLD CHINESE OBJECTS

An artist's collection of antique Chinese objects, including a terracotta head, scissors, and an arrowhead. At a glance, the scene in the way it is framed and cropped is average in tone, a fraction darker than average. In fact, I added a low, raking spotlight from lower left, quite weak, in order to liven up what was rather flat ambient lighting. Again at a glance, the only areas to draw attention for exposure are the highlights and shadows around the head. The bright patch on the chin facing the spotlight needs to hold, while the shadows on the other side of the head are really in no danger of blocking up. In other words, an average-toned scene which has had its range lifted by a spotlight. Strengthening the spot (it had a dimmer control) might take the highlight close to clipping, but adjusting it was completely under my control. Capture settings: 105 mm efl, ISO 160, 25 sec, ƒ38.

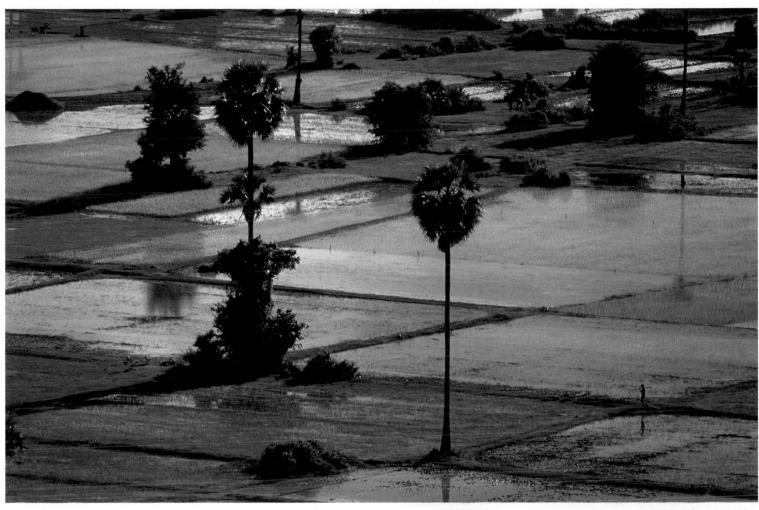

▲ ➤ ANGKOR RICEFIELDS SEQUENCE

Possibly more common than a defined single key tone is this kind of situation, when several tones are scattered around the frame, making it hard to say which, if any, should be the key. Nevertheless, the average of all of them, the entire frame, should be average. There is a very small subject that makes a difference to the image—the man walking between fields in the lower right of the frame—but while the timing of the shot was obviously made for him, he is so small in the frame as to be an irrelevance for working out the exposure. Notice that the average brightness for the frame is five percent less than mid-brightness. "Average" does not have to be precise; I simply preferred it be slightly darker. In practice, what happens with a shot like this is that a quick glance shows it is within range and is simply a candidate for unadjusted average metering. The capture settings were 400 mm efl, ISO 50, ¹/₁₂₅ sec, f8.

46%

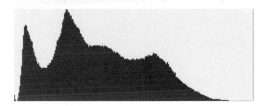

In this scene, the range is still neither high nor low, but the difference is that the subject (or most of it) is light by nature, and we want to keep it that way. Some of the naturally light subjects that immediately spring to mind are snow, white walls in an interior and a white dress. These are, of course, the lightest things, but there are many other surfaces that are not quite so light yet are still light in the way we expect them to look, such as pale Caucasian skin. Whether or not the dynamic range fits is down to the other objects in the scene, and in these two examples there is nothing seriously dark that would make the dynamic range high. If the key tones take up much of the frame, as in the examples here of the interior and the aerial snowscape, an average meter reading will *not* give the right result, and both these scenes called for adjusting the exposure to be higher than average. These are the simplest kinds of images that are bright but the dynamic range-fits.

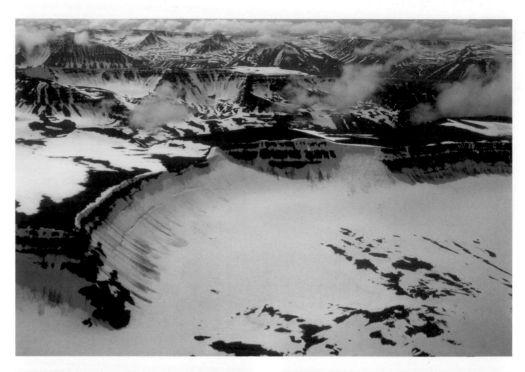

80%

▲ SNOW AND ROCK

An aerial view of an Icelandic snowscape. It's not all snow, as there are many dark cliffs, and in fact the upper third of the picture is such an even mix of dark rock, snow and clouds that it would merit a normal average exposure. The key tone, however, is the large expanse of a snowfield in the lower center, which, added to the one on the far left, make up a quarter of the area of the image. Smooth and featureless, it must not be clipped, yet it needs to be rendered as bright as possible—around 80% brightness would be safe, meaning about two *f*-stops higher than average. The ideal method here would be a center-circle reading aimed at the snowfield, then compensated two stops up.

EXPOSURE TYPE Nº 2 SUMMARY
The important areas are bright and need to stay bright, but not so much that they are likely to be clipped in an average exposure. Stay alert for clipping.

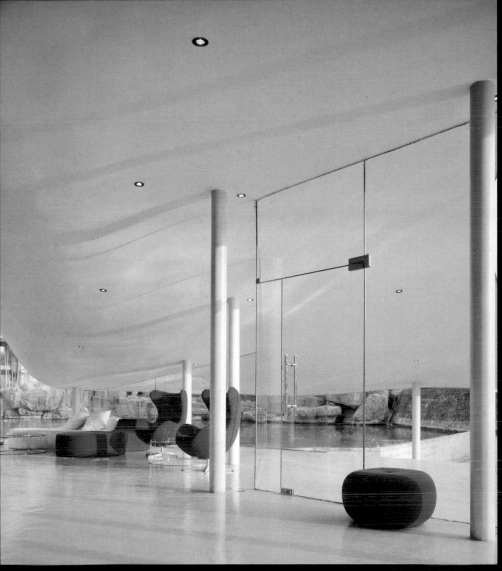

◄ BRIGHT INTERIOR

A modern interior, of a clubhouse in China, has, like many of its kind, white walls and a white ceiling, and these dominate the visitor experience. Even the floor is white. Choosing a wide-angle treatment so that white dominates the view (90% of it) makes this automatically the key tone. Naturally, the red furniture needs to appear somewhere near the middle of the tonal scale, but because of the all-round reflection of light from the surroundings there are no dense shadows, and this is not a significant exposure issue. There is some variation of tone in the ceiling and floor area, but overall I would want it to be around 75% brightness—almost two stops brighter than an average reading. The pixelated diagram and the histogram show the effect.

75%

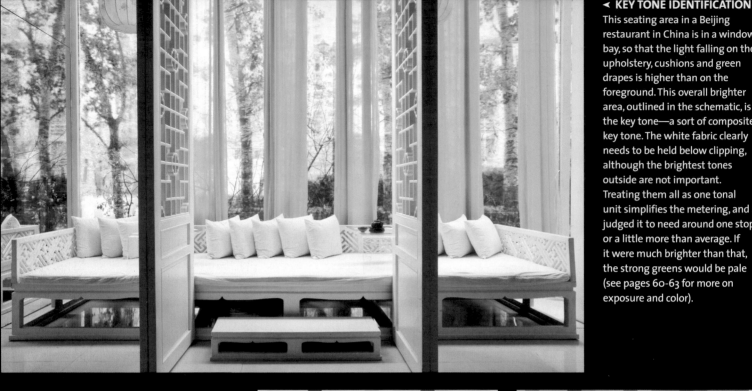

◄ KEY TONE IDENTIFICATION

This seating area in a Beijing restaurant in China is in a window bay, so that the light falling on the upholstery, cushions and green drapes is higher than on the foreground. This overall brighter area, outlined in the schematic, is the key tone—a sort of composite key tone. The white fabric clearly needs to be held below clipping, although the brightest tones outside are not important. Treating them all as one tonal unit simplifies the metering, and I judged it to need around one stop or a little more than average. If it were much brighter than that, the strong greens would be pale (see pages 60-63 for more on exposure and color).

A variation on bright key tones is when they take up only a part of the scene. Here you need to exercise a little more judgment than in the very obvious cases shown on the previous pages. It goes back to the first step in the Decision Flow shown on pages 14-15—knowing what you want from the image. Here, in the case of the two girls on the grass, it's easy to see that their blouses are the key tones, and that they need to appear white and light but without clipping. As they are the smaller part of the image, adjusting the exposure so they look like this is not as obvious as it was on the last two pages, so the exposure needs to be upped by around ½ stop. The interior with the green drapes is a slightly different case from the interior on the previous pages. The key tones are general—a mixture of the drapes, sofa and cushions—and we want to keep them fairly light and upbeat.

60+%

70%

◄ TWO TONES

There are really only two tonal blocks in this image; the white blouses and the grass. Everything else is just a minor variation. When a white-ish subject is prominent it usually becomes the key tone, so you need to decide just how bright it should be. This isn't snow so it doesn't need to be blindingly white, perhaps around 70%. The white blouses take up less than 10% of the area, so just a touch lighter than an average reading will do. I compensated from an overall reading by increasing just half a stop.

The third alternative when the dynamic range fits is when the subject is naturally dark, meaning we know or expect it to appear darker than average. The examples I've chosen here are both works of art. One is a picture of a ceramic sculpture, the other of a painting, and in the case of the painting I had both the opportunity and need to think very carefully about exactly how dark it should be. I discussed this at length with the artist as we photographed the painting, then looked at the results on a laptop. In some ways, dark subjects are open to more interpretation than the light ones. The danger of clipping is always uppermost in my mind with a light subject, and this tends to dictate the exposure, but absolute clipping in the shadows doesn't happen quite so readily—there are often some very low pixel values that look black but are not quite, at around levels 1 to 5. This gives more flexibility, while at the same time there is also an innate tendency among many people to want to open up shadows and see more detail. However, this does not always lead to better results. It may be clearer and with more information, but perhaps with less atmosphere. Nevertheless, if there's a possibility that you may later want to open up the shadows, doing it at the processing stage, even with the Raw converter, may show up unwanted noise.

20%

➤ BLACK CERAMIC

The modern Chinese ceramic sculpture, of which this is a detail view, is black. The smaller inset picture shows others in the series. Being black, we need to keep it that way, and there is some flexibility of choice that is limited only by the highlights on the collar and the left pocket, which need to be held. In fact, it is these highlights that keep the dynamic range up and improve definition. As seen, the perceived effect was more open —brighter—than the final image, which I wanted to keep distinctly rich and dark. Essentially, this meant metering just the dark area, which took up most of the frame, and compensating by reducing the exposure 2 ½ stops down from the average reading—hence 20% brightness for this area.

EXPOSURE TYPE №3 SUMMARY

The important areas are darker than average, and want to stay dark in the image. The danger in keeping them dark is not so much clipping but poor visibility of shadow detail and the possibility of noise if they are lightened later in post-processing.

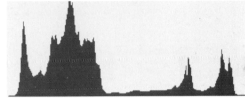

◄ DARK ARTS

Staying with modern Chinese art, here is a portrait of Shao Fan, a leading Beijing artist, painting one of his *Black* series. Here again, we have a subject that we *know* is and should remain very dark—dark enough to qualify as being "black." With the portrait, however, there's a small dilemma. Exposing to render the painting as dark as this, around 15% brightness, would mean under exposing by around 3 stops, and this would look too dark for the rest of the image. I've included a picture (below) to show where the painting falls on the histogram. The choice I made here was to moderate the darkness of the painting in favor of the artist and white wall, on the grounds that this is a photograph rather than a copy-shot of a painting for reproduction. This meant about 40% brightness, which is one stop less than average. It is more realistic for the scene as a whole, but less realistic for the painting.

➤ DARK AS THE SUBJECT

This picture, intended to show a light in its switched off state on a black background, needed the exposure to be set so even the relative highlights were in the low midtones to shadow range.

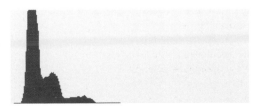

SECOND GROUP (LOW RANGE)

Surprisingly few scenes across the full range of photography come in significantly under the average for dynamic range, or "flat" as many people would call them. This is surprising because you would expect that if the dynamic range of the sensor fitting the scene is some kind of norm, there would be a more or less equal spread of high and low dynamic range scenes around it. Ultimately, this reflects the present state of sensors more than anything else. Technically, there is still some way to go.

Yet apart from this sensor issue, just our ordinary experience of seeing suggests that this kind of scene is less than common. In interiors and in studio photography, subjects and lighting can usually be arranged to create whatever dynamic range you want, but in regular outdoor shooting the main ingredient is usually atmosphere. Haze, mist, fog, and dust all diffuse the light and act like a filter that evens out tones in the scene. This does not mean that these

atmospheric conditions automatically produce a low dynamic range—far from it, if you explore the possibilities of viewpoint. There is usually some directionality to the light, and if you shoot in the direction of the sun, however muffled it is by fog or mist, you will usually find a distinct gradient of brightness.

The significant feature of low dynamic range images is that they offer major choice in the overall brightness. Having so much choice makes it especially important to exercise caution in not overdoing the adjustments. In particular, there's often a temptation to expand the range of tones to fit the scale, to close up the black and white points as a basic processing procedure. Indeed, choosing the auto option in Photoshop Levels does this. Superficially it may look like an improvement, but it's easy to lose the essential softness of these lighting conditions by doing this.

˅ ➤ LOW DYNAMIC RANGE

A typical low dynamic range scene, due entirely to early morning fog along a river in wetlands. The histogram shows better than anything else its short range of tones, which sit centered with large gaps on either side. That the histogram is centered also shows that the metering method was essentially averaging, without compensation. The extra space on the left (towards dark) and on the right (towards bright) allows a range of exposure choice without incurring clipping. Here are the simulated results of lowering and raising the exposure as far as possible while still staying within range.

4 LOW—AVERAGE AVERAGE

If the key tones are average and the dynamic range is low, it's likely that the range of tones in the histogram will be centered and with quite a bit of room to spare on either side. This exposure situation offers more choice than any other, because there is room up and down the exposure scale without the risk of clipping. So, freedom of choice is the main characteristic, especially when shooting Raw, which allows later adjustments if you want, with no quality cost.

As mentioned on the previous pages, the choice to vary the exposure also extends to expanding the tonal range, with a corresponding increase in contrast. If you are shooting Raw, which is always recommended, the contrast settings are unimportant as you can choose these later when you process through a Raw converter. If you are shooting TIFF or JPEG, on the other hand, consider whether your default contrast settings will be useful for these uncontrasty scene conditions. The temptation to smarten things up by setting a higher contrast may be natural, but it's essential first to consider the character of the lighting and how you want it to appear in the final image. If you want to maintain the low contrast, and perhaps even accentuate it, then avoid the usual processing method of closing up the black and white points.

An important point to note with low dynamic range lighting—or "flat" lighting as it is sometimes called—is that because there is no great difference between the various areas within the scene, average readings of the whole frame work well. Unlike higher dynamic range situations, there is no urgency to find a particular key tone and meter for that. There are rarely any mistakes with this kind of lighting situation.

ORIGINAL EXPOSURE

▲ ➤ AVERAGE TONED IMAGE
A woodland field of bluebells, shot using average metering and with the accompanying histogram. The bell-shaped curve of tones sit in the middle with room to spare on the left and right, although there is not quite as much room on the right because of small highlights. Shooting Raw allows the exposure to be re-visited, which in the case of a low dynamic range scene is especially useful, like that shown. Also shown are the minimum and maximum exposures without clipping, and finally a version in which the raw processor settings of Exposure and Contrast have been adjusted for an "equalized" effect, essentially stretching the tones to fill the range.

EXPOSURE TYPE № 4 SUMMARY
The range of tones is in the middle, with no blacks and no whites. Equalizing by pushing in the black and white points is tempting, but it will change the character of the scene dramatically, and not necessarily for the better.

FULL EXPOSURE

MINIMUM EXPOSURE

MAXIMUM EXPOSURE

‹ ▲ ORIGINAL SCENE ⊘

This is the original scene, again low in range because of atmospheric conditions, processed with the Raw converter settings in "neutral" —that is, default. Compare the histogram with the scale on pages 16-17 and you can see that there is a combined almost 3 stops spare left and right. The dynamic range covers only around 6 stops.

▲ MAXIMUM EXPOSURE
As this Raw processed result shows, the Exposure can be pushed a stop and a half without any clipping.

▲ MINIMUM EXPOSURE
In the opposite direction, the Exposure can be pulled down by almost a stop. The mood changes created by these exposure adjustments are significant.

A ➤ BLACK AND WHITE

The initial delicacy of the scene makes it tempting to treat it in monochrome, which gives full play to subtle tonal adjustments. I decided here to pursue delicacy and the kind of dark low range associated with platinum and palladium printing. In the first step, the image is converted to grayscale using the auto setting, which lowers the values of the warm end of the spectrum plus aquas. Next, the Exposure is lowered strongly, the black point moved in substantially, and Clarity (medium-scale spatial contrast) moved to a high setting (90 in ACR). Finally, a reverse, contrast-lowering tone curve is applied.

BLACK AND WHITE

REDS	-11
ORANGES	-20
YELLOWS	-24
GREENS	-27
AQUAS	-18
BLUES	-10
PURPLES	-15
MAGENTAS	+3

A SPLIT TONE

Taking this somber theme further, we can also add split toning to give a suggestion of color and an almost historical effect. As usual with split toning, contrasting the hue between highlights and shadows emphasizes the effect. Here, the sky highlights (and their reflections in the water) are pushed towards the cool colors (Hue 200°, Saturation 114), while the shadows of the marshland are pushed towards warmer colors—where they were in the color original (Hue 33°, Saturation 18).

◄ EQUALISED IMAGE

Equalizing the image involves stretching the tones to fit the range, which in a raw converter involves the combination of increased Exposure, pushing in the Blacks (black point) and increasing Contrast and Clarity for good measure. The equivalent of this in Levels, with an already processed TIFF or JPEG, is to push in the black point and white point sliders until they touch the ends of the tonal range. The effect is stronger, with more punch, although I think it loses the essential soft quality of the original scene.

5 LOW—BRIGHT BRIGHT

This exposure situation has a lot in common with that on pages 70-74 (the range fits type #2), but the difference is that here there are no important shadow areas. The subjects are naturally light, as we expect them to be, and the exposure needs to be pitched high, by possibly one or two stops according to the scene. Doing this will give you true high-key photography, and for more on this style see page 128. Naturally light subjects include snow, white walls, white fabrics and puffy summer clouds. Enveloping lighting conditions with plenty of reflectors often feature in this kind of exposure situation as the diffuse illumination keeps shadows light and soft, and sometimes removes them altogether,

such as with mist and fog outdoors, light tents and large cyclorama lighting in a studio. The usual precaution, as with any scene that has light tones, is to avoid highlight clipping. Judging the exposure needs care to get the result bright but also making sure you stop short of losing all detail. As with Low—Average situations, overall metering of the entire frame is fine; the only difference is that you need to increase the exposure from the reading. As you can see from the examples here, "bright" generally means somewhere between 1½ and 3 stops brighter than average or, in percentages, around 65-85% brightness overall.

▼ SHAKER HOUSE IN FOG

A foggy view *without* foreground. *With* would have encouraged an exposure closer to average overall. As it is, the appeal of the scene, looking down a slope towards a Shaker village in Maine, is an evenness of tone with the sense of buildings just emerging from the fog. As fog in principle is perceived to be light, like cloud, this suggested a light treatment of almost two stops more than average, around 70% brightness, as the histogram (above the image) shows.

➤ WHITE SHELVES

The dynamic range in this lit shot of shelves in a modern design shop appears to be greater than it really is, due partly to the red splash of color that gives a different sensation of contrast, and partly to our expectations of hard-edged shadows. In fact, as the histogram shows, the range covers about two-thirds of the scale including the red, and half if we discount the red. As the surfaces are all obviously intended to be white from our experience, the exposure needs to be very full. In fact, it is overall the same as for the foggy Shaker view, but the range within it goes from 50% mid-tone for the bottom left shadow to 90% brightness for the fully lit surfaces.

HISTOGRAM INCLUDING RED

HISTOGRAM EXCLUDING RED

EXPOSURE TYPE № 5 SUMMARY

The scene is expected to be bright, mainly from our experience. Snow, white walls, most clouds, mist and fog all qualify, particularly in enveloping light. High-key images are of this type.

6 LOW—DARK DARK

This exposure situation is by no means as common as the other two in the Low group, and the reason for this is the simple average of most people's taste. There seems to be a natural human tendency to want images brighter rather than darker, all other things being equal. Because the dynamic range is low, the problems of avoiding clipping are much less urgent, so this choice of darker or brighter exists. This is one kind of low-key situation, but as we'll see later (from page 136), most low-key images tend to have some small bright tones, which raises the dynamic range.

This is prime territory for moody, somber, subdued imagery, and I'll explore this more in Chapter 4 Style, under *Low key*, *In praise of shadows*, *Deep shadow choices* and *Another kind of low key*. Ultimately, it comes down to having a reason for the general mood of the image to be darker than usual, as you can see with these two examples.

➤ DARKER SKIN TONES

This is a portrait taken in Swat, northern Pakistan, that I deliberately made darker than average, for a simple matter of taste rather than for any technical reason. The brighter version, again a simulated exposure in Photoshop, is perfectly average for the man, excluding the almost uniformly dark background. Metering here is reasonably straightforward so long as the face is the area of attention. The normal option would be the brighter one—a 50% mid-tone for all except the background. Yet the skin, the incredible lines and the dark intensity of the area around the eyes all seemed to me to want a richer, deeper treatment. In addition, I did not want the beard to contrast too strongly with the darker face. For these reasons, compensating by one stop to make it darker was what I chose.

EXPOSURE TYPE №6 SUMMARY
The scene is expected to be dark, again mainly from our experience. It includes dusk, dawn and night in general, black skin, surfaces known to be black or a deep color like indigo or purple. Some low-key images are of this type.

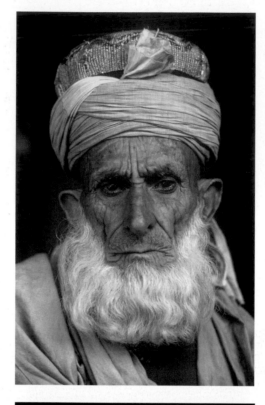

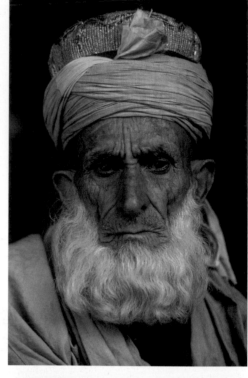

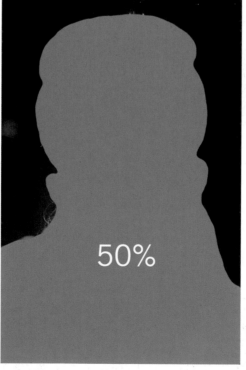

50%

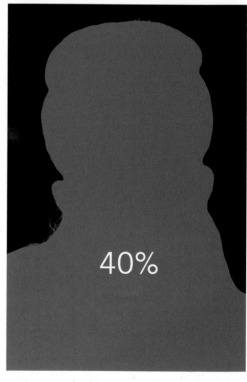

40%

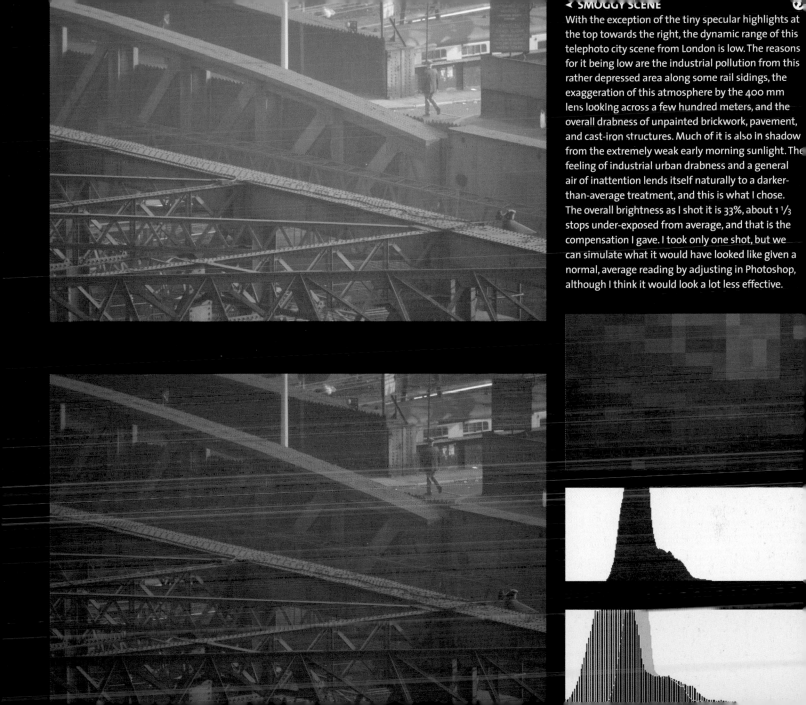

With the exception of the tiny specular highlights at the top towards the right, the dynamic range of this telephoto city scene from London is low. The reasons for it being low are the industrial pollution from this rather depressed area along some rail sidings, the exaggeration of this atmosphere by the 400 mm lens looking across a few hundred meters, and the overall drabness of unpainted brickwork, pavement, and cast-iron structures. Much of it is also in shadow from the extremely weak early morning sunlight. The feeling of industrial urban drabness and a general air of inattention lends itself naturally to a darker-than-average treatment, and this is what I chose. The overall brightness as I shot it is 33%, about 1 ⅓ stops under-exposed from average, and that is the compensation I gave. I took only one shot, but we can simulate what it would have looked like given a normal, average reading by adjusting in Photoshop, although I think it would look a lot less effective.

THIRD GROUP (HIGH RANGE)

This is where exposure decisions become very interesting, when the range of the scene is too much for the sensor. Something has to give, and in every one of these six situations the photographer needs to think about potentially lost highlights or shadows. The solutions, however, are many and various, and by no means is the high range necessarily a problem. In the next chapter we'll look in more detail at creative and stylistic ways of handling a high range, but here too, over the following pages, I present a variety of solutions. High range is also referred to traditionally as over-scaled and sometimes as high-contrast, though that strictly should refer to the gamma rather than the lost ends of the scale (pages 40-43 *Contrast, high and low*). I try to avoid using the expression "high dynamic range" because that now has a very specific meaning, which includes special HDR techniques, and should, in my view, be limited to images with at least 14-15 stops of range (see pages 38-39 *Scene*

dynamic range and pages 182-185 *HDR*).

All the examples shown in this section are necessarily compressed into the range of the printed paper, which makes it a little dangerous to compare them directly with, for example, the low range images we've just been looking at. This might seem obvious, but I think it's worth the reminder. The images here, such as the two on this page, have all been rendered in a way that makes them acceptable, but in fact the only way you can get a true sense of a high-range image is by shooting in Raw and examining it in a Raw converter such as Photoshop's ACR.

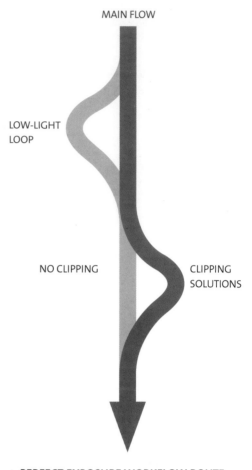

MAIN FLOW

LOW-LIGHT
LOOP

NO CLIPPING

CLIPPING
SOLUTIONS

▲ PERFECT EXPOSURE WORKFLOW ROUTE
Some solution to clipping is always called for, even if you decide that it doesn't matter for a particular image. In the Decision Flow process, consider the clipping solution loop.

◄ DAYLIGHT THROUGH WINDOWS
One predictable high-range situation is an unlit interior with views out onto a sunlit exterior. Within the interior part of the image the dynamic range is already high, as it is a combination of the fairly bright sunlight streaming in, a number of deeply recessed shadows, and surfaces that vary from white paint to black cast iron. Yet even this range of about 8 stops is only a part of the full range that includes the scene outside, which extends it to 12 stops or more.

Bright sunlight through a window falling across a sofa and an old Chinese opium pillow creates standard conditions for a medium-high dynamic range— a range that will probably exceed the dynamic range of the camera's sensor. The distance from the window, which is a few meters, gives the shaft of light the quality of a spotlight, and ensures that the shadows remain dense, with little spill to lighten them.

This is the most common lighting situation when the range is high, which means, given that camera sensors in general have a lower dynamic range than ideal, this is *overall* one of the most common situations faced by many photographers. It's worth stressing again, however, that it depends very much on your style of photography. As a simple example, if you favor shooting *into* the light for its atmospheric effect, you will inevitably face more high-range situations and clipped images than normal.

By definition, high range means that some clipping is inevitable, so typically the scene has an extreme mixture of tones, as the pixelated version shows. This splattering of tones from potentially blown highlights to blocked-up shadows is what tends to distract people from thinking clearly about the exposure. What do you base the exposure on when there is so much to choose from? For one answer to this let's go back briefly to the idea of the default, the "normal," exposure, as on pages 50-51 *Objectively correct*. For reasons to do with perception, the eye feels comfortable when the main focus of interest in an image—in other words, the subject—appears at medium brightness. Medium brightness means a mid-tone, or average, around 50%, and this, as we've seen in Chapter 2, is the premise for all meter measurements. This is what viewers tend to expect, and qualifies it for the default. However, as we'll see throughout this book, and especially in Chapter 4 *Style*, default is only ever a starting point. Ultimately, the choice is a creative one— that of the photographer.

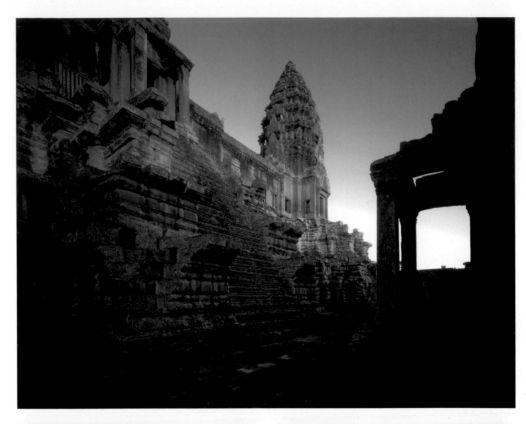

➤ MORNING LIGHT

A sunrise view of the central towers of Angkor Wat, Cambodia. The clear winter air makes it certain that with a camera viewpoint like this, from deep shadow into the light, the range will be very high. The schematic shows how the scene blocks out into five main areas of tone and color. The brightest areas of the sky and the deepest shadows were certain to be out of range in a single exposure, but I didn't mind this. In fact, I positioned the camera to make the strong shadow area on the right, a stone portico, work simply as a silhouette. The two key tones were the sunlit areas of stone, and second, the mid-shadow areas. The sunlit part was measured and the exposure set for exactly that (in the schematic diagram it is 50% mid-tone). This means the mid-shadows are dark but still full of recognizable detail (in the Zone System this would be called *textured shadow*), at about 2 1/2 stops less.

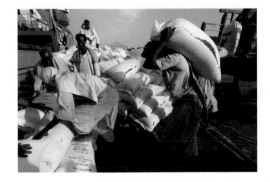

◄ ▼ BRIGHT LIGHT AND MIDTONES

This is a different kind of situation, though still high-range, in which there are certainly mid-tones but they are scattered. The mixture of tones is less cohesive than in the Angkor Wat picture, with the result that, in a fast-moving situation such as this of a scene at Port Sudan docks, there is no obvious large area to measure. At the same time, as the schematic diagram shows, the different tonal groups are fairly evenly represented, which is something that was obvious at first glance. Given this, and also being cautious about clipping, which would be expected in the brightest highlights and the deepest shadows, I could be fairly sure that an average meter reading would work. Indeed, this was what I did, on the reasonable assumption that there would be enough leeway with a Raw file to recover any small amount of clipping easily. The clipping is, as shown here, quite small, and simply choosing the auto option in Photoshop ACR recovered it all. A little extra work, mainly raising Exposure, Blacks and Clarity, gave more shadow recovery and better mid-scale contrast.

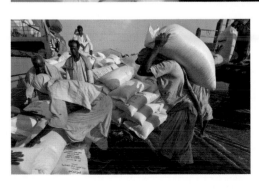

Highlights Lights Mid-tones Shadow

50%

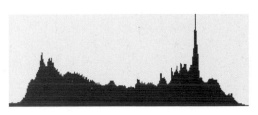

A street scene in Lijiang, Yunnan, China, which is high range because of the altitude and clarity of the air (strong sun, deep shadows) and because of the range of reflective surfaces, from a bright white wall to dark stone. It was clear that there would be strong clipping at whatever exposure, but the important question was, would it matter? The important areas for content and tone are as shown in the schematic diagram. The deepest shadows on the right were in fact irrelevant to the image, and most of the white wall is featureless so that could be allowed to clip with no harm done. As for the metering method, I used the smart, predictive mode, and this automatically protected the whites from clipping excessively—the result is as shown with the clipping warnings. This, incidentally, is a reduction of almost one stop from an overall average, and that's the camera's exposure algorithms at work. During Raw processing, choosing auto in Photoshop's ACR completed the highlight recovery.

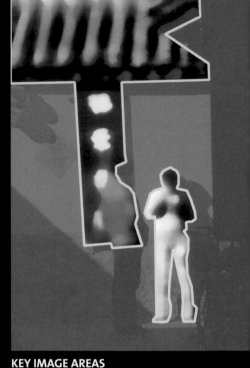

BEFORE

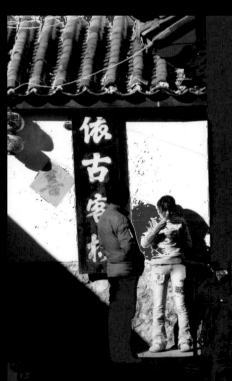

KEY IMAGE AREAS

EXPOSURE TYPE №7 SUMMARY
Bright, mid- and dark are all present, and favoring the mid-tones is the default. Nevertheless, this may not suit the character of the image you want. Qualify all decisions with the knowledge of what can be done to recover tones in post-processing.

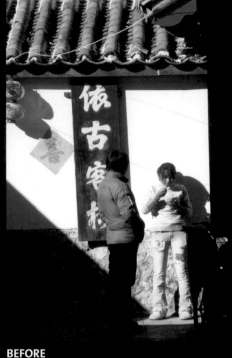

SCHEMATIC

CLIPPED AREAS

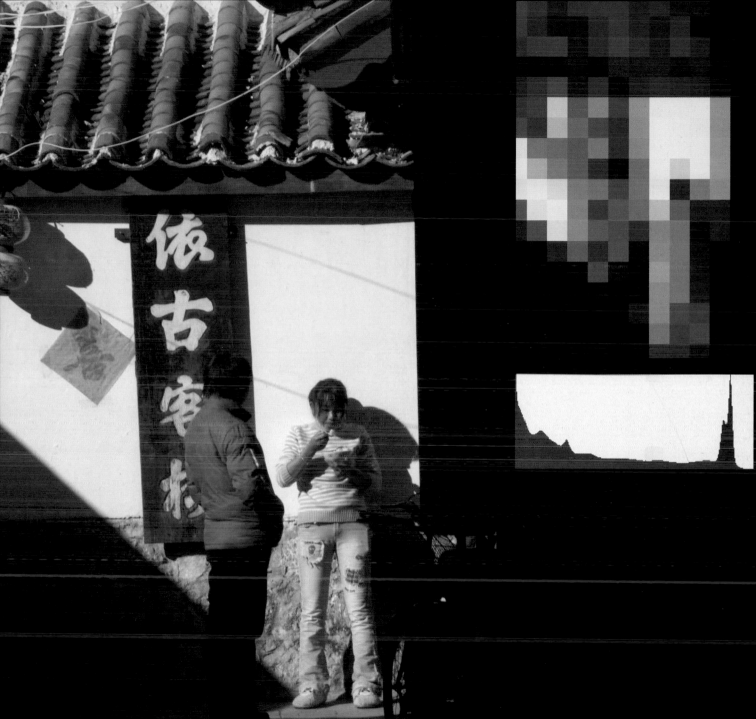

In this high-range situation, the subject is much brighter than the surroundings and usually there are reasons for wanting it to be brighter than an average rendering. As we've seen already in the other two groups, Range Fits and Low, some subjects are inherently light. This means that we feel they should be lighter than an average mid-tone from our familiarity and experience. The usual examples are pale skin, the kind of clouds that do not threaten rain, anything obviously painted white (and our perception is instinctively good at realizing that a white picket fence *should* be white rather than gray), and large sources of light. Light sources can be light emitters, like a lamp or the sun, in which case they are normally small in the frame if you include them, but they can also include, for instance, a window seen from inside. Naked lamps and any source that appears small in the frame can usually be treated as a specular and allowed to burn out (see pages 150-151). Broad sources, on the other hand, like a lightly draped window seen from inside, call for some care.

EXPOSURE TYPE Nº 8 SUMMARY
This implies that you have decided that the dominating brighter tones are the key. Typically these appear in the image as brighter than average as well as brighter than the surroundings.

➤ SUBJECT ON DARK STUDIO BACKGROUND
This example, of a Fabergé cigarette case in the Louvre in Paris, is drawn from controlled studio shooting, where everything can be adjusted and there is plenty of time to make decisions. The background, which is a rich purple velvet crumpled slightly to reveal its texture, was chosen specifically for contrast—contrast of tone and of color. This contrast would give the jeweled gold case maximum visual punch. The case needed to sparkle, show off its different metallic lusters, and be bright, by about 2 stops above average, I judged. This is the result. The metering method was a handheld meter with incident-light attachment, as I would always use whenever I have the time and opportunity. Equally well, however, would have been a center-circle or even spot-metering through the camera, making a 2-stop upwards compensation.

75%

ʌ ➤ DARK BACKGROUND OUTSIDE

An almost identical lighting situation as that of the cigarette case—a significant coherent area that needs to be bright against a dark background, but in totally different circumstances. Here, there is no time to play around with measurements and make test exposures, just an urgent need to shoot quickly because in Buddhist prayer people do not usually hold this position for long. The lighting, from a late afternoon sun, was fairly frontal, and the surface is skin, which is itself an entire topic for consideration. How light should skin be? This depends on ethnicity, but also on the lighting conditions and on personal taste. We'll look at this again under *Memory tones* on pages 120-121. Here, the man is Burmese, so the skin tone could well have been treated as darker. However, I wanted a strong contrast with the background, so I opted for fairly light, meaning a little less than 1 stop lighter than average. The metering method was center-circle with the appropriate compensation.

This is a more difficult kind of situation to measure, simply because of the discrepancy between the bright subject area and the overwhelming dark background. The metering method of choice outside the studio is spot-metering, although the size of the spot-metering circle is usually so small that it pays to make several measurements to make sure. Center-circle measurements suffer because the diameter of the measuring circle is larger than a key tone of the size shown here. The metering method of choice in a studio or other controlled shoot is incident-light handheld.

Note that the histogram is of little practical use with this kind of lighting situation because the small delimited area of brightness is displayed as relatively few pixels.

➤ BLACK BACKGROUND

A studio shot, this time of bizarrely shaped diamonds. The background is black velvet, chosen so that it would drop right out. No texture at all was wanted from that. These are raw diamonds, so they are uncut, but nevertheless some of them show natural facets, and the colorless ones have expectedly bright highlights on the facets that reflect the overhead softbox area light. One precaution was to avoid these clipping, but given the time available this was hardly an issue—there was ample time to make tests. More important was judging the precise key tone among the varied diamonds. They all needed to be rendered lighter than average (diamonds are not perceived as or expected to be dark, or even mid-toned), but even so there is variety of tone, as the pixelated version shows. In my judgment, the brown diamond on the lower left made a good subject for the key tone, and I wanted it to be around 60% brightness, which is about 2/3 stop above average. I used a handheld meter with incident-light attachment for the reading, and compensated upwards by 2/3 stop.

EXPOSURE TYPE №9 SUMMARY
When the key tone is small but still principal, there is more likelihood of over-exposure. This type of subject needs much more care than most to avoid clipping while keeping the exposure high enough to show all detail.

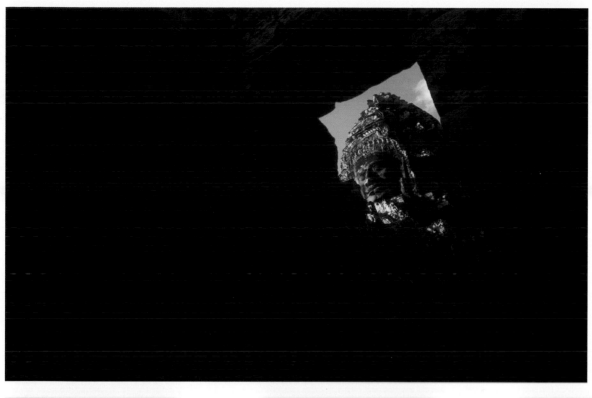

 7%

 20%

 50%

 45%

◄ ʌ LIMITED LIT AREA

A view from within the maze-like temple of Bayon at Angkor, Cambodia, looking up through a stone window towards one of the many face towers. The lit area plus sky takes up less than 5% of the picture area, which is much less than the approximately 12% of a 12 mm center-circle. An overall average reading is useless—as you can see here, the average brightness of the whole frame is only 7%. The average reading from within a 12 mm circle is also dark, 20% brightness, meaning that a center-circle reading is likely to over-expose the shot by between one and two stops. A spot reading on the sunlit stone gets the exposure where it should be.

10 HIGH—EDGE-LIT EDGE-LIT SUBJECT

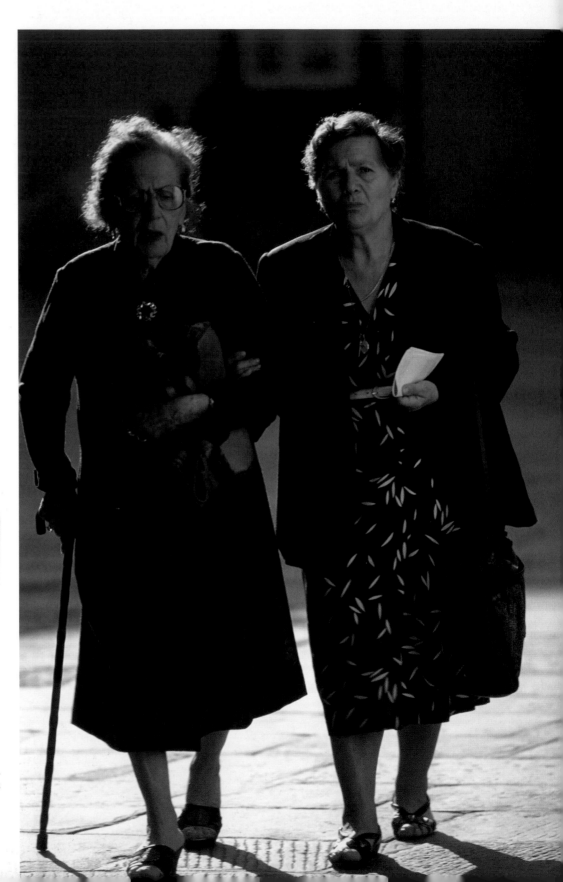

Of all the 12 lighting situations, this is the most specific, probably the rarest and undoubtedly the most tricky. As we'll see in the next chapter, *Style*, edge lighting is one of the core conditions of low-key imaging. It certainly merits its own entry in our list of lighting situations.

One thing that makes this situation special is that the brightness of the edge that works best varies according to the situation, and also according to what you want from the image. For example, if the edge is very thin, it may be acceptable to expose so that it is completely blown out as a highlight. If it is broader, then it is likely to be showing more detail and possibly color, in which case there is more of a case for exposing so that it is simply bright, not clipped. But then also consider a situation in which the shadowed area of the subject has a good amount of fill, from light reflected by the surroundings. The picture of the two women walking is an example of this. In this case, you might well choose an exposure that takes this filled shadow as the key tone, rendering it somewhat darker than average, and let the edge blow out. Clearly these are fast decisions to make and they are heavily influenced by taste.

EXPOSURE TYPE №10 SUMMARY

A special case, in which the edge highlights *can* blow out. Although the *subject* is the thing being outlined, the bright edge is usually the key tone. So long as the outline is clear, you can get away with considerable loss of shadow detail in the subject. This is very difficult to meter, so it needs testing first, and calls for bracketing when this is possible. This is one kind of low-key image.

➤ EDGE BUT NOT KEY
The edge-lighting on the hair and shoulders of two women walking cross an Italian piazza helps significantly to make the picture, but the key tone arguably is their faces and dresses, in shadow but illuminated by reflected sunlight from the pavement. This needs to be readable, even if more than 2 *f*-stops darker than average.

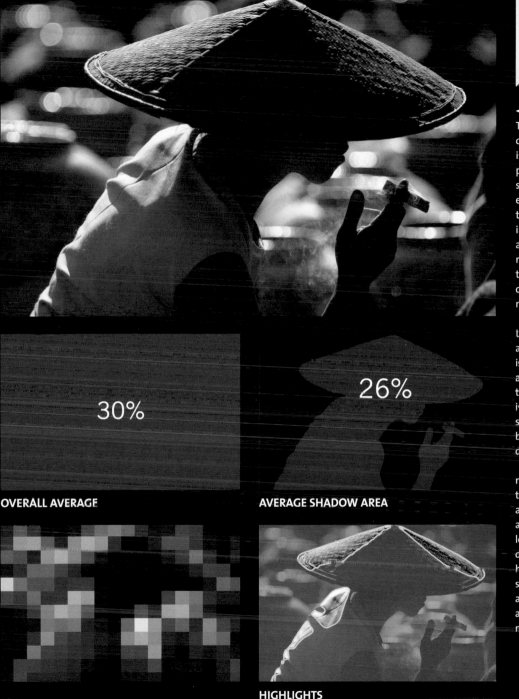

◄ PERSONAL JUDGMENT ONLY

There are no typical edge-lit shots: each one is different, not only in the way that the light falls and is reflected but also in the interpretation that each photographer makes. This scene, of a Shan woman smoking a cheroot in a morning market, is just one example. It is by no means typical or translatable to other images, but it will serve to show the issues involved in judging exposure. Edge-lit subjects always have a significant dark area, though this is rather less than usual here because sunlight catches the out-of-focus objects behind. The exposure compensation will have to be darker than a normal meter reading, but the trick is deciding by how much.

The woman takes up about half of the area of the frame, and the edge-lit areas *as I define them* about 10%—that is, about 20% of her. The lighting is made less clear by the bright reflections behind, although as it turns out not by as much as you might think. The average brightness for the entire frame is quite low, as you might expect—30%, around a stop and a half darker than average—but the overall brightness for just the woman is not that much different, at 26%.

Basically, this means that an average in-camera meter reading would *over-expose* according to my taste by a stop and a half, and indeed what I did at the time was to use center-weighted metering and compensate with about a stop and a half less exposure. Could the shot have been exposed differently yet still be good? Yes, of course. It could have gone darker by about half a stop for more of a silhouette, and it could also have been opened up by a little less than a stop to reveal more shadow detail at the expense of small clipped highlights. This was my choice, but yours might be different.

30%

OVERALL AVERAGE

26%

AVERAGE SHADOW AREA

HIGHLIGHTS

60%

Having worked through the theory of judging the right brightness for these edge-lit subjects, the practical matter of metering is still a major problem, particularly if you have to shoot quickly, as in street photography. The most reliable method takes time and works only for static subjects—incident light metering with a handheld meter—and you could argue that if you have enough time to measure the exposure in this way, you have enough time to bracket the exposures and choose the best from the camera's screen review.

There is no easy and foolproof answer, because the intensity and area of edge lighting varies so much. The examples here go into some detail to show this. Any direct meter reading, which is what all SLRs use (even though a few modify this with an incident measurement via a small diffused sensor on the camera body) is influenced by the *area* measured. Obviously, the more concentrated this is on the actual edge-lit surface, the more accurate it can be, but this is often impractical. In other words, of the three usual metering modes, which are evaluative or matrix (entire area divided into regions and processed predictively by the camera), center-weighted, and spot, the last is the natural accurate choice. However, in a moving situation such as photographing people, there just isn't time. Center-weighting is particularly dangerous to rely on, not only because the central area shades off, but also because many cameras do not show its extent. Worse still, as most of the image area in an edge-lit shot is dark, even if the spot or center-weighting options *do* display the circular metered areas, they are very difficult to see against black.

➤ MEASURING THE EDGE

Let's take a detailed look at a shot that relies almost completely on edge lighting. Given the nature of this situation, which is a man in a Burmese café photographed surreptitiously from quite close (the next table), there was time for only one shot so it isn't possible to show what it would have looked like with different settings. It is, however, exposed exactly as I hoped (and there's enough uncertainty in these situations for hope to play a part). No metering system currently available can cope satisfactorily with a lighting situation like this. Smart, predictive systems are not yet smart enough to know that this might be the effect you want, although frankly it should be possible.

If we do some post-analysis on the image, we can see how far off an average reading would be—the overall brightness is only 12%, meaning around 3 stops darker than average, so that in-camera an average reading would *over-expose* by that amount. The difference is too great to allow accurate compensation. If we measure just the equivalent of a 12 mm center-circle, the overall brightness comes out as 18%, which is one stop more. This means that a center-circle reading when shooting would over-expose by about 2 stops, which is better. In this case the edge light is conveniently in the middle, but this is by no means always the case so let's do something

that *can* always be reproduced—aim the center-circle at the brightest part of the edge lighting. Doing this in Photoshop, as here, gives an overall brightness for that area of 20%, which is more or less the same.

This is my own preferred method in uncontrolled situations—center-circle, aim at the brightest, compensate with 2 stops less. The problem, of course, is that edge lighting can vary wildly in how it looks. In this case, the area that I've outlined contains all the important tones, and takes up only 3% of the area of the frame, even though it looks more. Within this small area there are still differences, and in this case I would want, if I had time to think about it, an average exposure, meaning 50% brightness. A 12 mm center-circle actually occupies 12% of the area of a full-frame SLR image, so we're taking a reading of an area that is around four or five times less. If you think about it like this, in terms of area, then an adjustment of 2 stops (which is four times more) makes sense.

This is a long-winded analysis, but it's intended to make the point that with edge lighting and a direct reading through the camera's system, you will always need to compensate by reducing exposure, and it helps to have some kind of method. The only accurate measurement methods for edge lighting are spot-metering and incident-light handheld readings, and neither is possible in a situation like this.

OVERALL BRIGHTNESS

12%

12MM CENTER CIRCLE

18%

OFF-CENTER CIRCLE

20%

HIGHLIGHT BRIGHTNESS

50%

In the absence of anything better, my method is to use the matrix or smart predictive metering mode and reduce the exposure from that according to informed guesswork. You might think it's not much of a method, but it gets me to within a stop. Practice and experience are the keys here. And there *is* a way that you can practice at home. It's disarmingly simple. Just put up a previously photographed edge-lit shot on your monitor, making sure that the screen background is black, turn the room lights off and aim the camera at the screen, just filling the viewfinder with the image. This is better done on a tripod. The actual light measurements are unimportant; what you can experiment with is the *exposure compensation*. With my camera, a Nikon D3, the compensation needed with smart mode is in the region of 2 ½ stops (minus, that is). Or, if you don't have a suitable previously shot image, use this one of mine, available via web-linked.

➤ PRACTICE AT HOME

Take any edge-lit photograph that you have already shot, display it on a monitor screen, darken the room, and re-photograph it at different exposures using your preferred metering mode (such as center-weighted or smart). Open the results in Photoshop (here in the Raw converter) and keep the clipping highlight warning on. The setting at which the highlights are *not* clipped will give you an indication of the compensation you need, as described in the text. Here, minus 2½ stops is about right for me. Depending on the metering mode, there may be differences according to how centered or off-centered the edge light is in the frame—these are the results of shooting an L-shaped mask made from black card placed on a lightbox and photographed.

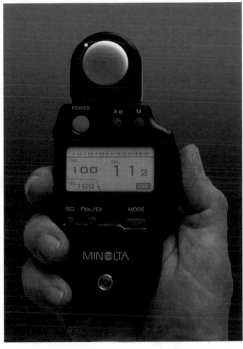

◄ INCIDENT-LIGHT READINGS WHEN POSSIBLE

This studio lit shot of a small sculpture, aiming for a black-on-black low-key effect, allowed enough time to use the most sensible metering methods for edge lighting—a handheld meter fitted with an incident-light dome. The dome stands in for a three-dimensional object, and as you can see when you take the reading, by aiming the dome at the camera from the subject's position, it collects the edge light from behind and whatever degree of shadow fill there is in front—which is not much in this case. There are two lights here, one behind and above right, the other behind and to the left. As they are each lighting different parts of the sculpture, and just the edges at that, when they are combined the reading is essentially the same, at just over f11. Unlike the much more uncertain direct meter readings through an SLR, no compensation is needed. The exposure is just as the incident-light reading indicates.

11 HIGH—LARGE DARKER LARGE DARKER AGAINST BRIGHT

In this lighting situation, the subject of interest and key tone is darker than its background, and this means inevitably that either the background is going to suffer from over-exposure, or you deal with the contrast by adding light, using software recovery, multiple shooting, altering the composition or choosing to forego detail in the dark subject in favor of the lighter background. In a sense, this is the inverse of lighting situation #8, but there's an important perceptual difference. Blocked-up shadows, as we've seen earlier, are generally more acceptable to look at than burned-out highlights. (The emphasis here is on "generally", because highlight areas can be made to work in high-key images and exploiting flare

for effect, as we'll explore in *High key*, *Light and bright*, *Highlight glow* and *Flare*, pages 138-145). Just because the main area is darker than its bright setting or background does *not* mean that it has to reproduce in the photograph as dark. It may do, but not necessarily.

This is probably the second most common lighting situation in the high-range group after average, simply because it includes a very common kind of scene—the outdoor shot with a band of sky at the top. The *arrangement* is different from an object sitting entirely within the frame, but the principle is the same.

▼ DARKER TOWERS BEFORE LIGHT SKY

The central towers of Angkor Wat, as on pages 92-93 but from a different angle and in very different weather. This is early morning in the rainy season, shooting into the light, and; shot before the days of HDR and exposure blending, so there is only a single frame. While I might possibly have tried exposure blending from two or three different exposures if I had been taking the picture now, I'm still happy with the way this shot worked. In particular, I wanted a brooding, looming sense, appropriate to the moss—and lichen—covered stones, which called for an intentionally dark treatment. I had decided on an exposure around 2 *f*-stops less than average for the stone—a drastic reduction, but necessary for the effect to have the atmosphere I was looking for. The reading was taken with a handheld meter and reflected-light attachment, the equivalent of using a camera's center-circle measurement. A secondary advantage of this low exposure was that some of the sky would read well. Vignetting from the wide-angle lens (efl 21mm) accounts for some of the darkening towards the corners, but this helped rather than harmed the effect of light streaming out from behind the towers. The average brightness from the entire frame was a mid-tone, but I did not use that for a reading.

47%

20%

WHOLE IMAGE

BUILDINGS ONLY

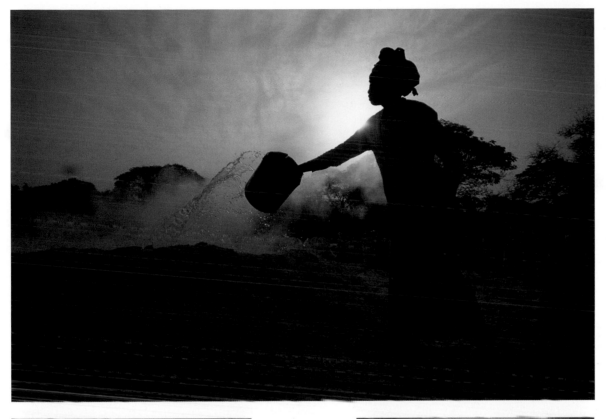

◄ SILHOUETTE

This is an example of the silhouette option (for more on silhouettes, see *Silhouette* on pages 152-153). Silhouettes, which by definition are devoid of almost all detail, work because of their outlines, and so long as this makes visual sense to a viewer, they solve the high-range exposure problem by letting you expose for the bright background. I chose this case because there was a little uncertainty about how well the image (a Burmese construction worker pouring water on lime) would work as a silhouette. The upper half of the woman is clear, the lower half less so, and the exposure needed to show some separation between the legs and the background. The tree behind confuses it slightly. Even so, I chose this route for what I thought would be a graphically more interesting image, and relied on the timing of her outstretched arm, the bucket and the flow of water. Given the movement and need to shoot quickly, there was a considerable amount of guesswork in the exposure. I used the camera's smart metering and compensated by opening up one *f*-stop for this shot, but I also shot many frames and bracketed the compensation to be on the safe side. The average overall brightness for this shot was 28%.

28%

9%

EXPOSURE TYPE № 11 SUMMARY

The dominant area is darker than its background or setting, and larger, but there is a choice between exposing for it to be average in tone or darker. A special case of this is a silhouette shot, in which outline dominates and shadow detail is generally unwanted.

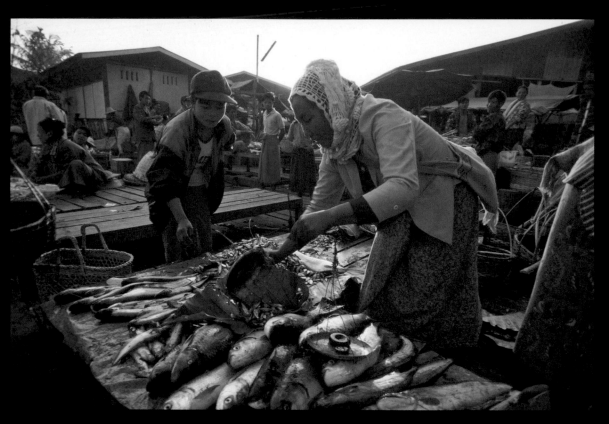

◄ **HIGH HORIZON**

A typical example of a high horizon line with a sky that will inevitably clip if the main subject—and key tone—is the foreground. Shooting into the light in this kind of situation, with a low morning sun, gives attractive reflections and a pleasantly atmospheric flare (see *Flare* pages 142-143), all of which I wanted. The backlighting meant that most of the foreground subjects, like the two women, were showing their shadowed sides towards the camera. This, plus the highlight reflections on the scales and fish, made a darker-than-average treatment appropriate. In fact, I underexposed by 1/2 stop from the center-weighted meter reading (which as usual is already compensating for a bright strip of sky at the top, see *Metering Modes* pages 44-45), and the result is as I wanted it. Note also that I kept the framing so that only a narrow strip of sky shows.

60%

35%

An arranged and lit photograph of one of the copies of the famous *Domesday Book*. This is a very typical product-shot arrangement, out of any context and as simple as possible. The background, while not irrelevant, is definitely subsidiary to the group of books. This being a studio shot, the lighting is under control, and so the dynamic range can and should be brought within the range of the camera sensor. Nevertheless, I wanted two things that would make the range high. One was to have strong contrast within the composition of the books to avoid the rather bland subject matter appearing even blander. The other was to knock out the lower part of the background. I used a light table, comprising an upward curving sheet of translucent Plexiglas lit from beneath, and the idea was for this base lighting to give some "lift" to the books and the gentle gradation behind to help the sense of presence. In other words, I wanted the base to go to pure white. For the grouping of books, I wanted an average exposure, 50% brightness, and used an incident-light attachment to my flashmeter. An average reading of the entire frame, as shown, was 65%, but as this depends on the amount of background visible, it would never be a sensible reading to follow.

65%

50%

The final lighting situation in the list is a small subject and key tone that is darker than its surroundings. The major difference between this and the previous one, in which the dark subject occupies a reasonable amount of the frame, is that here the background always dominates exposure decisions, and is often the part of the image area that you need to measure. This very much depends on how important it is to open up shadow detail within the small subject. The smaller it is in the frame, the less this matters.

EXPOSURE TYPE № 12 SUMMARY

With the subject being small, it often works well as a silhouette, in which case the background is really the key tone. On the other hand, it may call for some visible tones in the shadow areas in order to read well.

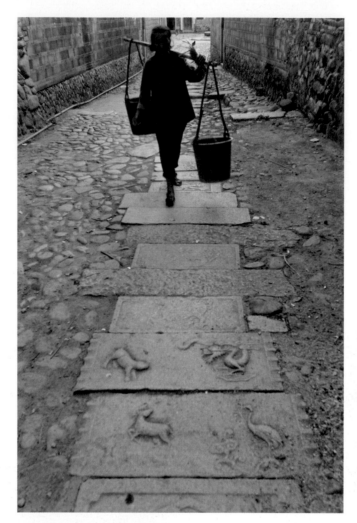

➤ DUAL SUBJECTS

There are two subjects in this photograph taken at the entrance to an old communal circular clan building in China's Fujian province—the woman walking with panniers and the animals carved in relief on the flagstones. In fact, I had started with the animals, but when the woman approached I decided quickly to use her as a kind of indicator to the unusual carvings, pointing the way, so to speak. The eye is first drawn to the woman, because she's moving, and because of the contrast in tone. In terms of exposure, the woman as the subject is small enough in the frame, and has such a clear outline that she works as a near-silhouette. In other words, the real key tone is the ground. A slightly brighter-than-average treatment seems to works best here, and in fact I used the camera's smart metering mode and compensated upwards ⅓ stop.

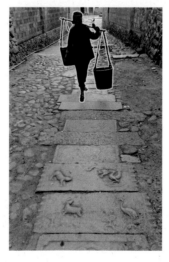

14%

56%

58%

OVERALL

SILHOUETTED PERSON ONLY

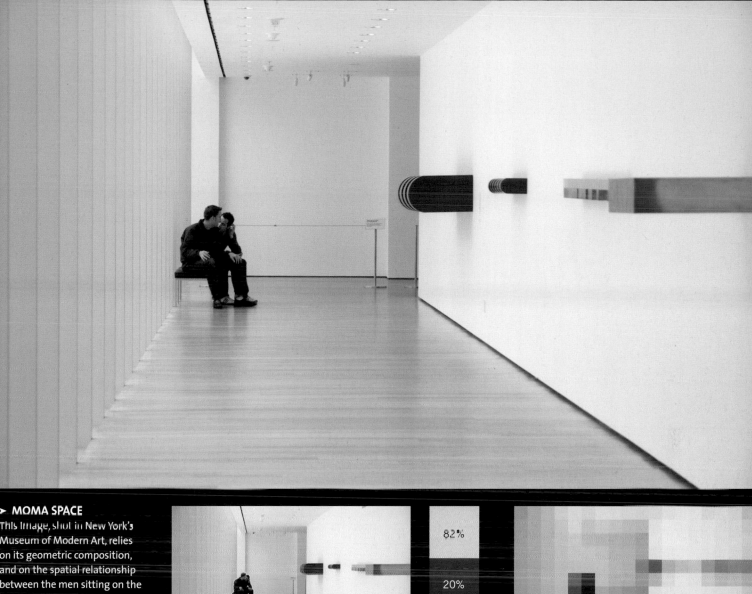

► MOMA SPACE

This image, shot in New York's Museum of Modern Art, relies on its geometric composition, and on the spatial relationship between the men sitting on the bench and the artworks on the wall. Strictly speaking, the key tone would be their skin tones, but this area was too small in the frame to measure, and in any case, a simpler, faster, and more practical method was to increase the exposure by almost f-stops from the overall reading. A glance shows that the walls and ceiling are white, and a workable rule of thumb when this tone dominates the frame is to compensate the exposure upwards by 1½ stops.

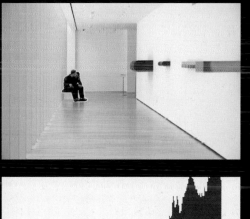

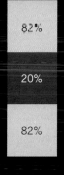

82%

20%

82%

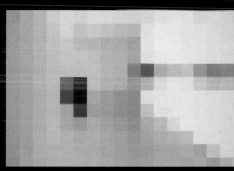

OVERALL

FIGURE ONLY

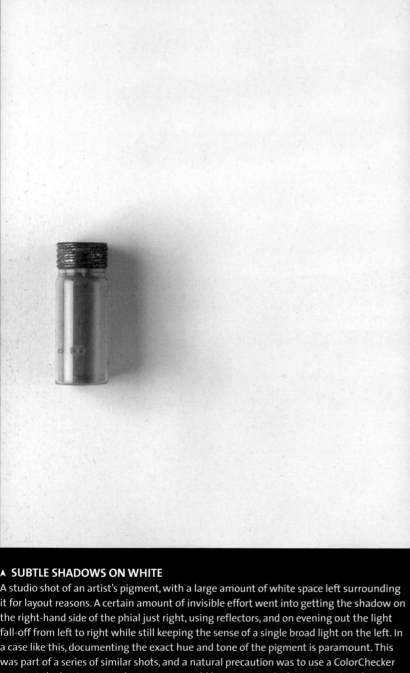

8%

65%

▲ SUBTLE SHADOWS ON WHITE

A studio shot of an artist's pigment, with a large amount of white space left surrounding it for layout reasons. A certain amount of invisible effort went into getting the shadow on the right-hand side of the phial just right, using reflectors, and on evening out the light fall-off from left to right while still keeping the sense of a single broad light on the left. In a case like this, documenting the exact hue and tone of the pigment is paramount. This was part of a series of similar shots, and a natural precaution was to use a ColorChecker target at the beginning so that accuracy could be guaranteed when processing the Raw files. The only sensible metering method in a situation like this is a handheld meter with incident-light attachment. As the tone patches show, the (correct) brightness of the phial is 65%, while the overall reflected-light reading would have been pointless with so much white paper background.

WHOLE IMAGE

PIGMENT VILE ONLY

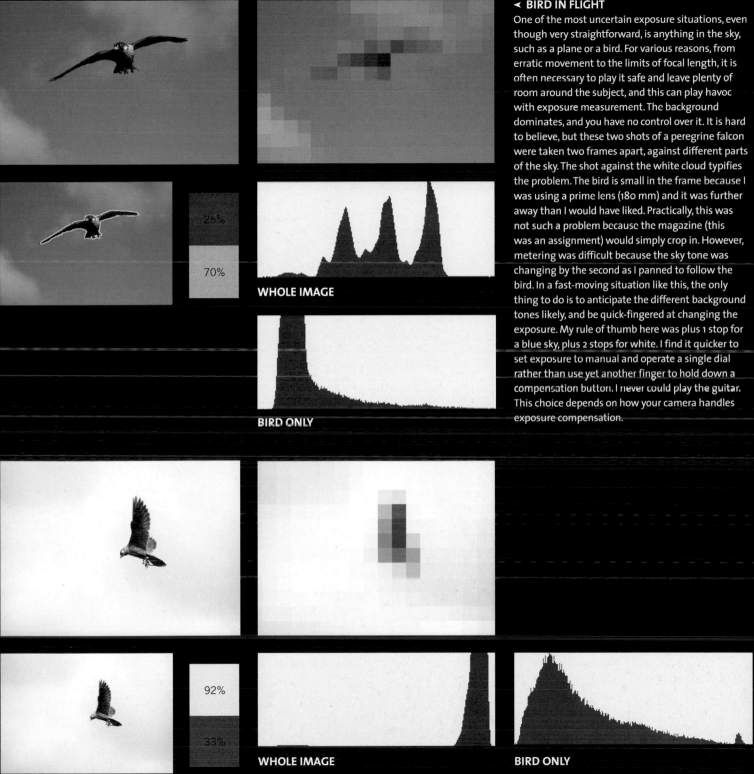

◄ BIRD IN FLIGHT

One of the most uncertain exposure situations, even though very straightforward, is anything in the sky, such as a plane or a bird. For various reasons, from erratic movement to the limits of focal length, it is often necessary to play it safe and leave plenty of room around the subject, and this can play havoc with exposure measurement. The background dominates, and you have no control over it. It is hard to believe, but these two shots of a peregrine falcon were taken two frames apart, against different parts of the sky. The shot against the white cloud typifies the problem. The bird is small in the frame because I was using a prime lens (180 mm) and it was further away than I would have liked. Practically, this was not such a problem because the magazine (this was an assignment) would simply crop in. However, metering was difficult because the sky tone was changing by the second as I panned to follow the bird. In a fast-moving situation like this, the only thing to do is to anticipate the different background tones likely, and be quick-fingered at changing the exposure. My rule of thumb here was plus 1 stop for a blue sky, plus 2 stops for white. I find it quicker to set exposure to manual and operate a single dial rather than use yet another finger to hold down a compensation button. I never could play the guitar. This choice depends on how your camera handles exposure compensation.

25%

70%

WHOLE IMAGE

BIRD ONLY

92%

33%

WHOLE IMAGE

BIRD ONLY

CHAPTER 4:
STYLE

The theme of the last two chapters has been finding the exposure that best suits the situation. This has meant taking into account some important technical issues, such as the dynamic range of the sensor and of the scene, taking accurate measurements, and identifying what is the important area or subject in the scene. Now I want to move things on to the next level, which is to take all this and temper it with judgment and creativity. As I already touched on in *Objectively correct* on pages 50-51, the notion of just one exposure being "right" is quite risky. While there's no doubt that there is a fairly narrow band of exposure for any one image that the majority of people would prefer, good photography involves self-expression, and this opens up the choice even for something that might seem so mundane as exposure.

In exposure, there is no wrong and there is no right: If you embrace this, and I believe you should, you take your chances and fall back on your judgment. Like any artist, you have to stand by your own opinion. Not everyone will agree with what you do, but does that matter? There's a certain safeness in trying to get the image to a state that most of your audience will like. It's safe, yes, but courageous, no. If you treat photography as a kind of business, with results based on market acceptance, as many people do, then you should stick with the received wisdom and the objective "rightness" that the last chapter dealt with. However, rest assured that the imagery will fall short of being interesting, personal and, dare I say it, completely worthwhile. This applies across the range of creative expression in photography, and exposure is very much a part of this. Most photographers tend to play safe, and it's entirely forgivable, but nevertheless...

It's fashionable but trite to claim that there is no such thing as correct exposure. However, for each individual photographer in every picture situation there is indeed one perfect exposure that satisfies both technical and creative needs. It matters less that the result may differ according to personal taste than knowing how to achieve what you want from a photograph.

MOOD, NOT INFORMATION

The idea of optimal exposure, which, as we've seen, is largely built around assigning mid-tones to most subjects, follows the premise of delivering good information. A clear view with all the essential detail visible is about as close as we can get to the concept of an objectively "correct" exposure, and many—probably most—situations warrant this kind of treatment.

However, it by no means applies to *all* situations. Photography in all its aspects starts to become interesting when you make your own interpretation of a scene, not just following the obvious. This applies to composition—what you define as the subject, viewpoint, and much else,

including exposure. It may seem on the face of it that in choosing an individual expression of brightness all you are doing is making the image darker or brighter, but this apparently simple action influences much more in the way the photograph will be read.

Here, for example, are three images that have been given extreme exposure, all for good reasons, even though not everyone would agree with the results. The silhouetted shot of the rock arch, in particular, has become quite a different kind of image from what it ordinarily would have been, and the content is hardly recognizable.

∨ SKYE

Black-and-white imagery lends itself particularly well to strong variations in exposure for mood, because there are no associated shifts in hue (see pages 62-65 *Exposure and color* and *Exposing for color* for more on this). Shooting into the light, this river on the Isle of Skye in the Scottish Hebrides, lent itself to a dark, brooding treatment by underexposing, and by recovering sky detail and shadows by dodging and burning. In fact, the visual impression of the scene was much less dramatic, brighter, and flatter than the image here. Exposure is one of the most powerful techniques for interpretation in photography.

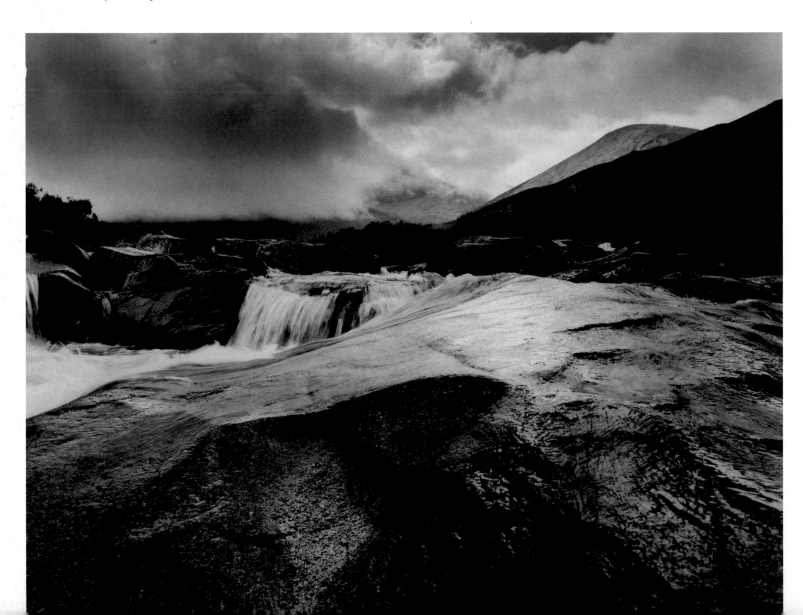

One of many natural sandstone arches in Utah. Their outlines against the sky make these arches prime material for graphic compositions, but they are also over-photographed. On this occasion, in the late afternoon, the sky was a flawless blue—and boring. Changing the camera position with a view to hiding the sun's disc behind the thin span of rock, I was looking for a silhouette. Then I found a more interesting, slightly surreal effect with a dark exposure that made it only just possible to distinguish black from dark, rich blue. The key to this was holding down the camera's depth-of-field preview button with the small aperture chosen (*f*22). This is something I frequently do with potential silhouettes (see pages 152-153 which cover silhouettes).

> **EXTREMF EXPOSURE**

The opposite direction is to over-expose to extreme, as here with a backlit arrangement of orchids. With this kind of lighting set-up, a studio flash aimed directly towards the camera from behind a sheet of milky translucent Plexiglas, the usual precautions are to mask right down to just outside the image area, using black card, so as to minimize lens flare. The version on the left is the conventional bright-but-not-quite-clipped treatment, basically 2 stops brighter than a direct through-the-lens reading. The second version is over-exposed by one *more* stop. Maybe I should be careful with using the term "over-exposed" in case it suggests some kind of wrong exposure. The result is certainly not conventional, and many people would consider it a mistake, but what it does is to stress color and light at the expense of shape —which is perfectly valid personal interpretation. Note that increasing the exposure opens up the

CONVENTIONAL

"OVER" EXPOSED

PERSONALIZED EXPOSURE

Extending the idea of the last two pages, the argument is that exposure can be taken further than the technical skill needed to suit the scene and the subject. It can be made into a creative tool to help explore personal ideas about imagery. Some photographers even develop what others would call under- or over-exposure into a signature. One great photographer who comes to mind is Don McCullin, the famous war photographer, who has since turned to landscapes—his self-termed "peace pictures." In an interview with photographer Frank Horvat he said, "…my favorite time to photograph landscape is evening, I cannot avoid wanting everything to go dark, dark, dark. I also like wind and rain, it messes up my equipment, but I like

being in the rain." The reasons for wanting to go dark or go bright are always personal, and not even necessary to explain, but they require that, as a photographer, you know what you want from the image.

▼ PAKISTANI CLOUDS
Overlooking the hills of Pakistan's North-West Frontier, bordering Afghanistan, I waited for dawn to shoot an overview of the tribal area where I was shooting on a *Time Life* assignment. I did this several times, and on most days the view was clear but uninteresting during the long, dry August days. On this day, however, we had storm clouds gathering in the east, and I finally had the makings of a landscape. This being an assignment, I needed a scenic view like this in order to set the scene for the book, which was about the lives of the Pathan people living here. It wasn't a matter of responding to an interesting view, more of making something interesting out of a landscape lacking in conventional physical drama. "Barren" and "arid" are the usual inevitable descriptions of this land. My solution was to use the sky and make more of it in the composition. The multi-layered clouds and the arrangement of the light created a landscape in the sky, and I made sure that I exposed for this, leaving the land below, with its low hills and farms, still in pre-dawn light.

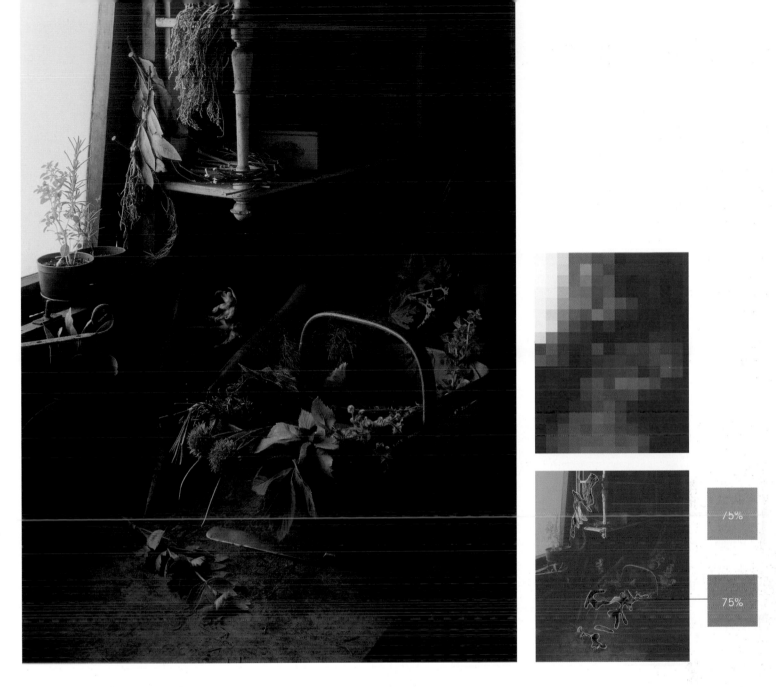

▲ AN EXERCISE IN ATMOSPHERE

This assembled shot in an old garden shed, to illustrate a feature on herbs, needed to balance information (the assemblage of fresh and dried plants and leaves) with atmosphere (the evocation of old country life, hidden corners, and the sense of time stood still). The solution was to light the shed in a completely natural way, with minimum shadow fill and including the window in frame (for atmosphere) while positioning the herbs in light that would reveal them clearly. In other words, composition here is the main technique for dealing with the lighting. To heighten the desired atmosphere further, I wanted no hint of detail from the garden outside, which is the opposite of what is normally sought from an interior looking out.

To do this, I hung a large sheet of tracing paper outside the window, and aimed a 1600 joules naked flash from directly outside, boosting the weak, cloudy daylight and making it more directional. A single white card reflector on the right gave a hint of detail to the deep shadows. The plan view shows how the light fell, and why the right place for the two important groups of herbs was chosen—one hanging out of a basket on the worktop, the other, brighter and nearer the window, hanging from the shelf. The relative brightness of each was acceptably close—one slightly more than average, the other rather less. The actual metering was done with a handheld incident-light meter, this being a set-up allowing plenty of time, and the exposure was ƒ16 at ISO 200, which is 1/3-stop less than the incident-light reading.

MEMORY TONES

Most people are probably familiar with the idea of memory colors—those colors that are so familiar we expect them to reproduce in a certain way and are especially sensitive to them in our perception. Less commonly referred to are memory tones, but the principle is the same. Indeed, most of the subjects and surfaces are the same, with skin leading the list, but in this instance it is the lightness or darkness that is important. In practice, it is not easy to separate our judgment of tone from that of color, and as we'll see over the following four pages, altering the exposure to change the lightness definitely affects our sense of the precise color. In black-and-white, of course, there is only tone to consider, and if your camera allows you to shoot monochrome; judging memory tones is simpler, although it is complicated by deciding how bright different colors should appear in black-and-white.

Skin is arguably the most "memorized" of memory tones, given the overwhelming visual importance of people and in particular faces. And it varies hugely according to ethnicity and taste. Just as some people sunbathe to darken their skin tone by choice, others use hats, sunblock and even parasols to keep it pale, and ideals of how dark or light skin should appear differ between individuals and societies. That is why this exposure decision properly belongs here in the *Style* chapter rather than earlier under *Technical*.

Green vegetation, from grass to leaves, also raises expectations about how light or dark it should appear. Unlike skin, which most people tend to prefer to be less saturated rather than more saturated in color, the general preference is for a strong sense of "greenness," and usually this encourages images a little lighter than average. There is a more technical reason as well, which is that the sensitivity of the HVS (Human Visual System) peaks in the yellow-green part of the spectrum. It is still a good idea to avoid paleness, especially for grass, but most people would rather not see green leaves distinctly dark. Again, though, this is a matter of personal taste.

Skies are the third major subject in photographs that tend to be judged against how we remember them. Like green plants, blue skies are often remembered as being more colorful than they actually were. Not only did film manufacturers acquire a lot of experience in formulating emulsions to match customers' ideals, but camera manufacturers also now regularly adjust settings to give people what they want, rather than realism and accuracy. Richness in a blue sky generally calls for a *lower* exposure.

⋀ GREENS
The full range of greens is more varied than most people imagine, and even in a single view, like this of a valley in Yorkshire, it reveals a range of hues and tones. Indeed, hue and tone are closely related because, as most people's preference is for over-saturation of "grassy" green (a fact well known by film manufacturers, some of whom, notably Fuji, adjusted the dyes in certain emulsions to suit popular taste), this effect comes across better when lighter. In other words, popular taste wants grass to be bright and strongly hued.

MEAN SKY BRIGHTNESS 166

MEAN SKY BRIGHTNESS 160

◄ SKY BLUE?
How blue should the sky be? Again, this is influenced strongly by popular taste, which tends towards better saturation of the blue. As this pair of images shows, perhaps counter-intuitively, a more saturated blue sky is also lighter, by a small amount.

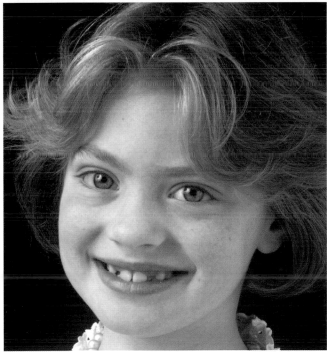

DARKER

◄ FLESH TONES

Perceptually, we are highly sensitized to flesh tones, or rather, to the flesh tones with which we are familiar. There is a surprisingly narrow range of acceptability, as illustrated here with a picture of a girl with pale Caucasian skin. The middle exposure looks "right", but even the modest change of ²/₃ stop up or down, as in the other versions, looks "wrong." If we take just the skin area, we can see that from shadow to light (see diagram below) there is a range of about 2 stops, with an average overall brightness of 67% for the "correct" exposure. What makes this interesting is that this exposure range is perfectly acceptable *because* the eye sees it as related to the way in which the light falls on the face and the shadows that are cast. In other words, we perceive the skin as being of the same lightness, simply varying because of the illumination (see pages 28-29 *Exposure terms*). The average brightness for this kind of Caucasian skin needs to be between about 60% and 70%, around 1 stop brighter than an average reading. Other kinds of skin need very different exposure compensations.

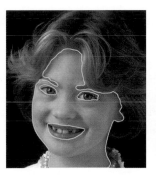

67%

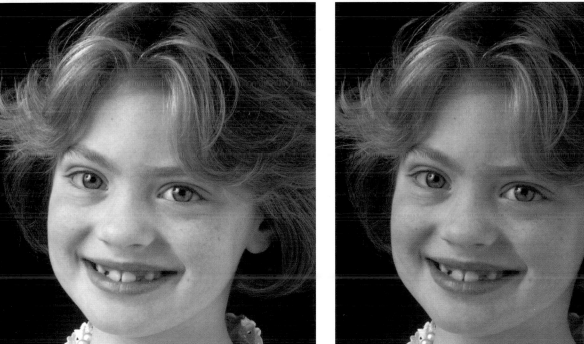

LIGHTER

MID

ENVISION

I use the term envision to refresh a clear idea that has become clouded by, of all things, the Zone System of Ansel Adams et al. I'll get on to that topic in a few pages, but one of the crucial steps in exposure is being able to imagine how the image will look if you give it a certain exposure—in other words, being able to envision it.

For many photographers, this concept was hijacked by the clumsy term previsualization, invented unnecessarily by Ansel Adams to describe the first step in his Zone System. However, whereas the Zone System always has been a method best suited to landscape and architectural photography, or at least those scenes where the photographer has lots of time to stand around thinking, the idea of envisioning how the shot will look at any given exposure is universal. It is also logical, and something that really does come naturally to many photographers who spend their time regularly shooting, day after day. If you don't care for either word, just think of it as forming a mental picture.

It takes a certain leap of imagination to jump from simply absorbing the scene to translating it into a photograph with a fixed and limited dynamic range. Without laboring the point, the Human Visual System (HVS) operates by rapidly and constantly scanning the scene, focusing on small areas and very quickly building up a mental picture. An essential mechanism is a kind of normalization as the eye scans. As the gaze flicks from a shadow area to a highlight, we can perceive the detail within each, and with very little delay. The result is that we perceive the full dynamic range of the scene in microseconds.

A single photographic image clearly doesn't work in this way, and a key skill is to envision how it might look before shooting. There are also likely to be choices, as the examples here show. Moreover, if the light is changing over the period you are shooting, this adds more variables. A landscape that is shot as the sun rises or sets, or under fast-moving clouds, is a typical case. This involves another HVS feature, called brightness constancy. This is our ability to perceive surfaces

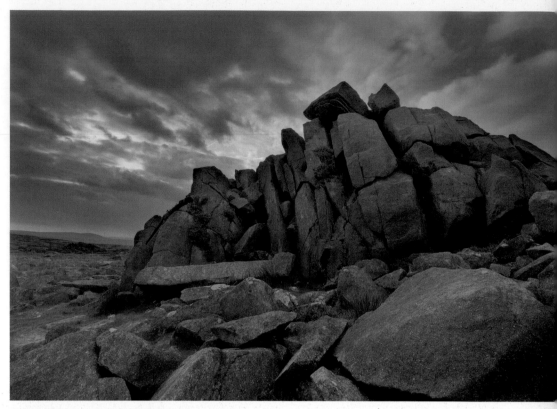

SIMULATED HUMAN OBSERVATION

having the same brightness even though the light may change. In practice, this means, for example, that we tend not to notice the full pace of failing light at dusk, and is something to be overcome if you want to envision how a late afternoon scene will look in an hour or two's time.

So, there is more than one action involved in this process of forming a mental picture. In fact, there are up to four quite distinct steps, as follows:

1. Learn to discount your eye's great efficiency at seeing detail in deep shadows and bright highlights, as your camera cannot do both.
2. Be able to imagine how a scene will reproduce if given a "normal" "average" exposure.
3. Decide how you would *like* it to look.
4. Anticipate how it might look under different lighting conditions that are practically possible, such as change in the angle of sunlight, or under controlled conditions by changing the lighting.

On the following pages we'll look at how to put this into practice.

HORIZON AREA

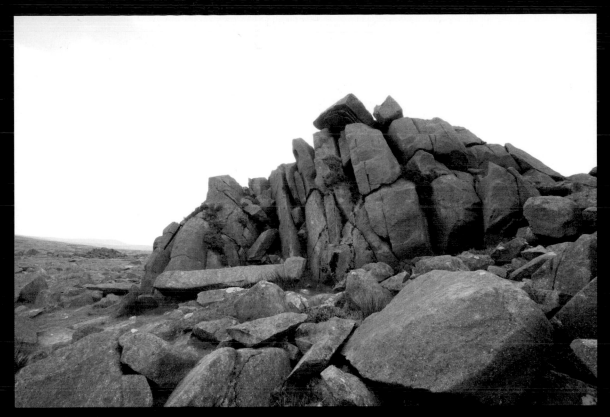

ISO 200 ¹/₄ SEC *f*22

◄ DISCOUNTING THE WAY WE SEE

Most failures in exposure, even the small ones when the image didn't quite appear as imagined, are failures to translate from how we perceive to a strictly sensor-recorded image. Reproducing exactly how the Human Visual System perceives a scene is impossible on a printed page, but with practice all photographers learn to recognize what the eye can do that the camera cannot. In an exposure situation like this, with two quite sharply distinct areas of brightness—the ground and sky—it's important to know that a single shot will not deliver what you see. In this view of a Welsh mountain landscape looking towards a cloud-strewn sunset, what I could see approximated to the image, but it was built up from the eye's brightness adjustment for the sky and another for the rocks, and a third that spanned the transition on the horizon from ground to sky. I shot a range of exposures in order to eventually be able to reproduce this. The two exposures shown here are spaced 2 stops apart, which is a substantial range.

ISO 200 ¹/₆₀ SEC *f*22

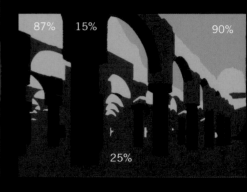

EXPOSURE

RAW SOFTWARE AUTO

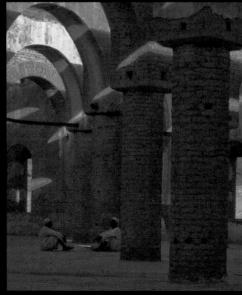

OPEN SHADOWS IN SOFTWARE

SOFTWARE RECOVERY

▲ HOW YOU WANT IT TO BE

There are often a number of ways of treating a shot simply through exposure. This view of a ruined, though still used, mosque in eastern Sudan is a case in point. The contrast is high, and that was a prime consideration, to avoid clipping as much as possible, but I had another motive as well for this exposure. I had envisioned this as a large print, and wanted the viewer's attention to come slowly to the two men sitting on the ground in the middle distance, so as to give a slight surprise at the size of the structure. The other versions of this detail show more expected treatments, that open up the shadows and rely on the Raw processor to recover some highlight detail. However, I wanted the attention to begin higher in the frame, where all the contrast is, and only later drift down to the men. The solution was exposing so that the open shadows were around only 25% brightness,

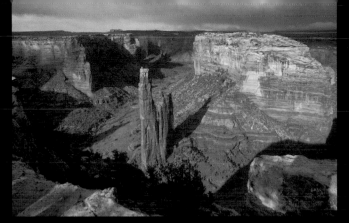

ISO 64 ¹/₃₀ SEC *f*8

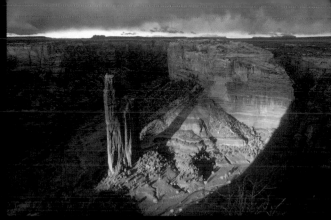

ISO 64 ¹/₃₀ SEC *f*9

ISO 64 ¹/₃₀ SEC *f*11

ISO 64 ¹/₃₀ SEC *f*11

▲ ANTICIPATING LIGHT

This kind of anticipation has a broader use than just for the exposure; as it affects the composition, the atmosphere, and the overall success or failure of the shot. However, imagining how the exposure might be as the light changes is an essential component. Let's return to an image that I analyzed on pages 58-59 in *Scene priorities*. In this example, there was, as usual, no guarantee that the light would turn out to be in any way special as I waited for sunset. Sunlight was sporadic, and the gathering clouds threatened to extinguish it soon after the first of these images, which is fairly ordinary. Nevertheless, I needed to prepare for this possibility, however remote, because any late flash of sunlight might well be short-lived and I wanted to be able to shoot quickly, with confidence in my exposure settings. If this were going to work out at all, I wanted to know how the light and shadow would fall on the scene.

One of the things I was banking on, and suggested by this first shot, was that the movement of the sun would make it cast a large shadow behind Spider Rock. I use my viewpoint to anticipate this, as I wanted

the thin pillar isolated by the lighting. The sunlight then disappeared for half an hour and the shoot looked pointless, but suddenly a gap began to open in the clouds (top right). At this point, the sun in its descent had not quite cleared the lower edge of the clouds, leaving the upper part of Spider Rock weakly lit. I wasn't happy with this, but shot it nevertheless. The sunlight continued across the scene for the next quarter hour, with the contrast getting stronger until this final moment (bottom left). As I had already thought about what I wanted, as explained on pages 58-59, I knew exactly what the exposure settings should be, even though the sunlight intensity was increasing. I kept metering the brightest part of the cliff face and applying the same compensation (plus 1 ¹/₃ stop, as I had already decided). By the final shot, the light has begun to go, though the gap in the clouds has persisted. Note the change in camera position in an attempt to do something with the changed distribution of light, as I stepped back to let the foreground rocks take up some of the attention lost to shadow in the lower right of the frame.

THE ZONE SYSTEM

The Zone System, which is seemingly held in greater and greater reverence now that its reasons for invention recede into history, was an attempt to coordinate exposure and printing for black-and-white photography.

Yet how relevant is it for digital shooting, and indeed for shooting in color? The answer is not much, at least not in the way it was originally intended to be used. There are many people who believe in the Zone System, and there is even one excellent software processing application based on zones (LightZone), which is actually why I include it here. Ultimately, the Zone System was a solution for inadequacies in the basic photographic process—inadequacies that I believe are being tackled digitally in quite different ways. This is not what you will usually read by Zone System enthusiasts, but that's because of the mistaken belief that you can go on adapting old techniques to new circumstances.

The key concept, which remains valuable even with digital processing, is the division of the tonal range of a scene into 10 zones (although there are variations of 9 and 11). Photographing by the Zone System involved three actions. The first was to form a mental picture of how you wanted the final print to look in terms of brightness and contrast. The second was *placement*, meaning that you decided which tone in the scene you would place in which zone—in other words, assigning it a brightness level. By *placing* one tone in one zone, the other tones in the scene would naturally *fall* in other zones. The third action was to adjust how tones would fall by varying the combination of exposure and development—essentially, contrast control. Reducing development time for a black-and-white negative, or weakening the solution, made the image lighter and less contrasty, while increasing it made the image darker and more contrasty. So, for example, if the scene were contrasty (we would now say it had a high dynamic range), you could increase the exposure and reduce the development.

Clearly, this procedure has very little relevance to modern digital shooting, especially because of the need to hold highlights. Over-exposing for a high-range scene could be disastrous, because nothing would be able to restore the clipped highlights. What *is* of value, however, is the way of looking at a scene that the Zone System encouraged. The 10 zones are sensible and practical, and not at all a bad way of evaluating scenes and images.

ZONE 0
Solid, maximum black. 0,0,0 in RGB. No detail.

ZONE I
Almost black, as in deep shadows. There is no discernible texture.

ZONE II
First hint of texture in a shadow. Mysterious and only just visible.

ZONE III
TEXTURED SHADOW. A key zone in many scenes and images. Texture and detail are clearly seen, such as the folds and weave of a dark fabric.

ZONE IV
Typical shadow value, as in dark foliage, buildings, and landscapes.

ZONE V
MID-TONE. The pivotal value. Average, mid-gray, an 18% gray card. Dark skin and light foliage

ZONE VI
Average Caucasian skin, concrete in overcast light, shadows on snow in sunlit scenes

ZONE VII
TEXTURED BRIGHTS. Pale skin, light-toned and brightly lit concrete. Yellows, pinks, and other obviously light colors.

ZONE VIII
The last hint of texture. Bright white

ZONE IX
Solid white, 255,255,255 in RGB. Acceptable for specular highlights only.

COLOR ORIGINAL

AREAS FLATTENED TO CLARIFY ZONES

This is an example of dividing an image into meaningful zones. Only reasonably sized areas are worth designating, as very small areas are unlikely to influence your exposure choices. However, this is not an exact procedure. In this architectural shot of a portico in quite bright sunlight, there are six obviously separated tonal blocks or zones. Assigning these to specific zones requires some judgment, and if you follow the Zone System it also means that all the zones will have a one-stop relationship to each other. In this case, using Zone System methodology, I would *place* the shadowed area inside the dome in Zone III (textured shadows), see how the other values *fall* and aim for a result in which the bright stone surrounding the entrance is in Zone VII (textured brights). In practice, the processing choices in digital photography, particularly with Raw files, have overtaken the more limited ambitions of the Zone System. Note the difference between judging zones in black-and-white and in color. Colors can be distracting for this exercise.

BLACK-AND-WHITE CONVERSION

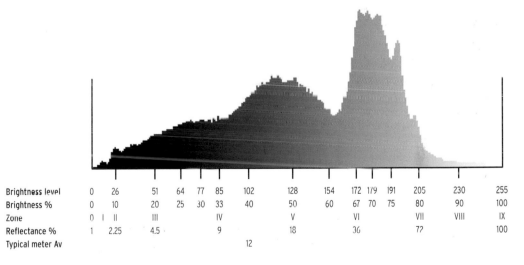

Brightness level	0	26	51	64	77	85	102	128	154	172	179	191	205	230	255
Brightness %	0	10	20	25	30	33	40	50	60	67	70	75	80	90	100
Zone	0	I	II	III			IV	V		VI			VII	VIII	IX
Reflectance %	1	2.25	4.5				9	18		36			72		100
Typical meter Av								12							

▲ RELATING ZONES TO BRIGHTNESS

A useful *aide-mémoire* shows the zones (10) on the same scale as the levels of a histogram and percentage brightness, with percentage reflectance thrown in for good measure. Each zone represents one stop, but close to the ends of the scale on the left and right these relationships become impractical. The histogram displayed is arbitrary, and is included simply to show the gradation of tones from black on the left to white on the right. Note that 18% reflectance is mid-tone, which is the standard photographic gray card, but the typical in-camera meter average is about half a stop less than this, at around 12%. (See pages 54-55 for more on this).

REPRODUCING THE SCALE

It's important not to take the division into solid tones literally. The tonal range grades smoothly, and dividing it into blocks is for convenience only. For example, Zone III (textured shadow) shades from around 25% brightness to a little less than 40%. Some Zone System users prefer their zone scales to have some texture to make the tones seem more solid and recognizable. Also, the zones are always easier to judge in monochrome and with a monochrome image, but real life has color so there is an argument for the zone scale to contain arbitrary color.

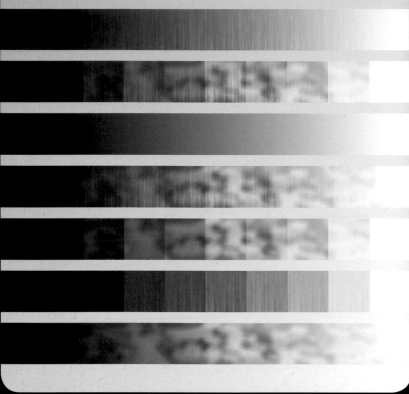

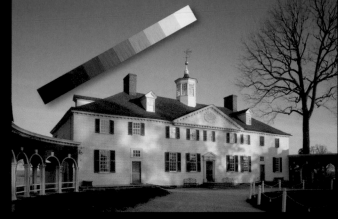

ORIGINAL COLOR

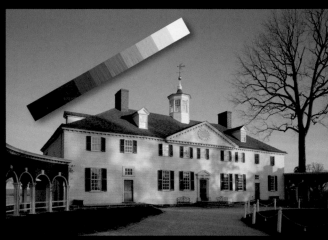

ORIGINAL IN MONO

➤ IDENTIFYING ZONES IN DETAIL

Traditional Zone System practice is first to make your own zone scale and then hold it in front of the scene to be photographed. I've simulated this here with a view of Mount Vernon, Virginia. Note the difference between viewing in color and in monochrome; we'll return to this later. Sliding the scale around the view, which is more obvious here with an image than with the real scene, the tones can be matched. Because the zone scale is printed, it accurately represents the range of what is possible to print—although, of course, it works better in black-and-white.

- Zone VII matches the gable, and also the areas of the white façade on which the shadows of the trees fall.
- Zone VIII matches the bright sunlit areas of white-painted façade.
- In this rendering of the scene there is not much Zone V material (the gravel driveway) and it is a less important zone than others for exposure decisions affecting this image.
- Zone IV matches the roof tiles, but with a strong warning because their red color can be translated digitally into a variety of tones.
- Zone III matches the shadowed areas behind this arch.

ZONE III

ZONE IV

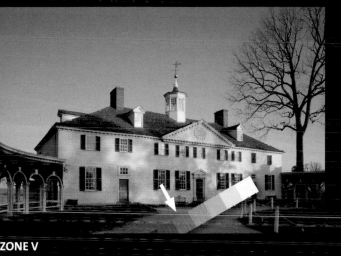

ZONE V

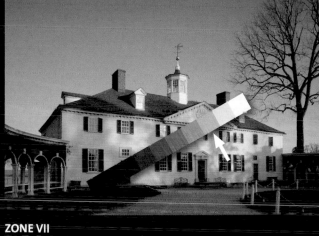

ZONE VII

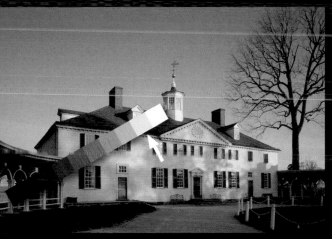

ZONE VIII

WHAT ZONES MEAN

What survives from the Zone System that is of lasting value is the description of the zones, and what they mean perceptually—and conceptually. Three zones in particular have special significance because they mark key points on the scale. These are Zones III, V, and VII. Zone V is the mid-tone, so it is important for obvious reasons. Metering and exposing for it gives a 50% brightness in the image. This is also where the Human Visual System perceives the maximum information. Zone III is the darkest tone that still retains full shadow detail, while Zone VII is the lightest tone to hold full detail. Below Zone III and above Zone VII, texture and detail begin to be swallowed up by darkness and brightness respectively—detail is hinted at rather than delivering full visual information.

A broader way of looking at the scale is to say that from Zone III to Zone VII is *textured*, while at either end is predominantly *tonal*. All the essential information detail will be in the central 5 zones on a 10-zone scale. This does not, however, make the tonal zones (0 to II and VIII to IX) unimportant for exposure decisions. As we saw on pages 38-41, most images benefit in appearance when they just touch pure black and pure white at either end. This is why in digital processing one of the most basic steps is to set the black and white points, as we'll see in Chapter 4. In Zone System terminology, this means that Zones 0 and IX (on the 10-zone scale) are just reached but not included. The zones just outside the "textured" limits, which is to say Zones II and VIII, can also be significant in images where you want to hint at detail in an area rather than have it fully revealed.

Let's look at parts of different images for which each of the zones is particularly important.

▲ ZONE 0 – BLACK POINT

As with Zone IX at the other end of the scale, some people avoid even the smallest part reaching Zone 0, but more often it is used to ensure good contrast and a "punch" to the lower end. In short, Zone 0 equals the black point! In this image, just the darkest part of the shadow is clipped (see arrow).

▲ ZONE I – ALMOST SOLID

For some photographers, this zone *is* the black point, meaning even more "punch" to the overall appearance of the image. To highlight the point, this image is the same as the one above, but with the black point moved in a little (using the Levels tool). The effect is subtle, particularly on a book's printed page.

⌃ ZONE II – HINT OF DETAIL

In this view looking down on buildings in the heart of the old city of Bruges in Belgium on a bright, clear day, the overall aim was to have rich, saturated colors for the sunlit rooftops, which called for less than typical exposure. This in turn made the dark shadowed areas in the narrow street important—to hold just a hint of detail.

⌃ ZONE III – SHADOW DETAIL

This is the standard zone in which to place areas that show full detail, but are still distinctly in shadow, being two stops darker than an average mid-tone. This is a typical case—the shadowed area of a portrait taken in sunlight of a person with slightly dark skin.

▲ ZONE IV – OPEN SHADOW

Often an alternative to Zone III, but the difference is that the shadows here feel very open. It is still a darker than average mid-tone, but by only one stop.

▲ ZONE V – MID-TONE

This is the default for all meters, and in a sense the default for the human eye and brain. What this means is that if the surface you are thinking about has no prior reason to be lighter (such as a white cloud) or darker (such as a black cat), then Zone V is the default

▲ ZONE VI – BRIGHT

Lighter than average without getting close to the sense of being a highlight. Caucasian skin, as here, is usually well suited to Zone VI—in other words, a stop brighter than the meter.

◢ ZONE VII – HIGHLIGHT DETAIL

The highlight equivalent of textured shadow, Zone III, and with the same general qualities of having full textural detail while being very much part of the highlights.

◢ ZONE VIII – BRIGHTEST ACCEPTABLE HIGHLIGHT

Here, the details are on the verge of disappearing into whiteness, but not quite. There is no clipping, but this is as bright as you would want a digital image to reach, short of small specular highlights.

◢ ZONE IX – WHITE POINT

There are two schools of thought for this top end of the scale, as there are for Zone 0. One holds that no part of the image should reach this clipping point, while the other allows it for that extra touch of clean contrast—but only if, as here, it is confined to small specular highlights and light sources.

UPDATING THE ZONE DESCRIPTIONS

This is my summary of the 10 zones that are relevant to digital photography:

IX	White point
VIII	Brightest acceptable highlight
VII	Highlight detail
VI	Bright
V	Mid-tone
IV	Open shadow
III	Shadow detail
II	Hint of detail
I	Almost solid
0	Black point

ZONE THINKING

While the Zone System, as invented, is fairly pointless for digital photography, and completely pointless when shooting Raw, the principle of analyzing scenes and images in zones is a good one. Ansel Adams's 10-zone division is perceptually spot-on, as each of the zones refers to a brightness level that triggers a particular response in the HVS. Here, let's take an image and see how dividing it into zones might help exposure decisions.

The photograph is a fairly straightforward scenic view, of Cape Town in South Africa. The light was changing frequently, which meant quick decisions were needed, and I was aiming for the obvious—a rich contrast between sunlit buildings on the waterfront and storm clouds over Table Mountain in shadow. According to my usual way of dealing with exposure, the key tones would be the façades of the buildings, and I knew that I would want them to be, en masse, about one stop lighter than average. I was not analyzing the scene via the Zone System—I never do—but we can still take this approach in retrospect, or at least imagine that we were doing it the Zone System way. To make things easier and less distracting, let's look at it in monochrome, by a straightforward desaturation, without bothering too much about how the colors would translate into levels of gray.

Here I've processed the Raw image to look as it would if the entire scene were metered and shot according to a center-weighted average reading. In fact, this is lighter than I shot for, but we'll come to that in a minute. Broken down into zones, the main blocks of interest fall as follows: the brighter buildings Zone VII; the mountainside Zone III; the darker clouds Zone IV; the gray cloud top left Zone V; the clear sky below it Zone VII; and the waterfront shops in shadow Zone II. The brightest highlights and darkest shadows, which are all small in area, are shown separately, and of these the only important thing is not to let the highlights clip.

It's now decision time: The bright building façades are the key, so where should we put

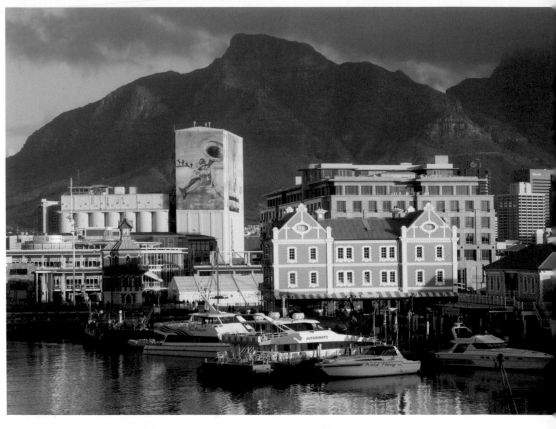

▲ ORIGINAL
Exposed as for a center-weighted average reading.

them on the zone scale? The predictable choice would be Zone VII, exactly where they are in this averagely exposed version. But taste comes into this, as does color. In this case, the two were inseparable. The weight of importance of color varies from scene to scene and from image to image, and this area of judgment is filtered first through the photographer and then through the viewer. The permutations are endless, and it makes a topic in its own right, although it is too long to discuss here. With this scene, I was looking for richness of color as much as for strong contrast between sunlight and shadow. As we've seen at the end of the last chapter, rich saturated color comes from some degree of under-exposure. This was exactly what I wanted, so in Zone System-speak I wanted to place the brightest sunlit buildings one zone lower than

the obvious—in other words, in Zone VI. If I had been shooting for black-and-white, I would probably have kept them at VII. Notice also that the mainly blue and green mural on the tall building *looks* darker in color than it does in the default desaturated monochrome version.

Shifting the exposure down one zone—in other words, one stop—has the advantage of darkening the mountainside behind and also enriching the blue sky. The downside of this is that it deepens the shadowed area of waterfront shops, and while I could live with this I would ideally like it to be opened up sufficiently to show what is going on there. However, this being a digital image, I can have my cake and eat it when I come to process the image in Photoshop or Lightroom, DxO Optics, or whatever software package I use.

+ ¹/₂ STOP

- ¹/₂ STOP

- 1 STOP
My final choice

▲ **MONO FOR CLEARER ZONE IDENTIFICATION**
The black-and-white version of this exposure, to make zone allocation easier.

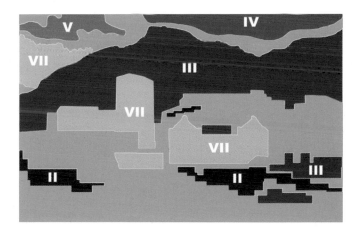

▲ **ZONE SCHEMATIC**
Allocation of zones according to this average-reading exposure.

EXPOSING FOR BLACK-AND-WHITE

You might reasonably have expected *Exposing for black-and-white* to come straight after *Exposing for color* in Chapter 2, but it really has to be treated under Style because black-and-white photography is almost entirely about *interpretation*. After all, we don't see in monochrome, except in very low lighting, so decisions about how a scene ought to look in black-and-white are always personal ones.

There are two ways of shooting black-and-white digitally, and they call for different approaches to exposure decisions. One is to shoot in black-and-white mode, which some cameras offer. The clear advantage here, at least for exposure, is that you immediately see what you get—and depending on the camera, this does not necessarily mean that you lose the color information in the image file. The other approach is to shoot in color as normal, and then use one of the several image-editing programs available to convert into black-and-white. The technique of channel mixing has opened up a completely new world of choice and craft for black-and-white photography, making it possible to translate any color into any tone. This is actually a processing matter, but it is obviously connected with the exposure and resulting brightness.

Because black-and-white images are exclusively tonal, you could argue that they have a more direct relationship with exposure as they are uncluttered by color that actually interferes with our perception of brightness. Standard procedures do not apply quite so stringently, so that, for instance, clipping at either end of the scale can be better accepted. I'm talking about general reactions, of course. And because the modulation of tones is so evidently a part of the craft and art of black-and-white photography, there is also more general acceptance of extremes of key—low key and high key, which we'll come to a little later in this chapter. Naturally, everyone makes their own decisions about what they like, but when it comes to general audience reactions there is more scope and more freedom in choosing exposure in black-and-white than in color.

► **CAMERA MONO MODE**
Some cameras have a monochrome display mode, and the value of this is that it removes the distraction of any strong colors, which can overwhelm envisioning a scene in black-and-white. The image file will still be in RGB, and so can be converted with all the usual channel mixing controls later.

ORIGINAL COLOR

◄ ▼ CONVERTING FROM RAW

Shooting Raw and then converting to monochrome with a Raw converter means that there is full choice of lightening or darkening individual colors. Although there may be a default setting, this in no way implies that there is a standard or correct method—and the results can alter tonal relationships in the image greatly. Here is a detail of the Mount Vernon image that we looked at under *Zone System*, with a textured zone scale overlaid. In the first monochrome conversion, Photoshop's Raw converter default is used. Note the relationship between the red brick tone and the blue sky tone. In the second conversion, the red channel is raised and the blue channel lowered to favor the brick with a lighter rendering. See how the brick and sky tones correspond—they are now higher at Zone VII. In the third conversion, the channel settings are reversed to favor a lighter sky. The brick tone is now at Zone III, with no area of sky that corresponds.

BLACK AND WHITE	
REDS	161%
YELLOWS	60%
GREENS	40%
CYANS	60%
BLUES	-111%
MAGENTAS	80%

CONVERSION TO FAVOR BRICK

BLACK AND WHITE	
REDS	85%
YELLOWS	60%
GREENS	40%
CYANS	60%
BLUES	149%
MAGENTAS	80%

CONVERSION TO FAVOR SKY

STANDARD CONVERSION

HIGH KEY

In photography, the key of an image is the range of brightness within which you compose it. For once, the term compose suggests a relevant connection with music. Just as a piece of music can be composed in a single key, so a photograph can inhabit just one part of the full range from black to white. High key means an image composed in the upper bracket, featuring whites and near-whites. It involves what in ordinary circumstances would be considered over-exposure.

These are easier to construct in the studio or other controlled situations than to find by chance in real life, as they call for more than just a full exposure. The requirements are large pale areas lacking detail (such as a white background), only very small areas that are mid-tone or darker, and especially important is a near-absence of shadows. This last point makes the light sources critical, and the most effective for high key is enveloping, diffuse light. After this, it is up to the exposure to complete the job, and there is always a choice, from normal and averaged to verging on the featureless.

As almost all hues weaken with increasing brightness, and certainly the primaries red, green, and blue, color plays very little part in most high-key images. Even so, there is scope for having an overall pastel tint, and also for judiciously introducing a single spot color that gains even more attention from being alone. On the whole, though, as with low key—the reverse of this style of exposure and composition—this is very much in the tradition of black-and-white photography. Generally, the less color there is, the more the eye pays attention to the subtleties of tone, and high key is very much about subtlety.

High-key images carry the expected associations of openness, flooding light, and if there are any emotional tendencies (by no means a given thing) they are generally upbeat and positive. As with low key, when this kind of

◄ ▲ HIGH KEY PORTRAIT
This portrait has been so highly exposed that almost all details other than the eyes and lips have been lost. The extreme high-key treatment works with a subject like this in which the key elements remain fully recognizable. Average brightness is almost 90%—a 3-stop exposure compensation upwards from average.

AUTO

exposure and composition succeeds, it does so by being unexpected in its avoidance of typical contrast strategies, and by showing off a certain technical mastery in achieving just the right separation of tones in a delicate, restricted range. "White-on-white" is a classic use of high key.

There's potential confusion with the cinematographic use of the term high key, as it means lighting in which key and fill lights are balanced more or less equally. The effect is bright, full, with no large shadow areas, and without mood of mystery. It's efficient rather than intriguing, but the exposure is average, not over-exposed.

▼ **PEARLS SEQUENCE**
Freshly extracted pearls wrapped in plastic at a pearl farm in southern Thailand. The subject and setting are both in varying shades of white, and not only call for a lighter than average exposure but also from a high-key treatment. Four alternatives are shown here—two of them compensated to give a high-key effect, while two are automated and are not at all satisfactory. The medium-bright version, which I preferred, was exposed 2 stops brighter than the overall average reading. Even so, an exposure 1 stop brighter than this is still acceptable if you look at it in the high-key idiom, which allows for significant areas losing all detail. Compare these with an averagely exposed version, and also with this version equalized in Photoshop (using the Auto button in the Levels window), which closes up the black and white points.

AVERAGE

LIGHT

LIGHTER

LIGHT AND BRIGHT

As we have just seen, true high key demands special conditions. Even without these, however, there is a range of tastes and styles in how bright overall an image should be. What we looked at in Chapter 2 are the technical ideals *as most people see them*. Nevertheless, this is open to considerable interpretation, and the scale of brightness preferences is wide—and often surprisingly so for photographers who deal only with their own images to their own liking. A magazine picture editor, however, or even more so a repro house, gets to see a wider range.

For fairly obvious reasons, the lower the dynamic range of the scene, the more flexibility there is in overall brightness. Here, by the way, I'm using the term brightness rather loosely, as a general appearance to do with exposure, and not in the specific sense we defined back on pages 26-27. When the dynamic range is high, the problems of clipping place more constraints. Low-range images—the second group in The Twelve—tend to be technically acceptable to anyone whether lighter or darker. However, irrespective of technical issues and the notion of keeping things within the bounds of correctness, bright is very much a point of view, or should I say a state of mind. It carries various associations, and although it would be too simple to claim that these are universal, they include being open, obvious, fully revealed, positive, and even

cheerful. So long as the degree of brightness stops short of appearing washed-out and glaring, most colors will appear purer and more saturated than in a darker version (a reminder that I'm using the word saturation in its true sense, rather than the co-opted digital imaging sense). So, in addition, bright imagery tends to be colorful.

It's also worth remembering that while we're dealing with differences in exposure—more

or less light on the sensor—digital processing offers many possibilities. The ways in which a change in the exposure gets translated into a final image are surprisingly varied. One Raw image, lightened by various means, is shown on pages 84-85 in the last chapter. It's no longer practical to consider exposure without taking into account the processing stage.

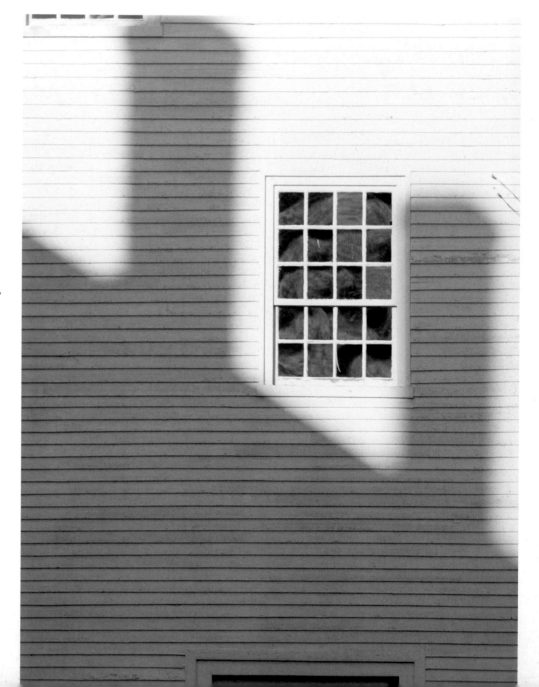

➤ **SHADOWS**
A distinctly brighter than average exposure has the effect of focusing attention on the shape of the shadows cast by two tall brick chimneys on the roofline of this New England building.

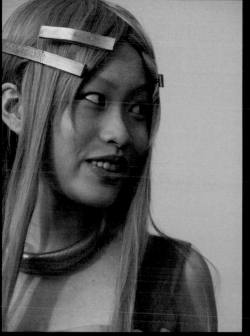
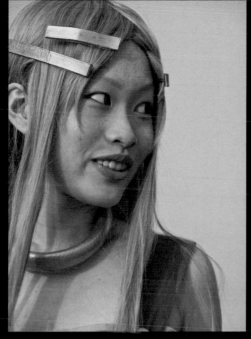

DARKER; ²/₃ STOP ABOVE AVERAGE

LIGHTER; 1 ¹/₃ STOPS ABOVE AVERAGE

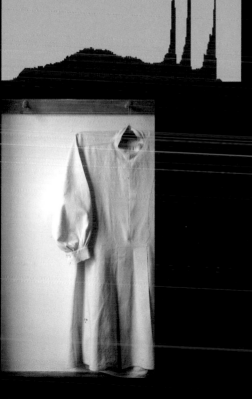
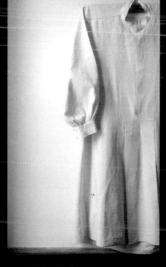

▲ BRIGHT PORTRAIT

So long as the range of the scene is not especially high, as in this portrait in slightly hazy late sunlight, there is some latitude for exercising taste. The darker version is exposed at about ²/₃ stop lighter than average, which is typical for a scene like this with pale skin tones (60% overall brightness). Yet the lighter version is also completely acceptable, exposed ²/₃ stop lighter again (70% overall brightness). The effect is in the direction of high key, though not that extreme. Note that this brightening gives a colorful treatment of the dress strap.

◄ SHAKER SHIRT

Two versions of a white Shaker shirt hanging on a rail against a white wall. "White-on-white" is usually a possible candidate for high-key exposure, as we just saw, and for the same reasons it is also possible to treat it in a less extreme way, with an exposure increase in the order of ¹/₂ to 1 stop. The difference here is ²/₃ stop.

FLARE

Flare is an artifact, in that it is non-image forming light. It also takes more forms than many people realize, from lines of polygons to halation. Most flare is optical, caused by light interacting with the surfaces of lens elements and internal structures inside the lens barrel, such as the aperture diaphragm and barrel walls. It is a direct result of shooting towards a light source, exaggerated by having a wide aperture and a full exposure. In addition, the sensor itself can contribute to flare in the form of blooming, which happens when individual photosites reach their full well capacity (see pages 26-27 *Light on the sensor*) and begin overflowing their charge into their neighbors. Flare can affect the entire frame or just a small area close to the brightest light in the shot. It can appear as a generalized loss of contrast and increase in brightness, or

as streaks from dirt and grease on the glass, or specific shapes—polygons of different colors related to the aperture blades.

The usual response to potential flare is to avoid it, and there are a number of practical things you can do to help. These include using a lens shade, shading the lens more precisely with a flag or even your hand held far in front, keeping lens surfaces spotlessly clean, choosing a viewpoint that avoids shooting into the sun or a similar light source, and positioning so that an obstruction hides the light source. Lens-manufacturing technology also employs sophisticated coatings to help reduce flare.

Nevertheless, flare can occasionally be put to creative use, both for its graphic effect and for the sense of actuality that it can give. Whether or not the graphic effect works depends on

personal taste, and there are no criteria for saying whether something works or not. The actuality argument is that because flare is an artifact that you would avoid on technical grounds, it adds to the realism by suggesting a hurriedly taken, rather careless shot. Motion-picture special effects, and in particular CGI (computer generated imagery) make frequent use of artificially computed flare for this very reason. Flare-generating programs are readily available, for stills as well as video, although this isn't of much interest to us here.

▼ MOUNTAIN AIR
In this shot of Iceberg Lake in Glacier National Park, Montana, there is a very distinct and deliberate use of flare. The polygon stripe adds a useful diagonal component to the composition, and the halation around the sun produces an atmosphere of bright mountain air.

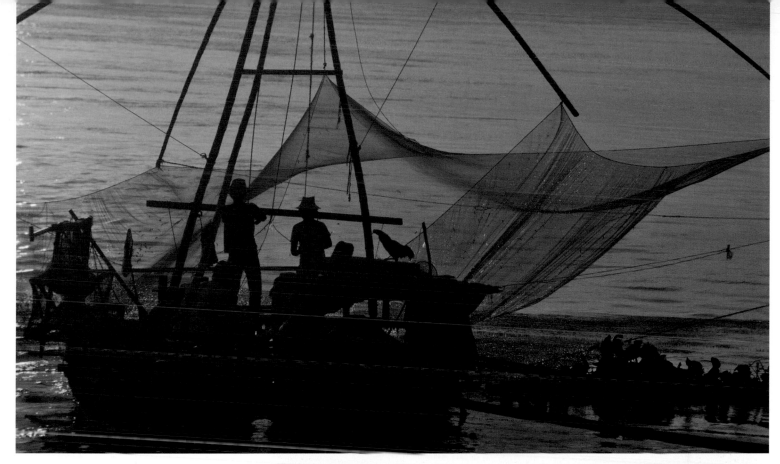

▲ REFLECTED FLARE

A subtle but noticeable halation suffuses this medium-telephoto into-the-light shot with a fogginess that affects the shadow areas of the boats. The sun and its reflection in the Mekong River at Phnom Penh in Cambodia are just out of frame, but the light striking the lens adds a veil of lightness. In post-processing it would be easy to "correct" this by tightening up the black point, but that would lose the point of the image and the atmosphere it evokes.

➤ SHAKER WINDOW FLARE

Flare in this unlit, un-doctored image of a Shaker Ministry room at Pleasant Hill, Kentucky, surrounds the window frame, while the view through to the exterior is grossly over-exposed. Nevertheless, this is exactly what I wanted, rather than a technically perfect, crisp, and flare-free image, which with multiple exposures and HDR techniques would have been possible. Indeed, this was the image chosen for the cover of the first major illustrated book published on Shaker communities and crafts.

HIGHLIGHT GLOW

Most kinds of flare that we just looked at involve over-exposure, simply because the usual cause is shooting towards a light source. In addition to whatever other image artifacts it might create, flare almost always involves halation—the creation of a halo or glow around the light source. This is by no means a bad thing, and gives a kind of atmosphere to the shot. However, for this flare-associated glow to work well, it needs to grade smoothly into the clipped area. Film, backed up by our own visual perception, records this highlight glow smoothly—an effect known as roll-off (see pages 34-35 *Highlight clipping and roll-off*).

This allows over-exposure to be a reasonably pleasant visual experience. Digital imaging's abrupt cut-off at the top end of the scale is what causes the majority of highlight problems, and a typical result is a sharp edge or band around the highlight. Cameras vary in how well they handle this banding, and the curve applied during the camera's processing to the original linear image can help. Even so, it may be necessary to do post-production work on this kind of area, by applying a controlled blur on a selection.

The other solution is to try to eliminate glow, and with a still scene and a fixed camera, shooting an exposure sequence means that HDR tone-mapping can be used. Some tone-mapping operators work at reducing the flare-like effect.

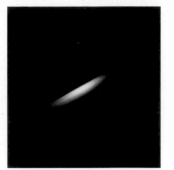

➤ HDR DETAIL

In an interior detail, two contemporary spotlights shine onto a structure of copper rods, one of which picks up the reflection strongly. As this image was shot for an HDR rendering, there were five frames spaced 2 stops apart, and the difference in the exposures shows how flare develops—it is strongest, naturally, with the brightest exposure. In HDR sequence shooting, one of the principles is to set the darkest exposure at the setting that holds the brightest highlight, and as the detail crop shows, this eliminates flare completely. The choice in processing this image, therefore, allowed for a completely flare-free treatment. However, for aesthetic reasons I felt that a controlled glow from the copper rod would be more attractive, and give a sense of the intensity of the lamp, which, when photographed from this angle, does not on its own look particularly bright.

➤ ARIZONA

Shot on film, this single exposure in a High Dynamic Range situation, in one of Arizona's well-known slot canyons, would inevitably be clipped. However, the non-linear response of film, even with the relatively short range of Fuji Velvia transparency stock, meant that at this exposure (33% brightness and one stop less than average) there would be a smooth roll-off into the blown highlights. This glow ensures that these three "wrongly" exposed areas of the image, even though devoid of detail, actually contribute to the atmosphere.

➤ NEON LIGHTING

Neon display lighting can react in unexpected ways to being photographed, because of the discontinuous spectrum. In this Beijing apartment, Chinese characters form a display along one wall, and I used this one, spelling "Revolution," in a composition taking in part of a corridor. The problem was to maintain both the color as it appeared to the eye (red) and the glow that it gave off. Without glow, the neon would lose its character as a light source. Increasing exposure, however, turned the neon tubing yellow, counter-intuitively. Different exposures and some careful post-processing were necessary to produce the final effect.

LOW KEY

As high key occupies the upper end of the brightness range, so low key falls into the darker, shadow bracket—but with a difference. For reasons that may be psychological, it is more difficult to make a successful, coherent image composed entirely of dark tones than it is of light tones. Simply lowering the exposure to make the image darker, and therefore low key, is never the entire answer. There has to be a reason for the scene to be rendered dark, otherwise it will be regarded by most viewers as a technical mistake—and they would probably be right.

One valid reason is to communicate dusk or night, another the sense of a gathering storm or massively overcast weather. In either of these cases, it's important to consider the textural qualities as well as the tonal. With less mid-tone detail than usual, dark areas of the image derive their interest from quite subtle modulations, The eye looks for, and gets satisfaction from, just discernible rich textures. This, together with the possibility of rich blacks and very fine separation between dark tones, makes these kinds of low-key images very rewarding for fine-print making. Some traditional processes, notably platinum printing, can handle such images with great delicacy and assurance. In color photography, this is lacking somewhat, but one compensation is the chance to explore rich, dense colors that are out of the usual range of experience.

▾ DUSK TREE

Here is a more traditional reason for working in low key. This is dusk in Kensington, London, and two versions show the difference between deciding exposure on automatic or more thoughtful grounds. The brighter version is averagely exposed, and reveals everything fully. However, it looks less like the evening view that it clearly is than the darker version, which is exposed by about one stop less.

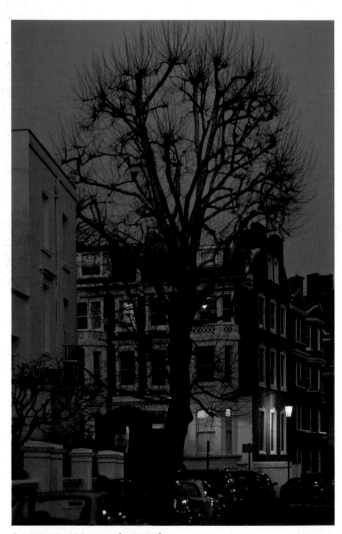

85MM EFL, ISO 250, ¹⁄₃₀ SEC, ƒ2

85MM EFL, ISO 250, ¹⁄₃₀ SEC, ƒ1.4

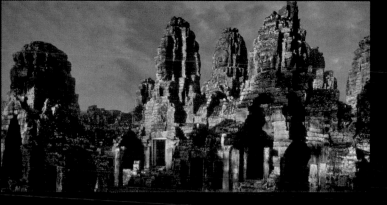

ORIGINAL

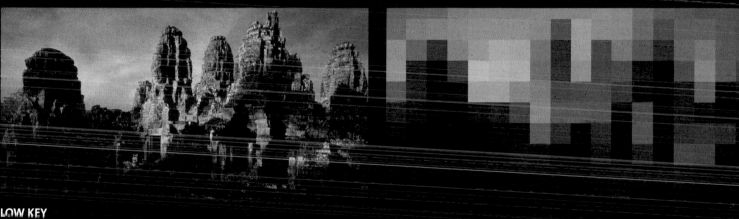

LOW KEY

▲ REDUCING DETAIL

As seen, the Angkor ruin of Bayon in Cambodia, bathed in afternoon sunlight, showed rather more detail than I wanted, and I felt it had much better potential as a low-key image with a brooding atmosphere. Accordingly, it was processed as black-and-white, considerably darker and with lower contrast. A second version reduced the lighter tones even more, especially the sky to the left of center.

IN PRAISE OF SHADOWS

The title *In Praise of Shadows* is stolen from an influential essay by Junichiro Tanizaki, written in the 1930s. In it he railed against the new tendency to install tungsten lighting in traditionally dark Japanese interiors, but the point is not completely alien to photography. In digital processing there is a tendency to choose auto—with its generic brightness—without thinking; but it doesn't have to be that way.

In addition to the logic on the previous pages for justifying low key is the personal, but entirely valid, preference for dark images. I'm sure that the materials in different kinds of photography have had their influence here—and I just mentioned platinum printing. This metal, often mixed with palladium, has some unique qualities in print making that have led a number of photographers into low-key. The platinum and palladium are laid on top of the paper, not suspended in a gelatin, and so are completely matte. Also, while the maximum density is actually less than a traditional silver print, the expansion of the middle tonal values and the way in which information is retained in very deep shadows is outstanding. All this makes it possible to produce low-key images of great tonal subtlety. Broadly similar effects are now possible with multi-ink digital printing, but I suspect part of the impetus came from this old chemistry. George Bernard Shaw, no less, wrote that platinum is "on the extreme margin of photographic subtlety."

In color, Kodachrome had a tremendous influence in numerous ways for many years. Practically, slide films bear much resemblance to digital imaging in that they have a less than ideal dynamic range and look terrible when over-exposed. This, like the platinum paragraph above, is something of a digression, but I think it is a necessary one, as it helps to explain how many experienced photographers came to think and feel about exposure. Given that the cardinal rule for professionals shooting slide film—and most did because magazine color printing was geared to slides—was to err on the side of underexposure. Kodachrome, with its unique

▲ GLOOMY WEATHER
Early morning rain clouds flow over the mountains in this remote part of the Venezuelan Andes, which prompted a reduced exposure to reveal the range of grays in the sky. However, I was also very drawn to the sense of the white buildings just emerging from darkness, as it seemed to reinforce the feeling of isolation.

silver-based chemistry, reacted to this treatment in a special way. Great detail, more than many people would suspect, was kept in the shadows, and when the repro house or printers got hold of it, they could successfully open up these shadows.

This, in turn, led to the common practice of photographers overrating Kodachrome by around a third of a stop—and sometimes even more. I'm convinced this, in turn, encouraged a culture of the dark, rich image, and many professionals came to like the restraint and subtlety of what were essentially low-key images. Much has been made of the strong saturation of underexposed Kodachrome, and while this is true up to a point, very often hues were rendered over-dense and so actually less saturated (see pages 60-63 for a

more thorough discussion of the confusion that still reigns over the meaning of "saturation"). The images here attempt to show what I mean by this. It is a matter of taste, but I like the somber and dark colors of the North West Frontier that I photographed many years ago. These images are on Kodachrome, but they have been scanned carefully to retain the low key. The dirt, ash, and general lack of color created a special atmosphere that I wanted to keep. Brightening the scenes and their attendant colors would have been easy, and tempting for some, but not for me.

▲ LIFE IN PAKISTAN
Scenes from Pathan life in the bazaar and streets of Peshawar, the chief
city of Pakistan's North West Frontier provinces. In each case I worked
deliberately in a lower tonal register that seemed to me to suit the
subject, as described in the text.

DEEP SHADOW CHOICES

Going further into the idea of subduing exposure for reasons of style, you can be selective about which part of the tonal range you choose to keep dark. In the examples on the previous pages, the entire range was considered and reduced in brightness. However, some scenes contain large, or at least important, shadow areas, and this tends to focus exposure decisions more on this lower end of the scale. In particular, the decisions tend to be about how much these will reveal, and how far down into the shadow scale you expect to be able to see detail.

Shadow areas behave differently from highlights in the way that they are recorded digitally, principally in that there is a more gentle roll-off. Even if you under-expose grossly there are still usually a few photons striking the sensor, so deep tonal values often hover a few levels above zero, even though by eye they may be difficult to distinguish from solid black. In these darkest areas, this raises the question of whether such low values matter at all—something I want to look at on pages 156-157.

Also, we perceive shadows in a different way from highlights, even though the loss of detail this far in distance from the mid-tones is similar. Compare, for example, the top and bottom 10% brightness in almost any photograph with a full range, as in the example here, a picture we saw earlier on pages 120-121 *Memory tones*. Highlights carry a sense of glare, while shadows are areas we tend to peer into. This is a perceptual matter: if the highlights are rendered so that we think of them as bright, we take them in but tend not to spend time on them; with shadows, if we think they have some relevance we look longer at them to discover detail. This is

all related to how we see scenes in real life, and our eyes' adaptation to brightness. It takes longer to adapt to darkness than to bright light. Clearly, this does not actually happen within the very limited brightness range of a print or even an on-screen display, but this is the way we *expect* to view scenes in real life.

Keeping shadows deep retains this sense. Indeed, revealing everything is rarely a good idea, though unfortunately this is becoming the default in digital processing. All the tools are there to recover detail, and this encourages many people to use them, which is a definite case of technology intervening in the creative process for the worse.

> **HIGHLIGHTS AND SHADOWS**
Isolating the deep shadows and the bright highlights (in each case the extreme 10% of the tonal range) emphasizes the difference in the way we normally look at detail within them. The shadow areas are the ones that encourage more examination, while the highlights tend to get simply a glance.

◄ ▲ FRONTIER LAND

About 40% of the area of this image, on the North West Frontier of Pakistan, is shadow area, and given the contrast between land and sky, and the decision to treat this darker as a pre-sunrise scene, the darkest area around the rocks will inevitably be very dark. Fine-tuning the exposure decision means dealing with very subtle rendering. The details (left) show exposure stop differences (simulated) and the effect on the amount of detail that is revealed. Ultimately this is a matter of taste.

▼ SCULPTURE SEQUENCE

This black sculpture, photographed in bright, clear sunlight, presents difficult choices in the treatment of the main upper area. Opening up the exposure, which is limited by the danger of highlight clipping on the bright lower part, has the effect of broadening the edge in from the outline in which detail can be seen. Each exposure is one stop different from the next.

EV -1 EV EV +1 EV +2

ANOTHER KIND OF LOW KEY

A completely different type of low key is created by stark and limited lighting from a single source to one side, and this inevitably gives the image a High Dynamic Range, although very skewed as any histogram will show. Edge-lit subjects, which are so specific that they warrant being a lighting type all on their own (see pages 100-103), are potentially one kind of low-key shot, and an important variety at that.

I say potentially, because raising the exposure changes the character of the shot, as does adding fill. This kind of low key is usually discussed as a studio lighting technique, and not so often as found lighting in real, uncontrolled situations. The technical conditions are a single key light, typically from behind the subject and off-axis, with little or no fill. In studio terminology, the key-to-fill ratio (that is, the brightness ratio

between the main light and whatever is used to fill the shadows opposite) is very high, such as 8:1, in comparison to a "normal" lighting set that might be between 3:1 and 1:1.

Low-key edge lighting is not at all common outside the studio, but this is precisely what makes it interesting, and also challenging for calculating the exposure. The circumstances needed—rear off-axis hard light falling on

◄ ▲ **DARTH VADER'S HELMET**
Overhead lighting from a square diffused window flash head, with a silver foil reflector below provide the modeling and establish the glossy texture of Darth Vader's iconic helmet in the props store of the film studio ILM, but the essential presentation is black on black. This is one of the basic low-key studio lighting styles.

a subject otherwise in shadow—are always localized, and this adds another challenge in documentary photography. Direct sunlight through a gap or slit is one such situation. Any moving subject passing through this kind of lighting, such as a person, will often be in position in the shot for only an instant, which gives no time to adjust exposure. You need to know in advance what the settings are, and get

them right first time. One saving grace is that edge-lit shots can work at different exposures, albeit each giving a different impression. If you over-expose, you lose the low-key effect, but the extra information in the shadows can compensate for the flared, blown edge highlights. That's fine if you are happy to accept the surprise about which of these you get, but to capture exactly the image you envisioned in this

kind of lighting, in a real-life situation, is a mark of real skill.

It's easy to make too much of the emotional content of a photograph simply through its lighting, but low-key images often do tend to express some mystery, threat, gloom, or melancholy. Not for nothing was low key a common technique in film noir.

ᴧ ➤ PERU

To the eye, this interior of a Peruvian cafe revealed more shadow detail than was kept in the image. The combination of camera angle and single light source from in front and to the left (the open doorway) was sufficient to edge-light or silhouette the key shapes. The men, table, harp, and flagstones all communicate clearly with the minimum of detail, which is another characteristic of low-key lighting.

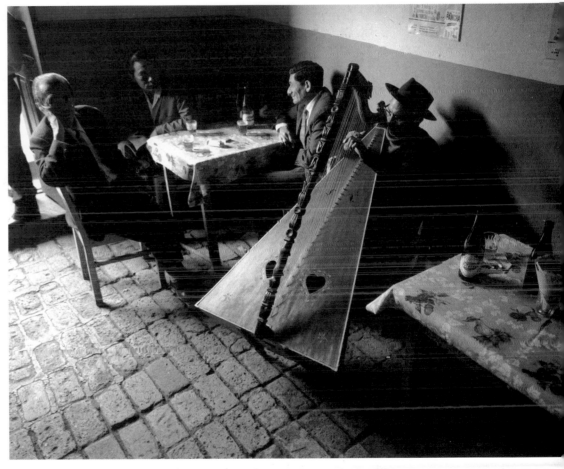

SILHOUETTE

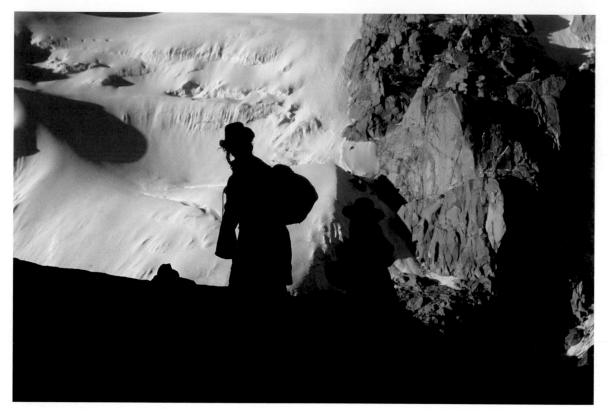

◄ **TIBETAN PILGRIMS**
On the edge of easy readability, this shot of Tibetan pilgrims crossing a high mountain pass would have been a little more obvious if the faces had been in profile and if a hand had been visible, but also possibly less interesting. When the shadow and lit areas (subject and background) are close to each other in area, images acquire the ambivalence of figure-ground relationships—a momentary confusion of which is which.

One special option for dealing with a sizeable dark subject that is in contrast to a light background is to expose it as a silhouette. A silhouette, which should be familiar to everyone, is by its nature black, and provided it fulfils the necessary criteria has no need to carry any shadow detail at all. We partly covered this on pages 106-109 when we looked at lighting situation #11 in *The Twelve: High Range — Large Darker Subject*. This very specific graphic representation had its origins before photography, often as cut-out black paper. It was a cheap art-form that became popular in the 18th Century and was named after Étienne de Silhouette, the then French Controller-General of Finances, in ironic reference to his unpopular cost-cutting measures, as silhouettes were economic in their means. The appeal, and the skill, of these silhouettes lay in creating recognizable forms, and even extracting personality from simply an outline. In this sense,

the silhouette had much in common with the cartoon, drawing out essential characteristics by simple means. Although at first glance all this may seem far removed from calculating exposure for a photograph, the interesting thing is how silhouettes, which were invented as a drawing-room diversion, have come to be almost solely the province of photography.

One of the reasons that silhouettes are popular in photography is that the dynamic range problem of contrasty scenes is equally relevant to film and to digital imaging. Backlit situations are so commonly out of range that a silhouette treatment, reducing the exposure so that everything within the outline is solid black, makes perfect sense. Another reason is the pleasure of surprise in discovering how a subject looks when reduced to an outline. One of the things that you quickly learn when trying to compose a silhouette shot is that only some viewpoints

work graphically, in the sense of showing clearly what the subject is, and also in the sense of being interesting. Faces, for example, tend to work best in profile. Figures are a little more complicated, and the way in which limbs cross when in action, for example, makes a great difference to the readability of an image. As an experiment, try photographing a hand holding a small object and treating it as a silhouette.

◄ FRACTION OF AN F-STOP

A ⅔ stop difference in exposure here makes a marked difference in this potentially silhouetted view of a Vietnamese monk repairing a temple roof. The fuller exposure reveals some detail in his robes, while ⅔ stop darker reduces the image to outline only. My preference was for the silhouette treatment, but you could argue either way.

▼ VIEWFINDER PAIR

Images suitable for silhouette treatment usually offer the alternative choice of an exposure that shows shadow detail. One useful way of deciding which way to go with the exposure, so long as the aperture is small, is to press and release the camera's depth-of-field preview button. The on-off darkening-lightening helps to show whether the image will work in outline.

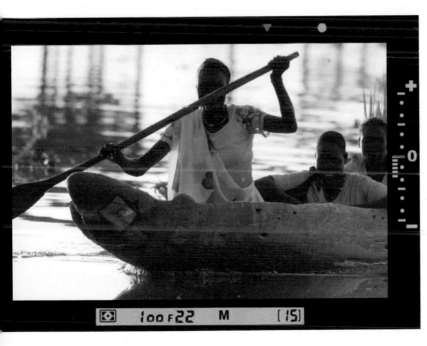
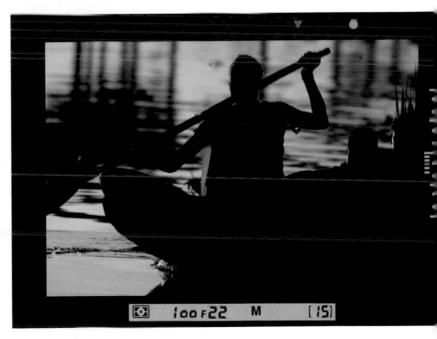

IRRELEVANT HIGHLIGHTS AND SHADOWS

I suppose the title *Irrelevant highlights and shadows* sounds a little provocative, with the implication that highlights and shadows just don't matter. In one sense, of course, everything in the frame matters, because it contributes to the composition and the sense of the photograph. Yet often there are times when it is simply not worth worrying about whether certain highlights should or will hold, or what is going on in the deepest shadow areas. Clipping, which so much of the time is presented as the great evil of digital exposure, may not always matter.

These are the two extremes of the tonal range in a scene with a full dynamic range (the issue doesn't arise with low-range scenes), and they behave differently, not only in the way the sensor records them but also perceptually. As we have seen, highlights clip decisively, so in a bright area that should grade smoothly towards over-exposure, such as the halo around the sun or another light source, there is usually a distinct edge—a form of banding. With the darkest shadows, however, in an area that shades to total black there are usually some lingering very low values, around 1 or 2 on the 0-255 scale, as the sensor picks up stray photons. Also, perceptually we pay much more attention to bright areas than to dark, something that is built into the HVS. Bright highlights are simply more noticeable than dark shadows, and this is helped even more by the difficulty of getting good separation of deep shadow tones when printing on many papers. Ink seepage tends to block up the shadows in a print, especially when the printer driver is laying down large quantities of ink.

There are two situations in which the information in the highlights ceases to be important. One is when the highlights are extremely small, and the other is when a light source is in shot—sometimes. There are no rules for this, simply the judgment when viewing an image that features in it which appear almost as points or edges are too small to carry any recognizable detail. We already saw this at work when considering, for example, some edge-lit

scenes in Chapter 3. With point sources of light, such as street lamps or the sun in a wide-angle shot, the small size also comes into it, and it is usually acceptable for these to be blown out because the light sources are perceived as being normally too bright to look at directly. In fact, using HDR (see pages 182-185) to compress all the tones into a viewable and printable image, and so being able to distinguish tone, detail, and color in a lamp, can come across as a little strange.

Because shadow clipping is much less obvious to the eye, especially in a print, it is less of a

serious issue and there is considerably more latitude. What matters is the context of other, lighter neighboring shadow tones. As we saw in *Deep shadow choices* (pages 150-151), there is room for personal judgment regarding the point at which total black is acceptable in an area of shadow that is getting darker in one direction. And, as in the images I showed in *Silhouette* (pages 154-155), massive areas of the frame can be acceptable as a solid, completely clipped black.

10 (4%)

7 (3%)

0 (0%) 5 (2%)

◄ SHADOW CLIPPING
The shadow area shades do vary, as indicated by the tonal values shown. Visually there is little to distinguish at first glance between even 10 and 0, while even close inspection reveals no difference between 5 and 0. This makes shadow clipping less of a problem aesthetically than highlight clipping. In brackets are the brightness percentages. The image is shown desaturated to avoid the complication of different tonal values between Red, Green, and Blue channels.

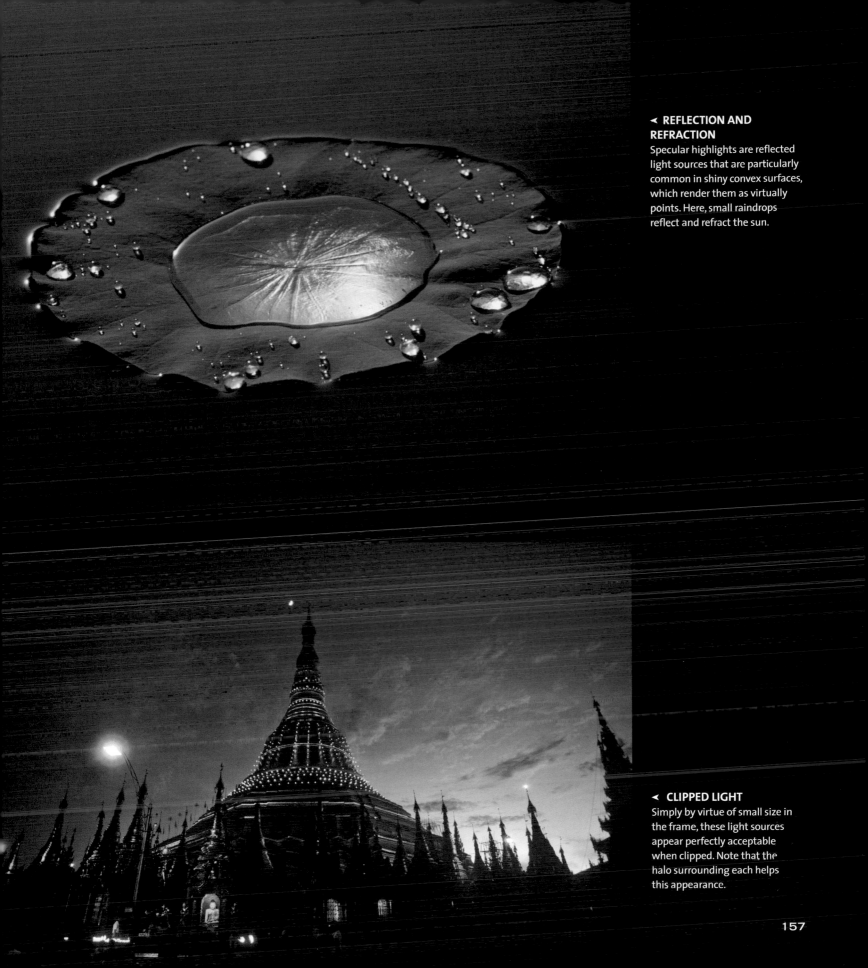

◄ REFLECTION AND REFRACTION
Specular highlights are reflected light sources that are particularly common in shiny convex surfaces, which render them as virtually points. Here, small raindrops reflect and refract the sun.

◄ CLIPPED LIGHT
Simply by virtue of small size in the frame, these light sources appear perfectly acceptable when clipped. Note that the halo surrounding each helps this appearance.

BRIGHTNESS AND ATTENTION

In certain kinds of image, the exposure, by controlling the brightness, also determines how a viewer's eye travels around the frame and what it focuses on. There's no great surprise in this, given that the HVS pays particular attention to brighter areas and also to the contrast between light and dark. In a situation that has a brighter area *emerging* from dark surroundings, however, it has a special relevance when choosing the exact exposure settings. The landscape here is a good illustration of this, and I'm using the term "emerging" in the sense that there is a gradation through the frame from dark at the edges to light in the center. Varying the exposure alters the area that is visible and readable. The usual vignetting from the wide-angle lens used (20 mm) adds to this effect.

The second part of the equation is that there is some latitude for choosing the exposure. Clearly, highlight clipping in any situation like this is a main concern, but even when staying within this upper limit there is a valid choice. In this example, the choice is in the order of 1 to 2 stops. The standard exposure would be one that keeps the center as bright as possible without clipping, but there are very good reasons why in this case I preferred a shorter exposure. One was that I wanted the sky colors rich, which is something we looked at on pages 60-61 *Exposure and color* in Chapter 2. I also wanted a sense of the world emerging from darkness, in the pre-dawn. There was also a third reason, which was to concentrate the attention on a relatively small area of the frame in a natural way, without resorting to filters or frame-within-a-frame viewpoint or manipulation. The two images here are ⅔ stop apart in exposure, but it makes a significant difference.

These are particular lighting circumstances, but not all that unusual. Much more common is when a patch of light is cast through an opening, like a window, with a more hard-edged division between light and shade. The second image illustrates this. Again, so long as there is some latitude for choosing the exposure, a darker treatment will close off the shadows more and prevent attention from straying away from the lit area. This is useful if you want to control and limit the viewer's attention in this way, which I did in this example. In any case, the way in which someone else will look at the image and what they will pay attention to is always something to consider in this kind of situation.

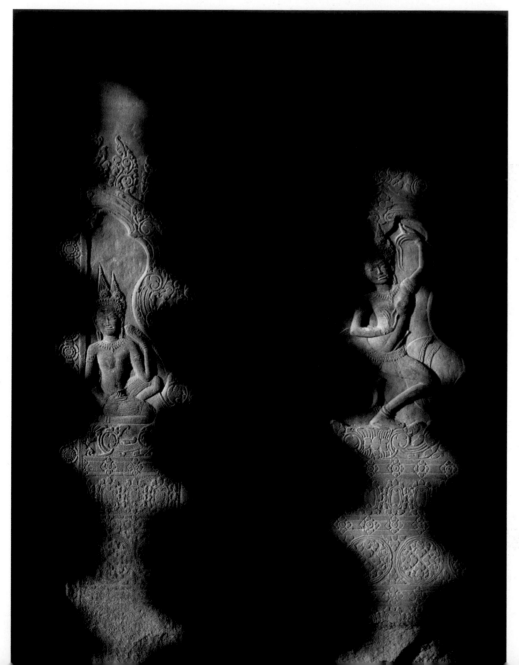

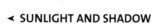

◄ SUNLIGHT AND SHADOW

Late afternoon sunlight shining between stone balusters in a gallery of Angkor Wat, Cambodia, onto a pair of bas-relief apsaras, or celestial dancers. The coincidence of spacing combined with the undulating outline of the balusters made the shot worthwhile, and it was then a matter of waiting several minutes for the passage of the sun to fit the shadows precisely to the carvings. A fuller exposure here would have been less unusual and less graphic, by revealing shadow detail. I preferred this treatment, and indeed did not shoot any other version.

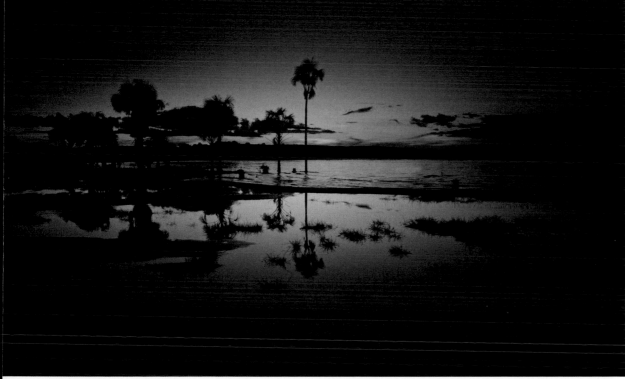

ORIGINAL

◄ **FOCUSSING ATTENTION**
Dawn just breaking across the Rio Carrao in the Guiana Highlands of Venezuela. The difference between the two exposures is more than just brighter and darker—it has a spatial effect as well. The $^2/_3$ stop darker exposure closes off more of the surroundings from sight and draws the eye inwards.

$^2/_3$ STOP DARKER

CHAPTER 5:
POST-PROCESSING

In a way, I would rather *not* talk about processing in this book, and instead concentrate solely on getting the exposure right at the start—right for the conditions and right for you, the person taking the picture. Processing and post-production are often, and maybe too often, used to sort out issues that should rightly have been taken care of at the moment of shooting. However, realistically, it's impossible to divorce digital shooting completely from digital processing, at least when shooting Raw.

Digital processing is a booming branch of software development. Feature upon feature is constantly being added to what is on offer, to the point where the choice verges on the bewildering. The leading software packages used by photographers, such as Photoshop, Lightroom, LightZone, Aperture, DxO Optics Pro, and Capture One, as well as the individual camera manufacturers' software, are already awash with sliders and presets. Competitors try to outdo each other, while the teams working on updated versions try to outdo themselves. The result is now more ways of processing a single image file than any normal person could hold in mind at one time

This is good from the point of view of potential. If you are prepared to put in the time, you can tweak, control, fine-tune, or however you like to put it, to an infinity of results, but it's not so good for encouraging the basic skills of shooting. There is a growing belief that digital processing can solve everything, and I suspect this encourages a number of people to be sloppy with their camerawork. The reality is that sophisticated processing techniques work best with well-exposed image files. No surprise there, but far from software being a crutch to support poor photography skills, I think I can convincingly argue that the progress in all this software actually calls for more accurate exposure. To get the most out of digital processing, you should have the maximum information and quality in the original files. The idea, after all, is to step final image quality up, not just perform feats of recovery.

CHOOSING EXPOSURE LATER

◄ **DEFAULT**
An unedited shot taken on the South Bank of the River Thames, facing Tower Bridge in London, before being opened in these different tools.

The core argument for shooting Raw is that with most images it gives some exposure latitude. From the point of view of traditional photography this really is a novel idea—that the exposure "condition" of an image is no longer fixed at the moment you squeeze the shutter release. Most people probably take this for granted, but it was never the case before digital technology. Among the changes this makes to shooting is that it draws processing into the equation. It makes no sense to treat shooting and processing as completely separate actions.

Does this invalidate the importance of getting the exposure exactly as you want it? The answer is, not at all. The perfect exposure for a particular image, and a particular photographer, will always give the best image quality in the form of smooth progression of tones, freedom from noise, and holding detail at the high and low ends. The

difference is that the extra bit depth from a Raw file makes it a cushion for error, or to be more polite about it, as a cushion that allows you to reconsider the nuances of exposure later, when you have more time and when you might have changed your opinion about what works best.

It's important to deflate any wild expectations about just how much you can choose the exposure at this stage rather than when shooting. In theory, this higher bit depth can give a four stop range to play with, but this is just the capability of the extra bit depth and it is limited by the performance of the sensor. Also, if you overexpose in a major way, not even this extra bit-depth will be able to recover the lost highlights.

The key question, then, is how much latitude Raw gives you, and the answer is not straightforward. Rather, it depends on the scene,

the sensor and on how accurate your exposure was in the first place. What confuses the situation is the bit depth, or rather, the different bit depths, because most camera sensors capture either 12-bits per channel or 14-bits, while image-editing software imports this as 16-bits. This does *not* mean that Raw files carry a full 16-bit range, which would be an exposure latitude of 8 stops more than 8-bits. It just means that the *potential* for exposure latitude is there. Currently, a good DSLR used in ideal conditions will offer an effective exposure latitude of around one or two stops more when shooting 14-bit Raw than when shooting 8-bit TIFF—and ultimately this involves your judgment. The latitude cannot be quantified precisely, because what may be acceptable noise or loss of detail at the ends of the scale for one photographer may not be for another.

▲ ADOBE CAMERA RAW

A scene typically exposed to hold the highlights often results in apparent under-exposure. The several sliders in a Raw converter, here Photoshop's ACR, offer many ways of interpreting the exposure and associated brightness controls.

▲ LIGHTROOM

The same Adobe Camera Raw converter is embedded in Adobe's Lightroom, an image processing tool aimed specifically at photographers and combined with database functions.

▲ C1 PRO

Phase One's Capture One Pro is a fully featured Raw conversion tool , showing this view on opening the file.

▲ LIGHTZONE

Here is the image as seen in LightZone, an image-editing program that also contains a Raw converter with Exposure, Color Noise, Temperature, and Tint options.

▲ DXO

The default interpretation of DxO Optics Pro v5, a tool that allows for exposure compensation and lighting adjustments.

EXPOSURE, BRIGHTNESS, AND LIGHTNESS

BRIGHTNESS -150

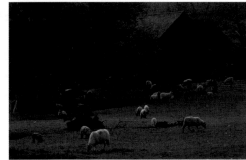

▲ **ORIGINAL** ⟳

Brightness / Exposure not adjusted

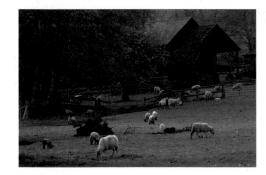

BRIGHTNESS -75

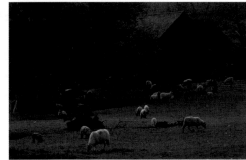

EXPOSURE -2 EV

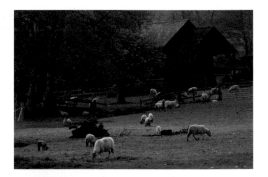

EXPOSURE -1 EV

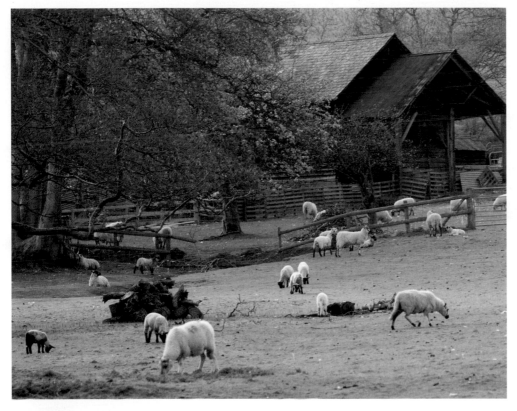

A **ORIGINAL** ⊙
Brightness / Exposure not adjusted

BRIGHTNESS +150

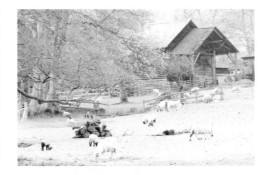

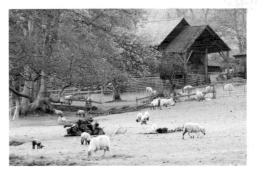

EXPOSURE +1 EV

EXPOSURE +2 EV

BRIGHTNESS +75

Here I want to look at the controls available in Raw processing, which extend beyond the exposure latitude that we just looked at on the previous pages. The effect of controls labeled "exposure", "brightness" and "lightness" are similar in general effect, but they are different in subtle ways. As always with imaging software, beware of the labels, because they may not mean what you think they should. Sometimes, software developers have strange ideas about meaning.

SOFTWARE ALTERNATIVES

This original image has been treated using both Raw conversion and image-editing software, and in a number of cases tools with the same name have had different results.

ORIGINAL

▲ **RAW BRIGHTNESS**
In this image, the brightness was adjusted using the Raw conversion software.

▲ **IMAGE EDITING BRIGHTNESS**
In this image, the brightness was adjusted using the image-editing software,.

▲ RAW EXPOSURE
In this image, the exposure was adjusted using the Raw software.

▲ EXPOSURE
In this image, the exposure was adjusted using the image-editing software,.

▲ RAW LAB LIGHTNESS
In this image, the lightness was adjusted using the LAB slider.

▲ POST LIGHTNESS
In this image, the lightness was adjusted using the post-processing software.

SELECTIVE EXPOSURE

The current trend in editing software is to move more and more adjustment tools into the Raw converter, so that in most cases photographs shot in Raw can be processed completely in one session, without then having to do more work on the TIFF file. As part of this trend, the major programs, including Photoshop, Lightroom, and LightZone, now include in their Raw editing suites means of selectively increasing or decreasing exposure. The means vary according to the software, from brushes to selection tools, but the principle is to use the normal Raw exposure slider to different settings in selected areas.

Adjustments related to exposure are also becoming increasingly possible at the Raw conversion stage. These include highlight recovery and shadow fill, contrast (both global and local), vibrancy and clarity. Highlight recovery, shown here in an example, takes advantage of the fact that highlight clipping due to over-exposure occurs at different points for each of the three color channels. It works by reconstructing tonal values in a clipped channel by using the information in another channel.

Contrast, in particular, has a valuable effect on the appearance of exposure, especially with the relatively new tools controlling local contrast—tone-mapping operators. One thing that digital post-processing has made relevant is the *spatial* range of contrast. If that description brings a glassy look to anyone, another way of putting it is that the contrast across a particular area of the image may well be, and often is, different from the contrast across the entire picture. Some people invoke a comparison with wet-darkroom dodging and burning, but this is not the same thing. In dodging and burning under an enlarger, local areas are either lightened or darkened. In local tone-mapping, the values of pixels are adjusted up or down according to their neighbors, and the effect is that contrast is adjusted locally. In the software, there is a radius slider, and this alters the size of the area.

◄ **HIGHLIGHT RECOVERY**
Highlight recovery is one important form of selective adjustment, also in Raw conversion. Here is Photoshop's Raw converter in action, with subtle but valuable restoration of the blown highlights at the upper right using the Recovery slider. Note that this high setting also affects midtones, which may or may not be a good thing. The red area is the highlight clipping warning, the lower image is adjusted to 100% to restore highlights.

► **ADAMS-INSPIRED SOFTWARE**
A local adjustment method unique to LightZone is selection by tonal zones. Working on a Raw file, the exposure of a particular range of tones can be reduced by dragging its lower limit downwards, or increased by dragging its upper limit upwards.
1 Here I attempt to reduce the exposure of the sky and the tops of the heads. As the cursor rolls over the ZoneMapper, the areas of the image that fall into each zone light up yellow in the Color Mask. The areas I want are all in the top zone.
2 I drag the lower edge of this top zone downwards, to darken these highlights. Other zones are affected to a lesser degree.
3 To restore the exposure of the mid-tones, I drag them selectively upwards.

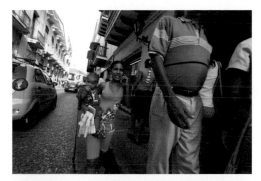

BEFORE

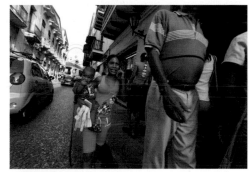

AREA CHOSEN

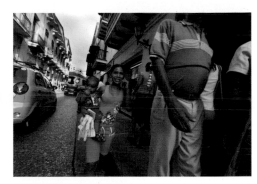

EXPOSURE ADJUSTED

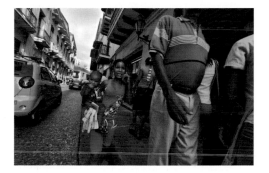

RESULT

EFFECT: CUSTOM	
EXPOSURE	-2.80
BRIGHTNESS	0
CONTRAST	15
SATURATION	8
CLARITY	15
SHARPNESS	0

◄ ▲ LIGHTROOM ADJUSTMENT BRUSH

Lightroom's selective controls use what is called an Adjustment Brush. Opening this enables a range of slider adjustments that include Exposure and Brightness, and the effect chosen—here mainly a reduced exposure with some increase in contrast and clarity—can then be applied to whatever area needs to be darkened. In this case, the brush is used to selectively darken the sunlit parts of the street, buildings, and sky.

1 The Adjustment Brush is selected, its size and feathering set, and the estimated adjustments chosen.
2 The first stroke of the brush applies the chosen settings.
3 After this, the mode switches to Edit, and the sliders can be altered to refine the effect of the stroke, in this case decreasing the exposure further.

ADJUSTMENT 1

ADJUSTMENT 2

ADJUSTMENT 3

RESULT

POST EXPOSURE CONTROL

As much as I'm trying to avoid getting stuck in specific software, Photoshop's Exposure control under Adjustments deserves special attention, if only because it appears to promise a kind of non-Raw exposure adjustment. It works on TIFFs and JPEGs, but naturally it cannot deliver real exposure adjustment in the way that a Raw converter can. What it does offer, though, is sufficient control to mimic the effect, which can be useful for recovering mistakes, with apparently similar results where possible. It is also good for working on images that were captured as TIFFs or JPEGs, or captured as scans from film. Other than that, it does not really belong in this book, but I am covering it for the sake of being thorough.

The important caveat, therefore, is that this is *not* an exposure control, but it can produce results which give that appearance.

The Exposure dialog offers three slider controls, which, though not especially intuitive, make a sensible attempt at allowing the user separate control over highlights, shadows, and contrast. As is increasingly common with imaging software, developers use terms to suit themselves rather than to stay true to the original meaning. The exposure slider in this case strongly affects the highlight end of the scale with, as Adobe puts it, "minimal effect in the extreme shadows." If you look at the effect illustrated here, you can see the histogram at Exposure minus one moves very

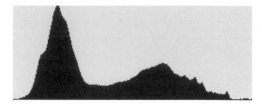

▼ **ORIGINAL IMAGE**
Some adjustments were made in Adobe Camera Raw, then the image was imported into Photoshop.

GAMMA 1.6

GAMMA 0.6

OFFSET -0.05

OFFSET +0.05

little at the left side, but is squeezed in from the right (the highlight end).

The next slider, Offset, does indeed offset the shadows. This is intended by Adobe to darken the shadows and midtones with "minimal effect on the highlights." So, increasing the Offset alone, which you would not normally have any reason to do, moves the entire shadow limit to the right, but leaves the right (highlight) end more or less unchanged. This is the opposite of closing in the black point in normal processing. Lowering the Offset strengthens the shadows in a way similar to closing in the black point.

The Gamma control does as all gamma sliders do, which is to use a simple power function that affects brightness and contrast. Here it is used for its contrast effect, although this is inseparable from its brightening/darkening effect. Sliding to the left weakens contrast and lightens, and is the equivalent of lowering the slope of the center of the tonal curve. Sliding to the right strengthens contrast and darkens, which is the equivalent of increasing the slope of the curve.

The way to use the Exposure control as a means of altering brightness and contrast in a photo-realistic way is to use the sliders from the top down. Begin with Exposure, then slightly alter Offset, either to strengthen shadows or to open them up, and finally move the Gamma to improve contrast to taste.

▼ ORIGINAL IMAGE

Some adjustments were made in Adobe Camera Raw, then the image was imported into Photoshop.

-1 EV

◄ ▼ **PHOTOSHOP EXPOSURE**

The Exposure tool makes adjustments to the apparent exposure of the image, measured in stops. The offset adjusts the shadows independently and the Gamma affects the contrast.

+1 EV

EXPOSURE

EXPOSURE	0.00
OFFSET	0.0000
GAMMA CORRECTION	1.00

HDR IMAGING

High Dynamic Range (HDR) imaging has developed from a highly specialized area of computer graphics in the motion-picture industry into surprisingly general use in still photography in a short period of time. All the processes are still by no means perfected, but it is extremely useful for the photography of high-range scenes—and very relevant indeed to exposure. The computing complexity involved in HDR imaging makes it look daunting, although it doesn't have to be. For photographers who are committed to the importance of shooting rather than messing around with software, it may seem too much and too artificial, but I would argue that the principle is photographically pure. It is an answer of sorts to the constant problem of dealing with high-range scenes using low-range camera sensors.

No current camera sensor can handle the full range of brightness in the kind of high-range scene that takes in, for example, the sun itself and deep, enclosed shadows. We've already looked at this in many ways in this book. However, a sequence of exposures, varying the shutter speed without moving the camera, can easily cover any range. The problem is that these different exposures are each on different frames—in separate image files. Along comes the first part of the HDR process, combining these into a single image file. This is relatively simple and extremely easy for users. There are by now a number of HDR image file formats, including a kind of TIFF, that will hold *all* the exposure information from a number of frames. There are also several makes of software that will do it for you automatically, including Photoshop and a dedicated application, Photomatix Pro.

➤ IMAGE SEQUENCE FOR HDR
This sequence of exposures was actually hand-held because I was in too much of a hurry to catch the light to go for the tripod. I was confident, nevertheless, that the software alignment function would work. There is a one stop difference between each. The bracketed sequence was shot automatically, and the camera does this by shooting first an averagely exposed frame, followed by a sequence from darkest to lightest.

▲ FINAL HDR

My final choice of a tone-mapped HDR image, using Photomatix Pro. As the sequences illustrate, there is almost endless room for choice of effect.

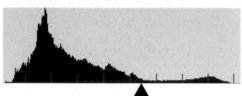

◄ ► 32-BIT PREVIEW
If you convert using Photoshop, the first stage is to see a 32-bit preview. Alongside thumbnails of all your source images, arranged according to Exposure Value, you'll see a histogram with a slider. The slider alters the (by its nature) low dynamic range on-screen preview, but does not affect the image.

Shooting an HDR sequence is not complicated, and as already suggested in *Fast-track and Foolproof* in the first chapter, it is one of the possible solutions for dealing with clipping and high-range situations. Going back to the Decision Flow, once you've entered the *Clipping Solutions* loop, HDR is one thing to consider. Pages 64-65 (*Bracketing*) explain the shooting procedure.

The next problem, however, is that while it is easy to combine the different exposures into one HDR image file, you still cannot view it! Currently only a very expensive monitor that uses combined LED and LCD technology, called Brightside, is capable of displaying an HDR image, and the effect is close to looking at a real scene. Other than this, with an HDR file we have

simply transferred the high-range scene faithfully without tackling the issue of making sense of it as a viewable photograph. It is not just the limitations of the camera sensor that come into play, but also the similar range limitations of a standard monitor and the even greater limitations of paper for printing.

The solution is somehow to compress the range contained in the HDR file to that of a normal image file, meaning 8-bits per channel. This is still work in progress and the perfect process has yet to be invented. Meanwhile, there are a number of very ingenious methods in the form of tone-mapping algorithms. The math here is complex, and while no one expects photographers to follow it, the competing processes can be frustratingly opaque in the

sense of understanding them and predicting their results. Now is not the time to go into HDR imaging in the great depth it deserves (I have another book, *Mastering High Dynamic Range Photography*, that does that) but as one of the solutions for dealing with some difficult exposure situations it is unavoidable. At the very least, when the situation allows multi-shooting and it is convenient, I strongly recommend it. Capturing the full range from a scene is a valuable form of archiving, even if you do nothing special with the range of frames later. You still have the opportunity, and as there is no doubt that HDR processing will improve and become more user-friendly, the exposure sequence you have on file will be more useful in the future than you might think.

◄ ▼ HDR CONVERSION

To begin the conversion, click *Image > Mode > 16-bit*. This selects the highest Low Dynamic Range mode, so the image must be converted using one of the four available methods; a basic Exposure and Gamma adjustment, which is more useful for the 32-bit editing procedures described on pages 186-187; Highlight Compression, which is not much use in this example; Equalize Histogram; and a local tone-mapping operator called Local Adaptation, which is based on a bilateral filter with an added tone curve for fine adjustment

EXPOSURE AND GAMMA	
EXPOSURE	+1.28
GAMMA	0.46

▲ EQUALIZE HISTOGRAM

Again there are no options with this conversion method, though the result is a little more interesting in this case.

▲ HIGHLIGHT COMPRESSION

There are no options associated with this conversion method, and, as you can see, it is of little use with this subject.

▲ LOCAL ADAPTATION

This method allows you to make adjustments to the toning curve and to the Radius and Threshold of the effect, which is applied regionally. Here the Radius has been reduced to 10 px and the threshold increased to 0.63. The tweaked curve applies a stronger effect to the darker areas of the image.

This may be late in the book to raise such a fundamental matter, but HDR imaging does trigger a special question. One complex perceptual issue that is still not fully tackled is what is expected from a photograph. In the sense of how realistic it should look, this is not something that has come up in any major way through traditional photography. HDR and exposure blending techniques, added to increasingly sophisticated Raw processing, now make it possible to make images that look any way you like. They certainly do not have to look like the photograph we have all learned to expect.

Most of the HDR tone-mapping work has gone into compressing all that wide tonal information into a viewable image in such a way that everything is readable at once. In a way, this is an attempt to mimic human vision, but as we've seen in *Objectively correct* (pages 50-51) and in *Envision* (pages 122-125), human vision works in quite a different way from photographic imaging, and how we look at a scene also differs from how we look at a *photograph* of the same scene.

The usual response from people working in HDR imaging is that we need to translate the experience of seeing something with our eyes into a flat, bounded photographic image. Yet this doesn't go far enough. The photograph itself is not the end of the line; rather it's how

we look at the photograph. All the complexities and mechanisms of human perception are still being put to work; it's just that we are looking at a different object. One of the major leaps in the study of the HVS was to understand that we construct an intelligible image from limited sensory input, and to do this the HVS uses a variety of means, not all of them yet fully understood. They include expectations based on experience. In a similar way, when we look at a photograph there are certain things we expect, mainly built up from many years of looking at photographs and having them a part of our daily lives.

Most people are surprisingly alert to the overall "realistic" appearance of a photograph. By this I mean whether or not it was made with a camera and not messed around with. This is extraordinarily difficult to define, yet most visually aware people, and certainly photographers, can spot "enhancement" a mile off. Many people indeed like the difference that comes from departing from photo-realism. Nevertheless, it remains a departure, and owes its existence to being compared with the perceived correctness of a "true and pure" photograph.

⋀ BEFORE MERGING
The HDR software displays a small preview window over a complete image which cannot show all the tones on screen. The small preview is processed according to the selected settings.

DEFAULT **PHOTO-REALISTIC EFFECT** **EXTREME**

◄ ▲ PHOTOMATIX

The sequence using Photomatix software. At the tone-mapping stage, two different methods are offered: Details Enhancer, which is a local tone-mapping operator; and Tone Compressor, which is a global tone-mapping operator. The global version (Tone Compressor), though less powerful in its ability to compress the range, has a more understandable, photo-realistic effect. The local version (Details Enhancer) is shown here with the default settings, and the most extreme and unrealistic settings.

EXPOSURE BLENDING

I considered dealing with this before HDR imaging, because it is the simpler and less troublesome option for handling multiple exposures, albeit less powerful. Nevertheless, HDR is what many people turn to first, even when it is not the most appropriate solution, and HDR certainly highlights the more fundamental issues of compressing all possible tones into one image. As a general recommendation, however, I believe HDR and tone-mapping may well be better left to seriously high dynamic range scenes, such as those that include the main light source. Much of the time, when dealing with high range situations covering an order of 10-13 stops, the latest exposure-blending algorithms behave in a more friendly and understandable way than HDR tone-mapping operators.

There is a reasonable choice, and more than one software that you can use. Photomatix Pro, the pioneer consumer HDR software, also has several exposure-blending methods that can make pleasing compressions from a range of exposures without having to go down the HDR route. Photoshop's Mean and Median stacking modes also perform a blend, and the examples on the following pages show the possibilities. As with any compression method, ultimately the choice is best made by comparison and according to your own taste. Some methods are more "photo-realistic," while others are more powerful at bringing everything into range. There is definitely no "objectively correct" image here.

⅋ ➤ DOUBLE RAW PROCESSING

One solution for dealing with a high range scene that has been shot in Raw is double-processing, followed by exposure blending. This problematic shot of Sudanese women finishing a meal before boarding a long-distance bus was processed in Photoshop's ACR twice—once for the shadow areas and another for the highlights. Attempting to manage both extreme ends of the scale in a single process failed to satisfy the needs of either, resulting in strong halos around the highlights due to the Recovery algorithm. In this way, each end of the scale could be given a fairly natural treatment. Photomatix Pro was then used to blend the two, although it needed the Intensive option and that involves long processing times.

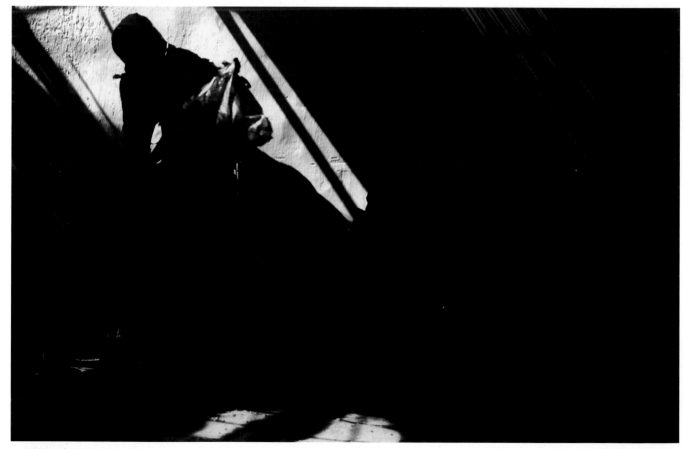

ORIGINAL DARKER EXPOSURE

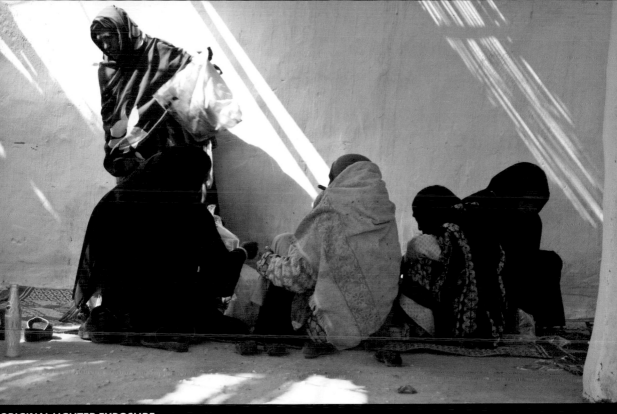

ORIGINAL LIGHTER EXPOSURE

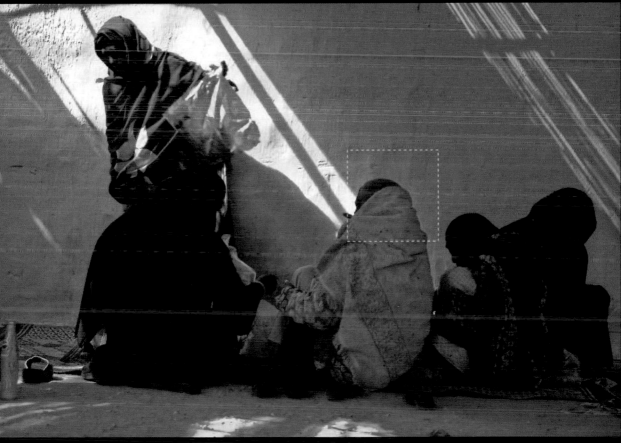

FINAL MERGED EXPOSURE

ORIGINAL LIGHTER EXPOSURE

ADJUST

AUTO

2 IMAGES

◄ ► MERGE METHODS

Here a number of different methods of merging two exposures, one lighter and one darker, are compared against the best possible single exposure (far left).

AVERAGE

INTENSIVE

BLENDING BY HAND

Given the recent advances in digital processing and in multi-shot blending and compression techniques, the idea of brushing and erasing layered images by hand may seem primitive, or at least slightly backward. However, abandoning sophisticated algorithms in favor of using simple tools manually has two compelling advantages. One is that you can see exactly what you are doing, to the pixel if necessary. The other is a reasonable guarantee of a result that looks as most people think a photograph should look like. Artificial and unexpected blends are, as we've just seen with HDR, the biggest source of headaches for professional work. The major disadvantage of manual brushwork is the time it takes.

There are no arcane techniques, or indeed pitfalls, in manual blending. In principle, nothing could be simpler than taking two or more different exposures, pasting one on top of the other to make a layered file, and then using brushes to reveal the best-exposed areas from each (or hide the least satisfactory). The most straightforward of all the techniques is to erase the less well-exposed areas from the upper layer, but there are others, including the history brush. For now, we'll keep it simple, with the eraser.

The source images are as for HDR and procedural blending, described on pages 64-65 (*Bracketing*). Step one is to copy and paste the images together into one image file, as layers. Step two is to make sure they are aligned. If the bracketed sequence has been shot carefully on a tripod this may not be necessary, although it is safe procedure to examine the file at 100% magnification and click the upper layer on and off quickly to see if there is a shift. Using Auto-Align in Photoshop is one of a number of ways of doing this. Content recognition is now sufficiently advanced in imaging software for this not to be a serious issue, even if the sequence of exposures has been shot hand-held.

In the case of two layers, simply use brushes of the appropriate sizes and feathering to erase through the upper layer to the better-exposed areas in the Background layer. Varying the opacity of the brush is another control. For areas that are well-defined segments, such as a window frame, use a selection-making tool, such as a lasso, magic wand, or a path, which is then converted into a selection. The edges of segments are the tricky zones when doing this, but there are a number of ways of modifying the selection, including feathering, smoothing, expanding, or contracting.

◄ ► HAND BLENDING

Some high-range images are easier to blend by hand than in an automated procedure, and this is one such image. All except two kinds of area were well exposed in the lightest version. The two areas not well exposed were the swimming pool, which has a well-defined edge, and the local areas around the lights near the walls. The first step was to copy and paste the three exposures into a single layered file, with the lightest on top. The next was to auto-align them, although this wasn't strictly necessary as they had been shot using a tripod. Erasing through the three layers was straightforward, beginning with the middle layer to the bottom and finishing with erasing through the top layer. The swimming pool with its straight lines was easy to outline using a path, then converted into a selection, and within this selection a large eraser brush was used. The small individual lights needed no selection, just several dabs of an appropriately sized eraser brush fully feathered and at 33% opacity.

LIGHTEST ORIGINAL

BLOWN HIGHLIGHTS IN LIGHTEST ORIGINAL

DARKEST ORIGINAL

ERASER USED ON UPPER LAYER

PATH DRAWN AROUND THE SHAPE OF THE POOL

GLOSSARY

aperture The opening behind the camera lens through which light passes on its way to the image sensor (CCD/CMOS).

artifact A flaw in a digital image.

axis lighting Light aimed at the subject from close to the camera's lens.

backlighting The result of shooting with a light source, natural or artificial, behind the subject to create a silhouette or rim-lighting effect.

ballast The power pack unit for an HMI light which provides a high initial voltage.

barn doors The adjustable flaps on studio lighting equipment which can be used to control the beam emitted.

barn door tracker A remarkably effective device used by amateur photographers to turn a camera to follow the movement of stars across the night sky.

bit (binary digit) The smallest data unit of binary computing, being a single 1 or 0.

bit depth The number of bits of color data for each pixel in a digital image. A photographic-quality image needs eight bits for each of the red, green, and blue channels, making for a bit depth of 24.

boom A support arm for attaching lights or fittings to.

bracketing A method of ensuring a correctly exposed photograph by taking three shots; one with the supposed correct exposure, one slightly underexposed, and one slightly overexposed.

brightness The level of light intensity. One of the three dimensions of color in the HSB color system. See also Hue and Saturation

byte Eight bits. The basic unit of desktop computing. 1,024 bytes equals one kilobyte (KB), 1,024 kilobytes equals one megabyte (MB), and 1,024 megabytes equals one gigabyte (GB).

calibration The process of adjusting a device, such as a monitor, so that it works consistently with others, such as scanners or printers.

candela Measure of the brightness of a light source itself.

CCD (Charge-Coupled Device) A tiny photocell used to convert light into an electronic signal. Used in densely packed arrays, CCDs are the recording medium in most digital cameras.

channel Part of an image as stored in the computer; similar to a layer. Commonly, a color image will have a channel allocated to each primary color (e.g. RGB) and sometimes one or more for a mask or other effects.

cloning In an image-editing program, the process of duplicating pixels from one part of an image to another.

CMOS (Complementary Metal-Oxide Semiconductor) An alternative sensor technology to the CCD, CMOS chips are used in ultra-high-resolution cameras from Canon and Kodak.

CMYK (Cyan, Magenta, Yellow, Key) The four process colors used for printing, including black (key).

color gamut The range of color that can be produced by an output device, such as a printer, a monitor, or a film recorder.

color temperature A way of describing the color differences in light, measured in Kelvins and using a scale that ranges from dull red (1900 K), through orange, to yellow, white, and blue (10,000 K).

compression Technique for reducing the amount of space that a file occupies, by removing redundant data. There are two kinds of compression: standard and lossy. While the first simply uses different, more processor-intensive routines to store data than the standard file formats (see LZW), the latter actually discards some data from the image. The best known lossy compression system is JPEG, which allows the user to choose how much data is lost as the file is saved.

contrast The range of tones across an image, from bright highlights to dark shadows.

cropping The process of removing unwanted areas of an image, leaving behind the most significant elements.

depth of field The distance in front of and behind the point of focus in a photograph, in which the scene remains in acceptable sharp focus.

dialog box An onscreen window, part of a program, for entering settings.

diffusion The scattering of light by a material, resulting in a softening of the light and of any shadows cast. Diffusion occurs in nature through mist and cloud cover, and can also be simulated using diffusion sheets and soft-boxes.

digital zoom Many cheaper cameras offer a digital zoom function. This simply crops from the center of the image and scales the image up using image processing algorithms (indeed the same effect can be achieved in an image editor later). Unlike a zoom lens, or "optical zoom," the effective resolution is reduced as the zoom level increases; 2× digital zoom uses ¼ of the image sensor area, 3× uses 1⁄9, and so on. The effect of this is very poor image quality; Even if you start with an eight megapixel sensor, at just 3× digital zoom your image would be taken from less than one megapixel of it.

DMax (Maximum Density) The maximum density—that is, the darkest tone—that can be recorded by a device.

DMin (Minimum Density) The minimum density—that is, the brightest tone—that can be recorded by a device.

dye sublimation printer A color printer that works by transferring dye images to a substrate (paper, card, etc.) by heat, to give near photographic-quality prints.

edge lighting Light that hits the subject from behind and slightly to one side, creating flare or a bright "rim lighting" effect around the edges of the subject.

feathering In image-editing, the fading of the edge of an image or selection.

file format The method of writing and storing information (such as an image) in digital form. Formats commonly used for photographs include TIFF, BMP, and JPEG.

fill-in flash A technique that uses the on-camera flash or an external flash in combination with natural or ambient light to reveal detail in the scene and reduce shadows.

fill light An additional light used to supplement the main light source. Fill can be provided by a separate unit or a reflector.

filter (1) A thin sheet of transparent material placed over a camera lens or light source to

modify the quality or color of the light passing through.

(2) A feature in an image-editing application that alters or transforms selected pixels for some kind of visual effect.

flag Something used to partially block a light source to control the amount of light that falls on the subject.

flash meter A light meter especially designed to verify exposure in flash photography. It does this by recording values from the moment of a test flash, rather than simply measuring the "live" light level.

focal length The distance between the optical center of a lens and its point of focus when the lens is focused on infinity.

focal range The range over which a camera or lens is able to focus on a subject (for example, 0.5m to Infinity).

focus The optical state where the light rays converge on the film or CCD to produce the sharpest possible image.

fringe In image-editing, an unwanted border effect to a selection, where the pixels combine some of the colors inside the selection and some from the background.

frontal light Light that hits the subject from behind the camera, creating bright, high-contrast images, but with flat shadows and less relief.

f-stop The calibration of the aperture size of a photographic lens.

gamma A measure of the contrast of an image, expressed as the steepness of the characteristic curve of an image.

gobo A corruption of "go between," this is anything used to block or partially block light.

gradation The smooth blending of one tone or color into another, or from transparent to colored in a tint. A graduated lens filter, for instance, might be dark on one side, fading to clear on the other.

grayscale An image made up of a sequential series of 256 gray tones, covering the entire gamut between black and white.

halogen bulb Common in modern spotlighting, halogen lights use a tungsten fillament

surrounded by halogen gas, allowing it to burn hotter, longer and brighter.

haze The scattering of light by particles in the atmosphere, usually caused by fine dust, high humidity, or pollution. Haze makes a scene paler with distance, and softens the hard edges of sunlight.

HDRI (High Dynamic Range Imaging) A method of combining digital images taken at different exposures to draw detail from areas which would traditionally have been over or under exposed. This effect is typically achieved using a Photoshop plugin, and HDRI images can contain significantly more information than can be rendered on screen or even percieved by the human eye.

histogram A map of the distribution of tones in an image, arranged as a graph. The horizontal axis goes from the darkest tones to the lightest, while the vertical axis shows the number of pixels in that range.

HMI (Hydrargyrum Medium-arc Iodide) A lighting technology known as "daylight" since it provides light with a color temperature of around 5600 K.

honeycomb grid In lighting, a grid can be placed over a light to prevent light straying. The light can either travel through the grid in the correct direction, or will be absorbed by the walls of each cell in the honeycomb.

hot-shoe An accessory fitting found on most digital and film SLR cameras and some high-end compact models, normally used to control an external flash unit. Depending on the model of camera, pass information to lighting attachments via the metal contacts of the shoe.

HSB (Hue, Saturation, Brightness) The three dimensions of color, and the standard color model used to adjust color in many image-editing applications.

hue The pure color defined by position on the color spectrum; what is generally meant by "color" in lay terms.

incandescent lighting This strictly means light created by burning, referring to traditional filament bulbs. They are also know as hotlights, since they remain on and become very hot.

incident meter A light meter as opposed to the metering systems built into many cameras. These are used by hand to measure the light falling at a paticular place, rather than (as the camera does) the light reflected from a subject.

ISO An international standard rating for film speed, with the film getting faster as the rating increases. ISO 400 film is twice as fast as ISO 200, and will produce a correct exposure with less light and/or a shorter exposure. However, higher-speed film tends to produce more grain in the exposure, too.

Joule Measure of power, see watt-seconds.

JPEG (Joint Photographic Experts Group) Pronounced "jay-peg," a system for compressing images, developed as an industry standard by the International Standards Organization. Compression ratios are typically between 10:1 and 20:1, although lossy (but not necessarily noticeable to the eye).

kelvin Scientific measure of temperature based on absolute zero (simply take 273.15 from any temperature in Celsius to convert to kelvin). In photography measurements in kelvin refer to color temperature. Unlike other measures of temperature, the degrees symbol in not used.

lasso In image-editing, a tool used to draw an outline around an area of an image for the purposes of selection.

layer In image-editing, one level of an image file, separate from the rest, allowing different elements to be edited separately.

LCD (Liquid Crystal Display) Flat screen display used in digital cameras and some monitors. A liquid-crystal solution held between two clear polarizing sheets is subject to an electrical current, which alters the alignment of the crystals so that they either pass or block the light.

light pipe A clear plastic material that transmits like, like a prism or optical fiber.

light tent A tent-like structure, varying in size and material, used to diffuse light over a wider area for close-up shots.

lumens A measure of the light emitted by a lightsource, derived from candela.

luminaires A complete light unit, comprising an internal focussing mechanism and a fresnel

lens. An example would be a focusing spot light. The name luminaires derives from the French language, but is used by professional photographers across the world.

luminosity The brightness of a color, independent of the hue or saturation.

lux A scale for measuring illumination, derived from lumens. It is defined as one lumen per square meter, or the amount of light falling from a light source of one candela one meter from the subject.

LZW (Lempel-Ziv-Welch) A standard option when saving TIFF files which reduces file sizes, especially in images with large areas of similar color. This option does not lose any data from the image, but cannot be opened by some image editing programs.

macro A mode offered by some lenses and cameras that enables the lens or camera to focus in extreme close-up.

mask In image-editing, a grayscale template that hides part of an image. One of the most important tools in editing an image, it is used to limit changes to a particular area or protect part of an image from alteration.

megapixel A rating of resolution for a digital camera, directly related to the number of pixels forming or output by the CMOS or CCD sensor. The higher the megapixel rating, the higher the resolution of images created by the camera.

midtone The parts of an image that are approximately average in tone, falling midway between the highlights and shadows.

modelling light A small light built into studio flash units which remains on continiously. It can be used to position the flash, approximating the light that will be cast by the flash.

monobloc An all-in-one flash unit with the controls and power supply built-in. Monoblocs can be synchronized together to create more elaborate lighting setups.

noise Random pattern of small spots on a digital image that are generally unwanted, caused by nonimage-forming electrical signals.

open flash The technique of leaving the shutter open and triggering the flash one or more times, perhaps from different positions in the scene.

peripheral An additional hardware device connected to and operated by the computer, such as a drive or printer.

pixel (PICture ELement) The smallest units of a digital image, pixels are the square screen dots that make up a bitmapped picture. Each pixel carries a specific tone and color.

photoflood bulb A special tungsten light, usually in a reflective dish, which produces an especially bright (and if suitably coated white) light. The bulbs have a limited lifetime.

plug-in In image-editing, software produced by a third party and intended to supplement a program's features or performance.

power pack The separate unit in flash lighting systems (other than monoblocks) which provides power to the lights.

ppi (pixels-per-inch) A measure of resolution for a bitmapped image.

processor A silicon chip containing millions of micro-switches, designed for performing specific functions in a computer or digital camera.

QuickTime VR An Apple-developed technology that allows a series of photos to be joined in a single file which the user can then use to look around, say, a product or a room.

RAID (Redundant Array of Independent Disks) A stack of hard disks that function as one, but with greater capacity.

RAM (Random Access Memory) The working memory of a computer, to which the central processing unit (cpu) has direct, virtually immediate access.

Raw files A digital image format, known sometimes as the "digital negative," which preserves higher levels of color depth than traditional 8 bits per channel images. The image can then be adjusted in software—potentially by three stops—without loss of quality. The file also stores camera data including meter readings, aperture settings, and more. In fact each camera model creates its own kind of Raw file, though leading models are supported by software like Adobe Photoshop.

reflector An object or material used to bounce light onto the subject, often softening and dispersing the light for a more attractive result.

resampling Changing the resolution of an image file either by removing pixels (lowering resolution) or adding them by interpolation (increasing resolution).

resolution The level of detail in a digital image, measured in pixels (e.g. 1,024 by 768 pixels), or dots-per-inch (in a half-tone image only, e.g. 1200 dpi).

RFS (Radio Frequency System) A technology used to control lights where control signals are passed by radio rather than cable. It has the advantage of not requiring line-of-sight between the transceiver and device.

RGB (Red, Green, Blue) The primary colors of the additive model, used in monitors and image-editing programs.

rim-lighting Light from the side and behind a subject which falls on the edge (hence rim) of the subject.

ring-flash A lighting device with a hole in the center so that the lens can be placed through it, resulting in shadow-free images.

saturation The purity of a color, going from the lightest tint to the deepest, most saturated tone.

scrim A light open-weave fabric, used to cover softbox lights.

selection In image-editing, a part of an on-screen image that is chosen and defined by a border in preparation for manipulation or movement.

shutter The device inside a conventional camera that controls the length of time during which the film is exposed to light. Many digital cameras don't have a shutter, but the term is still used as shorthand to describe the electronic mechanism that controls the length of exposure for the CCD.

shutter speed The time the shutter (or electronic switch) leaves the CCD or film open to light during an exposure.

SLR (Single Lens Reflex) A camera that transmits the same image via a mirror to the film and viewfinder, ensuring that you get exactly what you see in terms of focus and composition.

slow sync The technique of firing the flash in conjunction with a slow shutter speed (as in rear-curtain sync). The result is that motion blur is combined with a moment frozen by the flash.

snoot A tapered barrel attached to a lamp in order to concentrate the light emitted (narrow the beam) into a spotlight.

soft-box A studio lighting accessory consisting of a flexible box that attaches to a light source at one end and has an adjustable diffusion screen at the other, softening the light and any shadows cast by the subject.

spot meter A specialized light meter, or function of the camera light meter, that takes an exposure reading for a precise area of a scene.

sync cord The electronic cable used to connect camera and flash.

telephoto A photographic lens with a long focal length that enables distant objects to be enlarged. The drawbacks include a limited depth of field and angle of view.

TIFF (Tagged Image File Format) A file format for bitmapped images. It supports cmyk, rgb and grayscale files with alpha channels, and lab, indexed-color, and it can use LZW lossless compression. It is now the most widely used standard for good-resolution digital photographic images.

top lighting Lighting from above, useful in product photography since it removes reflections.

TTL (Through The Lens) Describes metering systems that use the light passing through the lens to evaluate exposure details.

tungsten A metalic element, used as the fillament for lightbulbs, hence tungsten lighting.

umbrella In photographic lighting umbrellas with reflective surfaces are used in conjunction with a light to diffuse the beam.

vapor discharge light A lighting technology common in stores and street lighting. It tends to produce color casts, especially the orange sodium vapor lights.

watt-seconds A measure of lighting power. One watt-second (Ws) is exactly equivalent to one joule (a more common measure in Europe). Because this is a scientific measure of the energy used by the light, rather than light output, it can sometimes be misleading. For example, a focussed spot using the same energy as a diffused light would be much brighter as all the energy is concentrated into a small beam of light.

white balance A digital camera control used to balance exposure and color settings for artificial lighting types.

window light A softbox, typically rectangular (in the shape of a window) and suitably diffused.

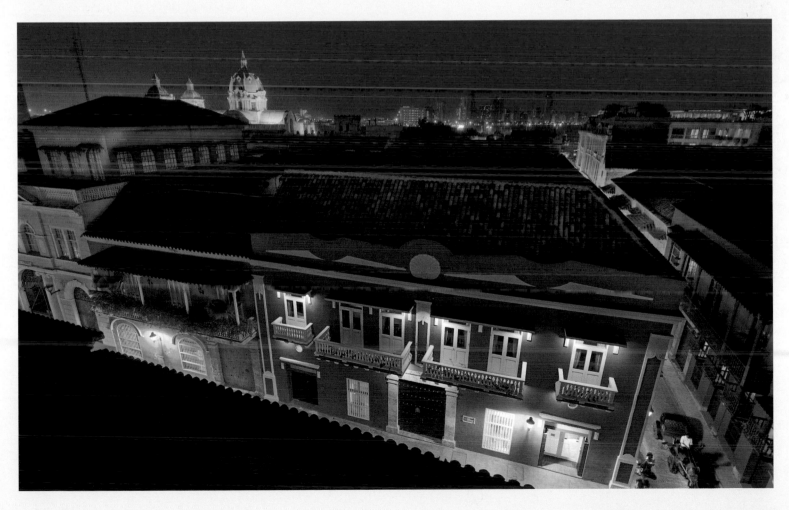

INDEX

A

ACR (Adobe Camera Raw) 21, 35, 85, 90, 93-94, 163, 180
Adams, Ansel 56, 122, 134
ADC (analog-to-digital converter) 26
Adjustment Brush 169
Adobe 55, 163, 170, 172
algorithms 32, 47, 176, 180, 184
anticipation 125
aperture 16, 55, 64, 117, 142, 155, 161
Apple 55
architecture 48, 52, 122, 127
archiving 176
artifacts 142, 144
attention 158-59
auto-bracketing 64
auto-exposure 48, 139
average range 68-79

B

background 13, 59, 88, 97-98, 104, 106-7, 109-10, 113, 138, 154, 184
backlighting 13, 36, 108, 117, 154
banding 144, 156
basic metering 44-45, 48
basic method 10-11
Bayer filter 27
bias 44
bit depth 162, 164, 176-77
black card 38, 117
black point 29, 80, 82, 85, 130, 133, 139, 143, 172
black-and-white mode 136
bracketing exposure 64-65, 100, 102, 107
bright key tones 74-77
brightness 13-14, 16-17, 22-23, 27-29, 32, 38, 42, 46, 50-51, 55-56, 58, 60, 62, 69-70, 73-75, 78-80, 86-87, 89, 92, 98-102, 106-7, 109, 112, 116, 119, 121-23, 126-28, 130, 134, 136, 138, 140-42, 145-46, 148, 150, 152, 156, 158-59, 163-67, 172, 174
Brightside 176

C

calibration 42, 54
camera settings 10, 12, 14
candelas 28

Capture One 161, 163
case studies 18-23
center-circle metering 44-45, 48, 53-54, 74, 96-99, 102, 106
center-weighted metering 11-12, 44-45, 101-2, 104, 108, 134
CGI (computer-generated imagery) 142
channel mixing 136-37
channel processing 38
chiaroscuro 20
cinematography 139
clarity 43, 85, 93, 168-69
clipping 11-14, 17, 20-21, 26, 29, 32-36, 38, 41, 43, 50, 58, 68, 70, 72, 74, 76, 78, 80, 82, 84, 86, 88, 90, 92-94, 98, 100-101, 104, 108, 117, 124, 126, 130, 133-34, 136, 140, 144-45, 151, 156-58, 168, 176
color balance 54-55
color casts 35
color control 60-63, 134, 137, 146, 158
color fringes 34
color shifts 37
ColorChecker 112
composition 12-14, 18, 39, 44-46, 106, 109, 111, 116, 118-19, 125, 138-39, 145, 154, 156
compression 156, 176-78, 180, 184
constancy 122
content recognition 46, 184
contrast 20-21, 23, 29, 42-44, 53, 56, 58-59, 82, 85, 87-88, 90, 93, 96-97, 106, 109-10, 124-26, 130, 133-34, 139, 142, 147, 151, 154, 168-70, 172-73
cropping 13, 72, 113
Curves 42
cut-off 44

D

damage control 14
dark current/noise 30
dark key tones 78-79
databases 46, 67, 163
default settings 13, 52, 82, 92, 132, 137, 150, 163
demosaicing 26-27, 30
depth of field 18, 64
depth-of-field preview button 117, 155
detail 26, 30, 32-34, 36, 44, 50, 56,

59-60, 78, 86, 92, 98, 100-101, 106-7, 110, 116, 119, 122, 124, 126, 130-31, 133, 138-39, 144-48, 150-51, 154-56, 158, 162
direct light readings 52
dodging/burning 116, 168
double-processing 180
DxO Optics 134, 161, 163
dynamic range 11, 13-14, 18, 20, 22, 29-30, 32-33, 36, 38-43, 50, 58, 64-65, 68-113, 115, 122, 126, 140, 148, 154, 156, 174-80, 184-85

E

edge lighting 100-105, 152-53, 156
efl 18, 73
engineering 26, 36, 47
envisioning 122-25, 153, 178
equalizing 82, 85
erasing 184-85
EV (Exposure Value) 16
evaluative metering 46
exposure blending 13, 22, 60, 64-65, 106, 178, 180-85
exposure compensation 48, 89, 96-98, 101-2, 104-5, 107-8, 110-11, 113, 121, 125, 139
exposure locking 45, 49
Exposure tool 170-73, 177

F

f stops 16-21, 32, 38, 41, 45, 48, 58-59, 62, 73-79, 86, 88-90, 94, 96-102, 104-6, 110-11, 113, 117, 119, 121, 123, 125, 127, 132, 134, 139, 141, 144-45, 148, 151, 155, 158-59, 162, 174, 180
faces 13, 21, 46, 52, 56, 59, 100, 120, 154
fall-off 112
file format 12, 14, 82, 85, 174
film noir 153
firmware 26
first group 68-79
flags 142
flare 41, 117, 142-44, 153
flash 119
flashmeters 109
flat lighting 80, 82
focal length 19, 113
foreground 13, 19, 76, 108, 125
framing 39

Fuji 120, 145
full well capacity 32-34, 142

G

gamma 42, 90, 171-73, 177
ghosting 65
global contrast 42-43, 168
glow 144-45
grain 30, 32
gray card 16, 28, 54-55, 127
grayscale 19, 85

H

halation 142-44, 156-57
hand blending 184-85
hand-held metering 14, 18, 44, 52-53,
 98, 102, 105-6, 112, 119
hardware 26
HDR (High Dynamic Range) 13, 22,
 38, 64-65, 90, 106, 126, 143-45, 152,
 156, 174-80, 184-85
HDRI (High Dynamic Range Imaging)
 38, 64, 174-80
high contrast 42-44, 53, 58, 82, 90
high key 29, 86-87, 106, 136, 138-41, 146
high range 90-113, 176
highlights 13, 20-21, 26, 29, 32-35, 41,
 43, 50, 58, 69-70, 74, 78, 85-86, 90,
 92-94, 100-101, 104, 106, 108, 122, 124,
 126, 133-34, 144-45, 150-51, 153, 156-58,
 162-63, 168, 170, 172, 177, 180
histograms 12, 40, 43, 50, 56, 68, 79-80,
 82, 86, 98, 127, 152, 170, 177
honeycomb metering 46
horizon 108, 123
Horvat, Frank 118
hotspots 13
HSB (Hue, Saturation and Brightness)
 16, 54, 60
hue 60, 62, 85, 112, 116-17, 120, 138
HVS (Human Visual System) 50-51, 120,
 122-23, 130, 134, 156, 158, 178

I

illuminance 28, 52
Imatest 36-37
incident-light metering 52-54, 96,
 98, 102, 105, 109, 112, 119
information 26, 116-17, 119, 130, 178

ink seepage 156
internet 28
interpolation 26-27
interpretation 116-17, 136, 140
ISO settings 14, 30, 36

J

JPEG files 12, 82, 85, 164, 170

K

key concepts 56-57
key tones 11, 13-14, 17-19, 21-23, 29,
 47-49, 56-58, 62, 67-68, 70, 73-80,
 82, 92-94, 98, 108, 110, 134
key-to-fill ratio 152
Kodachrome 148
Kodak 54

L

LAB 167
landscapes 13, 48, 52-53, 59-60, 64,
 70, 117-18, 122-23, 126, 158
lateral chromatic aberration 36-37
layers 184-85
lens shades 142
Levels 80, 85, 130, 139
lighting 12, 14, 38, 48, 52, 70, 72, 80,
 82, 86, 92, 97-98, 100-102, 106,
 109-10, 117, 119, 122, 125, 136, 139,
 145, 148, 152-54, 156, 158
lightness 28-29, 120-21, 143, 164-67
Lightroom 134, 161, 163, 168-69
LightZone 126, 161, 163, 168
local adaptation 177
local contrast 42-43, 168
low contrast 42-43
low key 29, 88, 100, 105, 136, 138,
 146-48, 152-53
low light 14, 30, 136
low range 80-89, 140, 156
luminance 28-29, 38, 52

M

McCullin, Don 118
manual exposure 48, 113
manufacturers 10, 12, 26, 28, 44, 46-
 47, 54, 120, 142, 161
market acceptance 115
matrix metering 46, 102, 104

memory cards 26
memory tones 120-21, 150
metering 11-14, 17-18, 20, 44-50, 52-54,
 67-68, 70, 73-74, 78, 80, 82, 86, 88,
 92-94, 96-98, 100-102, 104-8, 110, 113,
 119, 125, 127, 130, 132, 134
mid-tones 13, 16, 34, 42, 54, 56, 70, 88,
 92-94, 96, 98, 106, 116, 126-27, 130-33,
 138, 146, 148, 150, 168, 172
monitors 176
monochrome 85, 120, 128, 134, 136-37
mood 84, 88, 116-17, 139
mosaic system 26-27
MTF (Modulation transfer Function) 36
multi-pattern metering 46, 48
multi-zone metering 46
multiple exposures 13, 143, 174, 176, 184

N

Nikon 20, 46, 67, 104
noise 26, 30-33, 36, 162-63
noise floor 32

O

Offset 171-73
opacity 184-85
over-exposure 12-13, 29, 34, 38, 50, 56,
 58, 60-61, 98-99, 101-2, 106, 117-18,
 126, 138-39, 143-44, 148, 153, 156,
 162, 168
over-scaling 90

P

panning 113
perception 10, 28, 30, 50-51, 54, 56,
 62, 92, 96, 120-21, 130, 136, 150,
 156, 178
Photomatix 65, 174-75, 178, 180
Photoshop 10, 16, 35, 43-44, 54-55,
 62, 68, 80, 88-90, 93-94, 102, 104,
 134, 137, 139, 161, 163, 168, 170, 173-74,
 180, 184
photosites 26-27, 32, 142
pixel pitch 26
pixelation 19, 68, 70, 75, 92, 98
placement 126
Plexiglas 109, 117
polygons 142
predictive metering 46-48, 94, 102, 104

previsualization 122

prime lenses 113

printers 60, 148, 156

processing 13-14, 42, 50, 55-56, 58-59, 62, 64, 68, 78, 80, 82, 94, 112, 126-27, 130, 134, 140, 143-45, 147-48, 160-85

professionals 9-11, 16, 44, 49, 60, 67, 148

punch 130

R

Raw files 12, 14, 20, 33-35, 50, 55, 58, 62, 68, 78, 82, 84-85, 90, 93-94, 104, 112, 124, 127, 134, 137, 140, 162-64, 166-68, 170, 180

re-framing 45, 48-49

re-positioning 64

Recovery 35

reference shots 55

reflectance 16, 28, 38, 52, 54, 59, 127

reflected-light metering 52

reflections 75, 85, 101, 108, 143-44, 157

reflectors 86, 112, 119

refraction 157

register 64

repro houses 60, 140, 148

resolution 26, 36-37

roll-off 32, 34-35, 144-45, 150

S

S-curves 34, 43

saccades 51

sampling errors 30

saturation 60-62, 85, 120, 131, 134, 140, 148

scene priorities 58-59

second group 80-89

segment metering 46

selection tools 184

sensitivity 36, 53

sensor design 26, 30

SFR (Spatial Frequency Response) 36

shadow 13, 18-21, 26, 29-30, 32-34, 38, 41, 43, 50, 55-56, 58-59, 65, 69-70, 72, 75, 78, 85-94, 100-101, 105-8, 110, 112, 116, 119, 121-22, 124-28, 130-34, 138-40, 143, 146, 148-58, 168, 170, 172-74, 180

sharpness 36, 42-43

Shaw, George Bernard 148

shoulder 34-35

shutter speed 14, 16, 19, 64, 174

silhouettes 41, 60-61, 92, 101, 107, 110, 116-17, 154-56

skies 22, 30, 41, 44, 56, 59, 64, 85, 92, 99, 106, 108, 113, 116-18, 120, 123, 134, 137, 151, 158, 168

skin tone 56, 74, 88, 96-97, 111, 120-21, 126, 131-32, 141

SLRs 26, 32, 44-45, 48, 52-53, 64, 102, 105, 162

smart metering 46-48, 94, 102, 104, 107, 110

snowscapes 74, 86, 126

split toning 85

spot-metering 13, 44-45, 48, 96, 98, 102

Stouffer step wedges 36

studio shots 52, 70, 80, 96, 98, 105, 109, 112, 117, 138, 152

style 114-59

sunset 22, 60-61, 122-23, 125

SVG (Scalable Vector Graphics) 37

systems 9

T

Tanizaki, Junichiro 148

technical basics 24-65

telephoto lenses 89, 143

terminology 28-29, 42, 130

tests 36-37, 68, 98

third group 90-113

TIFF files 12, 82, 85, 162, 164, 168, 170, 174

toe 34

tone-mapping 38, 42, 144, 168, 175-78, 180

tripods 14, 22, 48, 64, 104, 174, 184-85

TTL (through-the-lens) readings 117

U

under-exposure 12, 29, 38, 50, 60-61, 79, 89, 108, 116, 118, 134, 148, 150, 163

V

value 29

vegetation 120

viewpoint 18, 20, 80, 92, 116, 125, 142, 154, 158

vignetting 19, 37, 106, 158

W

warping 64

wavelengths 26

weblink 6, 104

weighted metering 44-45

white card 38, 119

white point 29, 80, 82, 130, 133, 139

white-on-white 139, 141

wide-angle lenses 18-19, 75, 106, 156, 158

Z

Zone System 56, 92, 122, 126-35, 137

digits™

Student Companion

Grade 7

PEARSON

Boston, Massachusetts • Chandler, Arizona • Glenview, Illinois • Upper Saddle River, New Jersey

Acknowledgments for illustrations and composition: Rory Hensley, David Jackson, Jim Mariano, Rich McMahon, Lorie Park, Ted Smykal, Ralph Voltz, and Laserwords

PEARSON

ISBN-13: 978-0-13-327626-8
ISBN-10: 0-13-327626-0
8 9 10 V001 17 16

digits™ System Requirements

Supported System Configurations

	Operating System (32-bit only)	Web Browser* (32-bit only)	Java® Version**
PC	Windows® XP (SP3) Windows Vista (SP1) Windows 7	Internet Explorer® 7 Internet Explorer 8 Internet Explorer 9 Mozilla Firefox® 11 Google Chrome™	1.4.2 1.5 [5.0 Update 11 or higher] 1.6 [6.0 through Update 18]
Mac	Macintosh® OS 10.6.x, 10.7.x	Safari® 5.0 Safari 5.1 Google Chrome™	1.5 [5.0 Update 16 or higher]

* Pop-up blockers must be disabled in the browser.
** Java (JRE) plug-in must be installed and JavaScript® must be enabled in the browser.

Additional Requirements

Software	Version
Adobe® Flash®	Version 10.4 or higher
Adobe Reader® (required for PC*)	Version 8 or higher
Word processing software	Microsoft® Word®, Open Office, or similar application to open ".doc" files

* Macintosh® OS 10.6 has a built-in PDF reader, Preview.

Screen Resolution
PC
Minimum: 1024 x 768*
Maximum: 1280 x 1024
Mac
Minimum: 1024 x 768*
Maximum: 1280 x 960
*recommended for interactive whiteboards

Internet Connection
Broadband (cable/DSL) or greater is recommended.

AOL® and AT&T™ Yahoo!® Users
You cannot use the AOL or AT&T Yahoo! browsers. However, you can use AOL or AT&T as your Internet Service Provider to access the Internet, and then open a supported browser.

The trademarks referred to above are the property of their respective owners, none of whom have authorized, approved, or otherwise sponsored this product.

For *digits*™ Support
go to **http://support.pearsonschool.com/index.cfm/digits**

digits™ Learning Team

My Name: _____

My Teacher's Name: _____

My School: _____

Dana

Sara

Javier

Jay

Francis (Skip) Fennell
digits Author

Approaches to mathematics content and curriculum, educational policy, and support for intervention

Eric Milou
digits Author

Approaches to mathematical content and the use of technology in middle grades classrooms

Art Johnson
digits Author

Approaches to mathematical content and support for English language learners

William F. Tate
digits Author

Approaches to intervention, and use of efficacy and research

Helene Sherman
digits Author

Teacher education and support for struggling students

Grant Wiggins
digits Consulting Author

Understanding by Design

Stuart J. Murphy
digits Author

Visual learning and student engagement

Randall I. Charles
digits Advisor

Janie Schielack
digits Author

Approaches to mathematical content, building problem solvers, and support for intervention

Jim Cummins
digits Advisor

Supporting English Language Learners

Jacquie Moen
digits Advisor

Digital Technology

Go online for all your cool digits™ stuff!

Be sure to save your login information by writing it here.

My Username: _____

My Password: _____

First, go to **MyMathUniverse.com**. From there you can explore the **Channel List**, which includes fun and interactive games and videos, or select your program and log in.

Play some cool math **games!**

Complete your **homework** online!

Discover math **tricks** and **tips!**

Check out fun **videos!**

ACTIVe-book

No more pencils! No more books! Why? Because the Student Companion you have in front of you can also be found online in ACTIVe-book format. You can access your ACTIVe-book on a tablet or on a computer, so any questions you can answer in your Student Companion you can also master online.

1-1

Equivalent Ratios

CCSS: 7.RP.A.1: Compute unit rates associated with ratios of fractions, including ratios of lengths, areas and other quantities measured in like or different units.

Digital Resources

Launch

Your friend can't help but compare. During a game of stickball in the street, you notice him making all sorts of number comparisons. He asks for help making number comparisons on one building.

Name at least five number comparisons you can make by looking at the building.

© MP2, MP6

Reflect Do you make number comparisons? Provide an example of a number comparison you've made and why you made it.

vii

Contents

Unit A: Ratio and Proportional Relationships

Topic 1: Ratios and Rates . 1

Topic 2: Proportional Relationships . 23

Topic 3: Percents . 49

Unit B: Rational Numbers

Topic 4: Adding and Subtracting Rational Numbers 85

Topic 5: Multiplying and Dividing Rational Numbers 115

Topic 6: Decimals and Percent . 141

Unit C: Expressions and Equations

Topic 7: Equivalent Expressions . 171

Topic 8: Equations . 193

Topic 9: Inequalities . 215

Unit D: Geometry

Topic 10: Angles . 237

Topic 11: Circles . 263

Topic 12: 2- and 3-Dimensional Shapes 285

Topic 13: Surface Area and Volume . 315

Unit E: Statistics

Topic 14: Sampling . 337

Topic 15: Comparing Two Populations 373

Unit F: Probability

Topic 16: Probability Concepts . 405

Topic 17: Compound Events . 431

Glossary . G1

Formulas . A1

Math Symbols . A3

Measures . A4

Properties . A5

Welcome to digits™

Using the Student Companion

digits is designed to help you master mathematics skills and concepts in a way that's relevant to you. As the title **digits** suggests, this program takes a digital approach. The Student Companion supports your work on **digits** by providing a place to demonstrate your understanding of lesson skills and concepts in writing.

Your companion supports your work on **digits** in so many ways!

Focus and record your thinking on the key lesson **Question**.

Make sense of, break down, and solve the **Launch** problem for each **digits** lesson.

Reflect and connect your work on the Launch problem to larger mathematics concepts and the real world.

Show you know **HOW** to apply lesson skills.

Show you **UNDERSTAND** lesson concepts in depth.

Number	Standard for Mathematical Content

7.RP Ratios and Proportional Relationships

Analyze proportional relationships and use them to solve real-world and mathematical problems.

7.RP.A.1	Compute unit rates associated with ratios of fractions, including ratios of lengths, areas and other quantities measured in like or different units.
7.RP.A.2	Recognize and represent proportional relationships between quantities.
7.RP.A.2a	Decide whether two quantities are in a proportional relationship, e.g., by testing for equivalent ratios in a table or graphing on a coordinate plane and observing whether the graph is a straight line through the origin.
7.RP.A.2b	Identify the constant of proportionality (unit rate) in tables, graphs, equations, diagrams, and verbal descriptions of proportional relationships.
7.RP.A.2c	Represent proportional relationships by equations.
7.RP.A.2d	Explain what a point (x, y) on the graph of a proportional relationship means in terms of the situation, with special attention to the points $(0, 0)$ and $(1, r)$ where r is the unit rate.
7.RP.A.3	Use proportional relationships to solve multistep ratio and percent problems. Examples: simple interest, tax, markups and markdowns, gratuities and commissions, fees, percent increase and decrease, percent error.

7.NS The Number System

Apply and extend previous understandings of operations with fractions to add, subtract, multiply, and divide rational numbers.

7.NS.A.1	Apply and extend previous understandings of addition and subtraction to add and subtract rational numbers; represent addition and subtraction on a horizontal or vertical number line diagram.		
7.NS.A.1a	Describe situations in which opposite quantities combine to make 0. For example, a hydrogen atom has 0 charge because its two constituents are oppositely charged.		
7.NS.A.1b	Understand $p + q$ as the number located a distance $	q	$ from p, in the positive or negative direction depending on whether q is positive or negative. Show that a number and its opposite have a sum of 0 (are additive inverses). Interpret sums of rational numbers by describing real-world contexts.
7.NS.A.1c	Understand subtraction of rational numbers as adding the additive inverse, $p - q = p + (-q)$. Show that the distance between two rational numbers on the number line is the absolute value of their difference, and apply this principle in real-world contexts.		
7.NS.A.1d	Apply properties of operations as strategies to add and subtract rational numbers.		
7.NS.A.2	Apply and extend previous understandings of multiplication and division and of fractions to multiply and divide rational numbers.		

Number	Standard for Mathematical Content

7.NS The Number System (*continued*)

Apply and extend previous understandings of operations with fractions to add, subtract, multiply, and divide rational numbers.

7.NS.A.2a	Understand that multiplication is extended from fractions to rational numbers by requiring that operations continue to satisfy the properties of operations, particularly the distributive property, leading to products such as $(-1)(-1) = 1$ and the rules for multiplying signed numbers. Interpret products of rational numbers by describing real-world contexts.
7.NS.A.2b	Understand that integers can be divided, provided that the divisor is not zero, and every quotient of integers (with non-zero divisor) is a rational number. If p and q are integers, then $\left(\frac{p}{q}\right) = \frac{(-p)}{q} = \frac{p}{(-q)}$. Interpret quotients of rational numbers by describing real-world contexts.
7.NS.A.2c	Apply properties of operations as strategies to multiply and divide rational numbers.
7.NS.A.2d	Convert a rational number to a decimal using long division; know that the decimal form of a rational number terminates in 0s or eventually repeats.
7.NS.A.3	Solve real-world and mathematical problems involving the four operations with rational numbers.

7.EE Expressions and Equations

Use properties of operations to generate equivalent expressions.

7.EE.A.1	Apply properties of operations as strategies to add, subtract, factor, and expand linear expressions with rational coefficients.
7.EE.A.2	Understand that rewriting an expression in different forms in a problem context can shed light on the problem and how the quantities in it are related. For example, $a + 0.05a = 1.05a$ means that "increase by 5%" is the same as "multiply by 1.05."

Solve real-life and mathematical problems using numerical and algebraic expressions and equations.

7.EE.B.3	Solve multi-step real-life and mathematical problems posed with positive and negative rational numbers in any form (whole numbers, fractions, and decimals), using tools strategically. Apply properties of operations to calculate with numbers in any form; convert between forms as appropriate; and assess the reasonableness of answers using mental computation and estimation strategies.
7.EE.B.4	Use variables to represent quantities in a real-world or mathematical problem, and construct simple equations and inequalities to solve problems by reasoning about the quantities.
7.EE.B.4a	Solve word problems leading to equations of the form $px + q = r$ and $p(x + q) = r$, where p, q, and r are specific rational numbers. Solve equations of these forms fluently. Compare an algebraic solution to an arithmetic solution, identifying the sequence of the operations used in each approach.
7.EE.B.4b	Solve word problems leading to inequalities of the form $px + q > r$ or $px + q < r$, where p, q, and r are specific rational numbers. Graph the solution set of the inequality and interpret it in the context of the problem.

Grade 7 Common Core State Standards *continued*

Number	Standard for Mathematical Content

7.G Geometry

Draw construct, and describe geometrical figures and describe the relationships between them.

7.G.A.1	Solve problems involving scale drawings of geometric figures, including computing actual lengths and areas from a scale drawing and reproducing a scale drawing at a different scale.
7.G.A.2	Draw (freehand, with ruler and protractor, and with technology) geometric shapes with given conditions. Focus on constructing triangles from three measures of angles or sides, noticing when the conditions determine a unique triangle, more than one triangle, or no triangle.
7.G.A.3	Describe the two-dimensional figures that result from slicing three- dimensional figures, as in plane sections of right rectangular prisms and right rectangular pyramids.

Solve real-life and mathematical problems involving angle measure, area, surface area, and volume.

7.G.B.4	Know the formulas for the area and circumference of a circle and use them to solve problems; give an informal derivation of the relationship between the circumference and area of a circle.
7.G.B.5	Use facts about supplementary, complementary, vertical, and adjacent angles in a multi-step problem to write and solve simple equations for an unknown angle in a figure.
7.G.B.6	Solve real-world and mathematical problems involving area, volume and surface area of two- and three-dimensional objects composed of triangles, quadrilaterals, polygons, cubes, and right prisms.

7.SP Statistics and Probability

Use random sampling to draw inferences about a population.

7.SP.A.1	Understand that statistics can be used to gain information about a population by examining a sample of the population; generalizations about a population from a sample are valid only if the sample is representative of that population. Understand that random sampling tends to produce representative samples and support valid inferences.
7.SP.A.2	Use data from a random sample to draw inferences about a population with an unknown characteristic of interest. Generate multiple samples (or simulated samples) of the same size to gauge the variation in estimates or predictions.

Draw informal comparative inferences about two populations.

7.SP.B.3	Informally assess the degree of visual overlap of two numerical data distributions with similar variabilities, measuring the difference between the centers by expressing it as a multiple of a measure of variability.
7.SP.B.4	Use measures of center and measures of variability for numerical data from random samples to draw informal comparative inferences about two populations.

Investigate chance processes and develop, use, and evaluate probability models.

7.SP.C.5	Understand that the probability of a chance event is a number between 0 and 1 that expresses the likelihood of the event occurring. Larger numbers indicate greater likelihood. A probability near 0 indicates an unlikely event, a probability around $\frac{1}{2}$ indicates an event that is neither unlikely nor likely, and a probability near 1 indicates a likely event.

Number	Standard for Mathematical Content

7.SP Statistics and Probability (continued)

Investigate chance processes and develop, use, and evaluate probability models.

Number	
7.SP.C.6	Approximate the probability of a chance event by collecting data on the chance process that produces it and observing its long-run relative frequency, and predict the approximate relative frequency given the probability.
7.SP.C.7	Develop a probability model and use it to find probabilities of events. Compare probabilities from a model to observed frequencies; if the agreement is not good, explain possible sources of the discrepancy.
7.SP.C.7a	Develop a uniform probability model by assigning equal probability to all outcomes, and use the model to determine probabilities of events.
7.SP.C.7b	Develop a probability model (which may not be uniform) by observing frequencies in data generated from a chance process.
7.SP.C.8	Find probabilities of compound events using organized lists, tables, tree diagrams, and simulation.
7.SP.C.8a	Understand that, just as with simple events, the probability of a compound event is the fraction of outcomes in the sample space for which the compound event occurs.
7.SP.C.8b	Represent sample spaces for compound events using methods such as organized lists, tables and tree diagrams. For an event described in everyday language (e.g., "rolling double sixes"), identify the outcomes in the sample space which compose the event.
7.SP.C.8c	Design and use a simulation to generate frequencies for compound events. For example, use random digits as a simulation tool to approximate the answer to the question: If 40% of donors have type A blood, what is the probability that it will take at least 4 donors to find one with type A blood?

Number	Standard for Mathematical Practice
MP1	Make sense of problems and persevere in solving them.
MP2	Reason abstractly and quantitatively.
MP3	Construct viable arguments and critique the reasoning of others.
MP4	Model with mathematics.
MP5	Use appropriate tools strategically.
MP6	Attend to precision.
MP7	Look for and make use of structure.
MP8	Look for and express regularity in repeated reasoning.

Vocabulary

Language of Math for Topic 1

Lesson	Vocabulary	
	New	Review
Readiness 1 Planning a Concert	unit rates	divide by fractions simplify fractions
1-1 Equivalent Ratios	equivalent ratios ratio terms of a ratio	greatest common factor simplest form
1-2 Unit Rates	rate unit price unit rate	ratio
1-3 Ratios With Fractions		least common multiple ratio simplest form
1-4 Unit Rates With Fractions		unit rate
1-5 Problem Solving		ratio
Topic 1 Topic Review	equivalent ratios rate ratio terms of a ratio unit price unit rate	greatest common factor least common multiple simplest form

Vocabulary

Language of Math for Topic 2

Lesson	Vocabulary	
	New	**Review**
Readiness 2 Making and Editing a Video		equivalent ratios ordered pairs
2-1 Proportional Relationships and Tables	proportional relationship	equivalent ratios
2-2 Proportional Relationships and Graphs		proportional relationship
2-3 Constant of Proportionality	constant of proportionality	proportional relationship
2-4 Proportional Relationships and Equations	proportion	constant of proportionality proportional relationship
2-5 Maps and Scale Drawings	scale scale drawing	constant of proportionality proportional relationship
2-6 Problem Solving		proportional relationship
Topic 2 Topic Review	constant of proportionality proportion proportional relationship scale scale drawing	equivalent ratios

Vocabulary

Language of Math for Topic 3

Lesson	Vocabulary	
	New	**Review**
Readiness 3 Restaurant Math		order of operations percent
3-1 The Percent Equation	percent equation	percent ratio
3-2 Using the Percent Equation		percent equation
3-3 Simple Interest	balance interest interest rate principal simple interest	explain identify
3-4 Compound Interest	compound interest interest period	balance principal simple interest
3-5 Percent Increase and Decrease	percent decrease percent increase percent of change	percent
3-6 Markups and Markdowns	markdown markup	percent decrease percent increase
3-7 Problem Solving		percent percent decrease percent increase
Topic 3 Topic Review	balance compound interest interest interest period interest rate markdown markup percent decrease percent equation percent increase percent of change principal simple interest	percent ratio

Vocabulary

Language of Math for Topic 4

Lesson	Vocabulary New	Vocabulary Review
Readiness 4 Scuba Diving	absolute value	fractions integers
4-1 Rational Numbers, Opposites, and Absolute Value	absolute value opposites rational numbers	integers whole numbers
4-2 Adding Integers		integers opposites
4-3 Adding Rational Numbers		absolute value rational numbers
4-4 Subtracting Integers		integers opposites
4-5 Subtracting Rational Numbers		opposites rational numbers
4-6 Distance on a Number Line		absolute value distance
4-7 Problem Solving		interquartile range range
Topic 4 Topic Review	absolute value additive inverse Inverse Property of Addition opposites rational numbers	distance integers whole numbers

Vocabulary

Language of Math for Topic 5

Lesson	Vocabulary	
	New	**Review**
Readiness 5 Running a Bakery		dividing by fractions multiplying fractions
5-1 Multiplying Integers		integers
5-2 Multiplying Rational Numbers		rational numbers
5-3 Dividing Integers		integers quotient unit rate
5-4 Dividing Rational Numbers	reciprocals	denominator numerator quotient rational numbers
5-5 Operations With Rational Numbers	complex fraction	Distributive Property order of operations
5-6 Problem Solving		constant of proportionality mean proportional relationship
Topic 5 Topic Review	complex fraction reciprocals	denominator Distributive Property integers numerator order of operations quotient rational numbers unit rate

Vocabulary

Language of Math for Topic 6

Lesson	Vocabulary	
	New	**Review**
Readiness 6 Summer Olympics		decimals long division percent
6-1 Repeating Decimals	repeating decimal	decimal rational number
6-2 Terminating Decimals	terminating decimal	decimal
6-3 Percents Greater Than 100		percent
6-4 Percents Less Than 1		percent
6-5 Fractions, Decimals, and Percents		decimal fraction percent ratio rational number
6-6 Percent Error	accuracy percent error	dot plot
6-7 Problem Solving		percent percent error
Topic 6 Topic Review	accuracy percent error repeating decimal terminating decimal	decimal fraction percent ratio rational number

Vocabulary

Language of Math for Topic 7

Lesson	Vocabulary	
	New	**Review**
Readiness 7 Choosing a Cell Phone Plan		algebraic expression Distributive Property
7-1 Expanding Algebraic Expressions	expand an algebraic expression	algebraic expression Distributive Property
7-2 Factoring Algebraic Expressions	factor an algebraic expression like terms	algebraic expression Distributive Property greatest common factor (GCF)
7-3 Adding Algebraic Expressions	coefficient constant simplify an algebraic expression	algebraic expression like terms terms
7-4 Subtracting Algebraic Expressions		algebraic expression
7-5 Problem Solving		equivalent expression
Topic 7 Topic Review	coefficient constant expand an algebraic expression factor an algebraic expression like terms simplify an algebraic expression	algebraic expression Distributive Property greatest common factor (GCF)

Vocabulary

Language of Math for Topic 8

Lesson	Vocabulary	
	New	**Review**
Readiness 8 Gym Workouts		Distributive Property one-step equation
8-1 Solving Simple Equations	Addition Property of Equality Division Property of Equality isolate a variable Multiplication Property of Equality Subtraction Property of Equality	equation
8-2 Writing Two-Step Equations		two-step equation
8-3 Solving Two-Step Equations		isolate a variable two-step equation
8-4 Solving Equations Using the Distributive Property		Distributive Property
8-5 Problem Solving		isolate a variable
Topic 8 Topic Review	Addition Property of Equality Division Property of Equality isolate a variable Multiplication Property of Equality Subtraction Property of Equality	Distributive Property Equation two-step equation

Vocabulary

Language of Math for Topic 9

Lesson	Vocabulary	
	New	**Review**
Readiness 9 Taking Public Transportation		one-step inequalities
9-1 Solving Inequalities Using Addition or Subtraction	Addition Property of Inequality inequality solution of an inequality solution set Subtraction Property of Inequality	isolate a variable
9-2 Solving Inequalities Using Multiplication or Division	Division Property of Inequality Multiplication Property of Inequality	negative number positive number
9-3 Solving Two-Step Inequalities	equivalent inequalities	solution of an inequality
9-4 Solving Multi-Step Inequalities		Distributive Property
9-5 Problem Solving		inequality
Topic 9 Topic Review	equivalent inequalities inequality solution of an inequality	Distributive Property isolate a variable negative number positive number

Vocabulary

Language of Math for Topic 10

Lesson	Vocabulary	
	New	**Review**
Readiness 10 Miniature Golf		classifying angles measuring angles
10-1 Measuring Angles	acute angle angle obtuse angle right angle straight angle vertex of an angle	classify
10-2 Adjacent Angles	adjacent angles	angle vertex of an angle
10-3 Complementary Angles	complementary angles	adjacent angles right angle
10-4 Supplementary Angles	supplementary angles	adjacent angle straight angle
10-5 Vertical Angles	vertical angles	intersecting lines name
10-6 Problem Solving		acute angle obtuse angle
Topic 10 Topic Review	acute angle adjacent angles angle complementary angles obtuse angle right angle straight angle supplementary angles vertex of an angle vertical angles	classify intersecting lines

Vocabulary

Language of Math for Topic 11

Lesson	Vocabulary	
	New	**Review**
Readiness 11 Planning Zoo Habits		area perimeter
11-1 Center, Radius, and Diameter	center of a circle circle diameter radius	segment
11-2 Circumference of a Circle	circumference of a circle pi	diameter radius
11-3 Area of a Circle	area of a circle	pi
11-4 Circumference and Area of a Circle		area of a circle circumference of a circle
11-5 Problem Solving		circle
Topic 11 Topic Review	area of a circle circle circumference of a circle diameter pi radius	segment

Vocabulary

Language of Math for Topic 12

Lesson	Vocabulary	
	New	**Review**
Readiness 12 Architecture		angle prism pyramid triangle
12-1 Geometry Drawing Tools		parallelogram quadrilateral
12-2 Drawing 2-D Figures with Given Conditions 1	included angle included side	triangle
12-3 Drawing 2-D Figures with Given Conditions 2		included side net
12-4 2-D Slices of Right Rectangular Prisms	cross section	plane three-dimensional figure
12-5 2-D Slices of Right Rectangular Pyramids		cross section pyramid
12-6 Problem Solving		cross section
Topic 12 Topic Review	cross section included angle included side	net parallelogram plane pyramid three-dimensional figure triangle

Vocabulary

Language of Math for Topic 13

Lesson	Vocabulary	
	New	Review
Readiness 13 Growing a Garden		area right rectangular prism surface area volume
13-1 Surface Areas of Right Prisms	lateral area of a prism surface area of a cube surface area of a prism	lateral face prism regular polygon
13-2 Volumes of Right Prisms	volume of a cube volume of a prism	base area edge of a three-dimensional figure height of a prism
13-3 Surface Areas of Right Pyramids	lateral area of a pyramid slant height of a pyramid surface area of a pyramid	lateral face pyramid
13-4 Volumes of Right Pyramids	volume of a pyramid	base area height of a pyramid
13-5 Problem Solving		prism
Topic 13 Topic Review	lateral area surface area volume	base area height of a prism height of a pyramid lateral face prism pyramid

Vocabulary

Language of Math for Topic 14

Lesson	Vocabulary	
	New	Review
Readiness 14 Endangered Species		constant of proportionality fractions percents
14-1 Populations and Samples	bias biased sample inference invalid inference population representative sample sample of a population subject valid inference	proportional
14-2 Estimating a Population		population proportional representative sample
14-3 Convenience Sampling	convenience sampling	representative sample
14-4 Systematic Sampling	systematic sampling	representative sample
14-5 Simple Random Sampling	simple random sampling	population
14-6 Comparing Sampling Methods		convenience sampling representative sample simple random sampling systematic sampling
14-7 Problem Solving		convenience sample systematic sample valid inference
Topic 14 Topic Review	bias convenience sample inference population representative sample simple random sampling systematic sampling	proportional

Vocabulary

Language of Math for Topic 15

Lesson	Vocabulary	
	New	**Review**
Readiness 15 Tornadoes		box plot measures of center measures of variation
15-1 Statistical Measures	interquartile range mean median quartile range	box plot measure of center measure of variability
15-2 Multiple Populations and Inferences	comparative inference	inference population random sample
15-3 Using Measures of Center		comparative inference mean measure of center median
15-4 Using Measures of Variability		comparative inference interquartile range measure of variability range
15-5 Exploring Overlap in Data Sets	mean absolute deviation	absolute deviation deviation mean measure of variability
15-6 Problem Solving		measure of center measure of variability
Topic 15 Topic Review	comparative inference interquartile range mean mean absolute deviation median quartile range	inference measure of center measure of variability population random sample

Vocabulary

Language of Math for Topic 16

Lesson	Vocabulary	
	New	Review
Readiness 16 Basketball Stats		convert ratio
16-1 Likelihood and Probability	probability of an event	decimal fraction percent
16-2 Sample Space	action event outcome sample space	probability of an event
16-3 Relative Frequency and Experimental Probability	experimental probability relative frequency trial	event probability of an event
16-4 Theoretical Probability	simulation theoretical probability	action outcome probability of an event sample space
16-5 Probability Models	probability model uniform probability model	action event outcome probability of an event relative frequency sample space theoretical probability
16-6 Problem Solving		uniform probability model
Topic 16 Topic Review	action event experimental probability outcome probability model probability of an event relative frequency sample space simulation theoretical probability trial uniform probability model	decimal fraction percent

Vocabulary

Language of Math for Topic 17

Lesson	Vocabulary	
	New	**Review**
Readiness 17 Games and Probability		outcome probability sample space
17-1 Compound Events	compound event dependent events independent events	action
17-2 Sample Spaces		action outcome sample space
17-3 Counting Outcomes	counting principle	action event outcome sample space
17-4 Finding Theoretical Probabilities		theoretical probability
17-5 Simulation With Random Numbers		simulation
17-6 Finding Probabilities by Simulation		experimental probability simulation
17-7 Problem Solving		probability
Topic 17 Topic Review	compound event counting principle dependent events independent events	action event experimental probability outcome sample space simulation theoretical probability

Equivalent Ratios

CCSS: 7.RP.A.1: Compute unit rates associated with ratios of fractions, including ratios of lengths, areas and other quantities measured in like or different units.

Launch

© MP2, MP6

Your friend can't help but compare. During a game of stickball in the street, you notice him making all sorts of number comparisons. He asks for help making number comparisons on one building.

Name at least five number comparisons you can make by looking at the building.

Reflect Do you make number comparisons? Provide an example of a number comparison you've made and why you made it.

Got It?

PART 1 Got It

Write the ratio of the number of pins left standing to the number of pins knocked down in three different ways.

PART 2 Got It

Find a ratio equivalent to $\frac{12}{15}$ with lesser terms.

Got It?

PART 3 Got It (1 of 2)

A kitten weighs 12 oz. A puppy weighs 3 lb. Write the ratio of the kitten's weight to the puppy's weight as a fraction in simplest form.

PART 3 Got It (2 of 2)

Use the ratio of the kitten's weight to the puppy's weight. Describe the puppy's weight in terms of the kitten's weight.

Close and Check

Focus Question

MP4, MP6

What does it mean if two different ratios describe the same situation? How can being able to describe the situation in multiple ways help you to solve problems?

Do you know HOW?

1. Write the ratio of the number of bees to the number of flowers in three different ways.

☐ ☐ ☐

2. Find a ratio equivalent to $\frac{63}{77}$ with lower terms.

☐

3. A baby boy weighs 7 lb 8 oz. A five-year-old boy weighs 48 lb. Write the ratio of the baby's weight to the boy's weight as a fraction in simplest form.

☐

Do you UNDERSTAND?

4. Vocabulary How can the terms of a ratio be used to write an equivalent ratio?

5. Reasoning Two students each write a ratio comparing the two shapes in the group. Can both students be correct? Explain.

$\frac{6}{4}$ $\frac{2}{3}$

○ △ △ ○
○ △ ○ △ ○

Unit Rates

CCSS: 7.RP.A.1: Compute unit rates associated with ratios of fractions including ratios of lengths, areas and other quantities measured in like or different units.

Launch

© MP4, MP7

Three teams train turtles for the Third Annual Turtle Trot, a 30-foot race. If the turtles trot at their training pace, which turtle will win the race? By how many minutes? Explain your reasoning.

Team 1 Turtle
18 feet in 6 minutes

Team 2 Turtle
12 feet in 4 minutes

Team 3 Turtle
10 feet in 2 minutes

Reflect Could you have solved the problem without unit rates? Explain.

Got It?

PART 1 Got It

Find the unit rate for 219 heartbeats in 3 minutes.

$$\frac{73}{1}$$

PART 2 Got It

You also need to buy dye for the tie-dying activity. You can buy the dye in various sizes. Which is the best buy?

- 2 fl oz for $3.96 $= 1.98$
- 4 fl oz for $8.36 $= 2.09$
- 8 fl oz for $14.24 = 1.78$
- 16 fl oz for $28.96 = 1.56$

best buy = 1.56

PART 3 Got It

A satellite travels about 2,272 mi in 8 min. About how many miles does the satellite travel in 3 min?

Discuss with a classmate

Compare your answers to this problem.
Discuss what it means for an answer to be reasonable.
How can you apply what you know about checking an answer for reasonableness to the answers to this problem?

Close and Check

> ## Focus Question
> © MP1, MP7
>
> How can you identify a rate? How can unit rates help you to solve problems?
>
> _____
>
> _____
>
> _____
>
> _____

Do you know HOW?

1. The Earth rotates 1.25 degrees in 5 minutes. How many degrees does it rotate in 1 minute?

 [] degrees

2. A driver fills his tank with 15 gallons of gas for $45.60 at a gas station. The next time he stops he fills up with 12 gallons for $39.00. Find the unit price for gas at each station and circle which has the better deal.

 1st Station: []

 2nd Station: []

3. There are approximately 195 babies born each hour in the Philippines. Find the approximate number of babies born in the Philippines every 20 minutes.

 [] babies

Do you UNDERSTAND?

4. **Writing** A company earns a profit of $50 for every 10 items sold. Explain how the company can find the amount of profit for 50 items sold.

5. **Error Analysis** A classmate writes a rate for Exercise 1 to express the degrees rotated in 2 minutes. Explain her error and give the correct rate.

 $$\frac{1.25 \div 2}{5 \div 2} = \frac{0.625}{2.5}$$

This page intentionally left blank.

Ratios With Fractions

CCSS: 7.RP.A.1: Compute unit rates associated with ratios of fractions, including ratios of lengths, areas and other quantities measured in like or different units.

Launch

© MP2, MP8

How many pears must you place on Plate 3 so that the ratios of apples to pears are equivalent for all three plates?

Write the ratio of apples to pears for each plate. Explain your reasoning.

Plate 1

Plate 2

Plate 3

[] : []
apples to pears

[] : []
apples to pears

[] : []
apples to pears

Reflect Can you compare quantities that aren't in whole number units? Explain.

Got It?

PART 1 Got It

An athlete runs on a treadmill for $\frac{3}{4}$ h. The athlete then lifts weights for 2 h. Write the ratio of the running time to the weight-lifting time as a fraction in simplest form.

PART 2 Got It

Write the ratio $\dfrac{\frac{3}{4}\text{gal}}{\frac{9}{10}\text{gal}}$ in simplest form.

Got It?

PART 3 Got It

A model boat is $6\frac{1}{4}$ in. wide. The actual boat is $12\frac{1}{2}$ ft wide. What is the ratio of the width of the model boat to the width of the actual boat, in simplest form?

Close and Check

MP1, MP6

Focus Question

Previously you have written ratios as fractions. How can you write a ratio if at least one term is a fraction? How is this different from writing a ratio where both the terms are whole numbers?

Do you know **HOW?**

1. A bakery has $\frac{3}{4}$ dozen whole-grain muffins and 6 dozen mixed-berry muffins. Write the ratio of whole-grain muffins to mixed-berry muffins as a fraction in simplest form.

2. Write the ratio $\dfrac{\frac{6}{7}}{\frac{8}{9}}$ in simplest form.

3. A scale model of a van is $4\frac{1}{5}$ feet long. The actual van is $22\frac{2}{5}$ feet long. What is the ratio of the length of the model to the actual length of the van in simplest form?

Do you **UNDERSTAND?**

4. **Reasoning** Can any ratio be written as a unit rate? Explain.

5. **Error Analysis** A store sells 8 unscented candles for $2 or 9 scented candles for $3. A classmate writes the unit rates $\frac{4}{1}$ and $\frac{3}{1}$. She says one scented candle costs $3, and one unscented candle costs $4. Do you agree? Explain.

Unit Rates with Fractions

CCSS: 7.RP.A.1: Compute unit rates associated with ratios of fractions, including ratios of lengths, areas and other quantities measured in like or different units.

Launch

© MP3, MP4

Two clowns get a call as they race to the circus. Clown 2 pleads, "We're going 10 miles per half-hour. We can't go any faster." The caller replies, "You'd better double your speed or you'll never make it."

Show two different ways to write a speed that is twice as fast. Explain your reasoning.

10 miles per half-hour

Reflect Is reporting speed in miles per half hour useful? Is there a better way? Explain.

Got It?

PART 1 Got It (1 of 2)

Your dog eats $\frac{7}{8}$ lb of food in 4 meals. How much food does your dog eat per meal?

PART 1 Got It (2 of 2)

If your dog eats $\frac{7}{8}$ lb of food in 4 meals, how many meals will it take your dog to eat 1 lb of food?

Discuss with a classmate

Read the problem aloud. Discuss the units of measure in the problem and what they mean.

Then, use a graphic organizer, such as Know-Need-Plan, to manage all the units of measure in the problem.

Got It?

PART 2 Got It

You are planning to build a boat. You have a sample board of the wood that you want to use. The board has an area of $\frac{1}{3}$ ft² and weighs $\frac{1}{5}$ lb. What is the weight of the wood in pounds per square foot?

PART 3 Got It

You ran $3\frac{1}{2}$ mi in $\frac{3}{4}$ h. Your friend ran $1\frac{2}{5}$ mi in $\frac{1}{3}$ h. Which of you ran faster? Explain.

Close and Check

Focus Question

MP1, MP2

How can you write a unit rate if at least one term is a fraction? How is this different from writing a unit rate where both terms are whole numbers?

Do you know HOW?

1. A craft project requires $\frac{5}{6}$ yard of ribbon to make 4 refrigerator magnets. How many inches of ribbon are needed for each magnet?

 [] inches

2. If it takes $\frac{5}{6}$ yard of ribbon to make 4 magnets, how many complete magnets can be made with $\frac{2}{3}$ yard of ribbon?

 [] magnets

3. Machine A packs $4\frac{1}{4}$ cartons in $\frac{1}{5}$ hour. Machine B packs $4\frac{3}{5}$ cartons in $\frac{1}{4}$ hour. Which machine packs faster? How many cartons per hour can the faster machine pack?

 Machine: []

 Unit Rate:

Do you UNDERSTAND?

4. **Writing** How do you convert a rate to a unit rate?

5. **Error Analysis** An elevator has a floor area of 38 ft² and holds a load of 3,500 lb. The engineer writes this equation to find the number of pounds per square foot.

 $$\frac{\frac{3500}{1}}{\frac{38}{1}} = \frac{\frac{3500}{1} \cdot \frac{38}{1}}{1} = \frac{133,000}{1} \text{ lb/ft}^2$$

 Explain his error and write the correct pounds per square foot.

CCSS: 7.RP.A.1: Compute unit rates associated with ratios of fractions, including ratios of lengths, areas and other quantities measured in like or different units.

Launch

© MP1, MP4, MP7

Two nosy neighbors constantly try to outdo each other. Neighbor 1 mows her lawn in $1\frac{3}{4}$ hours. Neighbor 2 insists she's faster and she took $2\frac{1}{4}$ hours.

Who's correct? Show how you know.

Neighbor 1's Lawn
4,200 ft²

Neighbor 2's Lawn
5,400 ft²

Reflect How were unit rates useful in this problem? Explain.

Got It?

PART 1 Got It

The image on a digital camera's screen is $1\frac{1}{2}$ in. by 1 in. When the image is printed, it is $\frac{1}{2}$ ft by $\frac{1}{3}$ ft. What is the ratio of the area of the image on the camera's screen to the area of the print?

PART 2 Got It

You are parked $\frac{7}{8}$ mi from the football stadium. You walk at a constant speed of $3\frac{1}{4}$ mi/h. The game starts in 14 min. Will you make it to the stadium before the game starts? Explain.

Got It?

PART 3 Got It

The spice recipe calls for $\frac{1}{2}$ tsp of crushed red pepper flakes for every $1\frac{1}{4}$ tsp of black pepper. You use 3 tsp of crushed red pepper. How many teaspoons of black pepper do you need?

Close and Check

Focus Question

MP1, MP6

In this topic you have learned how to compare quantities other than whole numbers. Are some comparisons more helpful for solving problems than others?

Do you know HOW?

1. Your neighbor is replacing her old TV. The old TV screen is $14\frac{2}{5}$ in. tall by $21\frac{1}{2}$ in. wide. The new TV screen is $28\frac{4}{5}$ in. tall and 43 in. wide. What is the ratio of the area of the old TV screen to the area of the new TV screen?

2. A mountain bike race is two laps around a $25\frac{1}{2}$ mi course. Rider A completes the first lap in $1\frac{1}{4}$ hours and the second lap in $1\frac{1}{2}$ hours. Rider B completes both laps at a constant speed of 20 miles per hour. Which rider had the faster combined time for both laps?

3. A recipe for lemonade calls for a ratio of 1 part fresh lemon juice to 8 parts cold water. You have $\frac{2}{3}$ cup of lemon juice. How much water should you add?

Do you UNDERSTAND?

4. **Vocabulary** In one weekend, you earn $27 and your friend earns $35. Would a ratio or a unit rate be more helpful to compare the two amounts? Explain.

5. **Reasoning** An entertainment center for the new TV in Exercise 1 has an area of 1,548 ft². Explain how to find the ratio of the area of the entertainment center to the area of the TV. What is the unit ratio?

New Vocabulary: equivalent ratios, rate, ratio, terms of a ratio, unit price, unit rate
Review Vocabulary: greatest common factor, least common multiple, simplest form

Vocabulary Review

Identify two challenging vocabulary terms from this topic. Write one vocabulary term in the center oval, and fill in the surrounding boxes with details that will help you better understand the term.

Definition	Characteristics
Example	Nonexample

Definition	Characteristics
Example	Nonexample

Pull It All Together

TASK 1

Your neighbor's car uses $2\frac{1}{4}$ gallons of gasoline to travel 45 miles. Your neighbor is planning a trip of 243 miles. How many gallons of gasoline will your neighbor need for the trip if the car continues to use gasoline at the same rate?

TASK 2

Your neighbor needs $12\frac{3}{20}$ gal of gasoline for a trip of 243 mi. The car's tank holds $13\frac{1}{2}$ gal of gas.

a. Write the ratio of the number of gallons needed to the number of gallons the gas tank can hold as a fraction in simplest form.

b. If your neighbor needs to make this trip 10 times in a row, how many full tanks of gas will your neighbor need?

Proportional Relationships and Tables

Digital Resources

CCSS: **7.RP.A.2:** Recognize and represent proportional relationships **7.RP.A.2a:** Decide whether two quantities are in a proportional relationship, e.g., by testing for equivalent ratios in a table or graphing on a coordinate plane and observing whether the graph is a straight line through the origin.

Launch

© MP1, MP7

A company manufactures custom car paints. A manager receives orders for 25, 35, and 105 gallons of their Powerful Purple paint shade. The paint manager panics and says, "None of the orders match our mixing chart. How can we make these orders?"

Provide a solution for the panicked paint man.

Powerful Purple Mixing Guide

Gallons of Red Paint	Gallons of Blue Paint
2	3
4	6
20	30
40	60

Reflect How do you know if two ratios are equivalent?

Got It?

PART 1 Got It

The diagram shows a series of squares drawn on graph paper. The side length and area of each square are labeled.

Use the diagram to complete the table. Draw the next few squares as needed. Write all the ratios in simplest form.

Is the relationship between the side length and area of a square proportional? How do you know?

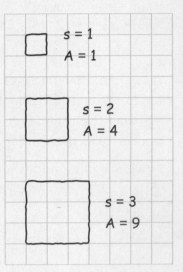

Side length	1	2	3		5	
Area	1			16		36
Ratio $\dfrac{\text{area}}{\text{side length}}$		$\dfrac{4}{2} = \dfrac{2}{1}$				

PART 2 Got It

Does the table show a proportional relationship between *x* and *y*? Explain.

x	y
5	1
3	15
2	$\dfrac{2}{5}$
$\dfrac{8}{5}$	8

Got It?

PART 3 Got It

Does the table show a proportional relationship between the number of heartbeats and time? Explain.

Resting Heart Rate

Time(s)	Heartbeats
4	6
6	9
10	15
12	18

Close and Check

Focus Question

 MP2, MP7

What does it mean for two quantities to have a proportional relationship? How can you tell if a table shows a proportional relationship between two quantities?

Do you know **HOW?**

1. The table shows a proportional relationship between the number of teachers and the number of students. Complete the table.

Teachers	3	5		10
Students		75	120	
Ratio students/ teachers				

2. Tell whether the relationship between *x* and *y* shown in the table is *proportional* or *not proportional*.

x	1	2	3	4
y	0	6	12	18

[]

3. Circle the ratios that are proportional to $\frac{27}{9}$.

$\frac{9}{3}$ $\frac{36}{4}$ $\frac{3}{1}$

$\frac{6}{2}$ $\frac{54}{18}$ $\frac{1}{9}$

Do you **UNDERSTAND?**

4. Writing Explain how you determined the proportional ratios in Exercise 3.

5. Writing Give a real-world example of when you might use proportional relationships. Explain why it is proportional.

Proportional Relationships and Graphs

CCSS: 7.RP.A.2a: Decide whether two quantities are in a proportional relationship, e.g., ... graphing on a coordinate plane and observing whether the graph is a straight line through the origin. Also, 7.RP.A.2c.

Digital Resources

Launch

© MP2, MP4

The manager of the car paint company prepares orders for its Granny Apple Green paint.

Tell how the graph can help you find the amounts of blue and yellow paint needed to make 8 gallons, 24 gallons, and 56 gallons of Granny Apple Green paint.

Granny Apple Green Mixing Graph

Reflect Do you think a graph or a table makes it easier for the company to find the correct mix of blue and yellow paint to make Granny Apple Green?

Got It?

PART 1 Got It (1 of 2)

Does the graph show a proportional relationship between *x* and *y*? Explain.

PART 1 Got It (2 of 2)

Does the graph show a proportional relationship between *x* and *y*? Explain.

Got It?

PART 2 Got It

> Does the equation $y = 4x + 1$ show a proportional relationship between x and y? Explain.

PART 3 Got It

> The graph shows a proportional relationship between the amounts of nuts and dried fruit in a trail mix. You want to know how many pounds of dried fruit there are per pound of nuts. What point represents this unit rate?

Trail Mix

Close and Check

Focus Question

How can you tell if a graph shows a proportional relationship between two quantities?

Do you know HOW?

1. The relationship between time x and distance y can be represented by the equation $y = 2x$. Complete the table and graph.

$y = 2x$

x	y
0	
1	
2	
3	
4	
5	

2. What is the distance when time is equal to 15?

 [] units

3. What is the unit rate of the graph?

 []

Do you UNDERSTAND?

4. **Writing** Does the graph in Exercise 1 represent a proportional relationship? Explain how you know.

5. **Reasoning** Do all linear graphs represent proportional relationships? Explain.

6. **Error Analysis** A classmate says that not all proportional relationships are linear. Do you agree? Explain.

Constant of Proportionality

Digital Resources

CCSS: **7.RP.A.2:** Recognize and represent proportional relationships between quantities. **7.RP.A.2b:** Identify the constant of proportionality (unit rate) in tables, graphs, equations, diagrams, and verbal descriptions of proportional relationships. Also, **7.NS.A.2d.**

Launch

© MP3, MP6

The car paint company provides a perplexing pay graph for new managers.

What does the graph show? Which point—*A*, *B*, or *C*—might be the most useful? Explain.

Manager Pay Graph

What the Graph Shows:

Which Point Might Be Most Useful:

Reflect Which point may be the least useful? Explain.

Got It?

PART 1 Got It

Each shoebox is the same height. The height of the display depends on the number of shoeboxes in one column of shoeboxes. What is the constant of proportionality for this situation?

45 in.

PART 2 Got It

You run on a treadmill daily at a constant speed. On Monday, you ran 2.25 mi in 22.5 min. On Tuesday, you ran 2.35 mi in 25 min. Are the constants of proportionality the same for the two days? How do you know?

Got It?

PART 3 Got It

The table shows the time it takes to pump gasoline based on the number of gallons pumped. What is the constant of proportionality for this situation?

Pump Rate

Gasoline (gal)	Time (s)
17	136
12	96
10.5	84
9.25	74

PART 4 Got It

The graph shows the distance a cyclist traveled based on time. What is the constant of proportionality for this situation?

Distance Traveled

Close and Check

Focus Question

MP1, MP4

What is a constant of proportionality? What does the constant of proportionality tell you?

Do you know HOW?

1. Each bus carries 24 passengers. The number of buses needed for a field trip depends on the number of students going on the trip. What is the constant of proportionality for this situation?

 [] per []

2. Your class collects cans for a local food bank. On Monday, 7 students collect 63 cans. Using the constant of proportionality, find the number of students who collect 90 cans on Tuesday.

 [] students

3. The table shows the number of concert tickets sold based on the number of hours the tickets are available. What is the constant of proportionality for this situation?

 Ticket Sales

Time (hr)	Tickets
3	240
5	400
9	720
15	1200

 []

Do you UNDERSTAND?

4. **Writing** Which variable in Exercise 3 represents the independent variable and which represents the dependent variable? Explain.

5. **Reasoning** How can you use the relationship between the independent and dependent variables to write a unit rate?

Proportional Relationships and Equations

CCSS: 7.RP.A.2: Recognize and represent proportional relationships between quantities. 7.RP.A.2b: Identify the constant of proportionality (unit rate) in … equations … of proportional relationships.
7.RP.A.2c: Represent proportional relationships by equations … .

Launch

© MP6, MP7

The paint company manager grows tired of answering a particular pay question from employees. He mulls over two equations to help the employees.

What question could employees keep asking? Which equation would help them? Explain.

Reflect If you could have had one more piece of information before starting to answer the problem, what would it be and why?

Got It?

PART 1 Got It

The equation $P = 4s$ represents the perimeter P of a square with side length s. What is the constant of proportionality? What is the perimeter of a square with side length 1.6 m?

PART 2 Got It

You paid $2.50 for 5 apples. Write an equation to represent the total cost y of buying x apples.

PART 3 Got It

You have returned from your trip with euros left over. Use the table to write an equation you can use to find about how many U.S. dollars y you will receive in exchange for x euros.

Currency Exchange

U.S. Dollars($)	Euros(€)
50	37.50
100	75
120	90
175	131.25

Discuss with a classmate

What does currency exchange mean? Have you ever traveled to a place where the currency was not the U.S. dollar?

Got It?

The ratio of defensive players to the total number of players in a different soccer league is about 9 to 30. If the league has 890 players, about how many defensive players are in the league?

Explain how you can solve the proportion $\frac{19}{x} = \frac{152}{4}$ for x.

Close and Check

Focus Question

 MP2, MP6

How can you tell if an equation shows a proportional relationship between two quantities? How can you identify the constant of proportionality in an equation that represents a proportional relationship?

Do you know HOW?

1. The equation $q = 12c$ represents the quantity q of t-shirts in any number of cartons c.

 a. What is the constant of proportionality?

 ☐

 b. How many shirts are in 8 cartons?

 ☐ shirts

2. A car manufacturer completes 81 cars every 180 seconds. Write an equation to represent the total number of cars y for x seconds of production.

 ☐

3. Use the table to write an equation to find how much money y is received for x ounces of silver on the open market.

Silver Exchange Rate			
Silver (oz)	5	9	12
Price ($)	151.35	272.43	363.24

 ☐

Do you UNDERSTAND?

4. **Writing** Can setting up a proportion help you find the constant of proportionality in a relationship? Explain.

5. **Error Analysis** Assume 130 out of 150 students buy lunch each day. There are 180 school days in a year. A classmate writes an equation to find how many lunches will be sold in one school year. Is he correct? Explain.

 $$\frac{130}{150} = \frac{x}{180}$$

Digital Resources

CCSS: 7.G.A.1: Solve problems involving scale drawings of geometric figures, including computing actual lengths and areas from a scale drawing and reproducing a scale drawing at a different scale.

Launch

© MP2, MP3

A peculiar professor wants a perfectly proportioned poster of a photo of her pet paper cup. She brings the 4-inch by 6-inch photo to your store and says the poster must be at least three feet tall.

Identify the side lengths of two possible posters.

4 in.

6 in.

Reflect What will the pet paper cup look like if the poster is not proportional to the photo? Explain.

Got It?

PART 1 Got It

What is the actual distance between Jacksonville and Orlando?

Discuss with a classmate

Maps contain lots of information.
Choose a piece of information provided on the map for this problem.
Explain what that piece of information tells you.
What pieces of information on the map were NOT needed to find the distance between Jacksonville and Orlando?

PART 2 Got It (1 of 2)

A state's driver's manual shows a scale drawing in the shape of a rectangular parking sign. The scale used is 1 in. : 0.5 ft. What is the area of the actual sign?

Got It?

PART 2 Got It (2 of 2)

A tennis court is 36 ft wide. A scale drawing of the court is $2\frac{1}{4}$ in. wide and $5\frac{1}{16}$ in. long. What was the scale used to make the scale drawing? Explain.

PART 3 Got It (1 of 2)

You are planning a neighborhood. The rectangle shown is a scale drawing of the roof of a rectangular building. You used a scale of 2 in. = 75 ft. What would be the dimensions of the roof in your drawing if you used a scale of 1 in. = 100 ft instead?

6 in.

8 in.

PART 3 Got It (2 of 2)

Consider two scale drawing of the same object. The drawings have scales of 1: 2 and 1: 3. Which drawing is larger? Explain.

Close and Check

Focus Question

MP4, MP7

How can you use proportional relationships to solve problems that involve maps and scale drawings?

Do you know HOW?

1. A replica of a popular car is built to a scale of 1 in. : 24 in. The length of the replica car is 5.6 inches. What is the length, in inches, of the actual car?

 []

2. The official ratio of length to width of the U. S. flag is 1.9 : 1. If the width of a flag is 3 ft, what is the area of the flag?

 []

3. A company designs a billboard to advertise their grand opening. They used a scale of 1 in. : 10 ft. What would be the dimensions of the billboard in the drawing if they use a scale of 2 in. : 25 ft instead?

 10 in.

   ```
   ┌──────────────┐
   │              │
   │              │  8 in.
   │              │
   └──────────────┘
   ```

 []

Do you UNDERSTAND?

4. **Writing** Can understanding scale drawings help you make decisions? Explain.

5. **Compare and Contrast** How are scale and ratio related?

CCSS: 7.G.A.1: Solve problems involving scale drawings of geometric figures, including computing actual lengths and areas from a scale drawing and reproducing a scale drawing at a different scale. Also, **7.RP.A.2, 7.RP.A.2a, 7.RP.A.2b, 7.RP.A.2c,** and **7.RP.A.2d.**

Launch

© MP6, MP7

The peculiar professor plans a room addition for her pet paper cup and poster. The scale of the model is 1 in. = 3 ft.

Draw a net for the walls and ceiling of the room on the inch grid. Label the dimensions.

9 ft

9 ft

12 ft

Reflect Is the ratio of the length to the width of the ceiling in the actual room the same as the ratio of the length to the width of the ceiling in the scale drawing? Explain.

Got It?

PART 1 Got It

Does the situation describe a proportional relationship?
A map is drawn using a scale of 1 in. = 75 mi.

PART 2 Got It

In the apartment, the walls are 9 ft high. You want to put a double coat of paint on the longest wall of the living room. A gallon of paint covers 350 ft². Will 1 gal of paint be enough? Explain.

Scale 1 in. : 10 ft

Got It?

PART 3 Got It

You and your friend are each drawing a map of your neighborhood. The graph shows the scale that you used. Your friend's scale is represented by the equation $y = \frac{1}{12}x$, where $x =$ the actual distance in feet and $y =$ the distance on the scale drawing.

Your driveway is 180 feet long. On which map will the driveway be longer? And by how much?

Your Scale

Actual Distance (ft): 0, 10, 20, 30, 40, 50

Map Distance (in.): 0, 1, 2, 3, 4, 5

Close and Check

Focus Question

MP1, MP4

In this topic you have studied different ways to represent proportional relationships. In what ways can you represent proportional relationships? How can knowing how to represent proportional relationships in different ways be useful in solving problems?

Do you know HOW?

1. Circle the situation(s) that describes proportional relationships.

 A. The number of roller coaster riders is 12 more than the number of seats.

 B. There are 2 pieces of pizza for every friend.

 C. There are 3 times as many books as there are children.

2. An office is drawn to a scale of 3 in. : 10 ft. The drawing measures 4.5 in. by 7.5 in. How many square feet of carpet are needed to carpet the office?

3. The Statue of Liberty is 151 ft tall from the base to the top of the torch. You make a scale drawing of the monument using a scale of 1 in. : 20 ft. Your friend uses a scale of 1 in. : 25 ft.

 a. Whose drawing is larger?

 b. How much larger?

Do you UNDERSTAND?

4. **Writing** Explain how you decided which relationships were proportional in Exercise 1 and which ones were not.

5. **Reasoning** The scale drawing in Exercise 2 is redrawn to a scale of 4 in. : 9 ft. Is this second drawing larger or smaller than the first? Explain.

New Vocabulary: constant of proportionality, proportion, proportional relationship, scale, scale drawing
Review Vocabulary: equivalent ratios

Vocabulary Review

Identify two challenging vocabulary terms from this topic. Write one vocabulary term in the center oval, and fill in the surrounding boxes with details that will help you better understand the term.

Definition

Characteristics

Example

Nonexample

Definition

Characteristics

Example

Nonexample

Pull It All Together

TASK 1

Can you use the information below to find how much a person who weighs 102 lb on Earth would weigh on the moon? Explain.

Earth: 174 lb
Moon: 29 lb

Earth: 126 lb
Moon: 21 lb

Earth: 249 lb
Moon: 41.5 lb

Your teacher asks you to write an equation to represent the relationship between the weight on the moon and the weight on Earth. One of your friends writes the equation $y = \frac{1}{6}x$. Your other friend writes the equation $y = 6x$. How can both of your friends be correct?

TASK 2

A building is drawn with a scale of 1 in. : 3 ft. The height of the drawing is 1 ft 2 in. After a design change, the scale is modified to be 1 in. : 4 ft. What is the height of the new drawing?

The Percent Equation

Digital Resources

CCSS: **7.RP.A.2b:** Identify the constant of proportionality (unit rate) in tables, graphs, equations, diagrams, and verbal descriptions of proportional relationships. **7.RP.A.2c:** Represent proportional relationships by equations Also, **7.RP.A.2.**

Launch

MP3, MP4

A down-in-the-dumps drummer scours the internet for a new kit to improve his mood and swing. Based on buyers' reviews, which kit should he get? Show how you decided.

**Kit 1: 9 of 13
buyers love this kit!**

**Kit 2: 15 of 21
buyers love this kit!**

Reflect Do you like the method of showing buyers' reviews (e.g., 9 of 13)? Explain.

Got It?

PART 1 Got It

Is the question "190 is 10% of what number?" looking for the *part*, the *percent*, or the *whole*?

PART 2 Got It

Which of the following is/are true?

I. 7 is 50% of 14.
II. 28 is 14% of 200.
III. 6 is 40% of 14.
IV. 40% of 35 is 14.

PART 3 Got It

Suppose your friend has given you a gift certificate for a haircut. After the haircut, you want to leave an appropriate tip for the hairdresser. The receptionist says you should leave exactly $3 if you want to tip 20% of the price of the haircut. What was the price of the haircut?

Discuss with a classmate

What are gift certificates and how do they work?
What are tips and how do they work?

Close and Check

Focus Question

MP1, MP4

How do percents and the percent equation help describe things in the real world?

Do you know HOW?

1. Is the question "What percent of 8 is 5?" looking for the *part*, the *percent*, or the *whole*?

 []

2. Read each statement. Write **T** if it is true or **F** if it is false.

 [] 9 is 15% of 60.

 [] 12% of 120 is 10.

 [] 32 is 40% of 80.

 [] 90% of 180 is 162.

3. A shoe store is having a closeout sale. All the prices are 80% of the original price. The shoes you want originally cost $40. Find the sale price of the shoes.

 []

Do you UNDERSTAND?

4. **Writing** The total bill at a restaurant equals $65.38. The waiter typically receives a tip equal to 15% of the total bill. He is given a $13 tip. Should he be happy with the amount of the tip? Explain.

5. **Vocabulary** Explain how to solve "72 is 18% of what number?" by using the terms *part*, *percent*, and *whole*.

This page intentionally left blank.

Using the Percent Equation

CCSS: 7.RP.A.2: Recognize and represent proportional relationships between quantities. **7.RP.A.3:** Use proportional relationships to solve ... percent problems. Examples: ... tax, gratuities and commissions

Launch

© MP3, MP4

A movie studio sets two offers in front of a movie star to act in a blockbuster upcoming action flick. The star can choose only one offer.

Make a case for accepting each offer. Then explain which offer you would choose.

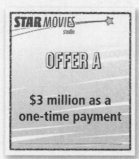

Reflect Which offer has a constant of proportionality? Explain.

Got It?

PART 1 Got It

Tips are calculated similarly to taxes. Suppose the team brought a total of $175 to pay for dinner. Do they have enough money to tip the waiter 18% of the subtotal? Explain.

The Diner

Hamburger (4)	$34.58
Spaghetti (5)	$40.09
Fries (4)	$17.00
Caesar Salad (2)	$16.57
Milkshake (11)	$33.76
Subtotal	$142.00
Meals Tax (5%)	$7.10
TOTAL	$149.10

Thank You!
Please Come Again 00310

Got It?

PART 2 Got It (1 of 2)

At a real estate agency, a real estate agent sold a house for $345,000. Her commission rate is 3%.

a. How much did the real estate agent earn on the house?

b. How much did the seller make on the house?

PART 2 Got It (2 of 2)

Suppose you are a car salesperson. Would you prefer to make a 6% commission on each car you sell, or would you prefer to get a flat fee of $1,500 per car? Explain.

Got It?

PART 3 Got It (1 of 2)

Jon has a new job at an electronics store. He has two options for how to be paid.

He plans to work 7 hours a day, 5 days a week. He also estimates that he can sell about $3,500 worth of electronics per week. Which option would give Jon more earnings per week? Explain.

Option A
Hourly wage of $16.00

Option B
16% commission on total sales

PART 3 Got It (2 of 2)

If you were Jon, which option would you choose if they both generate the same weekly pay based on his estimated work hours and sales predictions?

Option A
Hourly wage of $16.00

Option B
16% commission on total sales

Close and Check

> **Focus Question**
>
> In what situations are fixed numbers better than percents of an amount? In what situations are percents better than fixed numbers?
>
> _____
>
> _____
>
> _____
>
> _____

▶ Do you know **HOW?**

1. You pay $3.50 per gallon including taxes for 15 gallons of gas. Federal and state gas taxes make up 14% of the total cost. How much do you pay in gas taxes?

2. A new car depreciates (loses value) by 9% immediately after it is purchased and driven from the lot. If a new car costs $28,400, how much is it worth right after it is driven off the car lot?

3. A company expects a new sales employee to work 40 hours per week. The company offers the employee either $25 per hour or a salary of $500 per week plus a 7% sales commission. Each sales employee averages $7,800 in sales each week. Which offer pays more?

▶ Do you **UNDERSTAND?**

4. **Error Analysis** A basketball player made 88% of 125 free throw attempts. Your friend calculates how many free throws the player made below. Explain her error and find the correct number.

 total = 88% · 125
 = 88.0 · 125
 = 11,000

5. **Writing** Your uncle offers to sell your guitar at his auction. He offers you $75 or 50% of the final selling price. How would you choose? Explain.

This page intentionally left blank.

Simple Interest

CCSS: 7.RP.A.2: Recognize and represent proportional relationships between quantities. **7.RP.A.3:** Use proportional relationships to solve multistep ... percent problems. Examples: simple interest

Launch

© MP1, MP4

Two banks offer different incentives to make a deposit at their bank.
Bank A offers a $10 gift card for making a minimum initial deposit.
Bank B offers cash back equal to 2% of your deposit at the end of the year.

Tell which line represents each bank's offer. Explain your reasoning.

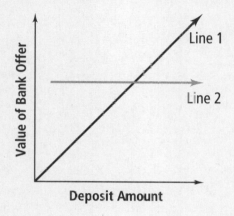

Reflect What would you need to know to decide which offer to choose? Explain.

Got It?

PART 1 Got It (1 of 2)

Suppose you deposit $500 in a bank account that earns simple interest at 1.2% per year. You keep it in the bank for two years. Which of the following is/are true?

I. $I = 12$ II. $p = 1.2\%$

III. $r = 500$ IV. $t = 2$

PART 1 Got It (2 of 2)

How does the formula for simple interest after one year relate to the percent equation?

Got It?

PART 2 Got It

A new bank customer with $5,000 to deposit looks at the manager's poster. The customer wants to open a CD to earn money for his retirement. If he wants to have $5,500 in the CD, how long does he need to keep the account?

	If you deposit $2,500 at 3.5% annual interest...	
Time (years)	**Simple Interest Earned**	**New Account Balance**
0	$0.00	$2,500.00
1	$87.50	$2,587.50
2	$175.00	$2,675.00
3	$262.50	$2,762.50
4	$350.00	$2,850.00

Discuss with a classmate

Choose a row from the table.
Explain what the entries in Columns 1, 2, and 3 mean for the row that you selected.
Take turns until you have reviewed all the rows in the table.

Got It?

After 16 months, does Mia still have the higher balance? Explain.

Name on Account: Alex
Principal: $2,950
Annual interest rate: 4%

Name on Account: Mia
Principal: $3,000
Annual interest rate: 2.5%

Got It?

Suppose your friend has earned $5.51 in interest after 9 months. If the annual interest rate is 3%, how much is the principal in the account? Round to the nearest dollar.

Close and Check

► Focus Question

Why is simple interest called "simple"? When would you use simple interest?

► Do you know **HOW?**

1. U.S. savings bonds pay 1.4% interest. You purchase $750 in savings bonds and hold them for $2\frac{1}{2}$ years. Circle the true statement(s).

 A. $I = 1.4\%$

 B. $p = 750$

 C. $r = 26.25$

 D. $t = 2.5$

2. You buy $2,500 of savings bonds at 1.7% interest. How many years will it take for your investment to equal $3,000? Round your answer to the nearest whole year.

3. Suppose after 15 months you earn $74.80 in interest on an investment that earns 1.6% interest. What was your principal investment?

► Do you **UNDERSTAND?**

4. **Reasoning** You and your friend both have savings accounts that pay 3.5% interest. Do you both earn the same amount of money in interest? Explain how you know.

5. **Error Analysis** Your friend says she has $75 in her savings account that pays 3.5% interest. She finds the amount of interest earned in one year. Is she correct? Explain.

 $I = 75 \cdot 3.5 \cdot 1$
 $I = 262.50$

Compound Interest

CCSS: 7.NS.A.3: Solve real-world and mathematical problems involving the four operations with rational numbers.

Launch

© MP1, MP3

A bank manager shows your friend a graph of different types of interest the bank can pay on her $100 deposit. The manager advises your friend to opt for 2% simple interest "because it's easy to compute and a good rate."

Tell which line represents simple interest. Explain whether your friend should listen to the bank manager.

Reflect What makes simple interest simple? How is the other interest line different? Explain.

Got It?

PART 1 Got It (1 of 2)

Make a table and find the balance after two years.
principal = $500
annual interest rate = 3%, compounded annually

PART 1 Got It (2 of 2)

Which account balance grows faster, an account that earns simple interest or an account that earns compound interest? Explain.

Got It?

PART 2 Got It

A graduate student has kept money in a savings account since middle school. After 12 years earning 4% annual interest compounded once a year, the account balance is $2,560. What was his original deposit to the nearest ten dollars?

PART 3 Got It (1 of 2)

Suppose you used a credit card to purchase a bicycle. If there are no additional late fees, how much would you owe after a year of not paying off the balance? Round to the nearest dollar.

Your Credit Card This Month

Bicycle..................................... $150
Balance.................... $150
Annual interest rate: 30%
Compound monthly

No late fees for a year!

Got It?

In the first Got It, you found the interest compounded monthly for a year. If the interest had been compounded annually instead, how much more or less would you owe after not paying off the balance for a year?

Your Credit Card This Month

Bicycle.. $150

Balance................... $150

Annual interest rate: 30%

Compound monthly

No late fees for a year!

Close and Check

© MP2, MP6

▶ Focus Question

How is compound interest different from simple interest? When do you use each kind?

▶ Do you know HOW?

1. You invest $750 in an account that earns 4.5%, compounded annually. Find the balance of the account after 2 years. Round your answer to the nearest cent.

2. A 10-year investment at 3.5%, compounded annually, totals $4,250. Find the amount of the original deposit to the nearest cent.

3. You qualify for a 5-year loan of $2,000. The interest rate is 9.5% with no late fees. How much more or less would you owe if interest is compounded quarterly rather than compounded annually?

▶ Do you UNDERSTAND?

4. **Writing** Explain how you can use what you have learned about compound interest to develop a savings or investment plan.

5. **Error Analysis** Your friend can get a 3-year car loan for $3,700 at 7.5% annual interest compounded quarterly. Explain the error she makes in calculating the amount of interest.

$$B = 3,700(1 + 0.01875)^4$$
$$= 3,985.40$$
$$I = 3,985.40 - 3,700$$
$$= 285.40$$

This page intentionally left blank.

3-5

Percent Increase and Decrease

Digital Resources

CCSS: **7.RP.A.2:** Recognize and represent proportional relationships between quantities. **7.RP.A.3:** Use proportional relationships to solve multistep ... percent problems. Examples ... percent increase and decrease

Launch

MP2, MP6

Two friends argue about which of their little town's populations grew the most between 2000 and 2009.

Write an argument to support each friend's point of view. Explain your reasoning.

Friend A

Friend B

U.S. Census Bureau Data

Population data	Little Falls, MN	Little Falls, WI
2009 population	8,067	1,540
2000 population	7,719	1,334

Reflect Which do you think tells more about the growth of a town — percent increase in population or increase in number of people? Explain.

Got It?

A pet frog measures 51 mm in body length while sitting. Its body length extends to 89 mm while jumping. Find the approximate percent increase in body length of the frog from sitting to jumping.

51 mm

89 mm

What does it mean for a quantity to increase by 100%? Explain.

Got It?

PART 2 Got It

Every 10 years, the U.S. government takes a census, or survey, of the population. One possible result of changes in population is that the number of U.S. representatives for a state may change. Find the approximate percent decrease in the number of representatives for Michigan.

Number of House Representatives for Michigan

In 2000	In 2010
15 representatives	14 representatives

PART 3 Got It

Estimate the percent of change.

$130 $100

Close and Check

Focus Question

How can you use a percent to represent change?

Do you know HOW?

1. The banded ribbon worm is a carnivorous aquatic worm. It measures about 2.5 ft when contracted and up to 25 ft when expanded. Find the percent increase between the contracted and expanded length of a banded ribbon worm.

2. The oceans' tide levels vary based on the phases of the moon. Find the percent decrease in tide levels when high tide is 4.25 ft and low tide is 0.75 ft above sea level.

3. The national debt in 2000 was about $5.7 trillion. In 2010, the national debt had risen to about $13.6 trillion. Find the approximate percent of change in the national debt during that ten-year period.

Do you UNDERSTAND?

4. **Reasoning** Explain how you know whether a percent of change is a percent increase or a percent decrease.

5. **Writing** Give a real-world example of when it might be useful to calculate a percent of change. Would you expect the percent of change to be a percent increase or a percent decrease?

3-6 Markups and Markdowns

CCSS: 7.RP.A.3: Use proportional relationships to solve multistep … percent problems. Examples: … markups and markdowns … .

Launch

A sporting goods store holds a storewide clearance sale. You comb the ads for boxing items.

Order the ads from best deal to worst deal. Explain your reasoning.

MP1, MP4

Now $32!
Was $40

Now $20!
Was $25

Now $44!
Was $55

Reflect Should you always choose the item with the greatest change in price when shopping? Explain.

Got It?

PART 1 Got It (1 of 2)

Airlines usually increase the price of their plane tickets as the day of the flight gets closer. What is the percent markup for the plane ticket below?

Base cost: $310
Selling price: $550

PART 1 Got It (2 of 2)

Concert halls change the price for concert tickets depending on the performer. What is the selling price for the concert ticket below?

Base cost: $20
Percent markup: 90%

Got It?

PART 2 Got It

Each month at an electronics store, new televisions come in. The store manager puts older televisions on sale. What is the percent markdown on the television below?

Selling Price: $250
Sale Price: $200

PART 3 Got It

Relax Yoga Store negotiates to buy even more yoga mats from their seller if he can give them 35% off the original $15. If the seller gets the mats for $8.50, would he still make a profit on each mat with this deal? If so, how much of a profit?

Close and Check

Focus Question

When are percent markups and percent markdowns used? How are they similar? How are they different?

Do you know HOW?

1. A car dealership pays $26,215 for a new car. They sell the car for $28,265. Find the percent markup on the car.

2. A computer is purchased by a store for $756 and offered to the customer for $1,200. At the end of the year, the store discounts the computer for quick sale. Find the greatest percent markdown possible without losing money.

3. Gaming Unlimited buys a gaming system for $249. It sells the system for $385. This week the system is on sale for 30% off. Find the amount of profit made on each gaming system sold.

Do you UNDERSTAND?

4. **Reasoning** Does a seller make a profit if the percent markdown on an item is equal to the percent markup? Explain using an example.

5. **Vocabulary** A $70 jacket is marked down to $52.50. Your friend says the markdown is 25%. You say the markdown is $17.50. Explain how both of you can be correct.

3-7

Problem Solving

Digital Resources

CCSS: 7.RP.A.3: Use proportional relationships to solve multistep ... percent problems. Examples: simple interest, tax, markups and markdowns, gratuities and commissions, fees, percent increase and decrease

Launch

© MP2, MP6

Two friends agree to pay half each for their mostly excellent meatloaf dinner and most excellent 20% tip. Each friend has $8.50.

Do they have enough money to complete their excellent plan? If so, by how much? If not, tell what they should do.

Meatloaf House	
Meatloaf Dinner	$5.50
Meatloaf Dinner	$5.50
Soda	$1.00
Soda	$1.00
Subtotal	$13.00
Tax	$1.30
Total	$14.30

Reflect How do you use percents in your life outside of school? Provide one example.

Got It?

PART 1 Got It

You bought three airplane tickets. Each ticket cost $110. If you paid a total of $353.10 including a processing fee, what is the fee as a percent rate?

PART 2 Got It (1 of 2)

The number 100 is increased by 100%.
The result is then decreased by 50%.
What is the final number?

The final number is 150 because the percent increase gives you 200 and then the percent decrease gives you 150.

Is Kit correct? Explain.

Got It?

PART 2 Got It (2 of 2)

Some stores consider percent markup as the percent of change based on selling price, not based on the original cost. Why do you think stores use this formula instead?

$$\text{percent markup} = \frac{\text{markup}}{\text{cost}}$$

$$\text{percent markup (in stores)} = \frac{\text{markup}}{\text{selling price}}$$

PART 3 Got It

After buying a board, you have $13 left. You decide to buy a surfboard leash, which prevents the surfboard from floating away from the surfer. Which leash(es) can you afford to buy after a 6.25% sales tax?

Leash A: Selling price $14.99; → Sale $\frac{1}{5}$ off!
Leash B: Selling price $17.99; → Our price 30% off!

Close and Check

Focus Question

MP1, MP3

How do percents help you compare, predict, and make decisions?

Do you know **HOW?**

1. You and 3 friends combine a snowboard purchase to save on shipping fees. Each board costs $82.50 after tax. The total bill is $392.70. Express the shipping fee as a percent rate to the nearest whole percent.

 []

2. The number 450 is increased by 75%. The result is then decreased by 90%. What is the final number?

 []

3. You receive a $50 gift card to your favorite store. If sales tax is 7.5%, what is the greatest amount you can spend without using any additional money?

 []

Do you **UNDERSTAND?**

4. **Writing** A researcher finds that 11 out of 15 people work within 30 miles of their home. He says 73% of people work within 30 miles of their home. Which statement do you find more useful? Explain.

5. **Reasoning** A bookstore special-orders books for a fee of $1.50 per book. Online orders have a shipping charge of 10% of the total order. If 5 books cost $70.96, which is the better offer?

New Vocabulary: balance, compound interest, interest, interest period, interest rate, markdown, markup, percent decrease, percent equation, percent increase, percent of change, principal, simple interest

Review Vocabulary: percent, ratio

Vocabulary Review

Identify two challenging vocabulary terms from this topic. Write one vocabulary term in the center oval, and fill in the surrounding boxes with details that will help you better understand the term.

Pull It All Together

TASK 1

A cell phone manufacturer is updating one of its phones. The current phone has a display size of 3.5 inches and weighs 5 ounces. The manufacturer increases the display size of the current phone by 20%. The manufacturer also decreases the weight of the cell phone to 4.4 ounces.

What is the display size of the updated cell phone? What is the percent decrease in the cell phone's weight?

TASK 2

The manufacturer charged the cell phone store $35 per phone.
The store is charging $75 per phone. What was the percent markup?

The store charges $75 per phone. The sale allows customers to purchase the phone for 25% off. If a salesperson earns 20% commission for each phone he or she sells, how much will a salesperson earn for selling 6 phones on sale?

Rational Numbers, Opposites, and Absolute Value

CCSS: 7.NS.A.1: Apply and extend previous understandings of addition and subtraction
7.NS.A.1a: Describe situations in which opposite quantities combine to make 0.

Digital Resources

Launch

© MP3, MP6

Why do we need −1? Couldn't we just count forward from 0 by ones and use those numbers?

On this number line, write −1 and two other missing numbers you think we need. For each number you place provide an example of why it's needed.

Why we need −1	Why we need	Why we need

Reflect Are all numbers either positive or negative?

Got It?

PART 1 Got It (1 of 2)

To which sets of numbers does $-1\frac{3}{5}$ belong?

I. Whole numbers

II. Integers

III. Rational numbers

PART 1 Got It (2 of 2)

One of your friends says the number $\frac{4}{4}$ belongs only in the category *Rational Numbers*. Another friend says it belongs in each category: *Whole Numbers*, *Integers*, and *Rational Numbers*. Who is correct? Explain.

Discuss with a classmate

Read each other's explanation to the problem.

Check for the following:

Is the explanation clear?

Are the key words, such as rational number, used correctly in the explanation? If not, discuss how to improve the explanation.

Got It?

PART 2 Got It

Which list of numbers is in order from least to greatest?

I. $\left|\frac{1}{2}\right|, \left|\frac{3}{4}\right|, |-3|$

II. $|-1|, |-0.8|, \left|\frac{1}{5}\right|$

PART 3 Got It

Write a positive or negative number to represent the change described in the situation. Describe the opposite change in words and with a number.

Situations and Their Opposites

	Words	Number
Situation	You win 50 tokens at the arcade.	
Opposite		

Close and Check

Focus Question

© MP5, MP6

When is it helpful to use a number's opposite?

Do you know HOW?

1. Circle the set(s) of numbers to which $4\frac{2}{7}$ belongs.

A. Whole numbers

B. Integers

C. Rational numbers

2. List the values in order from least to greatest.

$$\left|-\frac{4}{5}\right|, |0.5|, |-2|, |1|$$

3. Write a positive or negative number to represent the change described in the situation. Describe the opposite change in words and with a number.

	Words	Number
Situation	You spend $37 at the mall.	
Opposite		

Do you UNDERSTAND?

4. Vocabulary Is zero a rational number? Explain.

5. Reasoning How many rational numbers are there between −10 and 10? Explain.

Adding Integers

Digital Resources

CCSS: 7.NS.A.1b: Understand $p - q$ as the number located a distance $|q|$ from p, in the positive or negative direction Show that a number and its opposite have a sum of 0 Interpret sums of rational numbers by describing real-world contexts. Also, **7.NS.A.1.**

Launch

© MP1, MP4

Two rounds remain in a friendly video game of Zombie Pretzel Attack 2! Each zombie pretzel cheesed scores 100 points. Each player cheeses three zombie pretzels.

Write each player's new score. Tell how you found each score.

Player	Current Score	New Score
1	200 points	
2	−400 points	
3	−200 points	

Reflect Did any player's score change from negative to positive? Explain why.

Got It?

PART 1 Got It

−5 + (−6) is [] units from −5, in the [] direction.

−5 + (−6) = []

PART 2 Got It

Is the value of the expression −52 + (−52) *less than zero, equal to zero,* or *greater than zero*?

Got It?

Write and simplify an addition expression for the model.

Close and Check

Focus Question

What does it mean to add less than nothing to something?

Do you know HOW?

1. Complete the statement. Then find the sum.

 $-8 + 5$ is [] units from -8 in the

 [] direction.

 $-8 + 5 =$ []

2. Is the value of the expression $75 + (-75)$ *less than zero, equal to zero,* or *greater than zero*?

 []

3. Write and simplify an addition expression for the model.

 []

Do you UNDERSTAND?

4. **Reasoning** Does every rational number have an additive inverse? Explain.

5. **Error Analysis** A classmate says that the additive inverse of any rational number is negative. Is he correct? Explain.

Adding Rational Numbers

CCSS: 7.NS.A.1b: Understand $p + q$ as the number located a distance $|q|$ from p, in the positive or negative direction Interpret sums of rational numbers by describing real-world contexts. **7.NS.A.1d:** Apply properties of operations ... to add ... rational numbers.

Launch

© MP5, MP6

Without adding, tell whether $A + B$, $B + C$, and $A + C$ would result in a negative or positive sum.

Tell how you know.

Reflect Would you solve the problem differently if A, B, and C were integers? Explain.

Got It?

PART 1 Got It

What property can you use to write the step
"$[9.3 + (-9.3)] + (-3.4)$" in this addition problem?

$$9.3 + (-12.7) = 9.3 + [-9.3 + (-3.4)]$$
$$= [9.3 + (-9.3)] + (-3.4)$$
$$= 0 + (-3.4)$$
$$= -3.4$$

PART 2 Got It

What is the sum $-2.7 + 3.2$?

Discuss with a classmate

Circle the key word in the problem statement.

Read the word out loud.

Give a definition of the word.

What symbol used in the problem is a clue about what the key word means?

Got It?

PART 3 Got It

The diagram shows the changes in the water level after the 6:49 A.M. high tide. Which expression represents the water level, in feet, at the 7:15 P.M. high tide?

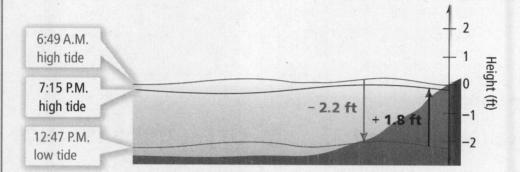

Close and Check

Focus Question

 MP2, MP7

How is adding rational numbers different than adding whole numbers?

Do you know HOW?

1. Identify the property of addition used to complete the 2nd step of the equation: *Commutative, Associative, Inverse, Identity,* or *Zero*.

$$-\frac{7}{9} + \frac{2}{3} = \left(-\frac{1}{9}\right) + \left(-\frac{2}{3} + \frac{2}{3}\right)$$

$$-\frac{7}{9} + \frac{2}{3} = \left(-\frac{1}{9}\right) + 0$$

2. What is the sum of $-\frac{7}{10} + \frac{1}{4}$?

3. What is the sum of $-4\frac{5}{6} + \left(-2\frac{5}{9}\right)$?

4. A homeowner owes the electric company $72.45. She pays $57.50. Write and simplify an expression to model this situation.

Do you UNDERSTAND?

5. Writing Describe a strategy you can use to find the sum of a positive and a negative integer.

6. Reasoning How can you tell without solving whether the sum or difference of a positive number and a negative number will be less than zero, equal to zero, or greater than zero?

Subtracting Integers

CCSS: **7.NS.A.1:** Apply and extend previous understandings of … subtraction to … subtract rational numbers; represent … subtraction on a … number line diagram. **7.NS.A.1c:** Understand subtraction of rational numbers as adding the additive inverse, $p - q = p + (-q)$ …

Launch

© MP1, MP4

Player 3 goes last in the final round of Zombie Pretzel Attack 2!
She loses 500 points when caught by two zombie pretzels.

What's her new score? How many points does she need to catch Player 1? Tell how you found out.

Player	Current Score	New Score
1	500 points	300 points
2	−100 points	−200 points
3	100 points	

Reflect How could the Zombie Pretzel Attack 2! game work without negative numbers? Would the game be as good? Explain.

Got It?

PART 1 Got It

Which expression(s) does the number line model represent?

I. $2 - 4$

II. $2 - 2$

III. $2 + (-4)$

IV. $2 + (-2)$

PART 2 Got It

The map shows the highest temperature ever recorded in the United States. The lowest temperature ever recorded in the United States was 214°F lower than this temperature.

Write and simplify a subtraction expression to represent the lowest temperature ever recorded in the United States.

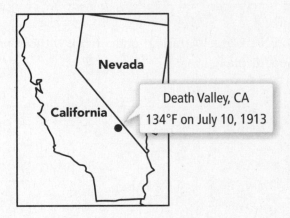

Got It?

PART 3 Got It

Which expressions are equivalent to $4 + (-9)$?

I. $-9 + 4$

II. $4 - 9$

III. $-9 - (-4)$

Discuss with a classmate

What key words or phrases do you need to use in order to explain whether one expression is equivalent to another expression?

After discussing the key words, choose one of the three answer choices.

Take turns explaining why the answer choice you selected is or is not equivalent to the given expression in the problem statement.

Close and Check

Focus Question

© MP3, MP6

What does it mean to subtract less than nothing from something?

Do you know **HOW?**

1. Write equivalent subtraction and addition expressions for the number line model.

$$\boxed{} - \boxed{} = \boxed{} + \boxed{}$$

2. The highest point in California is Mt. Whitney at 14,494 ft above sea level. The lowest point in the state is Death Valley, which is 14,776 ft lower than Mt. Whitney. Write and simplify a subtraction expression to represent the lowest point in California.

3. Write and simplify an equivalent expression.

$$-12 - (-8)$$

Do you **UNDERSTAND?**

4. Compare and Contrast How is adding two negative integers the same as and different from subtracting two positive integers?

5. Writing Explain why subtracting a positive number and adding a negative number result in the same solution.

Subtracting Rational Numbers

CCSS: 7.NS.A.1: Apply ... previous understandings of addition and subtraction to ... subtract rational numbers; represent ... subtraction on a ... number line diagram. **7.NS.A.1b:** ... Interpret sums of rational numbers by describing real-world contexts.

Launch

© MP5, MP6

Without subtracting, tell whether $A - C$, $A - B$, and $B - A$ would result in a negative or positive difference.

Tell how you know.

Reflect Would you solve the problem differently if A, B, and C were integers? Explain.

Got It?

PART 1 Got It

Is $-\frac{1}{5} - \left(-\frac{1}{5}\right)$ less than zero, equal to zero, or *greater than zero?*

PART 2 Got It

Which number line model represents the subtraction expression $1\frac{3}{4} - \left(-\frac{3}{8}\right)$?

I.

$1\frac{3}{8}$

II.

$2\frac{1}{8}$

Got It?

PART 3 Got It

The temperature at which a liquid turns to gas is its boiling point. The temperature at which a liquid turns to a solid is its freezing point.

Liquid nitrogen's boiling point is −195.79° C.

Liquid nitrogen's freezing point is −210°C.

What is −210 − (−195.79)? What does the difference mean?

Close and Check

Focus Question

 MP2, MP7

How is subtracting rational numbers different than subtracting whole numbers?

Do you know HOW?

1. Is $-\frac{5}{9} - \left(-\frac{7}{9}\right)$ _less than zero, equal to zero_, or _greater than zero?_

2. Write and simplify a subtraction expression for the number line model.

3. The lowest point in the United States is Death Valley with an elevation of −282 ft in relation to sea level. The lowest point on land in the world is the shore of the Dead Sea at −1,385 ft. What is the difference between the two elevations?

Do you UNDERSTAND?

4. **Writing** How would you explain the meaning of subtracting negative numbers to someone who had never heard of it?

5. **Error Analysis** The record high temperature in the United States is 134°F and the record low temperature is −80°F. A classmate writes an equation to find the difference between the two temperatures. Explain her error and give the correct answer.

$$134 - 80 = 54$$

Distance on a Number Line

CCSS: 7.NS.A.1c: Understand subtraction of rational numbers as adding the additive inverse Show that the distance between two rational numbers on the number line is the absolute value of their difference, and apply this principle in real-world contexts.

Launch

A family of runners position themselves near the starting line of a race to make the race fair.

Which runner has the greatest head start over another runner? Which runner has the least head start over another runner?

Reflect What number did you always use to make all the comparisons of head starts? Why?

Got It?

PART 1 Got It

What is the distance between the top and the bottom of this group of clouds?

PART 2 Got It

A whale dives from the Twilight Zone into the Midnight Zone. How far does the whale dive?

Got It?

PART 3 Got It

Which expression(s) represent the distance between −2 and 4 on the number line?

I. $|4 - 2|$

II. $|-2 + 4|$

III. $|-2 - 4|$

IV. $|4 + 2|$

Close and Check

Focus Question

Subtraction is not commutative. In what situations does the order in which you subtract two numbers not matter?

Do you know HOW?

1. A space shuttle can orbit the earth at 330 mi above sea level. The average commercial airplane can fly at 5.7 mi above sea level. What is the distance between the two aircraft?

2. The lowest point on Earth is in the Mariana Trench in the Pacific Ocean. It is $-10,924$ m from sea level. The highest point on Earth is Mount Everest in the Himalaya Mountains at 8,850 m from sea level. What is the distance between the highest and lowest points on Earth?

3. Write an expression using absolute value to represent the distance between -12 and 12 on the number line.

Do you UNDERSTAND?

4. **Writing** Explain when to use absolute value in solving integer equations and when not to use it.

5. **Error Analysis** The Roman Empire lasted from 27 BC to 476 AD. Using 0 as the division between BC and AD, a classmate says he can find the total length of the Roman Empire using the equation $-27 + 476 = x$. Is he correct? Explain.

Problem Solving

CCSS: 7.EE.B.3: Solve multi-step real-life and mathematical problems posed with positive and negative rational numbers in any form (whole numbers, fraction, and decimals), using tools strategically. Also, **7.NS.A.1b, 7.NS.A.1c.**

Launch

In the game of golf, players try to get negative scores, not positive scores, on each hole. Draw lines to order the players from 1st to 4th place. Then write how many shots each player was behind the winner. Explain your work.

MP1, MP6

Player A +6 Player B −2 Player C −7 Player D +2

1st 2nd 3rd 4th

Shots Behind:

Reflect Can a player in any game be −5 points behind the lead player? Explain why or why not.

Got It?

PART 1 Got It

Paul lives $1\frac{3}{4}$ blocks east of Michele. What is the coordinate of Paul's house?

Michele's House Amy's House Juan's House

-7 -6 -5 -4 -3 -2 -1 0 1 2 3 4 5 6 7

$-1\frac{1}{4}$ $2\frac{1}{2}$

PART 2 Got It

Use the equation $V = R - N$, where
V = Variation From Normal,
R = Recorded Temperature, and
N = Normal Temperature.
If $V = -2.6$ and $N = 5.3$. what is R?

Got It?

PART 3 Got It

 What is the range of the temperature data set?

Daily Low Temperature (°F), February 1 to February 14

13, 12, 15, 8, −1, −2, 0, 5, 3, −1, 9, 12, 14, 10

Close and Check

Focus Question

MP1, MP7

What kinds of problems can you solve by adding the different types of rational numbers? What kinds of problems can you solve by subtracting the different types of rational numbers?

Do you know HOW?

1. One cat weighs $5\frac{1}{4}$ lbs. Another cat's weight differs by $1\frac{5}{8}$ lbs. Place points on the number line to represent the possible weights of the second cat. Write the weights.

3 4 5 6 7

[] or []

2. Find the value of x.

$$x + 17.3 = -5.2$$

[]

Use the data set for Exercises 3 and 4.
$$-2, 6, -15, 0, 11, -9, 17, 9$$

3. Find the range of the data.

[]

4. Find the interquartile range of the data.

[]

Do you UNDERSTAND?

5. Reasoning The elevation of the basement floor of an office building is -18 ft. The height of the building above ground is 216 ft. To find the total distance between the basement floor and the top of the building, would you add or subtract the integers? Explain.

6. Writing Write another integer word problem about the office building that uses subtraction. Write the expression and solve the problem.

Topic Review

New Vocabulary: absolute value, additive inverse, Inverse Property of Addition, opposites, rational number
Review Vocabulary: distance, integers, whole numbers

Vocabulary Review

Identify two challenging vocabulary terms from this topic. Write one
vocabulary term in the center oval, and fill in the surrounding boxes with
details that will help you better understand the term.

Definition

Characteristics

Example

Nonexample

Definition

Characteristics

Example

Nonexample

Pull It All Together

TASK 1

Mauna Kea is a mountain in Hawaii with an elevation of 13,796 feet above sea level. The base of the mountain is actually deep in the ocean, about 19,204 feet below sea level.

What is the height of Mauna Kea from base to peak?

Mount Everest is 29,029 feet above sea level. Is Mauna Kea taller? Explain.

TASK 1

A college student is balancing his checkbook to see whether he has enough money to buy a movie for $14.98. At the beginning of the month, he had $50.99. He is recording the money that he has withdrawn and deposited since then.

Does the student have enough money to buy the movie?

Date	Category	Deposit	Withdrawal	Balance
Oct. 1				$50.99
Oct. 3	Groceries		$33.54	
Oct. 8	Work			$47.45
Oct. 15	Books			$5.32
Oct. 17	Computer game		$11.05	
Oct. 20	Bank charge		$10.00	
Oct. 21	Work	$30.00		

Multiplying Integers

Digital Resources

CCSS: 7.NS.A.2a: Understand that multiplication is extended ... to rational numbers by requiring that operations ... satisfy ... the distributive property, leading to ... rules for multiplying signed numbers. Interpret products of rational numbers Also, **7.NS.A.2, 7.NS.A.2c.**

Launch

Ⓒ MP2, MP5, MP8

Complete the multiplication table. Describe at least one rule for multiplying integers based on what you see in the table.

x	−3	−2	−1	0	1	2	3
3							9
2							6
1							3
0							0
−1							−3
−2	6	4	2	0	−2	−4	−6
−3							−9

Reflect What do you notice about the signs of the products in the four shaded sections of the grid?

Got It?

PART 1 Got It (1 of 2)

What is the product $-8(3)$?

PART 1 Got It (2 of 2)

Write -20 as the product of a negative and a positive integer in at least three different ways.

Got It?

PART 2 Got It

What is the product $-11(-7)$?

PART 3 Got It (1 of 2)

Which products are equivalent to 36?

I. $-6 \times (-2) \times 3$ II. $-1 \cdot 18 \cdot (-2)$ III. $-2(-18)(-1)$

PART 3 Got It (2 of 2)

Suppose p and q are nonzero integers with different signs. Is the product $p(-q)$ *positive* or *negative*? Explain.

Close and Check

MP1, MP8

Focus Question

How does knowing how to add positive and negative integers help you multiply positive and negative integers? How do properties of addition and multiplication help you multiply positive and negative integers?

Do you know **HOW?**

1. Find the product of $-5(8)$.

2. Find the product of $-9(-9)$.

3. Circle the products that are equivalent to -100.

 A. $-5 \cdot 2(-10)$

 B. $-1(25 \cdot 4)$

 C. $-4 \cdot 5^2$

 D. $(-2)(25)(-2)$

4. Suppose a and b are nonzero integers with the same signs. Is the product of a and b positive or negative?

Do you **UNDERSTAND?**

5. Writing Draw a model to show the product of a and b, where $a < 0 < b$. Explain your model.

6. Compare and Contrast How does the sign of the product of a positive and a negative number compare with the sign of the sum of a positive and a negative number?

Multiplying Rational Numbers

Digital Resources

CCSS: 7.NS.A.2: Apply and extend previous understandings of multiplication and division of fractions to multiply and divide rational numbers. **7.NS.A.2a:** Understand … the rules for multiplying signed numbers. Interpret products … by describing real-world contexts.

Launch

Ⓒ MP3, MP7, MP8

Sort the tiles into two groups. Describe each group.

| 1.5 • 3 | 1.5 • (−3) | 3 • 1.5 | −3 • 1.5 |

| −1.5 • 3 | −1.5 • (−3) | 3 • (−1.5) | −3 • (−1.5) |

Group 1 ⋮ **Group 2**

Reflect How would solving this problem be different if both factors of each expression were integers? Explain.

Got It?

PART 1 Got It (1 of 2)

Is the product $-8.1 \cdot 3$ positive or negative?

PART 1 Got It (2 of 2)

If a is negative and b is positive, is a^2b positive or negative? Explain.

Got It?

PART 2 Got It

Find the product.

$$\frac{3}{8}\left(-2\frac{1}{8}\right)$$

PART 3 Got It

Discuss with a classmate

What does it mean for the value of a stock to drop?

You own 57.08 shares of stock. The value of a share drops $.20. What is the total change in the value of your stocks?

Close and Check

Focus Question

How is multiplying rational numbers like multiplying fractions and multiplying decimals? How is it different?

Do you know HOW?

1. Write **P** next to the positive products and **N** next to the negative products.

 $\frac{5}{9} \cdot \left(-\frac{3}{7}\right)$

 $(-4.8)(-0.2)$

 $\left(-3\frac{2}{5}\right)\left(6\frac{1}{3}\right)\left(-1\frac{1}{9}\right)$

 $14.2 \cdot (-2)\left(-5\frac{2}{7}\right)(-0.25)$

2. Find the product of $-5.8(3)(-2.2)$.

3. In 1911, the temperature in Rapid City, South Dakota, dropped at an amazing rate of about 3.1°F per minute. This remarkable temperature change took place in a span of 15 minutes. Write the change in temperature.

Do you UNDERSTAND?

4. **Reasoning** Will the product of -3^{17} be positive or negative? Explain.

5. **Error Analysis** A classmate says that you can tell the sign of a product by comparing the number of positive and negative factors. If there are more negative factors, then the product will be negative. If there are more positive factors, then the product will be positive. Do you agree? Explain.

5-3 Dividing Integers

Digital Resources

CCSS: 7.NS.A.2b: Understand that integers can be divided, provided that the divisor is not zero, and every quotient of integers (with non-zero divisor) is a rational number. If p and c are integers, then $-\left(\frac{p}{q}\right) = \frac{(-p)}{q} = \frac{p}{(-q)}$ Also, **7.NS.A.2.**

Launch

Ⓒ MP2, MP3, MP5

Draw arrows to show how to redistribute the integer chips equally among the bags. Then write two equations, one using multiplication and one using division, to describe your distribution.

Reflect How is dividing integers similar to and different from dividing whole numbers?

Got It?

Find the quotient.

$-125 \div (-5)$

If possible, find a counterexample for one or both of these conjectures.

Conjecture 1
The quotient of any two nonzero integers is an integer.

Conjecture 2
For all whole numbers a and b, where $b \neq 0$:
$$-\frac{a}{b} = \frac{-a}{b} = \frac{a}{-b}$$

Got It?

PART 2 Got It

What is the value of a?

$\frac{8}{a} = -2$

PART 3 Got It

An elevator descends 1,000 feet in 8 seconds. Express the movement of the elevator as a unit rate.

Close and Check

Focus Question

© MP2, MP7

How does the relationship between multiplication and division help you divide integers? When does division of integers not have meaning and why?

Do you know HOW?

1. Write **P** next to the positive quotients, **N** next to the negative quotients, and **U** next to the quotients that are undefined.

 [] $-3 \div (-7)$

 [] $-4 \div 0$

 [] $-12 \div 2$

 [] $14 \div 7$

2. Solve $-\dfrac{75}{a} = -25$.

 $\dfrac{-75}{-25}$

 []

3. The stock market lost 7,695 points in a 17-month period. Express the change in the stock market as a unit rate. Round your answer to the nearest integer.

 []

Do you UNDERSTAND?

4. **Reasoning** Show that the quotient of two negative numbers is a positive number. Use multiplication to support your reasoning.

5. **Writing** Explain why division by 0 is undefined. Use an example.

Dividing Rational Numbers

Digital Resources

CCSS: 7.NS.A.2: Apply and extend previous understandings of multiplication and division of fractions to multiply and divide rational numbers. **7.NS.A.2b:** … Interpret quotients of rational numbers by describing real-world contexts.

Launch

© MP3, MP7, MP8

Sort the tiles into two groups. Describe your groups.

| $7\frac{1}{2} \div 3$ | $-7\frac{1}{2} \div 3$ | $7\frac{1}{2} \div (-3)$ | $-7\frac{1}{2} \div (-3)$ |

Group 1 **Group 2**

Reflect How would solving this problem be different if the dividend and divisors were always integers? Explain.

Got It?

What is the reciprocal of $-\frac{7}{21}$?

Does zero have a reciprocal? Explain.

Got It?

PART 2 Got It

Write $-\frac{9}{2} \div \frac{7}{5}$ as a multiplication expression.

PART 3 Got It

The equation $e = -\frac{1}{2}t$ describes the change in elevation, e, in miles, of a hiker t hours after beginning her descent into a canyon. The bottom of the canyon is $1\frac{1}{3}$ miles below the rim of the canyon. How long does it take the hiker to reach the bottom of the canyon?

Close and Check

Focus Question

 MP6, MP7

How does the relationship between multiplication and division help you divide rational numbers?

Do you know **HOW?**

1. Write the reciprocal of each number.

 -30

 $\frac{1}{12}$

 6

 $-\frac{6}{11}$

2. Write $-\frac{7}{8} \div \frac{3}{5}$ as a multiplication expression.

3. The equation $d = -\frac{3}{5}t$ describes the change in degrees Fahrenheit d after t hours. The temperature falls a total of $7\frac{1}{2}$ degrees. How long does it take the temperature to fall?

Do you **UNDERSTAND?**

4. **Reasoning** Can the product of reciprocals ever be equal to -1? Explain.

5. **Writing** Explain why multiplying by the reciprocal of a number is the same as dividing by that number. Use the equation in your explanation.

 $$-\frac{7}{9} \div \frac{3}{8} = -\frac{7}{9} \cdot \frac{8}{3}$$

Operations with Rational Numbers

CCSS: 7.NS.A.2c: Apply properties of operations as strategies to multiply and divide rational numbers.
7.NS.A.3: Solve real-world and mathematical problems involving the four operations with rational numbers. Also, **7.NS.A.2.**

Launch

ⓒ MP1, MP2

Is the value of this expression *positive* or *negative*? Show how to change the expression so that its value switches to the other sign. Do not change or move any numbers or operation symbols.

$$2 + \frac{1}{2} \cdot 1\frac{3}{4} - 3$$

Positive	Negative

Reflect How are the expression as shown and the expression after your change alike? How are they different?

Got It?

PART 1 Got It

Which expression is equivalent to $-10(5.8 - 6.2)$?
What is the value of the expression?

$$-10(5.8) - 10(6.2) \qquad -10(5.8) - (-10)(6.2)$$

PART 2 Got It

You can use the formula $C = \frac{5}{9}(F - 32)$ to convert a temperature given in degrees Fahrenheit to degrees Celsius. Convert the temperature shown on the thermometer to degrees Celsius.

5°F

Got It?

PART 3 Got It (1 of 2)

What is the simplified form of the complex fraction $\dfrac{-\frac{5}{6}}{\frac{15}{2}}$?

PART 3 Got It (2 of 2)

A fraction bar is a grouping symbol as well as a division symbol. In the expression $\dfrac{2+4}{3}$, the fraction bar groups $(2 + 4)$ and indicates that you add 2 to 4 before you divide by 3.

$$\frac{2+4}{3} = (2 + 4) \div 3$$
$$= 6 \div 3$$
$$= 2$$

Use this idea to simplify the complex fraction $\dfrac{-\frac{5}{6}}{\frac{1}{3} - 1}$.

Close and Check

Focus Question

Many problems involve more than one operation with rational numbers. How do you decide the order in which to carry out the operations?

Do you know HOW?

1. Write and simplify an equivalent expression by using the Distributive Property.

$$-7\left(\frac{5}{7} - \frac{12}{21}\right)$$

2. Antarctica holds the record for the lowest recorded temperature of $-129°F$. Use the formula to find the equivalent temperature in °C.

$$C = \frac{5}{9}(F - 32)$$

3. Simplify the complex fraction.

Do you UNDERSTAND?

4. **Writing** Describe another method for solving the expression in Exercise 1. Does this method always work? Explain.

5. **Error Analysis** Explain the error and find the correct answer.

$$\frac{\frac{7}{15}}{\frac{1}{6} - 1} = \frac{\frac{7}{15}}{-\frac{5}{6}} = \frac{7}{15} \cdot -\frac{5}{6} = -\frac{7}{18}$$

Problem Solving

Digital Resources

CCSS: **7.NS.A.3:** Solve real-world and mathematical problems involving the four operations with rational numbers. **7.EE.B.3:** Solve multi-step real life and mathematical problems posed with positive and negative rational numbers in any form

Launch

© MP1, MP4

A not-so-jazzed New Orleans dog forgets where she buries her favorite bone. She picks a spot and digs at a rate of 0.4 ft every 10 minutes for an hour to find it.

Write and evaluate an expression to represent the dog's elevation in relation to sea level after digging for one hour.

Sea Level
0 ft

New Orleans
−6.6 ft

Reflect Is there one right expression to represent the dog's situation? Explain.

Got It?

PART 1 Got It

Find the median daily high temperature in Montreal during the last two weeks of February.

Montreal, Daily High Temperatures: February 15–28

Temperature	−8°C	−5°C	−3°C	1°C	5°C
Frequency	4	2	1	3	4

PART 2 Got It (1 of 2)

Renee's work contains an error. What did Renee do incorrectly? What is the value of the expression?

Renee's Work

$$-8 \div \frac{1}{2} - \frac{1}{4}$$

$$-8 \times 2 - \frac{1}{4}$$

$$16 - \frac{1}{4}$$

$$15 \frac{3}{4}$$

Got It?

PART 2 Got It (2 of 2)

Paula's error when simplifying the expression $-2 - 4(5 - 1)$ was to subtract 4 from -2 before working inside parentheses and multiplying the result by 4.

Insert a pair of parentheses in the expression $-2 - 4(5 - 1)$ in order to make subtracting 4 from -2 the correct first step.

Paula's Work

$$-2 - 4(5 - 1)$$
$$-6(5 - 1)$$
$$-6(4)$$
$$-24$$

PART 3 Got It

The table shows the change in one bear's weight over 84 days of hibernation. Suppose the relationship between days of hibernation and change in weight is a proportional relationship.

What is the bear's change in weight over 112 days of hibernation?

Bear Hibernation

Days of Hibernation	Change in Weight (kg)
84	-7.56
112	

Close and Check

Focus Question

What types of problems can you solve using operations with rational numbers?

Do you know HOW?

1. Many places on land are located below sea level. The table shows the altitude of various locations. Find the mean altitude in relation to sea level. Round your answer to the nearest tenth.

Position Relative to Sea Level					
Altitude (ft)	−11	−13	−16	−20	−23
Frequency	2	4	6	2	4

2. Insert a pair of parentheses to make the expression true.

$$6 - 5 + 4 + 9 = 6$$

3. Complete the table to show the change in the water table levels during a severe drought. Assume the relationship is proportional.

Months of drought	3	5	8
Change in water level (cm)		−130	

Do you UNDERSTAND?

4. Writing An airplane descends from 35,000 ft at a rate of 33 feet per second. Explain how to use this information to find the altitude of the airplane after 12 minutes.

5. Error Analysis A classmate says that simplifying the expression is the same with or without parentheses. Do you agree? Explain.

$$-9 \times (6 + 3) + 8$$

Topic Review

New Vocabulary: complex fraction, reciprocals
Review Vocabulary: denominator, Distributive Property, integers, numerator, order of operations, quotient, rational numbers, unit rate

Vocabulary Review

Identify two challenging vocabulary terms from this topic. Write one vocabulary term in the center oval, and fill in the surrounding boxes with details that will help you better understand the term.

Definition

Characteristics

Example

Nonexample

Definition

Characteristics

Example

Nonexample

Pull It All Together

TASK 1

A rock climber is at an elevation of 10,000 feet. Four and a half hours later, she is at 7,751 feet.

Use the formula below to find the climber's vertical speed.

$$\text{vertical speed} = \frac{\text{final elevation} - \text{initial elevation}}{\text{time}}$$

Is the climber's vertical speed *positive* or *negative*? Explain the meaning of the sign of the vertical speed.

TASK 2

Use the equation $y = -\frac{1}{2}x - 3$.

Complete the table. Graph the points (x, y) from your table in the coordinate plane. Draw a line through the points.

x	−5	−4	−3	−2	−1	0	1	2
y	$-\frac{1}{2}$							

Repeating Decimals

Digital Resources

CCSS: 7.NS.A.2b: Understand that integers can be divided, provided that the divisor is not zero
7.NS.A.2d: Convert a rational number to a decimal using long division; know that the decimal form of a rational number terminates in 0s or eventually repeats.

Launch

Use a picture, words, and a number to represent the quantity 2 out of 3 in three other ways. Tell which of these ways may be best for problem solving and why.

ⓒ MP3, MP4

A Picture	Words	A Number

Reflect When have you represented quantities in different ways in your past mathematics work? How was that helpful?

Got It?

PART 1 Got It

 Identify the repeating decimal(s).

I. $3.9\overline{85}$ II. 0.404004 III. $1.72\ldots$

PART 2 Got It (1 of 2)

Write $\frac{7}{15}$ as a decimal.

PART 2 Got It (2 of 2)

Look at the decimal expansions below. Make a conjecture about the decimal expansions of $\frac{3}{7}$ and $\frac{6}{7}$. Then prove or disprove your conjecture.

$\frac{1}{7} = 0.\overline{142857}$

$\frac{2}{7} = 0.\overline{285712}$

$\frac{4}{7} = 0.\overline{571428}$

$\frac{5}{7} = 0.\overline{714285}$

Got It?

> In another scene, the special effects artist wants a model submarine to navigate through a cave 6.4 inches wide. The artist wants to make the submarine $6\frac{5}{12}$ inches wide. Will the submarine fit through the cave?

> Calculate $\frac{1}{3}$ of 100. Then calculate 0.33 of 100. What is the difference between the two results? When does the difference matter?

Close and Check

Focus Question

When is it helpful to be able to write fractions as decimals? Why is it helpful to show that a decimal repeats?

Do you know HOW?

1. Circle the repeating decimal(s).

12.34345 9.$\overline{012}$

5.25... 23.4380$\overline{2}$

2. Write $\frac{1}{13}$ as a decimal.

3. Write $6\frac{5}{12}$ as a decimal.

4. An electrician cuts away a 7.2-inch long section of drywall to make repairs to the electrical system. He has several scraps of drywall he can use to repair the hole. Circle the length(s) of drywall that is large enough to repair the hole.

$7\frac{2}{13}$ $7\frac{3}{14}$ $7\frac{5}{21}$

Do you UNDERSTAND?

5. Writing Your friend compares the values in Exercise 4. She writes the mixed number as an improper fraction. Next she divides the numerator by the denominator to find the decimal value of each number. Describe a shorter method.

6. Reasoning When converting a fraction to a decimal by using long division, how can you know when the decimal is beginning to repeat?

Terminating Decimals

CCSS: 7.NS.A.2d: Convert a rational number to a decimal using long division; know that the decimal form of a rational number terminates in 0s or eventually repeats. Also, **7.NS.A.2b.**

Launch

© MP2, MP6

A certain surly friend of yours likes 1 ÷ 2 far better than 1 ÷ 3. He says, "At least you can clearly see the answer to 1 ÷ 2."

Show and explain with decimals what might make your certain friend surly about 1 ÷ 3, but happy about 1 ÷ 2.

I hate 1 ÷ 3!

Reflect How could writing 1 ÷ 2 and 1 ÷ 3 each as fractions make your friend less surly?

Got It?

Which are terminating decimals?

I. 0.35

II. 0.00008

III. 16.98...

IV. 0.30030003

Is 407 a terminating decimal? Explain.

Got It?

PART 2 Got It

A recipe for a six-foot sub calls for $3\frac{7}{8}$ pounds of sliced deli meats. You want to get the exact amount from the deli counter. What decimal number should the digital scale show?

PART 3 Got It (1 of 2)

What is the decimal equivalent of $8\frac{1}{5}$?

PART 3 Got It (2 of 2)

Why isn't $4.67\overline{10000}$ a terminating decimal?

Close and Check

Focus Question

MP1, MP6

When is it helpful to be able to write fractions as decimals? How is a fraction written as a terminating decimal different from a fraction written as a repeating decimal?

Do you know HOW?

1. Circle the terminating decimal(s).

 10.243444 2.010110111...

 5.25... 43.98769876

2. Circle the fraction(s) that can be written as a terminating decimal.

 $8\frac{7}{12}$ $19\frac{12}{25}$

 $4\frac{3}{11}$ $26\frac{2}{15}$

3. The pediatrician weighs a newborn baby on a digital scale. He tells the parents that their baby weighs $6\frac{5}{8}$ pounds. What decimal number did the pediatrician read on the scale?

 []

4. A customer purchases $7\frac{13}{16}$ gallons of gas. What is the decimal equivalent of this mixed number?

 []

Do you UNDERSTAND?

5. **Reasoning** To compare the values of a decimal and a fraction, should you convert the decimal to a fraction or the fraction to a decimal? Explain.

6. **Error Analysis** Your friend says every decimal is a repeating decimal because there are an infinite number of 0s at the end of every decimal number. Explain the error in her reasoning.

Percents Greater Than 100

CCSS: 7.NS.A.3: Solve real-world and mathematical problems involving the four operations with rational numbers.

Launch

MP2, MP7

During a heated origami-making argument, you tell your surly friend that you always give 150% effort in folding paper animals. Your surly friend says that he doesn't even know what 150% looks like.

Show a way to represent 150% with pictures or numbers. Explain why your representation works.

Reflect Can you really give more than 100% effort? Provide a possible way in words.

Got It?

PART 1 Got It (1 of 2)

Which is the best estimate for 350% of 20?

I. greater than 0 but less than 20
II. greater than 20 but less than 50
III. greater than 50 but less than 100
IV. greater than 100

Discuss with a classmate

What does it mean to estimate 350% of 20?

Which answer choice could you eliminate because it is not reasonable as an estimate for this problem? Explain why it can be eliminated.

PART 1 Got It (2 of 2)

Student A says that 200% of 1 is 2.

Student B says that 200% of 1 is 200.

Which student is correct? Explain.

PART 2 Got It (1 of 2)

During harvest, a cranberry bog is flooded with water to a depth 4,800% of its usual depth of $\frac{1}{4}$ inch. How deep is the water during harvest flooding?

Got It?

96 is what percent of 12?

An artist is making a wall mural from a small sketch. He enlarges the $4\frac{1}{2}$-inch-wide sketch to 900% of the original size to create the final mural. Which statement(s) is/are true?

I. The mural is between 36 and 45 inches wide.
II. The final width of the mural is 4.5 times 900.
III. The final width of the mural is 9 times the width of the sketch.

Student A says, "A 200% increase of 24 is 48."

Student B says, "200% of 24 is 48."

Who is correct? Explain.

Close and Check

Focus Question
MP1, MP3

What does it mean to have more than 100% of something?

Do you know HOW?

1. Circle the best estimate for 450% of 15.

 A. greater than 0 but less than 30

 B. greater than 30 but less than 60

 C. greater than 60 but less than 100

 D. greater than 100

2. Suppose a small business employs 45 people. Five years later, the same small business employs 380% of the original number of employees. How many employees are there now?

 ☐ employees

3. Bacterial colonies multiply very quickly. Assume there is a small colony of 560 bacteria that increases 675%. Circle the true statement(s).

 A. The change in the number of bacteria is between 3,000 and 4,000.

 B. The total number of bacteria is 675 times greater than 560.

 C. The total number of bacteria grows to 3,780.

Do you UNDERSTAND?

4. **Compare and Contrast** Compare finding 150% of a number and finding 15% of a number.

5. **Reasoning** The selling price of a sweater is a 175% increase of the purchase price. The markup is $36.75. Explain how to find the purchase price and the selling price.

Percents Less Than 1

CCSS: 7.NS.A.3: Solve real-world and mathematical problems involving the four operations with rational numbers.

Launch

© MP3, MP6

Explain how these three shaded squares could be used in a representation of 300% or 30%. Use pictures, words, and numbers to model the mathematics.

How the Squares Could Model 300%:

How the Squares Could Model 30%:

Reflect What fractions and decimals would your models model?

Got It?

Which numbers are equivalent to $\frac{1}{4}$%?

I. 25%
II. $\frac{4}{100}$
III. 0.25
IV. 0.0025

Why isn't $\frac{1}{3}$% equivalent to $33.\overline{3}$%?

Got It?

PART 2 Got It

What is $\frac{1}{5}$% of 2,400?

PART 3 Got It

About what percent of Colorado's total area is covered by water?

The total area of the state is 104,100 mi^2.

Colorado

• Denver

Bodies of water cover 371 mi^2 of the state.

Close and Check

MP1, MP3

Focus Question

What does it mean to have a fractional percent of something?

Do you know HOW?

1. Circle the number(s) that is equivalent to $\frac{1}{5}$%.

 20% $\frac{2}{100}$

 0.002 0.20

2. Find the solutions.

 What is $\frac{1}{8}$% of 800?

 3 is what percent of 1,200?

 19.5 is 0.75% of what?

3. The unemployment rate falls 0.4%. Out of 3,500 unemployed workers, how many people find jobs?

 [] people

4. Washington, D.C., comprises about 0.0016% of the total area of the U. S. The U.S. covers about 3,790,000 square miles. About how many square miles is Washington, D.C.? Round your answer to the nearest whole number.

 [] square miles

Do you UNDERSTAND?

5. **Writing** Write a real-world problem that includes a percent less than 1%. Show how to solve your problem.

6. **Compare and Contrast** What is the same and different about a percent less than 100 and a fractional percent?

Fractions, Decimals, and Percents

CCSS: **7.NS.A.2d:** Convert a rational number to a decimal using long division **7.NS.A.3:** Solve real-world and mathematical problems involving the four operations with rational numbers. Also, **7.NS.A.2b.**

Launch

Ⓒ **MP2, MP4**

The results of an international origami competition show how many animals top folders perfectly folded in fifty minutes.

How could the origami competition organizers use fractions, decimals, or percents to better represent the results? Explain.

Origami Animal Folding Results		
Contestant	Perfectly Folded	Folded
Happy Friend	8	13
Surly Friend	6	10
New Friend	4	8
Not a Friend	10	15

Reflect Would you rule out using any form of these representations—fractions, decimals, or percents—to improve the results for any reason? If so, why?

Got It?

PART 1 Got It (1 of 2)

On an 85-question multiple choice exam, a student got 71 questions correct. What percent of the exam did the student get correct? Round to the nearest whole percent.

PART 1 Got It (2 of 2)

On an 85-question multiple choice exam, a student got 71 questions correct. When might representing the results as a fraction, a decimal, and a percent be useful in analyzing this situation?

PART 2 Got It

A koala sleeps for about 75% of the day. Write the ratio of hours a koala is asleep per day to the total number of hours in a day.

Got It?

PART 3 Got It (1 of 2)

Which statement(s) are true?

I. $\frac{1}{4}$, 0.25, and 2.5% are equivalent

II. $\frac{1}{5}$, 0.20, and 20% are equivalent

III. $\frac{2}{5}$, 0.20, and 25% are equivalent

IV. $\frac{5}{8}$, 0.62, and 62.5% are equivalent

Discuss with a classmate

Number lines are useful models for comparing numbers.
Use a number line to justify why the answer you selected shows the values are equivalent.
Use a number line to explain why the other answer choices are incorrect.

PART 3 Got It (2 of 2)

What is 24% of 50? Choose a rational number representation to find the exact answer. Explain why you chose the representation that you used. Use estimation to check your answer.

Close and Check

Focus Question

MP4, MP6

Why are there different representations of rational numbers?

Do you know HOW?

1. There are 78 varieties of cetaceans (whales, dolphins, and porpoises). 11 cetacean species are baleen whales. What percent of cetaceans are baleen whales? Round your answer to the nearest tenth.

 []

2. Cows eat 2.5% of their body weight in dry food each day. The average cow weighs 1,660 lbs. How many pounds of dry food will the average cow eat each day?

 [] pounds

3. Complete the table below by filling in equivalent values in different forms.

Fraction	$\frac{1}{4}$			
Decimal		0.04		0.005
Percent			112.5%	

Do you UNDERSTAND?

4. **Writing** Is it easier to change a fraction to a decimal and then to a percent, or is it easier to change a fraction directly to a percent? Explain.

5. **Error Analysis** A score of at least 85% of 220 points is needed to advance to the semi-finals. Can the equation be used to find the number of points needed to advance? Explain.

 $$220x = 0.85$$

Percent Error

CCSS: 7.RP.A.3: Use proportional relationships to solve multistep ratio and percent problems. Examples: … percent error.

Launch

© MP1, MP4

The surly friend and his remaining friends set out to set up an origami shop with a goal of selling 200 animals the first week. After the first week, the surly friend says, "Our sales total is 3 percent from the goal."

Tell how many animals the group sold. Explain whether they made their goal.

Reflect Was the surly friend clear about the sales results? If not, how could he have been clearer?

Got It?

Find the percent error of the estimated value to the nearest whole percent.

Estimated value: 250
Actual value: 200

Why does the percent error formula divide by the actual value instead of the estimated value?

A weatherman predicted 17 inches of snow. The town actually got $1\frac{1}{2}$ feet of snow. By what percent was the weatherman's prediction off?

Got It?

PART 2 Got It (2 of 2)

> Why is there an absolute value in the numerator of the percent error formula?

PART 3 Got It (1 of 2)

> The dot plot shows the measurements made by a science class. If the rock's actual mass is 5.9 g, what is the greatest percent error among the measurements? Round to the nearest tenth of a percent.

Measurements of a Rock

Grams

PART 3 Got It (2 of 2)

> The dot plot shows the measurements made by a science class. If the rock's actual mass is 5.9 g, what is the least percent error among the measurements? Explain.

Measurements of a Rock

Grams

Close and Check

> ### Focus Question
> © MP4, MP6
>
> How are percents helpful to describe and understand variability in data?
>
> _____
>
> _____
>
> _____
>
> _____

Do you know HOW?

1. Find the percent error of the estimated value to the nearest whole percent.
 Estimated value: 547
 Actual value: 562

 ░░░░░░

2. An event planner predicts 215 people will attend the party. The number actually attending is 241. To the nearest tenth, find the percent by which the event planner's prediction is off.

 ░░░░░░

3. The actual diameter of a redwood tree is 12.4 feet. To the nearest tenth, find the greatest percent error in the data.

 Diameter of a Redwood

 11.4 12.4 13.4 14.4 15.4
 Feet

 ░░░░░░

Do you UNDERSTAND?

4. **Reasoning** How does understanding percent error impact making decisions based on a set of data?

5. **Error Analysis** A classmate finds the percent error in Monday's predicted high temperature of 71°F and the actual high temperature of 78°F. Explain her error.

 $$\frac{(71-78)}{78} = -\frac{7}{78} \approx -9\%$$

Problem Solving

CCSS: 7.NS.A.3: Solve real-world and mathematical problems involving the four operations with rational numbers.

Launch

© MP1, MP3

Your surly friend plans a 400-ft^2 garden to improve his mood. 40% of the garden will be fruit, $\frac{1}{4}$ will be vegetables, 0.1 will be herbs, and the rest flowers.

Choose only one representation—fractions, decimals, or percents—to find the area of each part of the garden. Explain your choice after completing the area calculations.

Reflect Do you use fractions, decimals, or percents more often to solve problems? Explain.

Got It?

PART 1 Got It

A student mows a neighbor's lawn for $7.50 an hour. The student does such a good job that the neighbor gives him a 20% raise. Calculate the student's new hourly wage using a percent greater than 100.

PART 2 Got It

A school estimates that the expenses of running a fundraiser will be about 3.25% of the total amount that they collect. The fundraiser collects $16,000 in total, and the amount after expenses is $14,500. Is the estimated expense rate accurate? Explain.

Got It?

PART 3 Got It

Three friends went out to lunch. The bill came to $37.50. Each friend says that she ate 30% of the meal. They want to pay according to how much they ate.

a. How much more or less do they need to pay due to rounding?

b. What is the percent error on what the friends want to pay?

Close and Check

Focus Question

How does understanding the relationships among fractions, decimals, and percents help you solve problems?

Do you know HOW?

1. The minimum wage in 2007 was $5.85. The minimum wage rose 24% by 2009. To the nearest cent, find the minimum wage in 2009.

2. On Saturday, a store sells $2,700 in merchandise. The store makes a profit of 15.25% on all sales. The remaining income pays for the store's expenses. How much money goes toward expenses on Saturday?

3. Three roommates split their rent based on the sizes of their bedrooms. Roommate 1's bedroom takes up $\frac{3}{7}$ (43%) of total space. Roommate 2's and Roommate 3's each take up $\frac{2}{7}$ (29%). Find the estimated amount they will pay if total rent is $1900. Then find the percent error on the rent paid.

Estimated amount: _____

Percent error: _____

Do you UNDERSTAND?

4. **Writing** Explain how to use estimation to check the reasonableness of your solution to Exercise 2.

5. **Reasoning** If you were one of the roommates from Exercise 3, could you avoid overpaying your rent while still splitting costs according to your room sizes? Explain.

New Vocabulary: accuracy, percent error, repeating decimal, terminating decimal
Review Vocabulary: decimal, fraction, percent, ratio, rational number

Vocabulary Review

Identify two challenging vocabulary terms from this topic. Write one vocabulary term in the center oval, and fill in the surrounding boxes with details that will help you better understand the term.

Definition	Characteristics
Example	Nonexample

Definition	Characteristics
Example	Nonexample

Pull It All Together

TASK 1

A marathon is 26.2 miles. Your friend can run 5 miles. What percent of the race can your friend run?

Your friend could run 5 miles, but increased his running to 164.4% of that distance. How far can your friend run now?

TASK 2

Suppose you have $1,218.29 in a savings account. The equation below represents the account activity.

$1,218.29 = p(1.05)^n$

a. What is the interest rate compounded annually on the savings account?

b. At the end of one year, what percent of the principal is the balance?

You have had the account for 3 years. What was the principal originally deposited in the account?

Expanding Algebraic Expressions

CCSS: 7.EE.A.1: Apply properties of operations as strategies to add, subtract, factor, and expand linear expressions with rational coefficients. **7.EE.A.2:** Understand that rewriting an expression in different forms in a problem context can shed light on the problem

Launch

> © MP2, MP7
>
> Use the symbols, numbers, and a variable to make three equivalent expressions. Tell which properties (Commutative, Associative, and Distributive) you used. You can use each tile more than once.
>
> () + · 7 −3 −21 w

Reflect Your expressions are equivalent, but are they different in any way? Explain.

Got It?

PART 1 Got It

Which expressions show a *sum* or *difference* equivalent to $-\frac{1}{5}(-5m + 10)$?

I. $-\frac{1}{5}(10 - 5m)$

II. $m - 2$

III. $-m + 2$

PART 2 Got It

Which expression can be expanded? Write the expression in its expanded form.

$$(5 - x)(-y) \qquad\qquad\qquad (5 - x) - y$$

Discuss with a classmate

What does it mean to expand something?

Give a non-math example of something being expanded.

Got It?

PART 3 Got It

For your birthday party, you plan to buy 2 cupcakes for each guest and 5 additional cupcakes to have as extras. Cupcakes cost $2.25 each. Let x represent the number of guests you invite to your party. Use the expression below.

$2.25(2x + 5)$

a. What does each factor of the expression represent? What does the expression represent?

b. Use the Distributive Property to expand the expression. What does each term of your new expression represent?

Close and Check

 MP1, MP7

Focus Question

When would you want to expand an algebraic expression? What operation would you use? What does expanding an expression help you do?

Do you know **HOW?**

1. Circle the expression(s) that shows a sum or difference equivalent to $-0.9(3x - 2.6)$.

A. $-2.7x - 2.34$ B. $-2.7x + 2.34$

C. $-2.7x + 23.4$ D. $-27x - 23.4$

2. Write the expression in expanded form.
$(4.2z)(-5y - 3)$

3. You charge $2.50 per hour for each child you babysit. You also earn an activity fee of $2.75 for each hour. You babysit an average of 10 hours a month. Write an expression using the product of two factors to find how much you will earn on average each month for any number of children c.

4. Simplify the expression you wrote in Exercise 3.

Do you **UNDERSTAND?**

5. Writing What does each factor in the expression in Exercise 3 represent? What does the expression itself represent?

6. Error Analysis A classmate says that the expression $-5r(6s)$ can be expanded to $-30r - 5rs$. Explain his error.

Factoring Algebraic Expressions

CCSS: **7.EE.A.1:** Apply properties of operations as strategies to add, subtract, factor, and expand linear expressions with rational coefficients. **7.EE.A.2:** Understand that rewriting an expression in different forms in a problem context can shed light on the problem

Launch

© MP1, MP2

Your friends name five expressions—all using the same variable *p*—equivalent to the one shown. They say there's even more equality to be expressed.

What five equivalent expressions could they have named? Explain your reasoning.

$$12p + 3.6$$

Reflect Do you think there are only five expressions equivalent to $12p + 3.6$? Explain.

Got It?

PART 1 Got It

What is the factored form of this expression?

$$12x - 42y - 3$$

PART 2 Got It

Which expression has like terms? Combine the like terms.

$$-x + 3.5x \qquad 7 - 2x$$

Got It?

PART 3 Got It (1 of 2)

The bakery manager at the grocery store decides to have a 15% off sale on all bread. Let *b* be the original price of a loaf of bread. Use this expression for the new price of a loaf of bread.

$b - 0.15b$

Write an equivalent expression by combining like terms. What does your equivalent expression tell you about how to find the new price of a loaf of bread?

PART 3 Got It (2 of 2)

A clothing store advertises a sale. Your friend says that you can find the sale price of a shirt by multiplying the shirt's original price by 0.7. Do you agree? Explain.

SALE
30% off on all merchandise

Discuss with a classmate

Read your explanation for this problem out loud to your classmate.
Is your explanation convincing? What key math terms and phrases did you include in your response?

Close and Check

Focus Question

How does a common factor help you rewrite an algebraic expression?

Do you know HOW?

1. Write the factored form of the algebraic expression.

$$54f - 9g + 27h$$

2. Combine the like terms.

$$-17tr + 12tr$$

3. A video game store sells games for various prices. Sales tax is 7.5%. Let g be the price of a game. Use the expression to find the total cost of a video game.

$$g + 0.075g$$

4. A store advertises a sale of 15% off the total purchase price. Let p be the purchase price. Use the expression to find the final price.

$$p - 0.15p$$

Do you UNDERSTAND?

5. **Writing** How are the results of factoring the following expressions different?

$$2b + 6b$$ $$2b + 6$$

6. **Error Analysis** A classmate says the expression cannot be rewritten because it does not contain any like terms. Do you agree? Explain.

$$3x + (4y - 2xy)$$

Adding Algebraic Expressions

CCSS: 7.EE.A.1: Apply properties of operations as strategies to add, subtract, factor, and expand linear expressions with rational coefficients. 7.EE.A.2: Understand that rewriting an expression in different forms in a problem context can shed light on the problem … .

Launch

MP2, MP8

The twins hold a fundraiser for a local food pantry. People bring cash and food, so the twins struggle to state the total value of all items donated.

Write an expression to show the value of items donated. Explain your reasoning.

Reflect Could the twins find out how much money all the donated items are worth? Explain.

Got It?

PART 1 Got It

Identify the number of terms, the coefficients, and the constant term of this expression.

$6p - 7pc + 9c - 4$

PART 2 Got It

Which expressions are equivalent to $-6 + 5t$?

I. $(8t + 13) + (-3t + 7)$
II. $(t + 9) + (4t - 15)$
III. $5(-2 + t) + 4$
IV. $-1 + (2t + 3) + 2(t - 3)$

Got It?

PART 3 Got It

The width of the rectangle is one half of its length. Write and simplify an algebraic expression for the perimeter of the rectangle in terms of the rectangle's length ℓ.

Close and Check

Focus Question

 MP1, MP3

When would you want to add algebraic expressions? How do properties of operations help you add expressions?

Do you know HOW?

1. Identify the parts of the expression.

$$14d - 9 + 21k - 7dk + 2$$

A. number of terms

B. the coefficients

C. the constant terms

2. Circle the expressions that are equivalent to $12r - 4$.

A. $(9r + 6) - (-3r + 10)$

B. $-4(3r + 1)$

C. $(6r - 2) + (6r - 2)$

D. $-2(-6r - 2)$

3. The length of a box is 2.75 times greater than the width. Write and simplify an algebraic expression for the perimeter of the box in terms of the width w.

Do you UNDERSTAND?

4. **Reasoning** Is the coefficient of b in the expression below 2 or -2? Explain.

$$5c - 2b$$

5. **Error Analysis** A classmate simplifies the expression in Exercise 1. Is the expression he wrote equivalent to the original expression? Explain.

$$7dk(2 - 3 - 1) - 7$$

Subtracting Algebraic Expressions

CCSS: 7.EE.A.1: Apply properties of operations as strategies to add, subtract, factor, and expand linear expressions with rational coefficients. **7.EE.A.2:** Understand that rewriting an expression in different forms in a problem context can shed light on the problem and how the quantities in it are related.

Launch

© MP4, MP7

Your twin friends store the fundraiser items in a shed. Three raccoons break in and steal some of the food and money.
Write an expression that shows the value of the remaining fundraiser items in the shed. Explain your reasoning.

Fundraising Totals
Dollars: $65.50
Rice: 2 boxes
Peas: 3 cans
Corn: 5 cans

Reflect How are adding and subtracting expressions alike? Explain.

Got It?

Which expression(s) are equivalent to
$(6y + 15) - (4 - 8y)$?

I. $6y + 15 - 4 - 8y$

II. $6y + 15 - 4 + 8y$

III. $6y + 15 + (-1)(4 - 8y)$

IV. $6y + 15 + (-4) - (-8y)$

PART 2 Got It

What is the correct order for the steps of simplifying the expression
$(-9x + 15) - (2x - 1)$?

I. $-9x - 2x + 15 + 1$

II. $-11x + 16$

III. $-9x + 15 - 2x - (-1)$

IV. $-9x + 15 - 2x + 1$

PART 3 Got It

Write and simplify an expression for the area of the shaded region.

Close and Check

Focus Question

When would you want to subtract algebraic expressions? How do properties of operations help you subtract expressions?

Do you know HOW?

1. Rewrite the expression without parentheses.

$$4t - 4(3r - 2)$$

2. Number the steps of simplifying the expression in the correct order.

$$-3(-r + s) - 2(4r - 7s)$$

 $3r - 8r - 3s - (-14s)$

[] $3r - 8r - 3s + 14s$

[] $3r - 3s - 8r - (-14s)$

[] $-5r + 11s$

3. One friend buys a pair of shoes for $54.98 and 3 t-shirts. Another friend buys a sweatshirt for $26.49 and 5 t-shirts. Using one variable write a simplified expression to represent how much more one friend spent.

[]

Do you UNDERSTAND?

4. **Writing** Explain a different method for simplifying the expression in Exercise 2 than the method shown.

5. **Error Analysis** A classmate says she prefers to remove the parentheses before solving the equation. Can she do that and still find the correct solution? Explain.

$$(1.47a - 2.9) - (3.08a - 0.5)$$

Problem Solving

CCSS: 7.EE.A.1: Apply properties of operations as strategies to add, subtract, factor, and expand linear expressions with rational coefficients. **7.EE.A.2:** Understand that rewriting an expression in different forms in a problem context can shed light on the problem

Launch

© MP3, MP4

Two friends each write an expression to describe the total area, in square feet, of a three-panel mural. Each panel is a rectangle.

One friend wrote $6.7h + 12.4h + 5.9h$.

The other friend wrote $25h$.

Does one expression describe the area of the mural better than the other? Explain.

Reflect Does it help to show the equivalent expressions in different ways? Explain.

Got It?

PART 1 Got It

Write a difference of two products that is equivalent to $5x - 2y - 11$.

PART 2 Got It

A gardener plans to enlarge a small rectangular flower garden by x feet on all sides and then enclose the enlarged garden with a brick border. The border costs $2.30 per foot.

a. Write and simplify an expression for the cost, in dollars, of the brick border.

b. How much does the brick border cost if the gardener increases the length and width of the garden by 3.5 feet on each side?

Close and Check

Focus Question
MP1, MP6

How do different forms of an algebraic expression help you solve a problem?

Do you know HOW?

1. Write a difference of two products that is equivalent to $3x - 7y - 13$.

[]

2. Write a product of two factors that is equivalent to $35x - 21$.

[]

3. A homeowner wants to build a fence around her yard. Fencing costs $13.40 for each foot. Write and simplify an expression for the cost of the fencing.

2x ft

20 ft

5 ft deck

x ft

[]

Do you UNDERSTAND?

4. Reasoning One student wrote an expression for Exercise 3 by using addition. Another student wrote an expression by using subtraction. Can both students be correct? Explain.

5. Reasoning If the dimensions of the yard in Exercise 3 were doubled, would the total cost of the fencing double? Explain.

This page intentionally left blank.

New Vocabulary: coefficient, constant, expand an algebraic expression, factor an algebraic expression, like terms, simplify an algebraic expression

Review Vocabulary: algebraic expression, Distributive Property, greatest common factor (GCF)

Vocabulary Review

Identify two challenging vocabulary terms from this topic. Write one vocabulary term in the center oval, and fill in the surrounding boxes with details that will help you better understand the term.

Definition

Characteristics

Example

Nonexample

Definition

Characteristics

Example

Nonexample

Pull It All Together

TASK 1

A grocery store has a bottle return station where shoppers receive $.05 for each empty bottle returned. The drink you like to buy costs $1.25 per bottle. You usually return 40% of the bottles you buy.

a. Write the simplify an expression to represent your final cost after you return 40% of the bottles you buy one month.

b. What does your simplified expression tell you about your real cost per bottled drink? How would this change if you returned 80% of your bottles?

TASK 2

You buy a 24-pack of bottled water for $4.25 and a 24-pack of sports drinks for $20.50 to sell at the snack stand during a soccer game. You sell bottled water for $1.25 each and sports drinks for $1.50 each.

a. Write and simplify an expression for your total profit based on selling b bottles of water and c sports drinks.

b. Find a combination of b bottles of water and c sports drinks sold that gives you a profit of $30.

Solving Simple Equations

Digital Resources

CCSS: 7.EE.B.4: Use variables to represent quantities in a real-world or mathematical problem, and construct simple equations and inequalities to solve problems by reasoning about the quantities. Also, 7.EE.B.4a.

Launch

© MP1, MP7

A shaky egg bagel baker just wants to keep things equal. What should he charge for one bagel to match his cross-town rival?

Write and solve an equation to help him out. Explain your reasoning.

Reflect Can you represent this problem with more than one equation? Explain.

Got It?

PART 1 Got It

Solve the equation $b - 2 = -10$.

PART 2 Got It

Solve the equation $\frac{m}{0.5} = 11$. Check your answer.

PART 3 Got It

Which equation(s) have the same solution as $2.5a = 30$?

I. $\frac{4}{3}a = 16$ II. $a - 22.25 = -10.25$

Close and Check

Focus Question

How can writing two equivalent expressions help you solve a problem?

Do you know HOW?

1. Solve the equation $g + 12 = 18$.

2. Solve the equation $4r = -1.6$.

3. Solve the equation $\frac{w}{2.5} = 9$.

4. Which equation(s) has the same solution as $\frac{d}{6} = 7.3$?

A. $d - 15.9 = 27.9$

B. $2d = 87.2$

C. $-49 + d = 5$

D. $\frac{d}{4} = 10.95$

Do you UNDERSTAND?

5. Vocabulary What does it mean to isolate the variable?

6. Error Analysis A classmate solves the equation shown below. Explain her error and find the correct solution.

$$5t = 65$$
$$5(5t) = 65(5)$$
$$t = 325$$

This page intentionally left blank.

Writing Two-Step Equations

Digital Resources

CCSS: 7.EE.B.4: Use variables to represent quantities in a real-world or mathematical problem, and construct simple equations and inequalities to solve problems by reasoning about the quantities. Also, 7.EE.B.4a.

Launch

© MP1, MP2

The shaky mini-cheese bagel baker can't figure out how to calculate the price of each bagel for bagels one to twelve.

Write an equation the bagel maker could use to calculate the cost of each of the first twelve bagels. Explain your reasoning.

Reflect Can you represent the value of the 13 bagels as $13 \cdot b$? Explain.

Got It?

PART 1 Got It

A zookeeper takes care of 5 mountain lions. The keeper orders 32.5 pounds of meat for them each day. Each mountain lion receives the same amount. What equation can you use to find how much meat each mountain lion eats in a day?

PART 2 Got It

You have a 125-pound calf that you are raising for a 4-H project. You expect the calf to gain 65 pounds per month. Write an equation to find how many months it will take for the calf to weigh 1,000 pounds.

PART 3 Got It

Write an equation to represent the following description.
Eight less than ten times a number is 36.

Discuss with a classmate
Divide the word sentence of the problem into three parts.
Read each part out loud.
Then show how you wrote each word phrase using math symbols.

Close and Check

Focus Question

© MP1, MP6

What kinds of problems call for two operations?

▶ Do you know **HOW?**

1. An animal shelter houses 32 cats. The workers use 24 cups of cat food each day. Write an equation to find how many cups of food per cat the shelter uses each day.

2. An apartment rents for $725 per month plus a security deposit. The total cost for the apartment is $9,300 for the first year. Write an equation to find the security deposit amount.

3. Write an equation to represent the following description.
 The difference of seven times a number and 15 is 41.

▶ Do you **UNDERSTAND?**

4. **Writing** Describe your strategy for rewriting a word problem in the form of an equation.

5. **Reasoning** Is there more than one way to set up an equation based on a word problem? If so, give an example using Exercise 1, 2, or 3.

This page intentionally left blank.

Solving Two-Step Equations

Digital Resources

CCSS: **7.EE.B.3:** Solve multi-step real-life and mathematical problems posed with positive and negative rational numbers **7.EE.B.4a:** Solve word problems leading to equations of the form $px + q = r$... where p, q, and r are specific rational numbers Also, **7.EE.B.4.**

Launch

The shaky bagel baker decides to just divide by 13 to decide how much to charge for each bagel.

Does his method represent the per-bagel price his cross-town rival charges for bagels one to thirteen? Explain your reasoning.

Reflect What's the most important thing about solving equations? Explain.

Got It?

PART 1 Got It

Solve the equation $6x - 5 = 19$ using algebra tiles.

PART 2 Got It

Solve the equation $\frac{k}{2} + 7.3 = 29.3$.

PART 3 Got It

A boating club rents sail boats for $60 for the first hour and $20 for each additional hour. When you return your boat, your fee is $140. Write and solve an equation to find how many hours you kept the boat.

Close and Check

Focus Question

How is solving a two-step equation similar to solving a one-step equation?

Do you know HOW?

1. Write the modeled equation. Then solve it.

 Equation: _____

 Solution: _____

2. Solve the equation $24.8 = 6g + 10.4$.

 Solution: _____

3. You open a savings account with $30. You deposit an additional $20 every week. Write and solve an equation to find how many weeks it will take you to save $150.

 Equation: _____

 Solution: _____

Do you UNDERSTAND?

4. **Reasoning** Explain how to check the answer to Exercise 3.

5. **Error Analysis** Your friend says it will only take $4\frac{1}{2}$ weeks to save $150 in the account from Exercise 3 because you have to subtract the original amount of the deposit, which is equal to $1\frac{1}{2}$ weeks. Do you agree? Explain.

This page intentionally left blank.

Solving Equations Using the Distributive Property

CCSS: 7.EE.B.3: Solve multi-step real-life and mathematical problems posed with positive and negative rational numbers **7.EE.B.4a:** Solve word problems leading to equations of the form $px + q = r$... where p, q, and r are specific rational numbers ... Also, **7.EE.B.4.**

Digital Resources

Launch

© MP2, MP4

The shaky bagel baker boldly decides to charge 5¢ more per bagel than his rival does for whole-wheat bagels.

Write an expression to show how he could figure out a per-dozen price. Explain your reasoning.

Expression

Reflect What is the difference between an expression and an equation?

Got It?

PART 1 Got It

Solve the equation $\frac{3}{4}(8b - 4) = -2$.

PART 2 Got It

Which equations require two or more operations to solve?

I. $\frac{4}{5}x = 20$ II. $-5(3x - 1) = 40$ III. $\frac{3}{5}x - 19 = 17$

Got It?

PART 3 Got It

You mailed 20 identical invitations weighing more than 1 ounce each. Mailing each invitation cost $.44 for the first ounce, plus $.17 for each additional ounce. The postage for all of the invitations cost $15.60. Write and solve an equation to find the weight of each invitation.

Close and Check

Focus Question

MP4, MP6

When is it useful to model a situation in two different ways?

Do you know HOW?

1. Solve the equation.
 $-3.2(5d - 7) = -17.6$

2. Circle the equation(s) that requires more than two operations to solve.

 A. $\frac{2}{3}x = -15$

 B. $3(5h + 9) = 57$

 C. $4(8s) - 6 = 218$

 D. $4.5(r + 1) = 27$

3. Three families each buy the same number of $15 tickets to the zoo. Each family also pays $5.50 for parking. The total cost is $196.50. Write and solve an equation to find how many tickets each family buys.

 Equation: _____

 Solution: _____

Do you UNDERSTAND?

4. **Writing** Write a possible real-world problem to match the equation in Exercise 2, letter D.

5. **Error Analysis** A classmate says the first step to solve the equation $12(3g - 9) = 99$ is to add 9 to both sides. Do you agree? Explain.

Problem Solving

Digital Resources

CCSS: 7.EE.B.4: Use variables to represent quantities in a real-world or mathematical problem, and construct simple equations and inequalities to solve problems by reasoning about the quantities. Also, **7.EE.B.3** and **7.EE.B.4a.**

Launch

© MP1, MP4

Use words to describe or a picture to model a real-world situation that relates to the equation shown. Your situation must somehow involve the secret ingredient, bagels. Go!

$6b + 1.50 = 5.40$

Reflect Does describing an equation with words or modeling it with a picture help you solve an equation? Explain.

Got It?

PART 1 Got It

A company is relocating their office to a larger office space. The manager rents a moving truck for $39.95 plus $.99 per mile. Before returning the truck, the manager fills the tank with gasoline, which costs $65.32. The total cost is $164.67. Make a bar diagram to find how many miles they drove the truck.

PART 2 Got It

Orcas swim at a rate of 704 feet per minute.
a. Solve the distance formula $d = rt$ for time t.
b. Find the time it will take for an orca to swim 26,400 feet.

PART 3 Got It

Write a baking problem that you can model with the equation $\frac{1}{2}r = 1\frac{2}{3}$.

Then solve the problem.

Close and Check

Focus Question

Real-world situations can be complicated or hard to understand. What can models and equations show better than words?

Do you know HOW?

1. At an arcade you buy 5 game cards and your friend buys 3 game cards. Your lunch costs $6 and your friend's lunch costs $4. Altogether, the two of you spend $50. Complete the bar diagram to find the cost of one game card.

2. How much does each game card cost?

3. A ruby-throated hummingbird flies 9 miles in 20 minutes. Use the formula to find its average speed in miles per hour.

$$d = rt$$

Do you UNDERSTAND?

4. **Writing** Explain how formulas are helpful in problem solving.

5. **Reasoning** A classmate solves Exercise 3 by using division. Is this a reasonable method? Explain.

This page intentionally left blank.

Topic Review

New Vocabulary: Addition Property of Equality, Division Property of Equality, isolate a variable, Multiplication Property of Equality, Subtraction Property of Equality
Review Vocabulary: Distributive Property, equation, two-step equation

Vocabulary Review

 Identify two challenging vocabulary terms from this topic. Write one vocabulary term in the center oval, and fill in the surrounding boxes with details that will help you better understand the term.

Definition

Characteristics

Example

Nonexample

Definition

Characteristics

Example

Nonexample

Pull It All Together

TASK 1

This formula relates temperature in degrees Fahrenheit (*f*), to the number of cricket chirps (*n*) in one minute.

$$f = 50 + \left(\frac{n - 40}{4}\right)$$

a. Solve the formula for *n*.

b. How many chirps does a cricket make in one minute if the temperature outside is 67.5 degrees Fahrenheit?

TASK 2

Melvin the Mathemagician claims that if you tell him your result from the number trick shown, he can guess your original number by subtracting 5 and then dividing by 2. Is Melvin's claim true?

Step 1 **Think of any number.**

Step 2 **Add 3.**

Step 3 **Multiply the result by 2.**

Step 4 **Subtract 1.**

Use expressions and equations to explain his "secret method."

Solving Simple Inequalities

Digital Resources

CCSS: 7.EE.B.4: Use variables to represent quantities in a real-world or mathematical problem, and construct simple inequalities to solve problems by reasoning about the quantities. **7.EE.B.4b:** ... Graph the solution set of the inequality.

Launch

© MP3, MP4

A superstar challenges a track team's top three runners to beat his 100-meter time. "You can take 5 seconds from your times and still not best it," he says. Two runners fail. One runner doesn't.

Show their possible times and how you know you're right.

9.95 sec

100 m

Runner 1:

Runner 2:

Runner 3:

Reflect How many possible times minus 5 seconds could beat the runner's record? Explain.

Got It?

PART 1 Got It

Write an inequality to represent the following statement.

You drank less than $2\frac{1}{2}$ cups of water today.

PART 2 Got It (1 of 2)

Solve $8 + r \le 22.5$. Graph the solutions.

Got It?

PART 2 Got It (2 of 2)

Describe the error in the student's work in graphing the solution of $-3 < t + 3.6$.

PART 3 Got It

A number minus $3\frac{2}{5}$ is more than 17. Write and solve an inequality. Check your answer.

Close and Check

Focus Question

How is the solution to an inequality different from the solution to an equation?

Do you know HOW?

1. Use the symbol, $<$, \leq, $>$, \geq, $=$, or \neq, that best represents the statement.

 I walked no more than 12 blocks.

 b ⬚ 12

2. Solve $12.5 + c > 27.3$.

 ⬚

3. Graph $r \geq -3$.

 $$\begin{array}{cccccc} -5 & -4 & -3 & -2 & -1 & 0 \end{array}$$

4. Write and solve an inequality to represent the statement.

 $14\frac{3}{5}$ is less than $3\frac{1}{5}$ fewer than a number.

 Inequality: ⬚

 Solution: ⬚

Do you UNDERSTAND?

5. **Reasoning** Can the solution to an inequality ever be equal to only one value? Explain.

6. **Error Analysis** A classmate solves and graphs the inequality $-7 + k \leq 3$. Is her work correct? Explain.

 $$k \leq 10$$

 $$\begin{array}{cccccc} 7 & 8 & 9 & 10 & 11 & 12 \end{array}$$

Solving Inequalities Using Multiplication or Division

CCSS: 7.EE.B.4: Use variables to represent quantities in a real-world or mathematical problem, and construct simple inequalities to solve problems by reasoning about the quantities. **7.EE.B.4b:** ... Graph the solution set of the inequality.

Digital Resources

Launch

MP1, MP4

The superstar runner says he can beat the track team's best 400 m time four straight times. "You can double my time each time I run, and I'll be fine," he says. The superstar succeeds three times and fails the fourth.

Show his possible times and how you know you're right.

400 m 94 sec

Track Team Record

Run 1:

Run 2:

Run 3:

Run 4:

Reflect Did the superstar have to run a specific time to back his claim about beating the track team's time? Explain.

Got It?

PART 1 Got It

A mouse drinks at least 0.042 L of water a week. How many liters of water does a mouse drink in a day, on average?

Write and solve an inequality.

PART 2 Got It

Solve $-3.8g \geq 30.4$.

Got It?

PART 3 Got It (1 of 2)

What is the solution of $\frac{1}{12}b \le \frac{1}{12}$?

PART 3 Got It (2 of 2)

If half of a number is less than 100, what is a possible value of the number?

Do not write and solve an inequality. Instead, make a conjecture about the solution.

Close and Check

Focus Question

The *concept of balance* plays a large role when you solve equations. What role does the *concept of balance* play when you solve inequalities?

Do you know HOW?

1. A rain forest receives up to 260 inches of rain each year. On average, how many inches of rain fall each month? Write and solve an inequality. Round your answer to the nearest tenth of an inch.

Inequality: []

Solution: []

Inches of Rain: []

2. Solve $-3.7y \geq 9.62$.

[]

3. Solve $\frac{s}{-4} < 14$.

[]

4. Movie tickets cost at least $8. You want to buy as many tickets as possible with $36. Write and solve an inequality. Tell how many tickets you can buy.

Inequality: []

Solution: []

Tickets: []

Do you UNDERSTAND?

5. Reasoning What values of x make the statement below false? Explain.

$$3x \geq 2x$$

6. Error Analysis A classmate solves the inequality $-5b > 40$. Her solution is shown below. Explain how to use substitution to determine if her solution is correct.

$$b > -8$$

Solving Two-Step Inequalities

Digital Resources

CCSS: 7.EE.B.4: Use variables to represent quantities ... and construct simple inequalities
7.EE.B.4b: Solve problems leading to inequalities of the form $px + q > r$ or $px + q < r$, where p, q, and r are rational numbers. Graph the solution set ... and interpret it in the context

Launch

MP3, MP4

The superstar runner challenges the track team to a bowling match.
"You can each double your score and include 10 more, and I'll still top the top score," he says.

All three team members who try beat the runner using his scoring method. Show their possible scores and explain your reasoning.

Johnny's Score: 300

Track Team Bowler 1:

Track Team Bowler 2:

Track Team Bowler 3:

Reflect Are there an infinite number of scores that could beat the superstar runner's boast? Explain.

Got It?

PART 1 Got It

Half of a number *t* plus 25.9 is at most 203.56.
Write an inequality that represents the situation.

PART 2 Got It (1 of 2)

The magician's assistant needs to rope off a rectangle for his most famous trick.
The length of the rectangle must be exactly 7.5 ft, but he has at most 24 ft of rope
to use. What are the possible widths of the rectangle?
Write, graph, and solve an inequality.

Got It?

PART 2 Got It (2 of 2)

The assistant is making a rectangle with a length of 7.5 ft and
has at most 24 ft of rope to use. So the width w of the rectangle
is $w \leq 4.5$ ft.

Do you think that all values that satisfy the inequality $w \leq 4.5$ ft
are reasonable solutions? Explain your reasoning.

PART 3 Got It

What is the solution of $4f - 8 \geq -21$?

Close and Check

Focus Question

© MP1, MP8

What kinds of problems call for two operations?

Do you know HOW?

1. You have $54 to take yourself and some friends to the movies. Movie tickets cost $8.50 each. Write and solve an inequality to find how many tickets you can buy if you also want to spend $11.50 on snacks at the concession stand.

Inequality: _____

Solution: _____

2. Write and solve an inequality to represent 19 less than the product of −7 and a number is greater than or equal to 23.

Inequality: _____

Solution: _____

3. Write and solve an inequality to represent the difference of 3 times a number and 18 is less than 63.

Inequality: _____

Solution: _____

Do you UNDERSTAND?

4. Writing Explain how solving an inequality by multiplying or dividing by a negative value affects the solution. Why is the solution affected this way?

5. Vocabulary Explain how to solve an inequality by finding equivalent inequalities.

Solving Multi-Step Inequalities

Digital Resources

CCSS: 7.EE.B.4: Use variables to represent quantities ... and construct simple inequalities
7.EE.B.4b: Solve problems leading to inequalities of the form $px + q > r$ or $px + q < r$, where p, q, and r are rational numbers. Graph the solution set ... and interpret it in the context

Launch

© MP3, MP6

You and a friend spend Friday nights quizzing each other on math problems. Just as your friend races to show you the solution to $-2(x + 5.5) = 20$, you say, "I meant $-2(x + 5.5) > 20$."

Did your friend waste her time solving the equation? Explain.

Reflect How is solving an inequality alike and different from solving an equation? Explain.

Got It?

PART 1 Got It

Solve $56 > 231(q - 35)$ and graph the solution.

PART 2 Got It

Solve $3\frac{2}{5}w + 1\frac{4}{5}w \le 26$.

Got It?

PART 3 Got It (1 of 2)

Find, describe, and correct the error in the student work shown.

$$3h + 5h + 8.6 \geq -23.4$$

$$8h + 8.6 \geq -23.4$$

$$8h \geq -32$$

$$h \leq -4$$

PART 3 Got It (2 of 2)

Your friend says that the solution of $2(m + 3) < 10$ is $m > 2$. Give a counterexample to show that she is incorrect.

Close and Check

Focus Question

How is it possible for two different inequalities to describe the same situation? What does it mean for two inequalities to be equivalent?

Do you know **HOW?**

1. Solve $58 \leq 29(7 - r)$.

2. Graph the solution to Exercise 1.

3. Solve $12.3g + 7.9g + 15.86 > 70.4$.

4. Graph the solution to Exercise 3.

5. Your friend makes $15 each week babysitting. She makes $7.50 a week doing yard work. How many weeks will it take her to make more than $75?

 weeks

Do you **UNDERSTAND?**

6. Writing Explain how to check the solution to Exercise 1.

7. Error Analysis A classmate writes the solution to $-10r - 2r - 2 < 22$. Use a counterexample to show that she is incorrect, and explain her error.

$r < -2$

Problem Solving

CCSS: 7.EE.B.4: Use variables to represent quantities in a real-world or mathematical problem, and construct simple inequalities to solve problems by reasoning about the quantities. **7.EE.B.4b:** Solve word problems leading to inequalities of the form $px + q > r$ or $px + q < r$....

Launch

© MP1, MP6

The Friday night math club wants to beat last year's fund drive of $40.25. The superstar runner shows his support by buying two club mugs.

Write and solve an inequality to show how many more mugs the club needs to sell to beat last year's total. Explain your reasoning.

Reflect Is an equation or an inequality better for solving this problem? Explain.

Got It?

PART 1 Got It

Write an inequality that has the solution $n \leq 8$.

PART 2 Got It

A salesperson has $375.80 in a savings account. Each week, she earns $865 and deposits 10% of the check into the account. After how many weeks will she have more than $1,000 in the account?

Got It?

PART 3 Got It

In the first quarter of the year, an applesauce company sells 721 units in the first month, 724 units in the second month, and 723 units in the third month.

How many units do they need to sell in the fourth month to average at least 724 units sold per month?

Close and Check

Focus Question

MP4, MP8

How can we describe problem situations that do not involve equal relationships?

Do you know HOW?

1. A credit card has a balance of $5,245 plus an interest of 13% of the balance. Write an inequality to find how much the cardholder will need to pay to bring the balance below $5,500.

2. For Exercise 1, what is the minimum amount the cardholder needs to pay to bring the balance below $5,500?

3. Write a 1-step inequality and a 2-step inequality that each have the solution $x > -12$.

 1-step:

 2-step:

4. The revenue from your lemonade stand is $R = 2(g - 10) + 50$ where g is the glasses of lemonade you sell. The cost to keep the stand running is $236. How many whole cups of lemonade do you have to sell to make a profit?

 Cups:

Do you UNDERSTAND?

5. **Writing** Give an example of how writing an inequality can help you make a decision in real life.

6. **Reasoning** The bank charges a low-balance fee to customers when their checking accounts fall below $100. A customer spends $27.50 at the grocery store. Can writing an inequality help the customer avoid the fee? Explain.

Topic Review

New Vocabulary: equivalent inequalities inequality, solution of an inequality
Review Vocabulary: Distributive Property, isolate a variable, negative number positive number

Vocabulary Review

Identify two challenging vocabulary terms from this topic. Write one vocabulary term in the center oval, and fill in the surrounding boxes with details that will help you better understand the term.

Definition	Characteristics
Example	Nonexample

Definition	Characteristics
Example	Nonexample

Pull It All Together

TASK 1

A *Moderato* piece of music has a tempo range of 66–126 beats per minute. A conductor is rehearsing the first minute of a *Moderato* piece. The diagram below shows how the conductor is going to monitor the beats for the piece. She counts the first 16 beats herself and then listens for the cymbal crashes (every 8 beats) for the remaining beats.

What are the least and greatest numbers of cymbal crashes she should count by the end of the first minute?

TASK 2

A music producer is editing a recording. He slows down the tempo by 8 beats per minute. Then he reduces the tempo by 15%.

His project requires the finished recording to have a tempo of less than 144.4 beats per minute. As he is wrapping up his work, he realizes that he forgot to write down the tempo of the original recording! What is the fastest possible tempo the original recording could have?

Digital Resources

CCSS: **7.EE.B.4:** Use variables to represent quantities in a real-world or mathematical problem, and construct simple equations and inequalities to solve problems by reasoning about the quantities. Also, **7.EE.B.4a** and **7.G.A.2.**

Launch

Ⓒ MP3, MP5

Compare Angle 1 and Angle 2. Tell which is greater.

Show how you know using only paper and pencil.

Reflect How does the length of the rays (or sides) in an angle relate to its measure?

Got It?

PART 1 Got It

What is the measure of ∠CAB?

PART 2 Got It (1 of 2)

You can classify angles as right, acute, obtuse, or straight. Which type of angle is *not* represented in the diagram?

Got It?

Can the sum of the measures of two acute angles be greater than the measure of a straight angle? Explain.

PART 3 Got It

The measure of $\angle ABC$ is 60°. Find the value of x.

Discuss with a classmate

How did you apply what you know about solving equations to solve this problem? Describe the steps you took to set up the equation to solve.

Close and Check

MP2, MP3

Focus Question

All angles are formed by two rays. What makes angles different from each other?

Do you know HOW?

1. What is the measure of ∠PQR?

2. Label each angle *acute, right, obtuse,* or *straight.*

3. The measure of ∠ABC is 70°. Find the value of x.

(7x + 35)°

x = _____

Do you UNDERSTAND?

4. **Error Analysis** Your friend measures the angle below and says it is 30°. Explain his mistake and find the correct angle measure.

5. **Reasoning** Can the sum of an acute and a right angle be equal to the measure of a straight angle? Explain.

Adjacent Angles

CCSS: 7.G.B.5: Use facts about supplementary, complementary, vertical, and adjacent angles in a multi-step problem to write and solve simple equations for an unknown angle in a figure. Also **7.G.A.2.**

Launch

© MP3, MP7

∠*BAC* measures 100°.

Identify at least three things that you know about the measures of ∠*BAD* and ∠*DAC* without measuring them.

Reflect Do you need to measure both ∠*BAD* and ∠*DAC* to know both of their measures? Explain.

Got It?

Which angles are adjacent to ∠EOD?

PART 2 Got It

The measure of ∠ABC is 100°. What is the value of x?

Close and Check

▶ Focus Question

© MP2, MP7

A whole is the sum of its parts. How can you apply this idea to angles?

▶ Do you know **HOW?**

Use the diagram below for Exercises 1 and 2.

1. Name two angles adjacent to ∠2.

2. Name two angles adjacent to ∠5.

3. The measure of ∠ABD is 40°. What is the value of x?

$x = $ ☐

▶ Do you **UNDERSTAND?**

4. **Vocabulary** Explain why ∠1 and ∠3 from Exercise 1 are not adjacent angles.

5. **Error Analysis** The measure of ∠JKL is 125°. The equation $3x + 5 - 40 = 125$ was written to find the value of x. Is this correct? Explain.

This page intentionally left blank.

Complementary Angles

CCSS: 7.G.A.2: Draw (freehand, with ruler and protractor ...) geometric shapes with given conditions 7.G.B.5: Use facts about ... complementary ... angles in a multi-step problem to write and solve simple equations for an unknown angle in a figure.

Launch

You make two rectangular picture frames. Your pieces line up on the first frame but not on your second frame.

 MP4, MP7

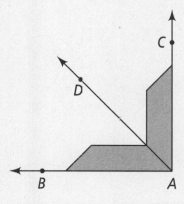

Explain why your first frame works and your second frame does not work. Explain what you know about frame angles and the adjacent angles in the frames.

Reflect If $m\angle BAD$ and $m\angle DAC$ are equal, explain how you can find the measure of each angle.

Got It?

Name two angles that are *not* complementary.

Your friend claims that all complementary angles must be acute angles. Is your friend right? Explain.

Discuss with a classmate

Read each other's explanations to this problem.
Are key words like complementary and acute part of the explanation?
Write down any key words used in the explanations that you are unfamiliar with and ask what the words mean.

Got It?

What is the value of x?

47.6°

$x°$

Close and Check

Focus Question

MP5, MP7

What do you know about the measures of two angles that form a right angle?

Do you know HOW?

1. What is the measure of the complement for the angle below?

35°

2. Name two complementary angles.

P V T
50° 40°
60°
30°
Q R S

3. ∠ABD and ∠DBC are complementary angles. What is the value of x?

A D
4x° 70°
B C

x = ___

Do you UNDERSTAND?

4. Reasoning Can two complementary angles form an obtuse angle? Explain.

5. Error Analysis Your friend says that the angles below are not complementary because they are not adjacent. Is she correct? Explain.

25° 65°

CCSS: 7.G.A.2: Draw (freehand, with ruler and protractor ...) geometric shapes with given conditions **7.G.B.5:** Use facts about supplementary ... angles in a multi-step problem to write and solve simple equations for an unknown angle in a figure.

Launch

© MP2, MP4

Hockey players want the blades of their sticks to lie flat on the ice.

45° Lie angle

If this player holds his hockey stick to the ice at a 45° angle, at what lie angle should his stick be? Explain how you know.

Reflect Will a taller player need a stick with a greater or lesser lie angle if he wants the blade to lie flat on the ice? Tell how you know.

Got It?

PART 1 Got It

Suppose $m\angle ABC = 48.4°$. Find the measure of its supplement.

PART 2 Got It (1 of 2)

What is the value of x?

PART 2 Got It (2 of 2)

Can the measures of supplementary angles be equal? Explain.

Close and Check

Focus Question

MP5, MP7

What do you know about the measures of two angles that form a straight angle?

Do you know HOW?

1. What is the measure of the supplement of the angle below?

135°

2. Suppose $m\angle PQR = 63.7°$. Find the measure of its supplement.

3. What is the value of x?

$4x°$ $64°$

$x = $ ⬚

Do you UNDERSTAND?

4. **Reasoning** What kinds of angles (acute, right, and obtuse) can form a pair of supplementary angles? Explain how you know.

5. **Error Analysis** A friend says that a straight line is a supplementary angle because it measures 180°. Do you agree or disagree with your friend? Explain.

This page intentionally left blank.

Vertical Angles

CCSS: 7.G.B.5: Use facts about supplementary, complementary, vertical, and adjacent angles in a multi-step problem to write and solve simple equations for an unknown angle in a figure. Also **7.G.A.2.**

Launch

MP7, MP8

Your friend claims to "know all the angles." She looks at Figure 1, laughs, and says, "All the angles are 90°."

So, you show her Figure 2 and tell her Angle 1 is 80°. She laughs and says she can find the other angle measures without measuring them.

Figure 1 **Figure 2**

Explain how she could do this. Describe any patterns that you see.

Reflect Did the patterns that you found in Figure 2 apply to Figure 1? Explain.

Got It?

PART 1 Got It (1 of 2)

Name the angle that is the vertical to ∠ABC.

PART 1 Got It (2 of 2)

Can vertical angles be supplementary angles? Explain.

Got It?

PART 2 Got It (1 of 2)

What is the value of *x*?

PART 2 Got It (2 of 2)

Your friend claims that vertical angles can be acute, right, or obtuse. Is your friend right? Explain.

Close and Check

Focus Question

 MP3, MP5

Two intersecting lines form angles. How can you describe the relationship between the angles that are opposite each other?

Do you know HOW?

1. Name the angle that is vertical to ∠ROQ.

2. What is the value of *x*?

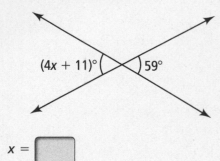

(4x + 11)° 59°

x = []

Do you UNDERSTAND?

3. Writing In the diagram, ∠1 and ∠3 are vertical angles. Why aren't ∠2 and ∠4 vertical angles?

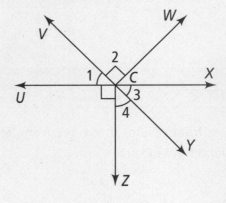

4. Reasoning If you know the measure of ∠4, how can you find the measure of ∠1?

Problem Solving

CCSS: 7.G.B.5: Use facts about supplementary, complementary, vertical, and adjacent angles in a multi-step problem to write and solve simple equations for an unknown angle in a figure.

Launch

© MP2, MP4

A dog on a leash buries bones in strategic positions in the backyard. You watch from Window 2.

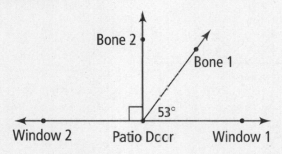

Look at the different angles formed by the leash and the house. How many degrees apart are Bones 1 and 2? How many degrees apart is Bone 1 and Window 2? Write and solve an equation for each situation.

Angle from Bone 1 to Bone 2:

Angle from Bone 1 to Window 2:

Reflect Think about the different types of angles you know about. Which ones did you use to solve the problem?

Got It?

PART 1 Got It

If $m\angle 2 = 90°$, which of the following statements must always be true?

I. $m\angle 1 = m\angle 3$

II. $m\angle 1 + m\angle 3 = m\angle 2$

III. If $\angle 3$ is acute, then $\angle 1$ is obtuse.

Got It?

PART 2 Got It

In the following diagram, $m\angle 1 = 46°$, $m\angle 3 = (2x - 6)°$, and $m\angle 4 = (y + 8)°$. Find the values of x and y.

Close and Check

Focus Question

You can use relationships between angles to break complex diagrams into smaller parts. How do you decide which relationships to use?

Do you know HOW?

1. Write True or False above each statement about the diagram.

$m\angle 2 = m\angle 3$ $m\angle 1 = m\angle 3$

$m\angle 6 = m\angle 8$ $m\angle 5 + m\angle 8 = 180°$

2. What is the measure of $\angle 1$?

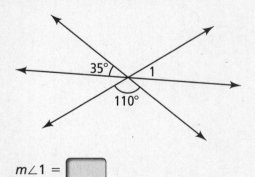

$m\angle 1 =$ []

Do you UNDERSTAND?

3. **Reasoning** In Exercise 1, $\angle 5$ and $\angle 12$ are congruent. Explain how to use the relationships between the angles in the triangle to find the $m\angle 1$?

4. **Writing** Explain how to find $m\angle 1$ in Exercise 1 if the $m\angle 5$ is 110°.

New Vocabulary: acute angle, adjacent angles, angle, complementary angles, obtuse angle, right angle, straight angle, supplementary angles, vertex of an angle, vertical angles
Review Vocabulary: classify, intersecting lines

Vocabulary Review

Identify two challenging vocabulary terms from this topic. Write one vocabulary term in the center oval, and fill in the surrounding boxes with details that will help you better understand the term.

Pull It All Together

Six students (*A*, *B*, *C*, *D*, *E*, and *F*) perform a maypole dance at your school's spring festival. The positions of *A* and *C* are given. Use the clues to determine the positions of the other students around the maypole (*M*).

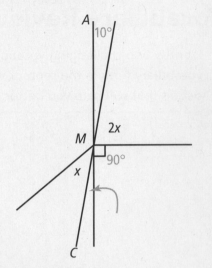

Then determine how many degrees separate each student from the students on his or her right and left.

Clues:

- *A* and *B* are 10° apart.
- ∠*AMB* and ∠*CMD* are vertical angles.
- ∠*AMB* and ∠*BMF* are complementary angles.

CCSS: 7.EE.B.4: Use variables to … construct simple equations … . **7.G.B.4:** Know the formulas for the area and circumference of a circle and use them to solve problems … . Also, **7.EE.B.4a** and **7.G.A.2.**

Launch

Ⓒ MP4, MP5

A landscaper wants to build a flower garden with a fountain in the center and a path on the outside. The landscaper wants the fountain to be same distance from anywhere on the path.

Draw the garden plan. Explain how it matches what the landscaper wants.

Reflect Could the garden path be any shape and still match what the landscaper wants? Explain.

Got It?

PART 1 Got It

How many radii are shown?

PART 2 Got It

In the diagram, $ST = 4\frac{1}{3}$ ft. What is SO?

Got It?

If $KM = 2x - 4$ and $LM = 12$, what is the value of x?

Discuss with a classmate

Name the parts of the circle that are key to solving this problem.
Identify each of these parts in the diagram.
How do you use what you know about solving equations and the parts of the circle
that are given to solve the problem?

Close and Check

MP1, MP7

▶ Focus Question

What are the relationships among the parts of a circle?

▶ Do you know HOW?

1. How many radii are shown?

[]

2. The radius of the circle above is 14.5 cm. Find the diameter.

[]

3. The diameter of a circle is $7x + 5$ and the radius is 13. Find the value of x.

[]

▶ Do you UNDERSTAND?

4. Reasoning If the length of the radius of a circle is increased 3 times, what happens to the length of the diameter? Write an equation to show how you know.

5. Writing A circular path surrounds a dog park. The developers want to build a supply shed in the center of the park. How can they determine where to build the shed?

CCSS: **7.G.A.2:** Draw ... geometric shapes with given conditions **7.G.B.4:** Know the formulas for the area and circumference of a circle and use them to solve problems

Launch

© MP2, MP8

For each circle, describe any pattern you see between the distance around the circle and the length of its diameter.

Reflect What do you think will be the distance around a circle with a diameter of 100 cm? Explain.

Got It?

PART 1 Got It (1 of 2)

What is the circumference of a circle with a diameter of 4 in.?

PART 1 Got It (2 of 2)

What effect does doubling the radius of a circle have on the circumference of the circle?

PART 2 Got It

To the nearest tenth of a meter, what is the circumference of a circle with a radius of 3.4 m? Use 3.14 for π.

Got It?

PART 3 Got It (1 of 2)

What is the diameter of a circle with a circumference of 88 ft?
Use $\frac{22}{7}$ for π.

PART 3 Got It (2 of 2)

Explain how you might decide whether to use $\frac{22}{7}$ or 3.14 as an approximation for π.

Close and Check

Focus Question

How is the diameter of a circle related to the distance around a circle?

Do you know HOW?

1. Find the diameter and radius of a circle with a circumference of 16π in.

 Diameter: Radius:

 [] []

For Exercises 2–4, use 3.14 for π.

2. The distance across a circular reflecting pool is 12 m. Find the distance around the pool.

 []

3. Find the diameter of a circle with a circumference of 62.8 yd.

 []

4. A roundabout is a circular road built at a traffic intersection. One city has a roundabout that is 1.5 mi long. A statue sits in the center. Find the distance from the outer edge of the roundabout to the statue to the nearest hundredth.

 []

Do you UNDERSTAND?

5. **Compare and Contrast** Two students find the circumference of a circle with a diameter of 16 ft. One student says the circumference is 50.24 ft. The other says it is 50.29 ft. Can both students be correct? Explain.

6. **Writing** Explain how to use a wheel's circumference to find its diameter.

CCSS: 7.G.B.4: Know the formulas for the area and circumference of a circle and use them to solve problems; give an informal derivation of the relationship between the circumference and area of a circle. Also, **7.G.A.2.**

Digital Resources

Launch

Each grid square represents **1 ft** by **1 ft**. Estimate the area of the circle. Explain how you made your estimate.

© MP2, MP5

Circle	Square	Triangle

Reflect Which shapes did you find the area of first? Why?

Got It?

What is the area of a circle with a radius of 3.2 m? Leave your answer in terms of π.

What is the radius of a circle that has the same numerical value for area and circumference? How do the units compare?

Got It?

PART 2 Got It

Bubble netting is a hunting technique used by humpback whales. They blow bubbles in a circular ring that drives fish toward the center of the circle. What is the area of a ring of bubbles 100 feet wide? Use 3.14 for π.

PART 3 Got It

How many smaller circles do you need to equal the area of the larger circle?

diameter = 12 in.

diameter = 4 in.

Close and Check

Focus Question

How are the areas of a circle and a parallelogram related?

Do you know HOW?

1. Find the area of a circle with a radius of 6.9 m to the nearest tenth. Leave your answer in terms of π.

 []

2. The average crop circle is between 100 and 300 ft in diameter. Find the area of a crop circle that is 300 ft in diameter. Use 3.14 for π.

 []

3. A baker makes a giant cookie for special occasions that is 16 in. in diameter. How many 4-in. diameter cookies would it take to equal the area of one giant cookie?

 [] cookies

Do you UNDERSTAND?

4. **Compare and Contrast** What is the difference between the circumference and area of a circle?

5. **Reasoning** A round pizza has an area of 254.34 in.2. Explain how to estimate the length and width of the square box needed to package the pizza.

Relating Circumference and Area of a Circle

CCSS: 7.G.B.4: Know the formulas for the area and circumference of a circle and use them to solve problems; give an informal derivation of the relationship between the circumference and area of a circle.

Launch

© MP3, MP5

Does a greater distance around a shape always mean a greater area?
Show one pair of rectangles and one pair of circles where greater distance around does not mean a greater area. If you can't show an example, explain why.

Rectangles

Circles

Reflect Besides size, can you change a circle's basic shape? Can you change a rectangle's basic shape? How might this relate to the problem above?

Got It?

PART 1 Got It

A circle has a circumference of 22 cm. What is the approximate area of the circle? Use 3.14 for π.

PART 1 Got It (1 of 2)

The ratio of the area of a circle to the circumference of a circle $\left(\frac{A}{C}\right)$ is $\frac{11}{1}$. What is the circumference of the circle? Leave your answer in terms of π.

Got It?

Use formulas to show why $\frac{A}{C} = \frac{1}{2}r$.

e and Check

Focus Question

How are the area of a circle and the circumference of a circle related?

Do you know HOW?

1. A circle has a circumference of 38 yd. Find the approximate area of the circle. Use 3.14 for π.

```
┌─────────────────┐
│                 │
└─────────────────┘
```

2. The ratio of the area of a circle to the circumference of the circle $\left(\frac{A}{C}\right)$ is $\frac{7}{1}$. Find the circumference of the circle. Leave your answer in terms of π.

```
┌─────────────────┐
│                 │
└─────────────────┘
```

3. The ratio of the area of a circle to the circumference of the circle $\left(\frac{A}{C}\right)$ is $\frac{5}{1}$. Find the area of the circle. Leave your answer in terms of π.

```
┌─────────────────┐
│                 │
└─────────────────┘
```

4. The ratio of the area of a circle to the circumference of the circle $\left(\frac{A}{C}\right)$ is $\frac{6}{1}$. Find the circumference and area of the circle. Leave your answers in terms of π.

$C = $
```
┌─────────────────┐
│                 │
└─────────────────┘
```

$A = $
```
┌─────────────────┐
│                 │
└─────────────────┘
```

Do you UNDERSTAND?

5. Reasoning The ratio $\left(\frac{A}{C}\right)$ of a circle is $\frac{3}{1}$. Explain how to use this information to find the radius and circumference of the circle.

6. Error Analysis The ratio $\left(\frac{A}{C}\right)$ of a bike wheel is $\frac{4}{1}$. Your friend says $C = 8\pi$ and $A = 16\pi$. Explain and correct the error your friend made.

Problem Solving

Digital Resources

CCSS: 7.G.B.4: Know the formulas for the area and circumference of a circle and use them to solve problems; give an informal derivation of the relationship between the circumference and area of a circle.

Launch

MP1, MP8

A T-shirt company plans a logo with green circles on yellow squares. Which logo has the most green? Explain.

24 in.

Plan A

24 in.

Plan B

24 in.

Plan C

Reflect Which logo did you think had the most green before you found the areas? Why?

Got It?

To the nearest square inch, what is the total area of glass in the window shown? Use 3.14 for π.

24 in.

36 in.

Got It?

PART 2 Got It

What is the area of the shaded region? The diameter of each half-circle is 1.5 in. Use 3.14 for π.

4 in.

3 in.

PART 3 Got It

The area of a rectangular skating rink with a width of 10 ft is 300 ft². Suppose you dismantle the surrounding fence and reuse it to surround a new circular skating rink. What is the approximate area of the new rink?

Discuss with a classmate

Draw diagrams to show the two skating rinks described in the problem.
Compare your diagrams.
Did you label the parts correctly?
How do diagrams help you to solve the problem?

Close and Check

Focus Question

MP2, MP6

When do you use circumference to measure a circle? When do you use area?

▶ Do you know **HOW?**

1. You buy a square tablecloth with a side length of 5 ft. You place it on a round table with a diameter of 4 ft. Find the area of the tablecloth that is hanging off the edge of the table. Use 3.14 for π.

2. The radius of each half circle is 2 cm. The length of the figure is twice the diameter of the half circles. Find the area of the figure. Use 3.14 for π.

$r = 2$ cm

▶ Do you **UNDERSTAND?**

3. Reasoning A fence encloses a circular area of 530.66 ft². Can the same fence be used to enclose a rectangular area with perimeter 90 ft? Explain how you know.

4. Error Analysis Your friend says that if you double a circle's radius, the circumference and area double as well. Explain his error.

New Vocabulary: area of a circle, circle, circumference, diameter, pi, radius
Review Vocabulary: segment

Vocabulary Review

Identify two challenging vocabulary terms from this topic. Write one vocabulary term in the center oval, and fill in the surrounding boxes with details that will help you better understand the term.

Definition	Characteristics
Example	**Nonexample**

Definition	Characteristics
Example	**Nonexample**

Pull It All Together

TASK 1

A watch designer sketched a design for a new watch. The designer needs to send a description of certain measurements to the manufacturer.

a. A purple border will surround the inner circle of the watch. What will be the length of the border? Use 3.14 for π.

b. The half-circle and small circle designs will be metallic blue. How many square millimeters of the entire watch will be metallic blue? Use 3.14 for π.

c. The outer frame that contains the designs will be silver. How many square millimeters of the watch will be silver?

21 mm

7 mm

6 mm 1 mm

Not drawn to scale.

Geometry Drawing Tools

CCSS: 7.G.A.2: Draw (freehand, with ruler and protractor, and with technology) geometric shapes with given conditions. Focus on constructing triangles from three measures of angles or sides, noticing when the conditions determine a unique triangle . . .

Launch

MP6, MP8

A gift-shop owner sees the eight-sided sign she ordered from the local sign maker and says, "You got it wrong. I wanted an octagon like a stop sign."

Do you think the sign maker or the gift-shop owner was to blame for the wrong sign? Explain.

Reflect If you ordered a sign for a shop, what would you do to make sure you received the correct sign?

Got It?

PART 1 Got It

Sketch a quadrilateral with exactly one pair of parallel sides.

PART 2 Got It

Use a ruler and a protractor to draw a figure with two sides 1 in., two sides 3 in., and at least one right angle.

Got It?

PART 3 Got It

Draw a rhombus with side lengths of 4 units and angle measures 40°, 140°, 40°, and 140°.

Close and Check

Focus Question

(C) MP1, MP5

Which geometry drawing tools are best for drawing which types of figures?

Do you know **HOW?**

1. Sketch a quadrilateral with one right angle and no parallel sides.

2. Use a ruler and a protractor to draw a trapezoid that has two right angles, two parallel sides, and one 55° angle. Let one side of the figure measure 3 cm and another side measure 2 cm.

Do you **UNDERSTAND?**

3. **Writing** You try to quickly explain the difference between equilateral and isosceles triangles to your cousin. Which geometry drawing tools should you use? Explain.

4. **Error Analysis** An architect sketches a diagram for a square room. Does the sketch provide enough information to the builders? Explain.

Drawing Triangles with Given Conditions 1

CCSS: 7.G.A.2: Draw geometric shapes with given conditions. Focus on constructing triangles from three measures of angles or sides, noticing when the conditions determine a unique triangle, more than one triangle, or no triangle

Digital Resources

Launch

© MP1, MP5

The sign maker tries to sketch two possible triangle-shaped signs.
Sign 1 has side lengths 2 ft, 3 ft, and 3 ft. Sign 2 has side lengths 1 ft, 1 ft, and 3 ft.

Draw the two signs and label the side lengths. Let 1 in. = 1 ft. Can the sign maker make both signs? Explain.

Sign 1 Sign 2

Reflect What rule would you make about drawing triangles based on this problem?

Got It?

Suppose the set crew receives instructions for another triangle-shaped prop that uses wood pieces of lengths 5 ft, 10 ft, and 11 ft. Your friend sketched the plan shown. Would anyone using these three wood pieces build the exact same triangle-shaped prop? Explain.

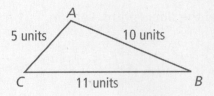

5 units A 10 units

C 11 units B

If you form a triangle from three given side lengths, do you always get a unique triangle or more than one triangle?

Got It?

PART 2 Got It (1 of 2)

Draw triangle QRS where $m\angle R = 40°$, $RQ = 12$ cm, and $RS = 8$ cm. Is the triangle unique? Explain.

PART 2 Got It (2 of 2)

If you form a triangle from two side lengths and the included angle measure, do you always get a unique triangle, or more than one triangle?

Got It?

PART 3 Got It (1 of 2)

Given triangle ABC, where AB = 5 units, CA = 5 units, and $m\angle ACB$ = 52°, can you draw a unique triangle, more than one triangle, or no triangle? Explain.

PART 3 Got It (2 of 2)

If you form a triangle from two side lengths and the measure of an angle that is not included, do you always get a unique triangle, or more than one triangle?

Close and Check

Focus Question

MP2, MP5

What information do you need to draw a unique triangle?

Do you know HOW?

1. Draw triangle DEF, where $m\angle D = 45°$ and $DE = 4$ cm.

2. Given triangle XYZ, where $XZ = 10$ cm, $YZ = 7$ cm, and $m\angle XZY = 115°$, can you draw a *unique triangle, more than one triangle,* or *no triangle?*

3. For triangle QRS with the given conditions, can you draw a *unique triangle, more than one triangle,* or *no triangle?*
 $QR = 15$ units, $RS = 10$ units, $ST = 5$ units

Do you UNDERSTAND?

4. **Writing** Is the triangle in Exercise 1 unique? Explain.

5. **Error Analysis** Your friend says that he can draw a unique triangle as long as he knows at least two sides and an angle. Explain the error in his reasoning.

This page intentionally left blank.

Drawing Triangles with Given Conditions 2

CCSS: 7.G.A.2: Draw geometric shapes with given conditions. Focus on constructing triangles from three measures of angles or sides, noticing when the conditions determine a unique triangle, more than one triangle, or no triangle.

Launch

Ⓒ MP5, MP6

The sign maker again tries to sketch two triangle-shaped signs. Sign 1 has angle measures 45°, 45°, and 100°. Sign 2 has angle measures 30°, 60°, and 90°.

Draw the two signs and label the angle measures. Can the sign maker make both signs? Explain.

Sign 1　　　　　　　　　　　　　　　Sign 2

Reflect What rule would you make about drawing triangles based on this problem?

Got It?

PART 1 Got It (1 of 2)

Draw two different triangles with angle measures 30°, 100°, and 50°.

PART 1 Got It (2 of 2)

If you form a triangle from three given angle measures, do you always get a unique triangle, or more than one triangle?

Got It?

Given triangle *ABC*, where *BC* = 10 units, $m\angle ABC = 35°$, and $m\angle ACB = 80°$, can you draw a unique triangle, more than one triangle, or no triangle? Explain.

If you form a triangle from two given angle measures and the length of their included side, do you always get a unique triangle, or more than one triangle?

Got It?

PART 3 Got It (1 of 2)

Given triangle ABC with $BC = 13$, $m\angle CAB = 70°$, and $m\angle ACB = 60°$, can you draw a unique triangle, more than one triangle, or no triangle?

PART 3 Got It (2 of 2)

If you form a triangle from two given angle measures and the length of a side that is *not* included, do you always get a unique triangle, or more than one triangle?

Close and Check

Focus Question
MP2, MP6

What is the minimum number of side lengths and angle measures you need to draw a unique triangle?

Do you know HOW?

1. Given triangle DEF, where $m\angle D = 72°$, $m\angle E = 96°$, and $m\angle F = 17°$, can you draw a *unique triangle, more than one triangle,* or *no triangle?*

2. Given triangle *LMN*, where $LM = 23$ units, $m\angle NLM = 33°$, and $m\angle NML = 97°$, can you draw a *unique triangle, more than one triangle,* or *no triangle?*

3. For triangle *JKL*, two side lengths and the measure of the nonincluded angle are given. Can you draw a *unique triangle, more than one triangle,* or *no triangle?*

Do you UNDERSTAND?

4. **Reasoning** If you are given the length of \overline{LN} instead of \overline{LM} in Exercise 2, would your answer be the same?

5. **Error Analysis** A classmate says that if you know either three angle measures or three side lengths, then there is one unique triangle that can be constructed. Do you agree? Explain.

This page intentionally left blank.

2-D Slices of Right Rectangular Prisms

CCSS: 7.G.A.3: Describe the two-dimensional figures that result from slicing three-dimensional figures, as in plane sections of right rectangular prisms and right rectangular pyramids.

Launch

© MP3, MP8

A chef needs a piece of cheese for a new recipe. The chef makes a straight top to bottom slice from a block of cheese.

How are the attributes of the piece of cheese and the attributes of the block of cheese alike? How are they different? Explain your reasoning.

4 in. 13 in.

4 in.

Alike:

Different:

Reflect Does it matter to your solution where the chef makes the straight up and down slice? Explain.

Got It?

PART 1 Got It (1 of 2)

What are the dimensions of the cross section formed by slicing the prism as shown?

5 cm

6 cm

4 cm

Not to scale

PART 1 Got It (2 of 2)

What is one dimension of the cross section formed by slicing the prism as shown?

3 in.

2 in.

10 in.

Got It?

PART 2 Got It (1 of 2)

Draw and describe a cross section formed by a vertical plane that slices the front and back faces of the prism.

PART 2 Got It (2 of 2)

Describe a cross section formed by a plane that cuts off a corner of a cube.

Close and Check

MP5, MP7

Focus Question

How can the faces of a rectangular prism determine the shape and dimensions of a slice of the prism?

Do you know HOW?

1. What are the dimensions of the cross section formed by slicing the rectangular prism vertically as shown?

9 m

3 m

2 m

[]

2. What are the dimensions of the cross section formed by slicing the same rectangular prism horizontally?

[]

3. Draw the cross section that is formed by the vertical plane that intersects the front and back faces of the rectangular prism.

9 m

3 m

2 m

Do you UNDERSTAND?

4. **Reasoning** Draw the 3-D figure that would result from slicing a corner from the prism in Exercise 1. Describe the faces of the new figure and tell its name.

5. **Writing** Explain how could you change one of the dimensions of the rectangular prism in Exercise 3 without changing the size and shape of the cross section you drew.

2-D Slices of Right Rectangular Pyramids

CCSS: 7.G.A.3: Describe the two-dimensional figures that result from slicing three-dimensional figures, as in plane sections of right rectangular prisms and right rectangular pyramids.

Launch

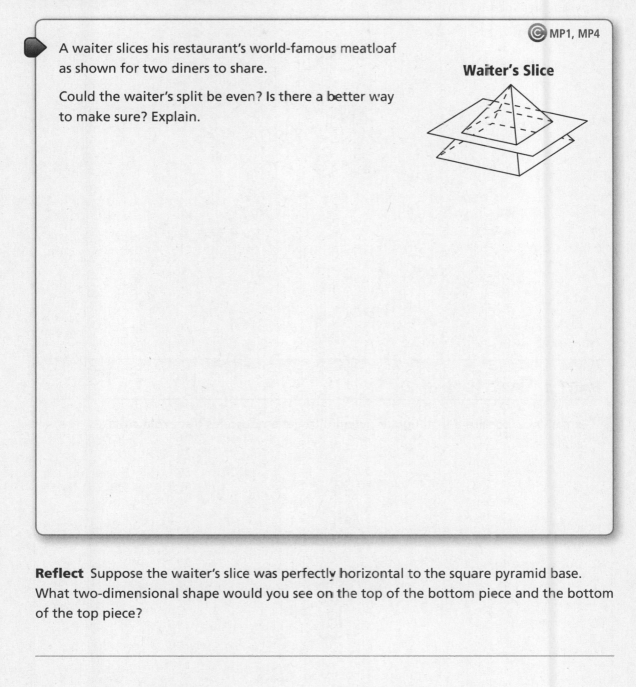

© MP1, MP4

A waiter slices his restaurant's world-famous meatloaf as shown for two diners to share.

Could the waiter's split be even? Is there a better way to make sure? Explain.

Waiter's Slice

Reflect Suppose the waiter's slice was perfectly horizontal to the square pyramid base. What two-dimensional shape would you see on the top of the bottom piece and the bottom of the top piece?

Got It?

PART 1 Got It (1 of 2)

What are the shape and dimensions of the cross section formed by slicing the pyramid as shown?

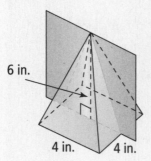

6 in.

4 in. 4 in.

PART 1 Got It (2 of 2)

Explain how to slice a rectangular pyramid to get an isosceles trapezoid cross section.

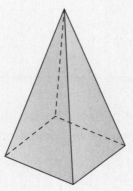

Got It?

 Draw and describe two triangular cross sections, each formed by a plane that intersects the vertex and is perpendicular to the base.

Explain how to slice a rectangular pyramid through the vertex to get triangles of many different heights.

Close and Check

Focus Question

MP2, MP7

How can the faces of a rectangular pyramid determine the shape and dimensions of a slice of the pyramid?

Do you know HOW?

1. Would the area of a slice perpendicular to the base of a rectangular pyramid that passes through the vertex be *greater than, less than,* or *equal to* the area of a side of the pyramid?

2. A horizontal slice is made halfway up the rectangular pyramid. What is the shape of this cross section?

5 in.

6 in. 4 in.

3. What are the dimensions of the cross section of the pyramid in Exercise 2?

Do you UNDERSTAND?

4. **Reasoning** Draw a slice from the rectangular pyramid that forms an isosceles trapezoid. Explain how you know your figure is correct.

5. **Writing** Explain how you determined the answer to Exercise 3.

Problem Solving

CCSS: 7.G.A.2: Draw (freehand, with ruler and protractor, and with technology) geometric shapes with given conditions **7.G.A.3:** Describe the two-dimensional figures that result from slicing three-dimensional figures **7.G.B.6:** Solve real-world and mathematical problems involving area

Launch

© MP3, MP6

Write detailed directions for someone else to draw a geometric figure. Test your directions by drawing the figure yourself.

Description	Drawing

Do you need to revise your directions? Explain.

Reflect Was the description or the drawing the most difficult part of the problem? Explain.

Got It?

PART 1 Got It

The jeweler told the assistant to sketch a pendant of a blue equilateral triangle on top of a green square. The assistant drew Sketch A, but the jeweler was expecting Sketch B. What other details should the jeweler have provided?

Sketch A

Sketch B

PART 2 Got It

Suppose the carpenter wants the box shown cut to have dimensions 16 in. × 6 in. × 4 in. About how many square inches of wood does the carpenter need to close the side of the new box?

4 in.

16 in.

8 in.

Got It?

Draw the cross section formed by a vertical slice through the vertex of the pyramid and perpendicular to the top face of each prism.

Close and Check

Focus Question

©MP3, MP6

Why might it be important to have precise descriptions for drawing or making figures?

Do you know HOW?

1. Label the top cross section **T**, the middle cross section **M**, and the bottom cross section **B**.

Do you UNDERSTAND?

2. **Reasoning** Two box makers want to slice the box so it has half the volume. One plans a 2 ft by 4 ft by 3 ft box. The other plans a 1 ft by 4 ft by 6 ft box. Explain which plan works.

2 ft 6 ft

4 ft

3. **Writing** Write a clearer description that their boss can use to explain that he wants a 2 ft by 2 ft by 6 ft box.

New Vocabulary: cross section, included angle, included side
Review Vocabulary: net, parallelogram, plane, pyramid, three-dimensional figure, triangle

Vocabulary Review

Identify two challenging vocabulary terms from this topic. Write one vocabulary term in the center oval, and fill in the surrounding boxes with details that will help you better understand the term.

Definition		Characteristics
Example		**Nonexample**

Definition		Characteristics
Example		**Nonexample**

Pull It All Together

TASK 1

A team of carpenters is building bookshelves for a new library. They have completed the frames and want to install the shelves.

a. The carpenters want the bookshelves to hold six rows of books. How many additional square inches of wood do they need?

b. They also want to divide the shelves into three columns. How many additional square inches of wood do they need?

90 in.

16.5 in. 129 in.

TASK 2

The carpenters will also build rolling ladders for the bookshelves. The following are instructions that two lead carpenters wrote for the workers:

1. Construct a ladder for each bookshelf where the angle at the top is 17° and the angle at the bottom, away from the shelf, is 73°.

2. Construct a ladder for each bookshelf where the ladder leans against the shelf at 80 inches above the ground and it touches the floor 24 inches away from the shelf.

Which instruction has enough information to ensure that all the workers make identical ladders?

Surface Areas of Right Prisms

Digital Resources

CCSS: 7.G.B.6: Solve real-world and mathematical problems involving area, volume and surface area of two- and three-dimensional objects composed of triangles, quadrilaterals, polygons, cubes, and right prisms.

Launch

Ⓒ MP4, MP7

One square foot of this cube-shaped sculpture takes you 10 minutes to polish. At this rate, how long will it take you to polish the whole thing? Justify your reasoning.

5 ft

Reflect Why do you need only the length of one edge to solve the problem?

Got It?

PART 1 Got It

What is the surface area of a cube with edge length $\frac{3}{4}$ ft?

PART 2 Got It

What is the surface area of the triangular prism?

Got It?

PART 3 Got It

To the nearest square inch, what is the surface area of the regular hexagonal prism?

1.7 in.

2 in.

8 in.

Close and Check

Focus Question

How can you apply what you know about finding the surface area of a right rectangular prism to finding the surface area of any right prism?

Do you know HOW?

Find the surface area of each figure below.

1.

3 ft 7 ft

2 ft

2.

12 cm

13 cm

23 cm

10 cm

3.

1.3 cm

5 cm

1.5 cm

Do you UNDERSTAND?

4. Error Analysis Explain the mistake made below. What is the correct surface area?

2 in.

2 in.

5 in.

S.A. = (2 + 2 + 2 + 2)(5) + 4

S.A. = (8)(5) + 4

S.A. = 40 + 4

S.A. = 44 in.2

5. Writing If you turned the rectangular prism from Exercise 1, would the surface area change? Explain.

13-2

Volumes of Right Prisms

Digital Resources

CCSS: 7.G.B.6: Solve real-world and mathematical problems involving area, volume and surface area of two- and three-dimensional objects composed of triangles, quadrilaterals, polygons, cubes, and right prisms.

Launch

© MP2, MP4

In Germany, Ms. Adventure packs cube-shaped candles in a box to send home. She plans to wrap the box in brown paper for shipping.

How many candles can she stack in each shipping box?

☐ candles ☐ candles

Which box should she choose? Explain your reasoning.

Reflect Do boxes with the same amount of space inside always have the same surface area? Why is this important?

Got It?

What is the volume of a cube with edge length $\frac{3}{4}$ ft?

A cube has an edge length of less then 10 units. The cube has a surface area of x square units and a volume of x cubic units. What is the edge length of the cube?

Got It?

The triangular prism has bases that are equilateral triangles. To the nearest cubic meter, what is the volume of the prism?

3.5 m

11.6 m

4 m

To the nearest cubic centimeter, what is the volume of the regular hexagonal prism?

5.2 cm

10.9 cm

6 cm

Close and Check

Focus Question

 MP2, MP7

How can you apply what you know about finding the volume of a right rectangular prism to finding the volume of any right prism?

Do you know HOW?

Find the volume of each figure below.

1.

1.3 ft

4 ft

1 ft

2.

2.6 in.

4 in.

3 in.

3. A shipping company packs ornaments in cubes that have an edge length of 4 inches. How many cubes can fit in a rectangular box that is 12 inches tall, 16 inches wide, and 20 inches long?

 cubes

Do you UNDERSTAND?

4. Compare and Contrast Compare the volume of the triangular prism in Exercise 1 with the volume of the rectangular prism below.

1.3 ft

4 ft

1 ft

5. Writing Why can the formula for the volume of a rectangular prism be written as $V = Bh$ or $V = lwh$?

Surface Areas of Right Pyramids

CCSS: 7.G.B.6: Solve real-world and mathematical problems involving area, volume and surface area of two- and three-dimensional objects composed of triangles, quadrilaterals, polygons, cubes, and right prisms.

Launch

MP2, MP4

Ms. Adventure plans a cardboard model of the Red Pyramid she saw in Dashur, Egypt. She only has one piece of colored construction paper to cover her pyramid.

Does she have enough construction paper? Explain your reasoning.

4 in.

5 in.

10 in.

Reflect Suppose you want to buy more than one piece of paper to cover an object. How would knowing the object's surface area help you decide how much paper to buy?

Got It?

PART 1 Got It

What is the surface area of the square pyramid?

11 in.

10 in.

PART 2 Got It (1 of 2)

To the nearest square foot, what is the surface area of the regular triangular pyramid?

5.2 ft

5.2 ft

6 ft

Got It?

PART 2 Got It (2 of 2)

> What conclusions can you draw about a triangular pyramid if the height of the base is equal to the slant height?

PART 3 Got It (1 of 2)

> You want to make a tent that has the shape of a regular hexagonal pyramid with the dimensions shown. To the nearest square foot, how much fabric do you need?

9 ft

6.1 ft

7 ft

PART 3 Got It (2 of 2)

> What are two different ways you could find the lateral area of a regular hexagonal pyramid?

Close and Check

Focus Question

©MP2, MP7

How can you apply what you know about finding the surface area of one right square pyramid to finding the surface area of any right pyramid?

Do you know HOW?

1. Circle the pyramid that has a surface area of 52 in.².

4.5 in.

4 in.

4 in.

7 in.

3 in.

3 in.

2. A paperweight is in the shape of a pyramid with an equilateral triangle for a base. Find the surface area of the paperweight.

8 cm

5.2 cm

6 cm

Do you UNDERSTAND?

3. **Reasoning** Is it possible to make a model of the pyramid below by using an 11-inch by 17-inch sheet of paper? Explain.

6 in.

3.5 in.

4 in.

4 in.

4. **Error Analysis** What mistake was made in the calculation? What is the correct surface area?

12 cm

13 cm

10 cm

$S.A. = \frac{1}{2}(4 \times 10)(12) + (10)^2$

$S.A. = \frac{1}{2}(40)(12) + 100$

$S.A. = 240 + 100 = 340 \text{ cm}^2$

Volumes of Right Pyramids

CCSS: 7.G.B.6: Solve real-world and mathematical problems involving area, volume and surface area of two- and three-dimensional objects composed of triangles, quadrilaterals, polygons, cubes, and right prisms.

Launch

© MP1, MP8

Look for a pattern in the volumes of the prism and pyramid pairs.
Then find the volume of the fourth pyramid. Explain your reasoning.

Pyramid volume: $\frac{1}{3}$ ft^3

Prism volume:

Pyramid volume: 2 ft^3

Prism volume:

Pyramid volume: 6 ft^3

Prism volume:

Pyramid volume:

Prism volume:

Reflect Describe another situation where you can use a pattern to figure out something you don't know.

Got It?

PART 1 Got It (1 of 2)

Ms. Adventure visited the Mayan pyramids in Mexico. The structure shown approximates a square pyramid with a height of 30 m. What is the approximate volume of the Mayan Pyramid?

55 m

PART 1 Got It (2 of 2)

What happens to the volume of a square pyramid when you double the side length of the base?

Got It?

PART 2 Got It

To the nearest cubic foot, what is the volume of the regular triangular pyramid?

8.2 ft

8.7 ft

10 ft

PART 3 Got It

To the nearest cubic foot, what is the volume of the regular hexagonal pyramid?

4 ft

2 ft

1.7 ft

Close and Check

Focus Question

How can you apply what you know about finding the volume of one right square pyramid to finding the volume of any right pyramid?

Do you know HOW?

1. Circle the pyramid that has the greater volume.

2. What is the volume of the pyramid below?

Do you UNDERSTAND?

3. **Compare and Contrast** What measures of a square pyramid do you need to calculate its surface area and volume?

4. **Error Analysis** Describe the mistake made when calculating the volume of the pyramid. What is the correct volume?

$V = \frac{1}{3}(165.6 \cdot 7.6)$

$V = \frac{1}{3}(1258.6)$

$V = 419.5 \text{ cm}^3$

CCSS: 7.G.B.6: Solve real-world and mathematical problems involving area, volume and surface area of two- and three-dimensional objects composed of triangles, quadrilaterals, polygons, cubes, and right prisms.

Launch

© MP4, MP7

On her trip to Morocco, Ms. Adventure finds a tea light lantern with the glass broken. How much glass will she need to fix the lantern? Explain your reasoning.

3 in.

4 in.

4 in.

4 in.

Reflect Describe another situation in mathematics where you can break apart a problem into simpler parts to solve.

Got It?

PART 1 Got It

In cubic feet, how much space is inside the doghouse?

PART 2 Got It

Ms. Adventure's friend takes home a slice of the hexagonal layer cake. The slice is one sixth of the whole cake. To the nearest cubic inch, how much cake is left?

Close and Check

Focus Question

When do you use surface area to measure a three-dimensional figure? When do you use volume?

Do you know HOW?

1. A packaging company makes a rectangular box that is 9 inches long, 5 inches wide, and 5 inches tall. How many whole boxes can be made from a sheet of cardboard that is 20 inches by 33 inches?

5 in.

5 in.

9 in.

 boxes

2. A company is redesigning a box to hold pencil erasers. The volume of the box must be 24 cubic inches. What are the dimensions of the box that uses the least amount of material?

length = []

width = []

height = []

Do you UNDERSTAND?

3. **Reasoning** You want to find out how much wrapping you need to wrap a gift for your friend. Do you need to calculate the surface area or the volume of the gift? Explain.

4. **Writing** Describe how the volume and surface area change when all of the dimensions (length, width, and height) of a rectangular prism are doubled.

This page intentionally left blank.

New Vocabulary: lateral area, surface area, volume
Review Vocabulary: base area, height of a prism, height of a pyramid, lateral face, prism, pyramid

Vocabulary Review

Identify two challenging vocabulary terms from this topic. Write one vocabulary term in the center oval, and fill in the surrounding boxes with details that will help you better understand the term.

Definition

Characteristics

Example

Nonexample

Definition

Characteristics

Example

Nonexample

Pull It All Together

TASK 1

Ms. Adventure bought a wooden puzzle while traveling abroad. The puzzle has the shape of a regular hexagonal prism. She wants to send the puzzle to a friend as a gift.

Ms. Adventure wants to wrap the gift before she sends it. What is the minimum number of square inches of wrapping paper she needs?

Justify your answer.

4 in.

3.5 in.

4 in.

TASK 2

Ms. Adventure has two shipping boxes that are rectangular prisms. She wants to choose one of them to ship the puzzle. She cares about the environment, so she wants to use the box that has the least amount of cardboard and requires the least amount of packing peanuts. Box A has a 12-in. by 12-in. base. Box B has a 16-in. by 9-in. base. The height of each box is 8 in. Which box should she choose? Justify your answer.

Populations and Samples

Digital Resources

CCSS: 7.SP.A.1: Understand that statistics can be used to gain information about a population by examining a sample of the population; generalizations about a population from a sample are valid only if the sample is representative of that population

Launch

© MP3, MP6

The tumultuous town mayor decides to trash the way the town collects trash. The mayor vows to knock on every door and talk to each household to get new trash collection ideas.

Describe a situation where this approach would be a good idea and a situation where it would be a bad idea.

Reflect When do you talk to everyone about an issue? Can the definition of "everyone" change depending on your issue?

Got It?

You are studying the T-shirts being sold at a clothing store. Which are *samples*?

I. every other T-shirt in the store
II. all of the T-shirts in the store
III. all of the medium-sized T-shirts
IV. one T-shirt in the store
V. all of the striped T-shirts in the store

Suppose you have a sample of 15 people. Can you tell what population you are studying? Explain.

PART 2 Got It

You are studying the people in the United States. You want to know who goes sledding each year. Which samples are likely to contain a bias? Justify your reasoning.

I. Everyone in Colorado, Utah, and Vermont
II. 200 people from each state
III. Everyone in Florida, Louisiana, and Texas
IV. Everyone who owns a sled

Discuss with a classmate

What do you know about the term bias?
Choose one of the numbered statements that you identified as having a bias. Explain to your classmate why you think there is a bias in that sample.

Got It?

PART 3 Got It (1 of 2)

A magazine company studies a representative sample of people who read their magazine. In the sample, there are 12 women and 8 men. Which inference(s) about their readership is (are) valid?

I. 60% of the magazine's readers are women.

II. 8 out of 12 of the magazine's readers are men.

III. More men read the magazine than women.

PART 3 Got It (2 of 2)

Suppose you are studying the people in the United States who read newspapers. Would the sample "1 person from each state" be a representative sample made up of 50 subjects?

Close and Check

Focus Question

MP1, MP7

When is it reasonable to use a small group to represent a larger group? When is it not reasonable?

Do you know HOW?

1. You are studying the nutritional value of all meals served at your school. Circle the samples.

 A. the nutritional value of all breakfasts served

 B. the nutritional value of meals served on Mondays

 C. the nutritional value of all meals served

 D. the nutritional value of all lunches served

2. You are studying the popularity of sports at your school. Circle the samples that are likely to contain a bias.

 A. students who play sports

 B. students who attend your school

 C. students who attend sporting events

 D. students who watch sports on TV

Do you UNDERSTAND?

3. **Reasoning** A shoe manufacturer surveys Midwest farmers about the popularity of work boots in the U.S. Can the manufacturer make a valid inference about boot popularity from the sample? Explain.

4. **Writing** Describe the population and representative sample of a study on high school graduates going to college. Explain how the study can limit bias.

Estimating a Population

Digital Resources

CCSS: 7.SP.A.2: Use data from a random sample to draw inferences about a population with an unknown characteristic of interest. Generate multiple samples (or simulated samples) of the same size to gauge the variation in estimates or predictions Also, **7.SP.A.1.**

Launch

MP2, MP4

A newspaper reporter arrives late to a game and sees a few remaining fans. The reporter knows nothing about the teams or the game but concludes that the home team lost. Describe how the reporter may have come to this conclusion.

Reflect Could the reporter be wrong? How?

Got It?

PART 1 Got It (1 of 2)

In a representative sample of 24 seventh graders, there are three students with April birthdays. Suppose there are 448 students in the seventh grade. Estimate how many students in the seventh grade you can infer have April birthdays.

PART 1 Got It (2 of 2)

How do you know that there is a constant of proportionality between a representative sample and the population?

Got It?

You want to find the number of fiction books in your local library. There are 5,000 books in the library. You have three samples. The actual number of fiction books in the library is 1,500. Which sample(s) best represent the population?

Sample A: fiction, children's, biography, fiction, non-fiction, poetry, p ay
Sample B: 12 "fiction," 15 "non-fiction," and 12 "biography"
Sample C: 40 "fiction," 29 "non-fiction," 7 "poetry," 19 "drama," and 39 "children's"

How is the estimate of a population affected by the size of the sample?

Got It?

PART 3 Got It (1 of 2)

An apple orchard has 874 apple trees. Three gardeners each checked 75 apple trees in different areas of the orchard and noted the number of trees that are ready for picking. Each gardener used his or her results to estimate the total number of trees in the orchard that are ready for picking.

Gardener A: 11 apple trees ready for picking
Gardener B: 18 apple trees ready for picking
Gardener C: 13 apple trees ready for picking

a. What was each gardener's estimate?
b. Suppose the actual number of trees ready for picking is 161. How can you use the information in the samples to get the best estimate?

PART 3 Got It (2 of 2)

The three samples in the Example were the same size. What could explain the differences in the inspector's estimates?

Close and Check

> ## Focus Question
>
>
> When can you use a small group to estimate things about a larger group?
>
> _____
>
> _____
>
> _____
>
> _____
>
> _____

▶ Do you know **HOW?**

1. In a representative sample of 100 vehicles in a parking lot, there are 15 vans. There are 480 vehicles in the parking lot. Estimate how many of them are vans.

 [____] vans

2. You want to find the number of red rubber bands there are in a bag of 540. The actual number of red rubber bands is 120. Which sample best represents the population?

 A. 1 red, 2 green, 1 blue rubber band

 B. 18 red, 28 green, 10 blue, 11 orange, and 23 purple rubber bands

 C. 61 red, 92 green, 29 blue, 28 orange, and 60 purple rubber bands

3. The widget factory samples 75 widgets and finds 3 defective ones. If the factory produces 500 widgets a day, how many defective widgets can they expect to produce?

 [____] defective widgets

▶ Do you **UNDERSTAND?**

4. **Reasoning** You record the number of students in your class who have green eyes. Is this enough information to estimate the total number of green-eyed students in the school? Explain.

5. **Error Analysis** Three friends each visit 10 of the 60 area homes to find how many have pets. One friend finds 3 homes; the others find 7 and 5. They conclude that 15 of 60 homes have pets. Explain their error.

This page intentionally left blank.

Convenience Sampling

CCSS: 7.SP.A.1: Understand that statistics can be used to gain information about a population by examining a sample of the population; generalizations about a population from a sample are valid only if the sample is representative of that population

Launch

MP1, MP3

The tumultuous town mayor wants to re-route the town bus routes. So, he goes to the two nearest bus stops and asks riders for their opinions.

Describe the good and not-so-good parts of this approach.

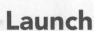

Reflect Describe a situation where just asking friends for their opinions would be a good idea.

Got It?

PART 1 Got It

Suppose you are doing research on the students in your grade. Which of the description(s) is *not* an instance of convenience sampling?

I. You choose the first 20 students that you see.
II. You choose all of the students in your school band.
III. You choose all of the students in your classroom.
IV. You choose 10 students from each classroom.

PART 2 Got It

Suppose you are a news reporter, investigating the town's opinion of the new shopping center. What are three ways to choose a convenience sample of town residents to interview? Are the samples that you chose representative samples?

Explain.

Got It?

PART 3 Got It (1 of 2)

Use the convenience sample to estimate how many of the 1,165 cars on Highway 60 are red. Is your estimate accurate?

Convenience sample: Out of the 40 cars that you can see, there are 16 red ones.

PART 3 Got It (2 of 2)

Suppose a business owner wants to determine what the site's visitors think of his Web site. He uses his e-newsletter list as his convenience sample. Does the sample have bias?

Explain.

Close and Check

Focus Question

How do you sample in a way that is convenient? What are the advantages and disadvantages of convenience sampling?

Do you know HOW?

1. Suppose you are doing research on the most popular snack foods. Circle the examples of convenience sampling.

 A. You ask your friends.

 B. You ask each person shopping at a convenience store.

 C. You give a survey to each household in your neighborhood.

 D. You ask all the students who ride your bus.

2. You want to find out how many people support the school tax. Circle the representative sample.

 A. You ask every adult in your extended family.

 B. You ask the first 25 adults you see at the mall.

 C. You ask the parents of your friends.

Do you UNDERSTAND?

3. **Writing** A new industrial plant moves into a city of 300,000 people. You want to know if the citizens support the industrial development. Describe a convenience sample and tell whether it would be a representative sample.

4. **Reasoning** A reporter finds that 9 out of the 10 people he interviews at a concert like the band. Use his data to estimate how many of the 40,000 people in the town like the band. Is it an accurate estimate? Explain.

Systematic Sampling

CCSS: 7.SP.A.1: Understand that statistics can be used to gain information about a population by examining a sample of the population; generalizations about a population from a sample are valid only if the sample is representative of that population

Launch

© MP3, MP4

Your school holds a school-wide kickball tournament. Your gym teacher lines your class up and starts picking every third person to make up your class team.

Describe a possible benefit and a possible drawback of this sampling approach.

Reflect How could the gym teacher make the sampling method better? Provide one idea.

Got It?

A movie theater wants to survey their customers to make sure they are maintaining a customer-friendly environment. Which sampling description is an instance of systematic sampling?

I. You ask every movie-goer that walks into the theater.

II. Choose one customer that comes into the theater.

III. Starting with the first movie-goer, choose every 5th movie-goer that comes into the theater.

IV. Select the first 20 customers that walk into the theater.

Discuss with a classmate

Choose one of the numbered answer choices. If it is an answer choice you selected as correct, explain why it is an example, or instance, of systematic sampling. If you did not select it as a correct answer choice, explain why it is NOT an example of systematic sampling.

How are convenience and systematic sampling similar? How are they different?

Got It?

Suppose you want to determine how many students in your grade have had a dream about flying. Suppose there are 340 students in your grade. Describe how you would choose a systematic sample of 20 students. Is the sample a representative sample? Explain.

When might a systematic sample *not* be a representative sample?

Got It?

PART 3 Got It

Suppose you want to estimate the number of purple lights in a light display. You decide to take a systematic sample using an interval of 6 lights, starting from the second light. The order of the lights is red, yellow, green, blue, purple, red, yellow, green, blue, purple, and so on.

Suppose there are a total of 300 light bulbs in the display. Using your systematic sample, how many purple light bulbs do you estimate are in the display? How accurate is your estimate? Explain.

Close and Check

Focus Question

How do you sample systematically? What are the advantages and disadvantages of systematic sampling?

Do you know HOW?

1. A moving company wants to survey their customers to find out what they like the most about the company's service. Circle the descriptions of systematic sampling.

 A. The company surveys every customer.

 B. The company chooses every 8th name from its alphabetized customer list to survey.

 C. The company sends a survey to every household.

 D. Each driver surveys every 5th customer.

2. Sixty people are in line for a show. Starting with the 3rd person, you ask every 5th person if they bought their ticket in advance. Nine people say yes. Based on the sample, how many people bought tickets in advance?

 ☐ people

Do you UNDERSTAND?

3. **Compare and Contrast** Describe a situation in which convenience sampling would be sufficient and a situation in which systematic sampling would be more appropriate.

4. **Writing** Fruit bars come in 5 flavors. Describe how to gather a systematic sample to find the least popular flavor in your grade.

This page intentionally left blank.

Simple Random Sampling

CCSS: 7.SP.A.1: Understand that statistics can be used to gain information about a population ... ; generalizations ... from a sample are valid only if the sample is representative ... **7.SP.A.2:** Use data from a random sample to draw inferences about a population

Launch

© MP3, MP5

The tumultuous town mayor decides he can't talk to every household to get ideas for a new trash plan. So, he puts all the town's phone numbers into a large hat and chooses at random some numbers to call.

Describe one possible benefit and one possible drawback of choosing a sample this way.

Reflect What makes the process of choosing phone numbers random in the problem?

Got It?

PART 1 Got It (1 of 2)

You are doing research on the number of pink flowers in a large field of red flowers. Which is an instance of simple random sampling?

I. You choose every 10th flower in the field starting with the third flower.
II. You choose 3 flowers from the field.
III. You choose the 50 flowers closest to you.
IV. You choose 50 flowers from different locations in the field.

PART 1 Got It (2 of 2)

How are systematic sampling and simple random sampling similar? How are they different?

Got It?

PART 2 Got It

The table shows the names of the 50 brightest stars in the night sky. Describe how you would collect a sample of 9 stars using simple random sampling. Then choose a simple random sample.

Arcturus	Alnilam	Capella	Koo She	Regor
Achernar	Alnitak	Castor	Menkalinan	Regulus
Acrux	Alphard	Deneb	Miaplacidus	Rige
Adhara	Altair	Dubhe	Mimosa	Rigil Kentaurus
Aldebaran	Antares	Elnath	Mirfak	Sargas
Algieba	Atria	Fomalhaut	Mirzam	Shaula
Alhena	Avior	Gacrux	Peacock	Sirius
Alioth	Bellatrix	Hadar	Polaris	Spica
Alkaid	Betelgeuse	Hamal	Pollux	Vega
Alnair	Canopus	Kaus Australis	Procyon	Wezen

Got It?

PART 3 Got It

You are studying the brightness of the stars in the night sky. The table shows the brightness of the nine stars in your simple random sample of the 50 brightest stars in the night sky. Based on this sample, how many stars can you infer are between 0.50 and 1.00 magnitude in brightness? Explain.

Number	Star	Brightness (magnitude)
1	Arcturus	−0.05
7	Alhena	1.93
14	Altair	0.77
25	Elnath	1.66
28	Hadar	0.61
33	Miaplacidus	1.67
36	Mirzam	1.98
41	Regor	1.81
47	Sirius	−1.46

Close and Check

© MP3, MP5

Focus Question

How do you sample randomly? What are the advantages and disadvantages of simple random sampling?

Do you know HOW?

1. Circle the example of simple random sampling.

 A. calling the first entry for each letter of the alphabet in the phone book

 B. surveying the first 10 students to enter the classroom

 C. choosing numbers randomly assigned to the population

2. The results of a simple random sample are shown in the table. There are 207 people in the population. Based on the results, estimate how many participants have 2 siblings.

# of Siblings	# of Sample Population
None	3
One	2
Two	8
Three	5

☐ participants

Do you UNDERSTAND?

3. **Reasoning** Could the simple random sample in Exercise 2 be biased? Explain.

4. **Error Analysis** A bag has 150 balloons. Your friend says the results of picking the first 10 balloons from the bag is an example of a simple random sample. Do you agree? Explain.

This page intentionally left blank.

Comparing Sampling Methods

Digital Resources

CCSS: 7.SP.A.1: Understand that statistics can be used to gain information about a population by examining a sample of the population . . . Understand that random sampling tends to produce representative samples and support valid inferences.

Launch

© MP4, MP6

The tumultuous town mayor decides to set an example for the town by buying recycling bins for city hall. He can choose among red, green, and blue bins but wants input from city hall workers.

Should he use convenience, systematic, or simple random sampling to get input? Tell which you would choose and describe your plan.

Reflect Which sampling method do you use most in your life? Explain.

Got It?

PART 1 Got It

Suppose workers at an amusement park want to find out how many customers like to ride the roller coaster. Identify the sampling method in each description. Does each description produce a representative sample?

a. Survey every 8th customer waiting in line for the roller coaster.

b. Survey the customers at the food court.

c. Survey every 12th customer who enters the park.

PART 2 Got It

Suppose you want to determine how many cars exceed the speed limit on a local highway. If about 2,480 cars travel on the highway per day, tell whether you would use systematic sampling or simple random sampling to choose a sample of 100 cars. Justify your choice of sampling method.

Got It?

PART 3 Got It

You want to know how many students in your school are double-jointed. If there are 400 students in your school, tell whether you would choose a sample of 20 students using either convenience or systematic sampling. Justify your choice of sampling method.

Close and Check

Focus Question

You have studied three sampling methods. For what situations is each type of sampling most effective?

Do you know HOW?

Name the sampling method described in Exercises 1-3.

1. The drama teacher wants to audition students for a play. She assigns each student a number as they enter the room. She then draws 6 numbers from a basket to choose the students.

 []

2. The music teacher wants to know how many people support the marching band. He asks 50 people attending a football game whether they support the band.

 []

3. A marketing analyst wants to know if coupons influence the products people purchase. She asks every 3rd person entering a grocery store.

 []

Do you UNDERSTAND?

4. **Reasoning** You want to know how many times each year students in your school visit an amusement park. Which sampling method will you use? Explain.

5. **Error Analysis** A pet shop owner wants to know which tropical fish to stock. On weekday mornings, customers are asked about their favorite tropical fish. Explain why this is not the best sampling method to use.

CCSS: 7.SP.A.1: Understand that … generalizations about a population from a sample are valid only if the sample is representative …. **7.SP.A 2:** Use data from a random sample to draw inferences …. Generate multiple samples … to gauge the variation in estimates or predictions ….

Launch

© MP2, MP3

To build morale, the radio station manager and the owner each separately ask station workers what special food item should be added in the cafeteria. They both systematically sample every 5th worker by last name.

Owner's Idea
Made-to-order salads

at Radio Digit

Manager's Idea
Made-to-order omelets

at Radio Digit

Explain how their recommendations could be so different.

Reflect Can a sample ever be completely free of bias? Explain.

Got It?

PART 1 Got It

> A researcher asked five of his dentist friends if they thought the new Brand X toothpaste that he developed was effective. Four responded "yes." The researcher used the information to write a TV advertisement claiming that "4 out of 5 dentists prefer Brand X toothpaste!" Is this a valid inference? Explain.

PART 2 Got It

> Suppose you are a wildlife researcher. You want to know the total number of deer in a reservation. You catch and mark 100 deer. Then you release them into the reservation. A month later, you fly over the reservation and count 64 marked deer out of the 1,200 deer that you see. How many deer are in the reservation?

PART 3 Got It

> The manager decided to buy enough bananas for half of the customers. Then a third assistant manager came on duty and decided to take a simple random sample of all the customers in the store. Should the manager change his order? Explain.
>
> **Assistant Manager 3:** A simple random sample of 30 out of 50 people said yes.
>
> Discuss with a classmate
>
> Read your explanation to the problem out loud.
> Discuss key words that you included in your explanation to make sure that you and your classmate understand the meaning of the words. Make a list of any words that you could not define so that you can discuss them with your teacher and other classmates.

Close and Check

Focus Question

© MP2, MP6

If you make a judgment about a population based on a sample, how accurate is that judgment? What determines how accurate that judgment is?

Do you know HOW?

1. A researcher attaches satellite tags to 36 sea turtles. Over the next 6 months she identifies 825 sea turtles in the same area. Nine of those turtles have satellite tags. Estimate how many sea turtles are in the area.

 [] sea turtles

2. A bookstore owner wants to know which department to expand. Manager A surveys every 3rd teenager that comes in the store. Manager B surveys every customer on Monday evening. Manager C surveys 25% of the customers chosen at random from the store's mailing list. Identify each type of sampling and circle the one that is the least biased.

 Manager A: []

 Manager B: []

 Manager C: []

Do you UNDERSTAND?

3. **Error Analysis** Choose one of the managers' surveys from Exercise 2. Explain how you would change the sampling technique in order to gather more accurate information.

4. **Reasoning** How might the results of the survey in Exercise 2 vary if Manager B repeated the survey every evening for a week and compared each day's results? Explain.

This page intentionally left blank.

Topic Review

New Vocabulary: bias, convenience sample, inference, population, representative sample, simple random sampling, systematic sampling
Review Vocabulary: proportional

Vocabulary Review

 Identify two challenging vocabulary terms from this topic. Write one vocabulary term in the center oval, and fill in the surrounding boxes with details that will help you better understand the term.

Definition

Characteristics

Example

Nonexample

Definition

Characteristics

Example

Nonexample

Pull It All Together

TASK 1

A laboratory technician places the contents of a well-mixed test tube of blood on a three-dimensional grid that holds a specified volume in each chamber. There are 25 chambers and the technician wants to count the red blood cells in 3 of them.

Decide whether the technician should use *convenience, systematic,* or *random sampling* to choose which chambers she will examine. Explain your reasoning.

TASK 2

Suppose you want to find out how many students in the 7th grade have stayed home from school this year because they were sick. There are 250 students in the 7th grade.

Write a survey. Choose a sampling method. Choose a sample size. Choose a sample.

Statistical Measures

CCSS: 7.SP.A.1: Understand that statistics can be used to gain information about a population by examining a sample of the population 7.SP.B.4: Use measures of center and measures of variability for numerical data from random samples .. .

Launch

© MP2, MP6

Ms. Adventure and Data Girl proposed different research studies to the local airline.

Which study should the airline fund? Explain.

How many people flew to Puerto Rico on Tuesday?

How many people fly to Puerto Rico on Tuesdays?

Reflect Which study could have a numerical result of 89.5? Explain.

Got It?

PART 1 Got It

During eruptions at Jewel Geyser, water soars up to various heights. What is the mean height of the geyser's eruptions?

Heights of Jewel Geyser Eruptions (feet)
15, 30, 27, 23, 28, 19, 14, 11, 22

PART 2 Got It

What is the IQR of the depths of a sample of hot spring pools in Yellowstone National Park?

Depths of Hot Springs (feet)
25, 6, 27, 23.5, 25, 32.5

Got It?

PART 3 Got It

Data Girl wants to buy a new suitcase for her next trip. She wants an unusual color to make the bag easy to spot, so she records every third suitcase that comes by on the baggage claim.

green, blue, red, green, blue

The store Data Girl shops at sells black, blue, red, and green suitcases. Which color suitcase should she buy?

Close and Check

Focus Question

What can you do to make data more useful? How does what you are looking for determine how data are best used and represented?

Do you know HOW?

Use the data set below for Exercises 1–4.

> **Monthly High Temperatures (°F)**
> Anchorage, Alaska
> 15, 18, 25, 36, 47, 55,
> 59, 57, 48, 35, 22, 16

1. Find the mean monthly high temperature to the nearest degree.

2. Find the median of the data set.

3. Find the range of the data set.

4. Find the IQR of the data set.

Do you UNDERSTAND?

5. **Reasoning** Is the mean or the median a better representation of the temperature data of Anchorage, Alaska? Explain.

6. **Error Analysis** Your friend uses the mean temperature to decide which clothes to buy for her move to Anchorage. Do you agree with the measure she chose? Explain.

Multiple Populations and Inferences

CCSS: 7.SP.A.1: Understand that statistics can be used to gain information about a population by examining a sample **7.SP.B.4:** Use measures of center and measures of variability ... to draw informal comparative inferences about two populations Also, **7.SP.B.3.**

Launch

© MP1, MP4

Data Girl plans out her research study for a local airline. The airline asks her to answer the following questions as part of her plan.

Provide a possible response for each question.

How many people fly to Puerto Rico on Tuesdays?

Who?

What?

Where?

When?

Why?

Reflect Which "W" question was the hardest to provide an answer for? Explain.

Got It?

The school nurse tested the eyesight of all the students in Grades 6, 7, and 8. To answer each question, should the nurse consider the grades as *three* populations or as *one* population?

| How many students have perfect vision in the school? | What is the mean eyesight score for each grade? | Do students' eyesight scores change more between 6th and 7th grades, or between 7th and 8th grades? |

Why can one population in a study be considered more than one population in another study?

Got It?

PART 2 Got It

A scientist is analyzing sea urchin samples taken from the ocean. For each question, how many populations should the scientist use? Describe the population(s).

Question

How many species of sea urchins exist?

Question

Which continent has the greatest population of sea urchins along its coast?

Question

Do more sea urchins live in the Atlantic Ocean or in the Pacific Ocean?

Got It?

PART 3 Got It

The table shows the number of hours that a random sample of students in two classes spent on schoolwork last night.

Class A	Class B
0	0
0	0
1	0
1	0
1	1
1	1
2	1
2	1
2	1
2	1
4	2
4	2
5	2
5	2
5	2
5	2
5	3
5	3
6	3
6	3
6	4
6	4

Hours of Schoolwork

Class A

a. Make a conjecture about why there are two peaks in the dot plot of Class A.
b. Based on your conjecture, make a comparative inference about the students in each class.

Close and Check

> ## Focus Question
> © MP1, MP4
>
> When does a group represent one population? When does it represent more than one population? How can you tell?
>
> _____
>
> _____
>
> _____
>
> _____

Do you know HOW?

1. The local newspaper is writing an article on the county schools. Write **S** if the question applies to a single population and **M** if the question applies to multiple populations.

 A. [] What percent of the total student population plays sports?

 B. [] What are the schools' rankings in the region?

2. The dot plots show the number of students who are in the marching band. Circle the valid inference.

 School A **School B**

 9 10 11 12 9 10 11 12
 Grade Grade

 A. School A's band is more popular.

 B. The number of band members from each grade is more evenly distributed in School B.

Do you UNDERSTAND?

3. **Writing** Write a question based on the dot plots in Exercise 2 that represents more than one population. Explain why it represents more than one population.

4. **Error Analysis** Based on the dot plots in Exercise 2, a classmate infers that School B has more students enrolled. Is this a valid inference? Explain.

This page intentionally left blank.

Using Measures of Center

CCSS: 7.SP.B.4: Use measures of center … for numerical data from random samples to draw informal comparative inferences about two populations.

Launch

© MP6, MP7

The lead local librarian and his lead assistant survey individual patrons on the number of e-books they read each week. The tablets show the survey results.

What inference should the librarians make based on the means of the data sets?

Survey Group A

6, 10, 8

Survey Group B

9, 7, 8

Reflect Can you always draw a clear inference from data? Explain.

Got It?

PART 1 Got It

A book publisher is testing two versions of a new book. A random sample of people is given 30 minutes to read each version. What is the median of each sample? Make a comparative inference based on the median values.

Version A

Number of pages

Version B

Number of pages

Got It?

A book publisher is testing two versions of a new book. A random sample of people is given 30 minutes to read each version. What is the mean of each sample? Make a comparative inference based on this measure of center.

Version A

Version B

Number of pages

Number of pages

Got It?

PART 3 Got It (1 of 2)

A book publisher is testing two versions of a new book. A random sample of people is given 30 minutes to read each version. Using the data and comparing the shapes of the graphs, what might the publisher conclude about the book versions?

Version A

Number of pages

median = 25
mean ≈ 24.4

Version B

Number of pages

median = 23
mean ≈ 23.7

PART 3 Got It (2 of 2)

Can you make more than one comparative inference about a population using the measures of center? Explain.

Close and Check

Focus Question

How can you compare two groups using a single number from each group?

Do you know HOW?

1. A city planner records the weight of a day's garbage from a random sample of households. Find the median weight of the garbage in each neighborhood.

 Neighborhood B

 Neighborhood A

 6 7 8 9 10 11 12 13 14
 Weight of Garbage (lbs)

 A: [] B: []

2. Next, the planner records the weight of a day's recycling from a random sample of households. Find the mean weight of recycling in each neighborhood to the nearest tenth.

 Weight of Recycling (lbs)

Neighborhood A	Neighborhood B
2.4, 0.5, 5.8, 3.3, 1.4, 2.2, 1.2, 0, 2.7, 2.5, 1.9	4.8, 3.5, 6.9, 5.5, 6.3, 4.9, 5.1, 6.1, 8, 5.8, 5.2

 A: [] B: []

Do you UNDERSTAND?

3. **Writing** Make a comparative inference based on the median values in Exercise 1. Support your statement.

4. **Writing** Make a comparative inference based on the mean values in Exercise 2. Support your statement.

5. **Reasoning** Based on the previous Exercises, describe one conclusion you can make about how the neighborhoods compare.

This page intentionally left blank.

Using Measures of Variability

Digital
Resources

CCSS: 7.SP.B.4: Use ... measures of variability for numerical data from random samples to draw informal comparative inferences about two populations.

Launch

© MP4, MP7

The data show a random sampling of heights in inches of female athletes in two different Olympic sports.

What inference(s) can you make about the sport each group plays?

Athlete Group A

60, 53, 54, 62,
55, 61, 63, 57

Athlete Group B

72, 70, 69, 74,
73, 71, 71, 75

Reflect Could someone else come up with a different inference on the sport of each group? Explain.

Got It?

PART 1 Got It

A researcher is studying the effects of owning a cell phone on the number of hours people sleep. What is the range of hours slept for each group? Make a comparative inference about the populations based on range.

PART 2 Got It (1 of 2)

A researcher is studying the effects of owning a cell phone on the number of hours people sleep. What is the interquartile range of hours slept for each group? Make a comparative inference about the populations based on IQR.

Got It?

PART 2 Got It (2 of 2)

Are the range and interquartile range by themselves enough information to determine which population sleeps more than the other? Explain.

Discuss with a classmate

Read the problem statement together.
Explain how you interpreted the problem statement in order to answer the question.
Then compare your answers to the problem.
Did you include enough detail in your answer to justify why you answered 'yes' or 'no'?

PART 3 Got It

A researcher is studying the effects of owning a cell phone on the number of hours people sleep. Using the data, what might the researcher conclude about the populations? Explain.

Hours Slept

■ Cell Phone ■ No Cell Phone

Close and Check

Focus Question

How else can you compare two groups using a single number from each group?

Do you know HOW?

1. Find the range of TV viewing time for each population.

T.V. Viewing (adults)

Number of Adults

12
10
8
6
4
2
0

30 60 90 120 150
Minutes/Day

T.V. Viewing (preschoolers)

Number of Preschoolers

20
16
12
8
4
0

30 60 90 120 150
Minutes/Day

Adults: _____

Preschoolers: _____

2. Your friend surveys dog owners with different yard sizes. Find the IQR of each population.

Yard size greater than 500 ft²

Yard size less than 500 ft²

5 10 15 20 25 30 35 40 45 50 55 60
Weight of Dog (lbs)

Yard > 500 ft²: _____

Yard < 500 ft²: _____

Do you UNDERSTAND?

3. **Writing** Write a comparative inference that you *cannot* make about the populations in Exercise 1 based on the ranges of the data. Explain.

4. **Writing** Make a comparative inference about the populations in Exercise 2 based on the IQR. Explain your inference.

Digital Resources

CCSS: **7.SP.B.3:** Informally assess the degree of visual overlap of two numerical data distributions with similar variabilities, measuring the difference between the centers by expressing it as a multiple of a measure of variability Also, **7.SP.B.4.**

Launch

© MP2, MP6

Each tablet shows a random sampling of heights in inches of male athletes in two different Olympic sports.

What inferences can you make about the sport played by each group based on the range and mean of heights?

Athlete Group A

76, 82, 74, 80, 78, 79, 75, 86, 84, 81

Athlete Group B

81, 76, 74, 72, 78, 75, 75, 74, 77, 76

Reflect The groups have heights in common. What impact did that have in your inferences about the sports of each group?

Got It?

PART 1 Got It (1 of 2)

Calculate the mean absolute deviation for the heights of seventh graders. The mean is about 61 inches. Round to the nearest whole number.

Sample of 7ᵗʰ Grade Students

Height (in.)

PART 1 Got It (2 of 2)

The graphs show the height distribution of samples of 2ⁿᵈ and 7ᵗʰ graders. Explain why the MADs of both samples are the same.

Sample of 2ⁿᵈ Grade Students

Height (in.)

Sample of 7ᵗʰ Grade Students

Height (in.)

Got It?

PART 2 Got It (1 of 2)

How does the mean height of the 7th graders compare to the mean height of the 9th graders? Express the difference as a multiple of the mean absolute deviation of either grade.

	Mean	MAD
7th Graders	61	2
9th Graders	66	2

PART 2 Got It (2 of 2)

The 2nd, 7th, and 9th grade height distributions have approximately the same mean absolute deviation. The means of the 2nd and 7th grade heights are 5.5 **MADs** apart. The means of the 7th and 9th grade heights are 2.5 **MADs** apart. How can you use the MAD to measure the degree of visual overlap of two distributions that have the same MAD?

Got It?

PART 3 Got It

The curve has a mean of 6 and a MAD of 0.5. Sketch a second data distribution that is eight mean absolute deviations away from the mean of the curve.

Close and Check

Focus Question

How do measures of center and variability help you determine how much two groups have in common?

Do you know HOW?

1. Find the mean absolute deviation to the nearest minute for the data set.

Flight Delays

Minutes

2. Express the difference between the grooming costs of Company A and Company B as a multiple of the mean absolute deviation of either company.

Pet Groomers

Cost (dollars)

Do you UNDERSTAND?

3. **Vocabulary** Explain what the mean absolute deviation in Exercise 1 represents.

4. **Reasoning** Curve 1 has a mean of 30. Your friend correctly sketches a curve three mean absolute deviations from Curve 1. How could your friend be correct?

Curve 1

This page intentionally left blank.

Problem Solving

CCSS: 7.SP.B.4: Use measures of center and measures of variability for numerical data from random samples to draw informal comparative inferences about two populations

Launch

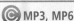 MP3, MP6

The data sets show the monthly average high temperature from January to December in degrees Fahrenheit for two U.S. cities. You must choose to live in one of the cities.

Justify your choice based on at least one measure of center (mean or median) or variability (range, interquartile range, or mean absolute deviation).

City A

22, 29, 41, 57,
70, 79, 83, 80,
71, 58, 40, 26

City B

68, 70, 70, 73,
75, 80, 84, 85,
83, 79, 73, 69

Reflect How did the measure(s) of center or variability you used help you decide?

Got It?

PART 1 Got It

Every two months, a bicycle company gives an award to the salesperson with the best sales record. The data show the sales results of the top two bicycle salespeople. Who should get the award? Use measures of center and variability to justify your choice.

Week	Caprice	Constance
1	2650	1225
2	3989	2008
3	2698	2314
4	2160	3978
5	2073	3007
6	4875	2832
7	1690	3316
8	2178	3548

Got It?

PART 2 Got It

The graphs show the number of minutes that a random sample of students from Grades 6 and 8 spend on their hair each morning. What can you infer about the relationship between the grade level and how long students spend on their hair? Explain.

Time Spent on Hair in the Morning

Close and Check

▶ Focus Question

How can you use measures of center and variability of a random sample to make inferences, predictions, and decisions? Which measures work best and why?

▶ Do you know HOW?

Use the data below to answer Exercises 1–3. Round your answers to the nearest hundredth.

Race Times (s)

Runner A: 12.52, 12.20, 8.89, 12.61

Runner B: 12.18, 12.13, 12.27, 12.15

1. Find the mean race time for each runner.

Runner A: []

Runner B: []

2. Find the median race time for each runner.

Runner A: []

Runner B: []

3. Find the IQR for each runner.

Runner A: []

Runner B: []

▶ Do you UNDERSTAND?

4. Reasoning Based on the data from Exercises 1–3, which runner should be chosen to compete in the regional track meet? Explain.

5. Writing A study is conducted on two cities in different climates. What inference can you make? Explain.

Hours spent outside per week

New Vocabulary: comparative inference, interquartile range, mean, mean absolute deviation, median, quartile, range

Review Vocabulary: inference, measure of center, measure of variability, population, random sample

Vocabulary Review

Identify two challenging vocabulary terms from this topic. Write one vocabulary term in the center oval, and fill in the surrounding boxes with details that will help you better understand the term.

Definition

Characteristics

Example

Nonexample

Definition

Characteristics

Example

Nonexample

Pull It All Together

TASK 1

In a cooking class, students make ice cream by mixing boiling milk with sugar. An impatient student put his mixture in the freezer before waiting for the milk to cool. To his surprise, his mixture froze into ice cream before those of other students. He mentioned his observation to his friend, but was told that this was impossible.

The student decided to test his observation further using warm and cold water. The data from the student's observations when using warm and cold water are below. Find the median and range of each experiment.

Trials	Warm Water Freeze Time (min)
1	22
2	21
3	23
4	22
5	24
6	23

Trials	Cold Water Freeze Time (min)
1	$24\frac{1}{2}$
2	25
3	27
4	26
5	24
6	25

Make box plots to compare the data sets.

TASK 2

A science teacher told the student that when hot water freezes faster than cool water, it is called the Mpemba Effect. Based on the student's data and your knowledge of measures of center and variability, can the teacher infer that the student's experiment is an example of the Mpemba Effect? If not, make a valid inference.

CCSS: **7.SP.C.5:** Understand that the probability of a chance event is a number between 0 and 1 that expresses the likelihood of the event occurring … . **7.SP.C.6:** … predict the approximate relative frequency given the probability … .

Launch

Ⓒ MP1, MP3

To be annoying, your friend says "probably" to every question about the future. Come up with a better way to describe the chance of each of these events happening. Describe your method.

| The Earth will go around the sun. |
| Tigers will fly. |
| It will rain this week. |
| Your team will win the big game. |
| You will write a best-selling novel. |

Reflect Are all ways to describe the chance of something happening equally effective? Explain.

Got It?

PART 1 Got It

What word best describes the likelihood that two people sitting next to each other on a bus have the same birthday?

Impossible Unlikely As Likely as Not Likely Certain

PART 2 Got It

The probability of choosing a flag with only two colors is 0.15. What is this probability written as a fraction and as a percent?

Got It?

PART 3 Got It

Based on data collected over thousands of flights, an airline believes that the probability of a passenger being a no-show on a morning flight is 12%.

If the airline overbooks a 300-seat morning flight by selling 350 tickets, how many empty seats should the airline expect to have on the flight?

Close and Check

Focus Question

MP3, MP4

What are effective ways to describe the likelihood of an event?

Do you know HOW?

1. Choose a word from the following list to best describe the likelihood that there will be 365 days in a year: *impossible, unlikely, as likely as not, likely,* and *certain.*

 []

2. The probability of a U.S. resident living in a state that begins with the letter M is 0.16. Write this probability as a fraction and as a percent.

 fraction: [] percent: []

3. There are 2,425 participants in a national phone survey that includes residents from every state. There is an 8% probability that a participant lives in a state that begins with the letter W. How many participants are expected to live in a state that begins with W?

 [] participants

Do you UNDERSTAND?

4. **Reasoning** Would you rather know the likelihood of winning a prize in words or percents? Explain.

5. **Writing** Why is *maybe* not a good term to use when describing the probability of an event?

Sample Space

CCSS: 7.SP.C.7: Develop a probability model and use it to find probabilities of events. Compare probabilities from a model to observed frequencies; if the agreement is not good, explain possible sources of the discrepancy.

Launch

Ⓒ MP2, MP7

Your annoying friend designs a dart game for you to play. She says, "I get a point when a dart hits a composite number, and you get a point when a dart hits a prime number."

Do you like her game? Who do you think will win? Explain.

91	64
48	57

Reflect Would you change the game above? If so, how?

Got It?

PART 1 Got It

Action: One spin of the spinner

What is the sample space for the action? How many outcomes are in the sample space?

PART 2 Got It (1 of 2)

Action: One spin of the spinner

Event: The spinner stops on an odd number.

Which numbers are in the event?

Got It?

Write a verbal description of the event.

Action: One spin of the spinner

Event: 3, 6, 9

PART 3 Got It

List the following in the order *action, sample space, event.*

Win the game. Play a game. win, lose, tie

Discuss with a classmate

Think about games you have played.
How do those experiences help you make sense of this problem?
Explain how you determined the order of action, sample space, and event.

Close and Check

MP3, MP6

Focus Question

What is the difference between an *action* and an *event*?

Do you know HOW?

Use the picture for Exercises 1 and 2.

1. Action: Choose one card.
 How many outcomes are in the sample space?

 []

2. Action: Choose one card.
 Event: Choose a striped card.
 How many cards are in the event?

 []

3. Number the following. Use 1 for *action*,
 2 for *sample space* and 3 for *event*.

 [] Left, right, forward

 [] Pick right.

 [] Choose a direction.

Do you UNDERSTAND?

4. **Vocabulary** The cafeteria sells sack lunches with either a ham sandwich, turkey wrap, peanut butter sandwich, or corn dog. The lunches are not labeled. Determine the action, sample space, and event for buying a sack lunch.

5. **Error Analysis** In a certain game, players roll again if they roll a 6 on a number cube. Your friend says that rolling a 6 is an action, but you say it is an event. Explain who is correct.

Relative Frequency and Experimental Probability

CCSS: 7.SP.C.6: Approximate the probability of a chance event by collecting data on the chance process that produces it and observing its long-run relative frequency, and predict the approximate relative frequency given the probability ...

Launch

© MP3, MP5

Lay your Companion page flat on your desk. Hold any coin about a foot directly above the circle on the page.

What is the probability that your coin will land completely inside the circle without touching the edge? Explain how you can find out.

Reflect Could your probability be a lot different from your neighbor's? Explain why.

Got It?

PART 1 Got It (1 of 2)

The table shows one class's results for spinning the spinner 40 times. What is the relative frequency of the event "spin a number less than 4"?

Experiment Table

Outcome	1	2	3	4
Frequency	10	12	4	14

Number of Trials: 40

PART 1 Got It (2 of 2)

The table shows one class's results for spinning the spinner 40 times.

a. Suppose the class spins the spinner 40 more times. Do you expect the relative frequency of the event "spin a 2" to change, or to remain the same?

Experiment Table

Outcome	1	2	3	4
Frequency	10	12	4	14

Number of Trials: 40

b. Suppose the class spins the spinner 400 times in all. Is there a value that you expect the relative frequency of the event "spin a 2" to be close to? Explain.

Got It?

PART 2 Got It (1 of 2)

Find the experimental probability that a customer will bring reusable bags.

Answers to "What type of bag would you like?"

Type of Bag	Number of Customer Requests
Plastic	18
Paper	6
Customer's own reusable bag	8

PART 2 Got It (2 of 2)

The experimental probabilities that you found in the Example and the Got It were based on data collected from 32 customers. Do you think that these experimental probabilities are good estimates of the actual probabilities that customers will ask for these three types of bags? Explain.

Close and Check

Focus Question

MP1, MP6

For some types of events there is more than one way to determine the probability. In what situations is conducting an experiment a good way to determine the probability of an event? How can you evaluate the reasonableness of an experimental probability?

Do you know HOW?

1. The table shows the results for rolling a number cube 100 times. What is the relative frequency for the event "roll a multiple of 3?"

Outcome	1	2	3	4	5	6
Frequency	22	14	23	19	10	12

2. Write the experimental probability for the event "roll a factor of 4" from the data above as a fraction, decimal, and percent.

3. A coin is tossed 50 times. What is the expected relative frequency of the coin landing on heads?

Do you UNDERSTAND?

4. **Reasoning** Assume the number cube in Exercise 1 is rolled 500 times. For which outcome listed would you not expect the experimental probability to change much? Explain.

5. **Writing** Your friend makes 3 free throws out of 5 attempts. Then she makes 1 basket and misses 2. Will your friend definitely make the next 2 shots? Explain.

Theoretical Probability

Digital Resources

CCSS: 7.SP.C.7: Develop a probability model and use it to find probabilities of events. Compare probabilities observed frequencies ... 7.SP.C.7a: Develop a uniform probability model by assigning equal probability to all outcomes

Launch

> MP6, MP7
>
> Your annoying friend devises another game. Before she puts the tiles in the bag, she says, "I get a point if a negative number is picked and you get a point if a positive number is picked."
>
> Is this game fair? Explain why or why not.

Reflect What makes a game fair? Explain.

Got It?

PART 1 Got It (1 of 2)

Suppose you choose a button at random from this bag of white, gray, and black buttons.

What is the probability of choosing a gray button?

What is the probability of choosing a two-hole button?

PART 1 Got It (2 of 2)

The spinner is divided into two unequal sectors. The outcomes for red and blue are *not* equally likely.

Explain how you can use the theoretical probability formula to find the probability of spinning red.

$\frac{1}{4}$ of the spinner is blue.

$\frac{3}{4}$ of the spinner is red.

Got It?

PART 2 Got It

Which probabilities are experimental?

I. An eye doctor examines 10 people and finds that 4 are color-blind.

$P(\text{color–blind}) = \frac{4}{10}$

II. A teacher chooses 1 student at random from a class of 13 boys and 12 girls.

$P(\text{boy}) = \frac{13}{25}$

III. You check 6 boxes of cereal and find that 1 box has a prize at the bottom.

$P(\text{prize}) = \frac{1}{6}$

PART 3 Got It

In one family, a child's chore for the day is chosen at random. The table shows the results of using the spinner to simulate 99 days of chores. For which chore is the number given by the simulation closest to the number predicted by the theoretical probability?

Chore Simulation	
Set the table (Red)	55
Clear the table (Blue)	32
Wash the dishes (Yellow)	12
Total	99

Close and Check

For some types of events there is more than one way to determine the probability. How do you tell the difference between a theoretical and an experimental probability?

Do you know HOW?

1. Suppose you chose a card at random. What is the probability of choosing a card with an even number and a ?

2. Circle the situation(s) that represents experimental probability.

 A. Every 100th customer receives a door prize.

 B. The gumball machine contains gumballs in six colors. You get a yellow gumball.

 C. A survey finds that 4 out of 25 people have green eyes.

Do you UNDERSTAND?

3. **Vocabulary** A card from Exercise 1 is chosen at random 15 times.

 Are the experimental probabilities and theoretical probabilities close? Explain.

4. **Reasoning** If a card were chosen at random another 100 times, what would you expect to happen to the comparisons between the theoretical and experimental probabilities?

Probability Models

Digital Resources

CCSS: **7.SP.C.7a:** Develop a uniform probability model by assigning equal probability to all outcomes, and use the model to determine probabilities of events **7.SP.C.7b:** Develop a probability model ... by observing frequencies in data Also, **7.SP.C.7.**

Launch

© MP4, MP6

Your annoying friend proposes another game as you wait for the bus. She says, "I get a point for every car that passes. You get a point for every truck. We each have a 1 out of 2 probability of getting a point."

Do you agree with your friend? Are you going to play by her rules? Explain.

Reflect Can you always figure out if a game is fair before playing? Explain.

Got It?

PART 1 Got It (1 of 2)

What probability statement would you add to each list to make a complete probability model of this action?

Action

The robotics team will choose one member at random to run the robot at the competition.

Sample Space

Robotics Team

Girl, age 10	Boy, age 13
Boy, age 12	Boy, age 10
Boy, age 13	Girl, age 12
Girl, age 11	Girl, age 14
Boy, age 14	Boy, age 12

List 1

$P(\text{boy}) = \dfrac{3}{5}$

List 2

$P(\text{younger than 12}) = \dfrac{3}{10}$

$P(\text{age 12}) = \dfrac{3}{10}$

PART 1 Got It (2 of 2)

Explain why this list of probabilities does not complete a probability model for the spinner.

$P(\text{red}) = \dfrac{3}{8}$ $P(\text{odd}) = \dfrac{1}{2}$ $P(\text{yellow}) = \dfrac{1}{8}$

Action: One spin of the spinner.

Sample space: Each of the eight sectors is one outcome.

Got It?

PART 2 Got It

For which situation(s) can you use a uniform probability model?

Situation A: You drop a thumbtack from a height of 1 foot. What is the probability that the thumbtack will land point up?

Situation B: This color cube has 2 red faces and 4 yellow faces. Suppose you roll the color cube. What is the probability that the cube will land with yellow facing up?

PART 3 Got It

The data in the table is from a survey of high school students with after-school jobs. Write the list of probabilities for a probability model that gives the probability that a student chosen at random from this group of high school students has each type of job.

Results of After-School Jobs Survey

Job Type	Number of Students
Store Cashier	67
Paper Route	8
Babysitting	120
Restaurant Work	55

Close and Check

Focus Question

© MP3, MP5

How do you choose the best type of probability model for a situation?

Do you know HOW?

1. Complete the probability model for the cards.

 Action: Choose one card at random.

 Sample space: Each card is one outcome.

 P(🌸) = [] P(✋) = []

 P(❄) = [] P(prime) = []

2. Circle the situation(s) for which you can use a uniform probability model.

 A. A student will bring a backpack to school.

 B. Tomorrow will be a school day.

 C. The football team will win their next game.

Do you UNDERSTAND?

3. **Error Analysis** A student records the number of boys and girls who bring backpacks to school. What mistake does he make when finding probabilities?

Boys	$P(\text{yes}) = \dfrac{75}{143}$	$P(\text{no}) = \dfrac{21}{34}$
Girls	$P(\text{yes}) = \dfrac{68}{143}$	$P(\text{no}) = \dfrac{13}{34}$

4. **Vocabulary** Explain how to determine whether to use a uniform or an experimental probability model to predict outcomes.

Problem Solving

CCSS: 7.SP.C.7: ... Compare probabilities from a model to observed frequencies; if the agreement is not good, explain possible sources of the discrepancy. 7.SP.C.7b: Develop a probability model ... by observing frequencies in data Also, 7.SP.C.7a.

Launch

© MP3, MP7

You are a basketball coach. You need to choose one player to take the shot that will determine the outcome of the game.

Which player should you choose? Support your choice by using the probability that the player chosen will make the winning shot.

Shooting Results

Player	Last Game	Last 5 Games	Last 10 Games
5	2 of 10	25 of 50	54 of 100
24	7 of 10	22 of 50	42 of 100

Reflect Did the shooting results for the last game for each player match expectations? Explain.

Got It?

PART 1 Got It

A basketball team has two 6th graders, five 7th graders, and three 8th graders. Each day the coach selects one team member at random to put away the equipment.
How can you assign the numbered sectors of the spinner so that the spinner can be used to simulate this situation?

I. Assign 2 to represent 6th graders.
Assign 5 to represent 7th graders.
Assign 3 to represent 8th graders.

II. Assign 0 and 1 to represent 6th graders.
Assign 2, 3, 4, 5, and 6 to represent 7th graders.
Assign 7, 8, and 9 to represent 8th graders.

III. Assign 1 and 3 to represent 6th graders.
Assign 0, 2, 4, 6 and 8 to represent 7th graders.
Assign 5, 7, and 9 to represent 8th graders.

Got It?

PART 2 Got It

 Each day, a bicycle manufacturer tests the brakes on a random sample of 50 new bikes.

New Bikes With Defective Brakes

Day	Monday	Tuesday	Wednesday	Thursday	Friday
Number	2	1	0	4	3

You want to buy a bicycle from this manufacturer only if the probability that the brakes are defective is less than 5%.

Should you buy a bike from this manufacturer?

Close and Check

> ## Focus Question
> MP1, MP5
>
> What types of predictions and decisions can you make using probability?
>
> _____
>
> _____
>
> _____
>
> _____

▶ Do you know HOW?

1. A dog has a litter of 6 puppies: 3 black, 2 brown, and 1 white. Circle the way you can assign the faces of a number cube to simulate randomly selecting a certain puppy.

 A. Assign 1 and 2 to black, 3 and 4 to brown, and 5 and 6 to white.

 B. Assign 1, 2, and 3 to black, 4 and 5 to brown, and 6 to white.

 C. Assign 1 to black, 3 to brown, and 5 to white. Assign 2, 4, and 6 to represent "roll again."

2. Every day, a widget company randomly samples 100 widgets and records how many are defective. Based on the week's data, write the probability that a widget will be defective as a fraction, decimal, and percent.

Day	1	2	3	4	5
Defective	2	3	3	2	2

 Fraction Decimal Percent

 [] [] []

▶ Do you UNDERSTAND?

3. **Reasoning** In Exercise 1, is there an equal chance of randomly selecting a puppy of each color? Explain.

4. **Writing** Based on the percent of defective widgets you found in Exercise 2, would you feel confident buying a widget from this company? Explain.

New Vocabulary: action, event, experimental probability, outcome, probability model, probability of an event, relative frequency, sample space, simulation, theoretical probability, trial, uniform probability model
Review Vocabulary: decimal, fraction, percent

Vocabulary Review

Identify two challenging vocabulary terms from this topic. Write one vocabulary term in the center oval, and fill in the surrounding boxes with details that will help you better understand the term.

Definition

Characteristics

Example

Nonexample

Definition

Characteristics

Example

Nonexample

Pull It All Together

TASK 1

The list shows the new numbers of each type of song you had on your music player.

On Monday, you set your music player to select songs at random. What is the probability that the first song played will *not* be a country song?

Rock: 30
Pop: 19
Rap: 3
Country: 5
Classical: 8

The list shows the number of songs you have on your music player on Monday. On Tuesday, you download 11 new pop songs. You set your music player to play pop and rap songs at random. What is the probability that the first song played is one of your new pop songs?

TASK 2

a. The list shows the new numbers of each type of song on your music player. Write a probability model to find the probability of hearing each type of song when the music player is set to play one song at random.

b. On Thursday, you set your music player to play 100 songs at random. The table shows what you heard.

Rock: 30
Pop: 30
Rap: 3
Country: 5
Classical: 8

Thursday's Songs

Rock	Pop	Rap	Country	Classical
23	50	7	9	11

Based on Thursday's data, what is the experimental probability that you will hear a pop song when your music player selects a song at random? How does your answer compare to the theoretical probability predicted by the probability model you wrote in part (a)?

Compound Events

CCSS: 7.SP.C.8: Find probabilities of compound events using organized lists, tables, tree diagrams, and simulation. **7.SP.C.8b:** Represent sample spaces for compound events using methods such as organized lists, tables and tree diagrams

Launch

© MP2, MP6

Draw lines to sort these tiles into two groups. Explain your groups.

Pick a number from 1–9.

Toss heads then tails.

Pick a number from 10–20.

Toss heads.

Spin red twice.

Spin red.

| Group 1 : Group 2 |

Reflect Could you sort the tiles in more than one way? Explain.

Got It?

PART 1 Got It

How many steps or choices does this action involve?

Action: Choose a sandwich filling and a type of bread.

Sandwiches
Filling:
Cheese, Ham, Tuna
Bread:
White, Whole Wheat, Rye

Got It?

PART 2 Got It

Which choices show a compound event for this action?

Action: Spin the spinner four times.

I. (R, B, G) II. (B, B, B, B) III. (R, B, G, B)

PART 3 Got It

Which compound event is composed of independent events?

I. **Action**
Roll a standard number cube twice.

Compound Event
Get an even number on each roll.

II. **Action**
Toss a coin once and roll a standard number cube once.

Compound Event
The coin lands on tails.
The number cube lands on 5.

Close and Check

Focus Question

©MP3, MP7

What makes an event a compound event? What are the different types of compound events?

Do you know HOW?

1. How many steps or choices does the action of creating a parfait cup involve?

Action: Choose a yogurt flavor, a type of fruit, and a topping.

Yogurt	Fruit	Topping
Plain	Blueberries	Granola
Vanilla	Strawberries	Nuts
Berry	Cherries	
	Bananas	

2. Are the events of creating a parfait cup in Exercise 1 dependent or independent?

3. In gym class, two students are chosen to pick teams for a game of soccer. Is the action of choosing team members a dependent or independent event?

Do you UNDERSTAND?

4. Writing Explain your answer to Exercise 3.

5. Error Analysis During a game, each player rolls a number cube and moves a game piece that number of spaces. A friend says each turn is a single independent event. Do you agree? Explain.

Digital Resources

CCSS: **7.SP.C.8:** Find probabilities of compound events using organized lists, tables, tree diagrams, and simulation. **7.SP.C.8b:** Represent sample spaces for compound events using methods such as organized lists, tables and tree diagrams … .

Launch

Ⓒ MP4, MP5

A new car company allows you to design your own Car Model D online. Show all the different ways you can design the car. Explain how you know you've shown all the different ways.

> **Car Model D Options**
>
> **Color**
> ○ Red ○ Black ○ Silver
>
> _____
>
> **Doors**
> ○ Two ○ Four
>
> _____
>
> **Transmission**
> ○ Automatic ○ Manual

Reflect Does it matter what order you list the different ways to design the car? Explain.

Got It?

PART 1 Got It

Three friends buy bagels, choosing from the kinds shown. They buy three different kinds. Use an organized list to show all possible combinations for the three friends' bagels.

Show each outcome in this form:
(friend 1's bagel, friend 2's bagel, friend 3's bagel)

Plain Sesame Cheese Onion

Discuss with a classmate

Compare the organized lists that you made for this problem.
Read the instructions for the problem together, paying particular attention to how to write each outcome using parentheses and commas.
Then use highlighting or color-coding to check your outcomes to see if your lists are complete. Revise your lists as needed.

PART 2 Got It

A clothing store sells sweaters in V-neck, crew neck, and cardigan styles. Each style is available in blue, gray, or red. How many different sweaters can you choose?

Got It?

PART 3 Got It (1 of 2)

On the school bus, two students sit in each seat, one by the window and one by the aisle. Make a tree diagram to show all possible arrangements of 5th, 7th, and 8th graders sharing a seat. List the possible arrangements in an outcome column.

PART 3 Got It (2 of 2)

Think about the sample spaces displayed in organized lists, tables, and tree diagrams in this lesson.

Make a conjecture about the relationship between the number of possible outcomes of each step of an action and the number of outcomes in the sample space of the action.

Close and Check

> ## Focus Question
> ⓒ MP3, MP7
>
> How do you know a sample space is complete? How do you know when you have accounted for all possibilities?
>
> _____
>
> _____
>
> _____
>
> _____

Do you know HOW?

1. How many possible combinations of parfait cups are there if one item is chosen from each list?

Yogurt	Fruit	Topping
Plain	Blueberries	Granola
Vanilla	Strawberries	Nuts
Berry	Cherries	
	Bananas	

2. A school offers three elective classes: art (a), band (b), and choir (c). Each student must choose a morning class and a different afternoon class. Make a tree diagram to show all possible class and time combinations.

Do you UNDERSTAND?

3. **Reasoning** The school in Exercise 2 adds an evening class time. Does the total number of combinations of classes change? Explain.

4. **Error Analysis** The table displays the outcomes for a sample space involving a spinner divided into colors. Your friend says the spinner was spun four times. Is she correct? Explain.

	R	B
R	R, R	R, B
B	B, R	B, B

Digital
Resources

CCSS: 7.SP.C.8a: Understand that … the probability of a compound event is the fraction of outcomes in the sample space for which the compound event occurs. **7.SP.C.8b:** … For an event described in everyday language … , identify the outcomes … . Also, **7.SP.C.8.**

Launch

© MP4, MP6

The new car company unveils two new models. Which car can you order in more ways? Explain your reasoning.

Car Model Q Options
Color
○ Silver ○ Black
Doors
○ Three ○ Four ○ Five
Transmission
○ Automatic ○ Manual

Car Model C Options
Color
○ Silver ○ Black ○ White
○ Green ○ Red ○ Tan
Doors
○ Two ○ Four
Transmission
○ Automatic

Reflect How would your method work for counting the different ways you could order a car with even more choices such as 12 exterior colors, 4 door options, 3 transmission options, 2 engine types, and 6 interior colors?

Got It?

PART 1 Got It

At Charlie's House of Chili, your chili can be mild, medium, spicy, hot, or superhot, and you can have it with or without cheese.

How many different ways can you order chili at Charlie's House of Chili?

PART 2 Got It

Use the table of possible outcomes of rolling two standard number cubes. How many outcomes are in this event?

Event: Get a sum of 7.

Sample Space for Rolling 2 Number Cubes

	1	2	3	4	5	6
1	1, 1	2, 1	3, 1	4, 1	5, 1	6, 1
2	1, 2	2, 2	3, 2	4, 2	5, 2	6, 2
3	1, 3	2, 3	3, 3	4, 3	5, 3	6, 3
4	1, 4	2, 4	3, 4	4, 4	5, 4	6, 4
5	1, 5	2, 5	3, 5	4, 5	5, 5	6, 5
6	1, 6	2, 6	3, 6	4, 6	5, 6	6, 6

PART 3 Got It

The number on your hockey jersey is 17. You decide to choose a three-character password by selecting at random two different letters, followed by one number, from the phrase below.

HOCKEY 17

How many different passwords can you make? How many of the passwords begin with the letter K?

Close and Check

Focus Question

How is the number of outcomes of a multi-step process related to the number of outcomes for each step?

Do you know HOW?

1. An online shoe store offers customized gym shoes. You have a choice of leather or canvas material; black, white, or gray shoe color; and red, pink, blue, green, or yellow lace color. How many different shoe choices are there?

2. Use a table to show all the possible outcomes of choosing a shape and a letter.

△ ○ □

A B C D E

3. Based on the table in Exercise 2, how many outcomes are in this event? Event: Choosing a polygon or a vowel.

Do you UNDERSTAND?

4. **Writing** Explain how you found the solution to Exercise 1.

5. **Reasoning** Explain how the number of possible outcomes for Exercise 3 would change if the event were choosing a polygon *and* a vowel.

This page intentionally left blank.

Finding Theoretical Probabilities

Digital Resources

CCSS: **7.SP.C.8:** Find probabilities of compound events using organized lists, tables, [and] tree diagrams **7.SP.C.8a:** Understand . . the probability of a compound event is the fraction of outcomes in the sample space for which the compound event occurs. A so, **7.SP.C.6.**

Launch

Ⓒ MP2, MP7

An online shoe clerk unfortunately erases your order options on Shoe Model W. So, she sends you four different pairs and asks you to return any that don't match your order.

What are the chances you'll get the shoes you ordered? Explain.

Shoe Model W

Color
○ Silver ○ Black ○ Brown ○ Green

Size
○ 5 ○ 6 ○ 7 ○ 8
○ $5\frac{1}{2}$ ○ $6\frac{1}{2}$ ○ $7\frac{1}{2}$ ○ $8\frac{1}{2}$

Reflect Will the chances be the same or different depending on which four different pairs the store clerk sent?

Got It?

The tree diagram shows the possible outcomes of choosing one card from the group shown, setting it aside, and then choosing a second card.

What is P(at least one fish or one apple)?

F
S A K L

S
F A K L

A
F S K L

K
F S A L

L
F S A K

Got It?

PART 2 Got It

It is your turn to pick a Geography Fair partner and country at random. Use an organized list, a table, or a tree diagram to find the probability of choosing your best friend, Miguel, and your favorite country, Greece.

Names still in box:
Nora, Miguel, Otis, Priya, and Quincy

Countries still in box:
Ethiopia, France, and Greece

PART 3 Got It

Action: Choose one marble at random from a bag that contains one red, one green, and one blue marble. Then toss a coin.

For which compound event is the result closest to the result predicted by theoretical probability?

Results of 60 Trials	
Event	Count
(R, H)	11
(R, T)	8
(G, H)	14
(G, T)	6
(B, H)	13
(B, T)	8

Discuss with a classmate

The table of results for 60 trials contains important information for this problem. Take turns choosing a row from the table and explaining what the notation in the left column and the number in the right column mean.

Then compare your answers to the problem. Revise your answers as needed.

Close and Check

▶ Focus Question

© MP2, MP5

In what situations should you use an organized list, a table, or a tree diagram to find the probability of a compound event?

▶ Do you know HOW?

1. Find the probability of rolling sequential numbers (for example; 1 then 2) in 2 consecutive rolls of a number cube.

P(2 sequential numbers) = []

or about [] %

2. Using a number cube and 4 marbles (red, blue, yellow, and green), what is the theoretical probability of rolling a specific number and choosing a specific marble without looking?

[]

3. For which compound event is the result closest to the result predicted by theoretical probability in Exercise 2?

Results of 100 Trials				
Event	(1, R)	(3, B)	(5, Y)	(6, G)
Count	6	2	4	3

[]

▶ Do you UNDERSTAND?

4. Writing Explain how the theoretical probability in Exercise 2 changes if the action is rolling an even number and choosing a red or yellow marble.

5. Reasoning If 60 trials are conducted using the compound event described in Exercise 4, how many favorable outcomes would you expect to get? Explain.

CCSS: **7.SP.C.8:** Find probabilities of compound events using organized lists, tables, tree diagrams, and simulation. **7.SP.C.8c:** Design and use a simulation to generate frequencies for compound events

Launch

MP1, MP7

Describe a pick-a-number game where contestants have a 1 in 4 chance of winning. Your game must have two rounds and use all the tiles shown.

Reflect What was most critical to you to design a game that worked?

Got It?

PART 1 Got It

A grocery store finds that 30% of its customers bring their own bags. Which ways of assigning numbers to outcomes can you use to simulate the probability that a customer chosen at random brings his or her own bags?

> I. own bags: 1, 2, 3
> other bags: 4, 5, 6, 7, 8, 9, 0

> II. own bags: 1 to 33
> other bags: 34 to 100

> III. own bags: 1 to 10
> other bags: 11 to 30

PART 2 Got It

A quarterback usually completes 60% of his passes. Use these numbers to represent possible outcomes of one pass:

> **Complete:** 1, 2, 3, 4, 5, 6
> **Incomplete:** 7, 8, 9, 0

Which list of random numbers simulates completing more than four passes?
I. 0 4 0 8 1 1 5 0 8 0
II. 7 0 4 0 3 0 1 1 3 9
III. 2 6 9 0 3 6 6 7 2 7

Got It?

PART 3 Got It

On a six-question multiple-choice quiz, each question has four answer choices. Only one answer choice is correct.

Use the Probability Tool to generate random numbers to simulate taking this quiz 20 times, guessing answers at random. Use your results to complete the frequency table of the results.

Six-Question Multiple-Choice Quiz

Number Correct	0	1	2	3	4	5	6
Frequency							

Close and Check

Focus Question

MP5, MP7

How can you use random numbers to simulate real-world situations?

Do you know HOW?

1. A survey finds that 49 out of 84 students ride the school bus each day. Assign numbers to simulate the outcomes that a student chosen at random rides the school bus each day.

 bus rider: []

 non-bus rider: []

2. Circle the list of random numbers that simulates the survey results given in Exercise 1.

 A. 3, 5, 9, 2, 11, 9, 5, 3, 8, 10, 12, 5

 B. 12, 11, 7, 9, 4, 6, 3, 5, 7, 3, 9, 10

3. Eight students take a four-question quiz. Correct answers are assigned a 1, and incorrect answers are assigned a 2. Record the results of the quiz in the frequency table.

1111	2122	1112	1122
1112	1221	1211	1112

 Quiz Results

Do you UNDERSTAND?

4. **Writing** Explain how you decided which numbers to assign in Exercise 1.

5. **Reasoning** According to Exercise 3, how many students got at least 3 items on the quiz correct? Explain how you found the solution.

Finding Probabilities Using Simulation

CCSS: 7.SP.C.8: Find probabilities of compound events using organized lists, tables, tree diagrams, and simulation.

Launch

© MP1, MP5, MP6

Your friend designs a game that involves drawing *makes* and *misses* blindly out of a bag to simulate a basketball free throw. He wants his game to have P(making two free throws) = 0.75.

Complete and explain the possible game rules using the items shown

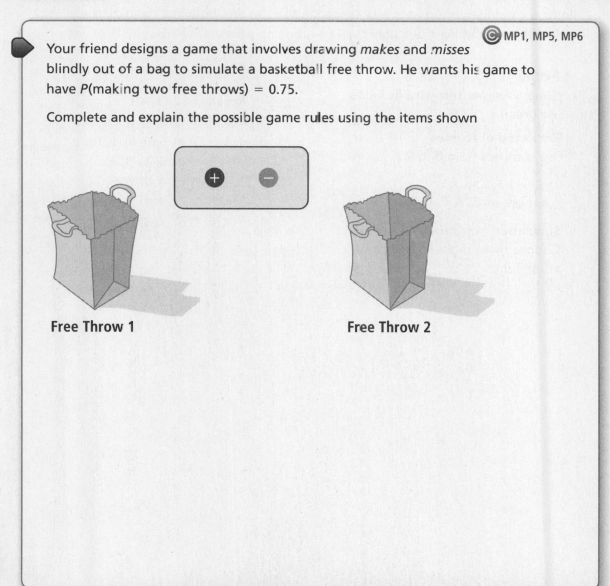

Free Throw 1 Free Throw 2

Reflect Does your game guarantee a 75% probability of making two free throws? Explain.

Got It?

PART 1 Got It

Traffic lights on Main Street are green 40% of the time. You travel through three lights on Main Street on your way to school. Use this simulation to estimate the probability that at least two lights will be green on your way to school.

Action
Check whether three traffic lights are green.

Simulated outcomes
Use numbers from 0 to 9.

 green: 1, 2, 3, 4
 not green: 5, 6, 7, 8, 9, 0

Simulation (one trial)
Choose three digits from 0 to 9 at random.

Results of 24 trials

(3, 3, 3) (0, 3, 5) (6, 9, 2) (7, 5, 8)
(0, 5, 6) (7, 9, 5) (0, 6, 6) (6, 0, 0)
(2, 6, 9) (5, 9, 3) (6, 6, 1) (1, 4, 5)
(0, 3, 8) (9, 6, 1) (9, 4, 9) (7, 9, 7)
(3, 7, 4) (4, 8, 5) (7, 2, 1) (2, 1, 9)
(5, 1, 6) (2, 0, 4) (4, 7, 8) (3, 3, 7)

Got It?

Traffic lights on School Street are yellow 10% of the time. You travel through four traffic lights on School Street on your way to soccer practice. Use a simulation to predict the probability that at least one light will be yellow on your way to soccer practice.

Close and Check

Focus Question

MP5, MP6

In what situations should you use a simulation to find the probability of a compound event?

Do you know **HOW?**

1. A survey finds that 39% of households in a certain town own at least one dog. Assign a range of numbers to simulate each possible outcome.

 Households that own at least one dog:

 []

 Households that do not own at least one dog:

 []

2. Use the pairs of random numbers to find the experimental probability that exactly one of the next two people you meet will own a dog. Express the solution as a percent.

 | (72, 30) | (15, 38) | (67, 93) |
 | (100, 2) | (80, 69) | (77, 89) |
 | (88, 45) | (22, 51) | (57, 62) |
 | (72, 59) | (74, 64) | (81, 97) |

 []

Do you **UNDERSTAND?**

3. **Writing** Describe one trial and tell what a favorable outcome would be for the simulation in Exercise 2.

4. **Reasoning** You decide to change the favorable outcome in Exercise 2 to _at least_ one of the next two people you meet owning a dog. Would you expect the experimental probability to change? Explain.

Problem Solving

Digital
Resources

CCSS: 7.SP.C.7: Develop a probability model and use it to find probabilities of events. Compare probabilities from a model to observed frequencies 7.SP.C.8: Find probabilities of compound events using organized lists, tables, tree diagrams, and simulation.

Launch

MP2, MP8

Design a three-spinner game in which contestants have a 30% chance of winning. Complete the spinners and describe the rules of the game.

Reflect What was the most challenging part of designing your game? Explain.

Got It?

PART 1 Got It

A class used the Probability Tool to roll two number cubes 300 times. About how many times should they expect to get either a sum or a product of 8?

Discuss with a classmate

Highlight the math terms *sum* and *product*.
Review the definitions for these terms, using the glossary in the back of the book as needed.
If you did not understand these terms when you solved the problem, revise your answer so that you use the terms correctly.

PART 2 Got It

Water flows from Start to End through a system of water pipes, as shown in the diagram. Water flows only in the direction of the arrows. At each point *W*, *X*, *Y*, and *Z*, there is a 50% chance that an obstruction prevents the flow of water.

What is the probability that there is an open path from Start to End at any given moment?

Close and Check

MP1, MP3

Focus Question

How do you choose a strategy for finding the probability of a compound event? Are there situations in which one strategy is better than another?

Do you know HOW?

1. You roll two number cubes 200 times. How many times should you expect to roll two number cubes that have an even sum?

2. You can travel from your house to a golf course by the roads shown. Any of the 3 intersections A, B, and C may be closed due to construction. Express the theoretical probability that there is an open path from your house to the golf course at any time as a fraction and as a percent.

Fraction:

Percent:

Do you UNDERSTAND?

3. **Reasoning** Explain how you found the solution to Exercise 1.

4. **Writing** Explain how you could set up a simulation to find the experimental probability for Exercise 2.

This page intentionally left blank.

New Vocabulary: compound event counting principle, dependent events, independent events
Review Vocabulary: action, event, experimental probability, outcome, sample space, simulation, theoretical probability

Vocabulary Review

Identify two challenging vocabulary terms from this topic. Write one vocabulary term in the center oval, and fill in the surrounding boxes with details that will help you better understand the term.

Definition

Characteristics

Example

Nonexample

Definition

Characteristics

Example

Nonexample

Pull It All Together

TASK 1

The table shows probabilities based on a town's weather records. Use the pairs of random numbers to estimate the probability of each event.

a. A partly cloudy day is followed by a clear day.

b. A cloudy day is followed by a partly cloudy day.

Sky Condition

Condition	Probability
Clear	23%
Partly Cloudy	48%
Cloudy	29%

25 Pairs of Random Numbers

(91, 96)	(28, 84)	(12, 25)	(89, 80)	(82, 93)
(15, 23)	(28, 62)	(70, 86)	(38, 56)	(99, 63)
(52, 37)	(13, 21)	(99, 38)	(12, 34)	(50, 34)
(41, 1)	(6, 99)	(64, 60)	(46, 22)	(41, 46)
(74, 94)	(73, 73)	(30, 61)	(99, 63)	(23, 81)

TASK 2

To win a prize in a carnival game, you must choose both a box with a marble and a curtain that hides a prize.

a. For the game shown, what is the probability of winning a prize?

b. A different game has two boxes and four curtains. One box contains a marble and one curtain hides a prize. Which game would you prefer to play? Explain.

Choose one box.
One box contains a marble.

Choose one curtain.
Two curtains hide prizes.

English/Spanish Glossary

······· A ·······

Absolute deviation from the mean Absolute deviation measures the distance that the data value is from the mean. You find the absolute deviation by taking the absolute value of the deviation of a data value. Absolute deviations are always nonnegative.

Desviación absoluta de la media La desviación absoluta mide la distancia a la que un valor se encuentra de la media. Para hallar la desviación absoluta, tomas el valor absoluto de la desviación de un valor. Las desviaciones absolutas siempre son no negativas.

Absolute value The absolute value of a number a is the distance between a and zero on a number line. The absolute value of a is written as $|a|$.

Valor absoluto El valor absoluto de un número a es la distancia entre a y cero en la recta numérica. El valor absoluto de a se escribe como $|a|$.

Accuracy The accuracy of an estimate or measurement is the degree to which it agrees with an accepted or actual value of that measurement.

Exactitud La exactitud de una estimación o medición es el grado de concordancia con un valor aceptado o real de esa medición.

Action In a probability situation, an action is a process with an uncertain result.

Acción En una situación de probabilidad, una acción es el proceso con un resultado incierto.

Acute angle An acute angle is an angle with a measure between 0° and 90°.

Ángulo agudo Un ángulo agudo es un ángulo que mide entre 0° y 90°.

Acute triangle An acute triangle is a triangle with three acute angles.

Triángulo acutángulo Un triángulo acutángulo es un triángulo que tiene tres ángulos agudos.

Addend Addends are the numbers that are added together to find a sum.

Sumando Los sumandos son los números que se suman para hallar un total.

English/Spanish Glossary

Additive inverses Two numbers that have a sum of 0.

Inversos de suma Dos números cuya suma es 0.

Adjacent angles Two angles are adjacent angles if they share a vertex and a side, but have no interior points in common.

Ángulos adyacentes Dos ángulos son adyacentes si tienen un vértice y un lado en común, pero no comparten puntos internos.

Algebraic expression An algebraic expression is a mathematical phrase that consists of variables, numbers, and operation symbols.

Expresión algebraica Una expresión algebraica es una frase matemática que consiste en variables, números y símbolos de operaciones.

Analyze To analyze is to think about and understand facts and details about a given set of information. Analyzing can involve providing a written summary supported by factual information, diagrams, charts, tables, or any combination of these.

Analizar Analizar es pensar en los datos y detalles de cierta información y comprenderlos. El análisis puede incluir la presentación de un resumen escrito sustentado por información objetiva, diagramas, tablas o una combinación de esos elementos.

Angle An angle is a figure formed by two rays with a common endpoint.

Ángulo Un ángulo es una figura formada por dos semirrectas que tienen un extremo en común.

Angle of rotation The angle of rotation is the number of degrees a figure is rotated.

Ángulo de rotación El ángulo de rotación es el número de grados que se rota una figura.

Annual salary The amount of money earned at a job in one year.

Salario annual La cantidad de dinero ganó en un trabajo en un año.

Area The area of a figure is the number of square units the figure encloses.

Área El área de una figura es el número de unidades cuadradas que ocupa.

English/Spanish Glossary

Area of a circle The formula for the area of a circle is $A = \pi r^2$, where A represents the area and r represents the radius of the circle.

Área de un círculo La fórmula del área de un círculo es $A = \pi r^2$, donde A representa el área y r representa el radio del círculo.

Area of a parallelogram The formula for the area of a parallelogram is $A = bh$, where A represents the area, b represents a base, and h is the corresponding height.

Área de un paralelogramo La fórmula del área de un paralelogramo es $A = bh$, donde A representa el área, b representa una base y h es la altura correspondiente.

Area of a rectangle The formula for the area of a rectangle is $A = bh$, where A represents the area, b represents the base, and h represents the height of the rectangle.

Área de un rectángulo La fórmula del área de un rectángulo es $A = bh$, donde A representa el área, b representa la base y h representa la altura del rectángulo.

Area of a square The formula for the area of a square is $A = s^2$, where A represents the area and s represents a side length.

Área de un cuadrado La fórmula del área de un cuadrado es $A = s^2$, donde A representa el área y l representa la longitud de un lado.

Area of a trapezoid The formula for the area of a trapezoid is $A = \frac{1}{2}h(b_1 + b_2)$, where A represents the area, b_1 and b_2 represent the bases, and h represents the height between the bases.

El área de un trapezoide La fórmula para el área de un trapezoide es $A = \frac{1}{2}h(b_1 + b_2)$, donde A representa el área, b_1 y b_2 representan las bases, y h representa la altura entre las bases.

Area of a triangle The formula for the area of a triangle is $A = \frac{1}{2}bh$, where A represents the area, b represents the length of a base, and h represents the corresponding height.

Área de un triángulo La fórmula del área de un triángulo es $A = \frac{1}{2}bh$, donde A representa el área, b representa la longitud de una base y h representa la altura correspondiente.

Asset An asset is money you have or property of value that you own.

Ventaja Una ventaja es dinero que tiene o la propiedad de valor que usted posee.

English/Spanish Glossary

Associative Property of Addition For any numbers a, b, and c:
$(a + b) + c = a + (b + c)$

Propiedad asociativa de la suma Para los números cualesquiera a, b y c:
$(a + b) + c = a + (b + c)$

Associative Property of Multiplication For any numbers a, b, and c:
$(a \cdot b) \cdot c = a \cdot (b \cdot c)$

Propiedad asociativa de la multiplicación Para los números cualesquiera a, b y c:
$(a \cdot b) \cdot c = a \cdot (b \cdot c)$

Average of two numbers The average of two numbers is the value that represents the middle of two numbers. It is found by adding the two numbers together and dividing by 2.

Promedio de dos números El promedio de dos números es el valor que está justo en el medio de esos dos números. Se halla sumando los dos números y dividiendo el resultado por 2.

B

Balance The balance in an account is the principal amount plus the interest earned.

Saldo El saldo de una cuenta es el capital más el interés ganado.

Balance of a checking account The balance of a checking account is the amount of money in the checking account.

El equilibrio de una Cuenta Corriente Bancaria El equilibrio de una cuenta corriente bancaria es la cantidad de dinero en la cuenta corriente bancaria.

Balance of a loan The balance of a loan is the remaining unpaid principal.

El equilibrio de un préstamo El equilibrio de un préstamo es el director impagado restante.

Bar diagram A bar diagram is a way to represent part to whole relationships.

Diagrama de barras Un diagrama de barras es una forma de representar una relación de parte a entero.

Base The base is the repeated factor of a number written in exponential form.

Base La base es el factor repetido de un número escrito en forma exponencial.

English/Spanish Glossary

Base area of a cone The base area of a cone is the area of a circle. Base Area = πr^2.

Área de la base de un cono El área de la base de un cono es el área de un círculo. El área de la base = πr^2.

Base of a cone The base of a cone is a circle with radius *r*.

Base de un cono La base de un cono es un círculo con radio *r*.

Base of a cylinder A base of a cylinder is one of a pair of parallel circular faces that are the same size.

Base de un cilindro Una base de un cilindro es una de dos caras circulares paralelas que tienen el mismo tamaño.

Base of a parallelogram A base of a parallelogram is any side of the parallelogram.

Base de un paralelogramo La base de un paralelogramo es cualquiera de los lados del paralelogramo.

Base of a prism A base of a prism is one of a pair of parallel polygonal faces that are the same size and shape. A prism is named for the shape of its bases.

Base de un prisma La base de un prisma es una de las dos caras poligonales paralelas que tienen el mismo tamaño y la misma forma. El nombre de un prisma depende de la forma de sus bases.

Base of a pyramid A base of a pyramid is a polygonal face that does not connect to the vertex.

Base de una pirámide La base de una pirámide es una cara poligonal que no se conecta con el vértice.

Base of a triangle The base of a triangle is any side of the triangle.

Base de un triángulo La base de un triángulo es cualquiera de los lados del triángulo.

Benchmark A benchmark is a number you can use as a reference point for other numbers.

Referencia Una referencia es un número que usted puede utilizar como un punto de referencia para otros números.

English/Spanish Glossary

Bias A bias is a tendency toward a particular perspective that is different from the overall perspective of the population.

Sesgo Un sesgo es una tendencia hacia una perspectiva particular que es diferente de la perspectiva general de la población.

Biased sample In a biased sample, the number of subjects in the sample with the trait that you are studying is not proportional to the number of members in the population with that trait. A biased sample does not accurately represent the population.

Muestra sesgada En una muestra sesgada, el número de sujetos de la muestra que tiene la característica que se está estudiando no es proporcional al número de miembros de la población que tienen esa característica. Una muestra sesgada no representa con exactitud la población.

Bivariate categorical data Bivariate categorical data pairs categorical data collected about two variables of the same population.

Datos bivariados por categorías Los datos bivariados por categorías agrupan pares de datos obtenidos acerca de dos variables de la misma población.

Bivariate data Bivariate data is comprised of pairs of linked observations about a population.

Datos bivariados Los datos bivariados se forman a partir de pares de observaciones relacionadas sobre una población.

Box plot A box plot is a statistical graph that shows the distribution of a data set by marking five boundary points where data occur along a number line. Unlike a dot plot or a histogram, a box plot does not show frequency.

Diagrama de cajas Un diagrama de cajas es un diagrama de estadísticas que muestra la distribución de un conjunto de datos al marcar cinco puntos de frontera donde se hallan los datos sobre una recta numérica. A diferencia del diagrama de puntos o el histograma, el diagrama de cajas no muestra la frecuencia.

Budget A budget is a plan for how you will spend your money.

Presupuesto Un presupuesto es un plan para cómo gastará su dinero.

English/Spanish Glossary

C

Categorical data Categorical data consist of data that fall into categories.

Datos por categorías Los datos por categorías son datos que se pueden clasificar en categorías.

Center of a circle The center of a circle is the point inside the circle that is the same distance from all points on the circle. Name a circle by its center.

Centro de un círculo El centro de un círculo es el punto dentro del círculo que está a la misma distancia de todos los puntos del círculo. Un círculo se identifica por su centro.

Center of a regular polygon The center of a regular polygon is the point that is equidistant from its vertices.

Centro de un polígono regular El centro de un polígono regular es el punto equidistante de todos sus vértices.

Center of rotation The center of rotation is a fixed point about which a figure is rotated.

Centro de rotación El centro de rotación es el punto fijo alrededor del cual se rota una figura.

Check register A record that shows all of the transactions for a bank account, including withdrawals, deposits, and transfers. It also shows the balance of the account after each transaction.

Verifique registro Un registro que muestra todas las transacciones para una cuenta bancaria, inclusive retiradas, los depósitos, y las transferencias. También muestra el equilibrio de la cuenta después de cada transacción.

Circle A circle is the set of all points in a plane that are the same distance from a given point, called the center.

Círculo Un círculo es el conjunto de todos los puntos de un plano que están a la misma distancia de un punto dado, llamado centro.

Circle graph A circle graph is a graph that represents a whole divided into parts.

Gráfica circular Una gráfica circular es una gráfica que representa un todo dividido en partes.

English/Spanish Glossary

Circumference of a circle The circumference of a circle is the distance around the circle. The formula for the circumference of a circle is $C = \pi d$, where C represents the circumference and d represents the diameter of the circle.

Circunferencia de un círculo La circunferencia de un círculo es la distancia alrededor del círculo. La fórmula de la circunferencia de un círculo es $C = \pi d$, donde C representa la circunferencia y d representa el diámetro del círculo.

Cluster A cluster is a group of points that lie close together on a scatter plot.

Grupo Un grupo es un conjunto de puntos que están agrupados en un diagrama de dispersión.

Coefficient A coefficient is the number part of a term that contains a variable.

Coeficiente Un coeficiente es la parte numérica de un término que contiene una variable.

Common denominator A common denominator is a number that is the denominator of two or more fractions.

Común denominador Un común denominador es un número que es el denominador de dos o más fracciones.

Common multiple A common multiple is a multiple that two or more numbers share.

Múltiplo común Un múltiplo común es un múltiplo que comparten dos o más números.

Commutative Property of Addition For any numbers a and b: $a + b = b + a$

Propiedad conmutativa de la suma Para los números cualesquiera a y b: $a + b = b + a$

Commutative Property of Multiplication For any numbers a and b: $a \cdot b = b \cdot a$

Propiedad conmutativa de la multiplicación Para los números cualesquiera a y b: $a \cdot b = b \cdot a$

Comparative inference A comparative inference is an inference made by interpreting and comparing two sets of data.

Inferencia comparativa Una inferencia comparativa es una inferencia que se hace al interpretar y comparar dos conjuntos de datos.

English/Spanish Glossary

Compare To compare is to tell or show how two things are alike or different.

Comparar Comparar es describir o mostrar en qué se parecen o en qué se diferencian dos cosas.

Compatible numbers Compatible numbers are numbers that are easy to compute mentally.

Números compatibles Los números compatibles son números fáciles de calcular mentalmente.

Complementary angles Two angles are complementary angles if the sum of their measures is 90°. Complementary angles that are adjacent form a right angle.

Ángulos complementarios Dos ángulos son complementarios si la suma de sus medidas es 90°. Los ángulos complementarios que son adyacentes forman un ángulo recto.

Complex fraction A complex fraction is a fraction $\frac{A}{B}$ where A and/or B are fractions and B is not zero.

Fracción compleja Una fracción compleja es una fracción $\frac{A}{B}$ donde A y/o B son fracciones y B es distinto de cero.

Compose a shape To compose a shape, join two (or more) shapes so that there is no gap or overlap.

Componer una figura Para componer una figura, debes unir dos (o más) figuras de modo que entre ellas no queden espacios ni superposiciones.

Composite figure A composite figure is the combination of two or more figures into one object.

Figura compuesta Una figura compuesta es la combinación de dos o más figuras en un objeto.

Composite number A composite number is a whole number greater than 1 with more than two factors.

Número compuesto Un número compuesto es un número entero mayor que 1 con más de dos factores.

Compound event A compound event is an event associated with a multi-step action. A compound event is composed of events that are the outcomes of the steps of the action.

Evento compuesto Un evento compuesto es un evento que se relaciona con una acción de varios pasos. Un evento compuesto se compone de eventos que son los resultados de los pasos de una acción.

English/Spanish Glossary

Compound interest Compound interest is interest paid on both the principal and the interest earned in previous interest periods. To calculate compound interest, use the formula $B = p(1 + r)^n$, where B is the balance in the account, p is the principal, r is the annual interest rate, and n is the time in years that the account earns interest.

Interés compuesto El interés compuesto es el interés que se paga sobre el capital y el interés obtenido en períodos de interés anteriores. Para calcular el interés compuesto, usa la fórmula $B = c(1 + r)^n$ donde B es el saldo de la cuenta, c es el capital, r es la tasa de interés anual y n es el tiempo en años en que la cuenta obtiene un interés.

Cone A cone is a three-dimensional figure with one circular base and one vertex.

Cono Un cono es una figura tridimensional con una base circular y un vértice.

Congruent figures Two two-dimensional figures are congruent \cong if the second can be obtained from the first by a sequence of rotations, reflections, and translations.

Figuras congruentes Dos figuras bidimensionales son congruentes \cong si la segunda puede obtenerse a partir de la primera mediante una secuencia de rotaciones, reflexiones y traslaciones.

Conjecture A conjecture is a statement that you believe to be true but have not yet proved to be true.

Conjetura Una conjetura es un enunciado que crees que es verdadero, pero que todavía no has comprobado que sea verdadero.

Constant A constant is a term that only contains a number.

Constante Una constante es un término que solamente contiene un número.

Constant of proportionality In a proportional relationship, one quantity y is a constant multiple of the other quantity x. The constant multiple is called the constant of proportionality. The constant of proportionality is equal to the ratio $\frac{y}{x}$.

Constante de proporcionalidad En una relación proporcional, una cantidad y es un múltiplo constante de la otra cantidad x. El múltiplo constante se llama constante de proporcionalidad. La constante de proporcionalidad es igual a la razón $\frac{y}{x}$.

English/Spanish Glossary

Construct To construct is to make something, such as an argument, by organizing ideas. Constructing an argument can involve a written response, equations, diagrams, charts, tables, or a combination of these.

Construir Construir es hacer o crear algo, como se construye un argumento al organizar ideas. Para construir un argumento puede usarse una respuesta escrita, ecuaciones, diagramas, tablas o una combinación de esos elementos.

Convenience sampling Convenience sampling is a sampling method in which a researcher chooses members of the population that are convenient and available. Many researchers use this sampling technique because it is fast and inexpensive. It does not require the researcher to keep track of everyone in the population.

Muestra de conveniencia Una muestra de conveniencia es un método de muestreo en el que un investigador escoge miembros de la población que están convenientemente disponibles. Muchos investigadores usan esta técnica de muestreo porque es rápida y no es costosa. No requiere que el investigador lleve un registro de cada miembro de la población.

Cost of attendance The cost of attendance of one year of college is the sum of all of your expenses during the year.

El costo de asistencia El costo de asistencia de un año del colegio es la suma de todos sus gastos durante el año.

Cost of credit The cost of credit for a loan is the difference between the total cost and the principal.

El costo de crédito El costo de crédito para un préstamo es la diferencia entre el coste total y el director.

Converse of the Pythagorean Theorem If the sum of the squares of the lengths of two sides of a triangle equals the square of the length of the third side, then the triangle is a right triangle. If $a^2 + b^2 = c^2$, then the triangle is a right triangle.

Expresión recíproca del Teorema de Pitágoras Si la suma del cuadrado de la longitud de dos lados de un triángulo es igual al cuadrado de la longitud del tercer lado, entonces el triángulo es un triángulo rectángulo. $a^2 + b^2 = c^2$, entonces el triángulo es un triángulo rectángulo.

Conversion factor A conversion factor is a rate that equals 1.

Factor de conversión Un factor de conversión es una tasa que es igual a 1.

English/Spanish Glossary

Coordinate plane A coordinate plane is formed by a horizontal number line called the x-axis and a vertical number line called the y-axis.

Plano de coordenadas Un plano de coordenadas está formado por una recta numérica horizontal llamada eje de las x y una recta numérica vertical llamada eje de las y.

Corresponding angles Corresponding angles lie on the same side of a transversal and in corresponding positions.

Ángulos correspondientes Los ángulos correspondientes se ubican al mismo lado de una secante y en posiciones correspondientes.

Counterexample A counterexample is a specific example that shows that a conjecture is false.

Contraejemplo Un contraejemplo es un ejemplo específico que muestra que una conjetura es falsa.

Counting Principle If there are m possible outcomes of one action and n possible outcomes of a second action, then there are $m \cdot n$ outcomes of the first action followed by the second action.

Principio de conteo Si hay m resultados posibles de una acción y n resultados posibles de una segunda acción, entonces hay $m \cdot n$ resultados de la primera acción seguida de la segunda acción.

Coupon A coupon is part of a printed or online advertisement entitling the holder to a discount at checkout.

Cupón Un cupón forma parte de un anuncio impreso o en línea que permite al poseedor a un descuento en comprueba.

Credit card A credit card is a card issued by a lender that can be used to borrow money or make purchases on credit.

Tarjeta de crédito Una tarjeta de crédito es una tarjeta publicada por un prestamista que puede ser utilizado para pedir dinero prestado o compras de marca a cuenta.

Credit history A credit history shows how a consumer has managed credit in the past.

Acredite la historia Una historia del crédito muestra cómo un consumidor ha manejado crédito en el pasado.

English/Spanish Glossary

Credit report A report that shows personal information about a consumer and details about the consumer's credit history.

Acredite reporte Un reporte que muestra información personal sobre un consumidor y detalles acerca de la historia del crédito del consumidor.

Critique A critique is a careful judgment in which you give your opinion about the good and bad parts of something, such as how a problem was solved.

Crítica Una crítica es una evaluación cuidadosa en la que das tu opinión acerca de las partes positivas y negativas de algo, como la manera en la que se resolvió un problema.

Cross section A cross section is the intersection of a three-dimensional figure and a plane.

Corte transversal Un corte transversal es la intersección de una figura tridimensional y un plano.

Cube A cube is a rectangular prism whose faces are all squares.

Cubo Un cubo es un prisma rectangular cuyas caras son todas cuadrados.

Cube root The cube root of a number, n, is a number whose cube equals n.

Raíz cúbica La raíz cúbica de un número, n, es un número que elevado al cubo es igual a n.

Cubic unit A cubic unit is the volume of a cube that measures 1 unit on each edge.

Unidad cúbica Una unidad cúbica es el volumen de un cubo en el que cada arista m de 1 unidad.

Cylinder A cylinder is a three-dimensional figure with two parallel circular bases that are the same size.

Cilindro Un cilindro es una figura tridimensional con dos bases circulares paralelas que tienen el mismo tamaño.

D

Data Data are pieces of information collected by asking questions, measuring, or making observations about the real world.

Datos Los datos son información reunida mediante preguntas, mediciones u observaciones sobre la vida diaria.

English/Spanish Glossary

Debit card A debit card is a card issued by a bank that is linked a customer's bank account, normally a checking account. A debit card can normally be used to withdraw money from an ATM or to make a purchase.

Tarjeta de débito Una tarjeta de débito es una tarjeta publicada por un banco que es ligado la cuenta bancaria de un cliente, normalmente una cuenta corriente bancaria. Una tarjeta de débito puede ser utilizada normalmente retirar dinero de una ATM o para hacer una compra.

Decimal A decimal is a number with one or more places to the right of a decimal point.

Decimal Un decimal es un número que tiene uno o más lugares a la derecha del punto decimal.

Decimal places The digits after the decimal point are called decimal places.

Lugares decimales Los dígitos que están después del punto decimal se llaman lugares decimales.

Decompose a shape To decompose a shape, break it up to form other shapes.

Descomponer una figura Para descomponer una figura, debes separarla para formar otras figuras.

Deductive reasoning Deductive reasoning is a process of reasoning logically from given facts to a conclusion.

Razonamiento deductivo El razonamiento deductivo es un proceso de razonamiento lógico que parte de hechos dados hasta llegar a una conclusión.

Denominator The denominator is the number below the fraction bar in a fraction.

Denominador El denominador es el número que está debajo de la barra de fracción en una fracción.

Dependent events Two events are dependent events if the occurrence of the first event affects the probability of the second event.

Eventos dependientes Dos eventos son dependientes si el resultado del primer evento afecta la probabilidad del segundo evento.

Deposit A transaction that adds money to a bank account is a deposit.

Depósito Una transacción que agrega dinero a una cuenta bancaria es un depósito.

English/Spanish Glossary

Dependent variable A dependent variable is a variable whose value changes in response to another (independent) variable.

Variable dependiente Una variable dependiente es una variable cuyo valor cambia en respuesta a otra variable (independiente).

Describe To describe is to explain or tell in detail. A written description can contain facts and other information needed to communicate your answer. A diagram or a graph may also be included.

Describir Describir es explicar o indicar algo en detalle. Una descripción escrita puede incluir hechos y otra información necesaria para comunicar tu respuesta. También puede incluir un diagrama o una gráfica.

Design To design is to make using specific criteria.

Diseñar Diseñar es crear algo a partir de criterios específicos.

Determine To determine is to use the given information and any related facts to find a value or make a decision.

Determinar Determinar es usar la información dada y cualquier otro dato relacionado para hallar un valor o tomar una decisión.

Deviation from the mean Deviation indicates how far away and in which direction a data value is from the mean. Data values that are less than the mean have a negative deviation. Data values that are greater than the mean have a positive deviation.

Desviación de la media La desviación indica a qué distancia y en qué dirección un valor se aleja de la media. Los valores menores que la media tienen una desviación negativa. Los valores mayores que la media tienen una desviación positiva.

Diagonal A diagonal of a figure is a segment that connects two nonconsecutive vertices of the figure.

Diagonal La diagonal de una figura es un segmento que conecta dos vértices no consecutivos de la figura.

Diameter A diameter is a segment that passes through the center of a circle and has both endpoints on the circle. The term diameter can also mean the length of this segment.

Diámetro Un diámetro es un segmento que atraviesa el centro de un círculo y tiene sus dos extremos en el círculo. El término diámetro también puede referirse a la longitud de este segmento.

English/Spanish Glossary

Difference The difference is the answer you get when subtracting two numbers.

Diferencia La diferencia es la respuesta que obtienes cuando restas dos números.

Dilation A dilation is a transformation that moves each point along the ray through the point, starting from a fixed center, and multiplies distances from the center by a common scale factor. If a vertex of a figure is the center of dilation, then the vertex and its image after the dilation are the same point.

Dilatación Una dilatación es una transformación que mueve cada punto a lo largo de la semirrecta a través del punto, a partir de un centro fijo, y multiplica las distancias desde el centro por un factor de escala común. Si un vértice de una figura es el centro de dilatación, entonces el vértice y su imagen después de la dilatación son el mismo punto.

Direct variation A linear relationship that can be represented by an equation in the form $y = kx$, where $x \neq 0$.

Dirija variación Una relación lineal que puede ser representada por una ecuación en la forma $y = kx$, donde x no iguale 0.

Distribution (of a data set) The distribution of a data set describes the way that its data values are spread out over all possible values. This includes describing the frequencies of each data value. The shape of a data display shows the distribution of a data set.

Distribución (de un conjunto de datos) La distribución de un conjunto de datos describe la manera en que sus valores se esparcen sobre todos los valores posibles. Eso incluye la descripción de las frecuencias de cada valor. La forma de una exhibición de datos muestra la distribución de un conjunto de datos.

Distributive Property Multiplying a number by a sum or difference gives the same result as multiplying that number by each term in the sum or difference and then adding or subtracting the corresponding products.
$a \cdot (b + c) = a \cdot b + a \cdot c$ and
$a \cdot (b - c) = a \cdot b - a \cdot c$

Propiedad distributiva Multiplicar un número por una suma o una diferencia da el mismo resultado que multiplicar ese mismo número por cada uno de los términos de la suma o la diferencia y después sumar o restar los productos obtenidos.
$a \cdot (b + c) = a \cdot b + a \cdot c$ and
$a \cdot (b - c) = a \cdot b - a \cdot c$

Dividend The dividend is the number to be divided.

Dividendo El dividendo es el número que se divide.

English/Spanish Glossary

Divisible A number is divisible by another number if there is no remainder after dividing.

Divisible Un número es divisible por otro número si no hay residuo después de dividir.

Divisor The divisor is the number used to divide another number.

Divisor El divisor es el número por el cual se divide otro número.

Dot plot A dot plot is a statistical graph that shows the shape of a data set with stacked dots above each data value on a number line. Each dot represents one data value.

Diagrama de puntos Un diagrama de puntos es una gráfica estadística que muestra la forma de un conjunto de datos con puntos marcados sobre cada valor de una recta numérica. Cada punto representa un valor.

E

Earned wages Earned wages are the income you receive from an employer for doing a job. Earned wages are also called gross pay.

Sueldos ganados Los sueldos ganados son los ingresos que usted recibe de un empleador para hacer un trabajo. Los sueldos ganados también son llamados la paga bruta.

Easy-access loan The term easy-access loan refers to a wide variety of loans with a streamlined application process. Many easy-access loans are short-term loans of relatively small amounts of money. They often have high interest rates.

Préstamo de fácil-acceso El préstamo del fácil-acceso del término se refiere a una gran variedad de préstamos con un proceso simplificado de aplicación. Muchos préstamos del fácil-acceso son préstamos a corto plazo de cantidades relativamente pequeñas de dinero. Ellos a menudo tienen los tipos de interés altos.

Edge of a three-dimensional figure An edge of a three-dimensional figure is a segment formed by the intersection of two faces.

Arista de una figura tridimensional Una arista de una figura tridimensional es un segmento formado por la intersección de dos caras.

English/Spanish Glossary

Enlargement An enlargement is a dilation with a scale factor greater than 1. After an enlargement, the image is bigger than the original figure.

Aumento Un aumento es una dilatación con un factor de escala mayor que 1. Después de un aumento, la imagen es más grande que la figura original.

Equation An equation is a mathematical sentence that includes an equals sign to compare two expressions.

Ecuación Una ecuación es una oración matemática que incluye un signo igual para comparar dos expresiones.

Equilateral triangle An equilateral triangle is a triangle whose sides are all the same length.

Triángulo equilátero Un triángulo equilátero es un triángulo que tiene todos sus lados de la misma longitud.

Equivalent equations Equivalent equations are equations that have exactly the same solutions.

Ecuaciones equivalentes Las ecuaciones equivalentes son ecuaciones que tienen exactamente la misma solución.

Equivalent expressions Equivalent expressions are expressions that always have the same value.

Expresiones equivalentes Las expresiones equivalentes son expresiones que siempre tienen el mismo valor.

Equivalent fractions Equivalent fractions are fractions that name the same number.

Fracciones equivalentes Las fracciones equivalentes son fracciones que representan el mismo número.

Equivalent inequalities Equivalent inequalities are inequalities that have the same solution.

Desigualdades equivalentes Las desigualdades equivalentes son desigualdades que tienen la misma solución.

Equivalent ratios Equivalent ratios are ratios that express the same relationship.

Razones equivalentes Las razones equivalentes son razones que expresan la misma relación.

Estimate To estimate is to find a number that is close to an exact answer.

Estimar Estimar es hallar un número cercano a una respuesta exacta.

English/Spanish Glossary

Evaluate a numerical expression To evaluate a numerical expression is to follow the order of operations.

Evaluar una expresión numérica Evaluar una expresión numérica es seguir el orden de las operaciones.

Evaluate an algebraic expression To evaluate an algebraic expression, replace each variable with a number, and then follow the order of operations.

Evaluar una expresión algebraica Para evaluar una expresión algebraica, reemplaza cada variable con un número y luego sigue el orden de las operaciones.

Event An event is a single outcome or group of outcomes from a sample space.

Evento Un evento es un resultado simple o un grupo de resultados de un espacio muestral.

Expand an algebraic expression To expand an algebraic expression, use the Distributive Property to rewrite a product as a sum or difference of terms.

Desarrollar una expresión algebraica Para desarrollar una expresión algebraica, usa la propiedad distributiva para reescribir el producto como una suma o diferencia de términos.

Expected family contribution The amount of money a student's family is expected to contribute towards the student's cost of attendance for school.

Contribución familiar esperado La cantidad de dinero que la familia de un estudiante es esperada contribuir hacia el estudiante es costado de asistencia para la escuela.

Expense Money that a business or a person needs to spend to pay for or buy something.

Gasto El dinero que un negocio o una persona debe gastar para pagar por o comprar algo.

Experiment To experiment is to try to gather information in several ways.

Experimentar Experimentar es intentar reunir información de varias maneras.

English/Spanish Glossary

Experimental probability You find the experimental probability of an event by repeating an experiment many times and using this ratio: $P(\text{event}) = \dfrac{\text{number of times event occurs}}{\text{total number of trials}}$

Probabilidad experimental Para hallar la probabilidad experimental de un evento, debes repetir un experimento muchas veces y usar esta razón: $P(\text{evento}) = \dfrac{\text{número de veces que sucede el evento}}{\text{número total de pruebas}}$

Explain To explain is to give facts and details that make an idea easier to understand. Explaining can involve a written summary supported by a diagram, chart, table, or a combination of these.

Explicar Explicar es brindar datos y detalles para que una idea sea más fácil de comprender. Para explicar algo se puede usar un resumen escrito sustentado por un diagrama, una tabla o una combinación de esos elementos.

Exponent An exponent is a number that shows how many times a base is used as a factor.

Exponente Un exponente es un número que muestra cuántas veces se usa una base como factor.

Expression An expression is a mathematical phrase that can involve variables, numbers, and operations. See algebraic expression or numerical expression.

Expresión Una expresión es una frase matemática que puede tener variables, números y operaciones. Ver expresión algebraica o expresión numérica.

Exterior angle of a triangle An exterior angle of a triangle is an angle formed by a side and an extension of an adjacent side.

Ángulo externo de un triángulo Un ángulo externo de un triángulo es un ángulo formado por un lado y una extensión de un lado adyacente.

F

Face of a three-dimensional figure A face of a three-dimensional figure is a flat surface shaped like a polygon.

Cara de una figura tridimensional La cara de una figura tridimensional es una superficie plana con forma de polígono.

English/Spanish Glossary

Factor an algebraic expression To factor an algebraic expression, write the expression as a product.

Descomponer una expresión algebraica en factores Para descomponer una expresión algebraica en factores, escribe la expresión como un producto.

Factors Factors are numbers that are multiplied to give a product.

Factores Los factores son los números que se multiplican para obtener un producto.

False equation A false equation has values that do not equal each other on each side of the equals sign.

Ecuación falsa Una ecuación falsa tiene valores a cada lado del signo igual que no son iguales entre sí.

Financial aid Financial aid is any money offered to a student to assist with the cost of attendance.

Ayuda financiera La ayuda financiera es cualquier dinero ofreció a un estudiante para ayudar con el costo de asistencia.

Financial need A student's financial need is the difference between the student's cost of attendance and the student's expected family contribution.

Necesidad financiera Una necesidad financiera del estudiante es la diferencia entre el estudiante es costada de asistencia y la contribución esperado de familia de estudiante.

Find To find is to calculate or determine.

Hallar Hallar es calcular o determinar.

First quartile For an ordered set of data, the first quartile is the median of the lower half of the data set.

Primer cuartil Para un conjunto ordenado de datos, el primer cuartil es la mediana de la mitad inferior del conjunto de datos.

Fixed expenses Fixed expenses are expenses that do not change from one budget period to the next.

Gastos fijos Los gastos fijos son los gastos que no cambian de un período económico al próximo.

English/Spanish Glossary

Fraction A fraction is a number that can be written in the form $\frac{a}{b}$, where a is a whole number and b is a positive whole number. A fraction is formed by a parts of size $\frac{1}{b}$.

Fracción Una fracción es un número que puede expresarse de forma $\frac{a}{b}$, donde a es un entero y b es un número entero positivo. La fracción está formada por a partes de tamaño $\frac{1}{b}$.

Frequency Frequency describes the number of times a specific value occurs in a data set.

Frecuencia La frecuencia describe el número de veces que aparece un valor específico en un conjunto de datos.

Function A function is a rule for taking each input value and producing exactly one output value.

Función Una función es una regla por la cual se toma cada valor de entrada y se produce exactamente un valor de salida.

G

Gap A gap is an area of a graph that contains no data points.

Espacio vacío o brecha Un espacio vacío o brecha es un área de una gráfica que no contiene ningún valor.

Grant A type of monetary award a student can use to pay for his or her education. The student does not need to repay this money.

Grant Un tipo de premio monetario que un estudiante puede utilizar para pagar por su educación. El estudiante no debe devolver este dinero.

Greater than > The greater-than symbol shows a comparison of two numbers with the number of greater value shown first, or on the left.

Mayor que > El símbolo de mayor que muestra una comparación de dos números con el número de mayor valor que aparece primero, o a la izquierda.

Greatest common factor The greatest common factor (GCF) of two or more whole numbers is the greatest number that is a factor of all of the numbers.

Máximo común divisor El máximo común divisor (M.C.D.) de dos o más números enteros no negativos es el número mayor que es un factor de todos los números.

English/Spanish Glossary

H

Height of a cone The height of a cone, *h*, is the length of a segment perpendicular to the base that joins the vertex and the base.

Altura de un cono La altura de un cono, *h*, es la longitud de un segmento perpendicular a la base que une el vértice y la base.

Height of a cylinder The height of a cylinder is the length of a perpendicular segment that joins the planes of the bases.

Altura de un cilindro La altura de un cilindro es la longitud de un segmento perpendicular que une los planos de las bases.

Height of a parallelogram A height of a parallelogram is the perpendicular distance between opposite bases.

Altura de un paralelogramo La altura de un paralelogramo es la distancia perpendicular que existe entre las bases opuestas.

Height of a prism The height of a prism is the length of a perpendicular segment that joins the bases.

Altura de un prisma La altura de un prisma es la longitud de un segmento perpendicular que une a las bases.

Height of a pyramid The height of a pyramid is the length of a segment perpendicular to the base that joins the vertex and the base.

Altura de una pirámide La altura de una pirámide es la longitud de un segmento perpendicular a la base que une al vértice con la base.

Height of a triangle The height of a triangle is the length of the perpendicular segment from a vertex to the base opposite that vertex.

Altura de un triángulo La altura de un triángulo es la longitud del segmento perpendicular desde un vértice hasta la base opuesta a ese vértice.

Hexagon A hexagon is a polygon with six sides.

Hexágono Un hexágono es un polígono de seis lados.

English/Spanish Glossary

Histogram A histogram is a statistical graph that shows the shape of a data set with vertical bars above intervals of values on a number line. The intervals are equal in size and do not overlap. The height of each bar shows the frequency of data within that interval.

Histograma Un histograma es una gráfica de estadísticas que muestra la forma de un conjunto de datos con barras verticales encima de intervalos de valores en una recta numérica. Los intervalos tienen el mismo tamaño y no se superponen. La altura de cada barra muestra la frecuencia de los datos dentro de ese intervalo.

Hundredths One hundredth is one part of 100 equal parts of a whole.

Centésima Una centésima es 1 de las 100 partes iguales de un todo.

Hypotenuse In a right triangle, the longest side, which is opposite the right angle, is the hypotenuse.

Hipotenusa En un triángulo rectángulo, el lado más largo, que es opuesto al ángulo recto, es la hipotenusa.

I

Identify To identify is to match a definition or description to an object or to recognize something and be able to name it.

Identificar Identificar es unir una definición o una descripción con un objeto, o reconocer algo y poder nombrarlo.

Identity Property of Addition The sum of 0 and any number is that number. For any number n, $n + 0 = n$ and $0 + n = n$.

Propiedad de identidad de la suma La suma de 0 y cualquier número es ese número. Para cualquier número n, $n + 0 = n$ and $0 + n = n$.

Identity Property of Multiplication The product of 1 and any number is that number. For any number n, $n \cdot 1 = n$ and $1 \cdot n = n$.

Propiedad de identidad de la multiplicación El producto de 1 y cualquier número es ese número. Para cualquier número n, $n \cdot 1 = n$ and $1 \cdot n = n$.

Illustrate To illustrate is to show or present information, usually as a drawing or a diagram. You can also illustrate a point using a written explanation.

Ilustrar Ilustrar es mostrar o presentar información, generalmente en forma de dibujo o diagrama. También puedes usar una explicación escrita para ilustrar un punto.

English/Spanish Glossary

Image An image is the result of a transformation of a point, line, or figure.

Imagen Una imagen es el resultado de una transformación de un punto, una recta o una figura.

Improper fraction An improper fraction is a fraction in which the numerator is greater than or equal to its denominator.

Fracción impropia Una fracción impropia es una fracción en la cual el numerador es mayor que o igual a su denominador.

Included angle An included angle is an angle that is between two sides.

Ángulo incluido Un ángulo incluido es un ángulo que está entre dos ados.

Included side An included side is a side that is between two angles.

Lado incluido Un lado incluido es un lado que está entre dos ángulos

Income Money that a business receives. The money that a person earns from working is also called income.

Ingresos El dinero que un negocio recibe. El dinero que una persona gana de trabajar también es llamado los ingresos.

Income tax Income tax is money collected by the government based on how much you earn.

Impuesto de renta El impuesto de renta es dinero completo por el gobierno basado en cuánto gana.

Independent events Two events are independent events if the occurrence of one event does not affect the probability of the other event.

Eventos independientes Dos eventos son eventos independientes cuando el resultado de un evento no altera la probabilidad del otro.

Independent variable An independent variable is a variable whose value determines the value of another (dependent) variable.

Variable independiente Una variable indepenciente es una variab e cuyo valor determina el valor de otra variable (dependiente).

Indicate To indicate is to point out or show.

Indicar Indicar es señalar o mostrar.

English/Spanish Glossary

Indirect measurement Indirect measurement uses proportions and similar triangles to measure distances that would be difficult to measure directly.

Medición indirecta La medición indirecta usa proporciones y triángulos semejantes para medir distancias que serían difíciles de medir de forma directa.

Inequality An inequality is a mathematical sentence that uses $<$, \leq, $>$, \geq, or \neq to compare two quantities.

Desigualdad Una desigualdad es una oración matemática que usa $<$, \leq, $>$, \geq, o \neq para comparar dos cantidades.

Inference An inference is a judgment made by interpreting data.

Inferencia Una inferencia es una opinión que se forma al interpretar datos.

Infinitely many solutions A linear equation in one variable has infinitely many solutions if any value of the variable makes the two sides of the equation equal.

Número infinito de soluciones Una ecuación lineal en una variable tiene un número infinito de soluciones si cualquier valor de la variable hace que los dos lados de la ecuación sean iguales.

Initial value The initial value of a linear function is the value of the output when the input is 0.

Valor inicial El valor inicial de una función lineal es el valor de salida cuando el valor de entrada es 0.

Integers Integers are the set of positive whole numbers, their opposites, and 0.

Enteros Los enteros son el conjunto de los números enteros positivos, sus opuestos y 0.

Interest When you deposit money in a bank account, the bank pays you interest for the right to use your money for a period of time.

Interés Cuando depositas dinero en una cuenta bancaria, el banco te paga un interés por el derecho a usar tu dinero por un período de tiempo.

Interest period The length of time on which compound interest is based. The total number of interest periods that you keep the money in the account is represented by the variable n.

Período de interés La cantidad de tiempo sobre la que se calcula el interés compuesto. El número total de períodos de interés que mantienes el dinero en la cuenta se representa con la variable n.

English/Spanish Glossary

Interest rate Interest is calculated based on a percent of the principal. That percent is called the interest rate (r).

Tasa de interés El interés se calcula con base en un porcentaje del capital. Ese porcentaje se llama tasa de interés, (r).

Interest rate for an interest period The interest rate for an interest period is the annual interest rate divided by the number of interest periods per year.

El tipo de interés por un período de interés El tipo de interés por un período de interés es el tipo de interés anual dividido por el número de períodos de interés por año.

Interquartile range The interquartile range (IQR) is the distance between the first and third quartiles of the data set. It represents the spread of the middle 50% of the data values.

Rango intercuartil El rango intercuartil es la distancia entre el primer y el tercer cuartil del conjunto de datos. Representa la ubicación del 50% del medio de los valores.

Interval An interval is a period of time between two points of time or events.

Intervalo Un intervalo es un período de tiempo entre dos puntos en el tiempo o entre dos sucesos.

Invalid inference An invalid inference is false about the population, or does not follow from the available data. A biased sample can lead to invalid inferences.

Inferencia inválida Una inferencia inválida es una inferencia falsa acerca de una población, o no se deduce a partir de los datos disponibles. Una muestra sesgada puede llevar a inferencias inválidas.

Inverse operations Inverse operations are operations that undo each other.

Operaciones inversas Las operaciones inversas son operaciones que se cancelan entre sí.

Inverse Property of Addition Every number has an additive inverse. The sum of a number and its additive inverse is zero.

Propiedad inversa de la suma Todos los números tienen un inverso de suma. La suma de un número y su inverso de suma es cero.

English/Spanish Glossary

Irrational numbers An irrational number is a number that cannot be written in the form $\frac{a}{b}$, where a and b are integers and $b \neq 0$. In decimal form, an irrational number cannot be written as a terminating or repeating decimal.

Números irracionales Un número irracional es un número que no se puede escribir en la forma $\frac{a}{b}$ donde a y b, son enteros y $b \neq 0$. Los números racionales en forma decimal no son finitos y no son periódicos.

Isolate a variable When solving equations, to isolate a variable means to get a variable with a coefficient of 1 alone on one side of an equation. Use the properties of equality and inverse operations to isolate a variable.

Aislar una variable Cuando resuelves ecuaciones, aislar una variable significa poner una variable con un coeficiente de 1 sola a un lado de la ecuación. Usa las propiedades de igualdad y las operaciones inversas para aislar una variable.

Isosceles triangle An isosceles triangle is a triangle with at least two sides that are the same length.

Triángulo isósceles Un triángulo isósceles es un triángulo que tiene al menos dos lados de la misma longitud.

J

Justify To justify is to support your answer with reasons or examples. A justification may include a written response, diagrams, charts, tables, or a combination of these.

Justificar Justificar es apoyar tu respuesta con razones o ejemplos. Una justificación puede incluir una respuesta escrita, diagramas, tablas o una combinación de esos elementos.

L

Lateral area of a cone The lateral area of a cone is the area of its lateral surface. The formula for the lateral area of a cone is L.A. $= \pi r \ell$, where r represents the radius of the base and ℓ represents the slant height of the cone.

Área lateral de un cono El área lateral de un cono es el área de su superficie lateral. La fórmula del área lateral de un cono es A.L. $= \pi r \ell$, donde r representa el radio de la base y ℓ representa la altura inclinada del cono.

English/Spanish Glossary

Lateral area of a cylinder The lateral area of a cylinder is the area of its lateral surface. The formula for the lateral area of a cylinder is L.A. = $2\pi rh$, where r represents the radius of a base and h represents the height of the cylinder.

Área lateral de un cilindro El área lateral de un cilindro es el área de su superficie lateral. La fórmula del área lateral de un cilindro es A.L. = $2\pi rh$, donde r representa el radio de una base y h representa la altura del cilindro.

Lateral area of a prism The lateral area of a prism is the sum of the areas of the lateral faces of the prism. The formula for the lateral area, L.A., of a prism is L.A. = ph, where p represents the perimeter of the base and h represents the height of the prism.

Área lateral de un prisma El área lateral de un prisma es la suma de las áreas de las caras laterales del prisma. La fórmula del área lateral, A.L., de un prisma es A.L. = ph, donde p representa el perímetro de la base y h representa la altura del prisma.

Lateral area of a pyramid The lateral area of a pyramid is the sum of the areas of the lateral faces of the pyramid. The formula for the lateral area, L.A., of a pyramid is L.A. = $\frac{1}{2}p\ell$ where p represents the perimeter of the base and ℓ represents the slant height of the pyramid.

Área lateral de una pirámide El área lateral de una pirámide es la suma de las áreas de las caras laterales de la pirámide. La fórmula del área lateral, A.L., de una pirámide es A.L. = $\frac{1}{2}p\ell$ donde p representa el perímetro de la base y ℓ representa la altura inclinada de la pirámide.

Lateral face of a prism A lateral face of a prism is a face that joins the bases of the prism.

Cara lateral de un prisma La cara lateral de un prisma es la cara que une a las bases del prisma.

Lateral face of a pyramid A lateral face of a pyramid is a triangular face that joins the base and the vertex.

Cara lateral de una pirámide La cara lateral de una pirámide es una cara lateral que une a la base con el vértice.

Lateral surface of a cone The lateral surface of a cone is the curved surface that is not included in the base.

Superficie lateral de un cono La superficie lateral de un cono es la superficie curva que no está incluida en a base.

English/Spanish Glossary

Lateral surface of a cylinder The lateral surface of a cylinder is the curved surface that is not included in the bases.

Superficie lateral de un cilindro La superficie lateral de un cilindro es la superficie curva que no está incluida en las bases.

Least common multiple The least common multiple (LCM) of two or more numbers is the least multiple shared by all of the numbers.

Mínimo común múltiplo El mínimo común múltiplo (MCM) de dos o más números es el múltiplo menor compartido por todos los números.

Leg of a right triangle In a right triangle, the two shortest sides are legs.

Cateto de un triángulo rectángulo En un triángulo rectángulo, los dos lados más cortos son los catetos.

Less than $<$ The less-than symbol shows a comparison of two numbers with the number of lesser value shown first, or on the left.

Menor que $<$ El símbolo de menor que muestra una comparación de dos números con el número de menor valor que aparece primero, o a la izquierda.

Liability A liability is money that you owe.

Obligación Una obligación es dinero que usted debe.

Lifetime income The amount of money earned over a lifetime of working.

Ingresos para toda la vida La cantidad de dinero ganó sobre una vida de trabajar.

Like terms Terms that have identical variable parts are like terms.

Términos semejantes Los términos que tienen partes variables idénticas son términos semejantes.

Line of reflection A line of reflection is a line across which a figure is reflected.

Eje de reflexión Un eje de reflexión es una línea a través de la cual se refleja una figura.

Linear equation An equation is a linear equation if the graph of all of its solutions is a line.

Ecuación lineal Una ecuación es lineal si la gráfica de todas sus soluciones es una línea recta.

English/Spanish Glossary

Linear function A linear function is a function whose graph is a straight line. The rate of change for a linear function is constant.

Función lineal Una función lineal es una función cuya gráfica es una línea recta. La tasa de cambio en una función lineal es constante.

Linear function rule A linear function rule is an equation that describes a linear function.

Regla de la función lineal La ecuación que describe una función lineal es la regla de la función lineal.

Loan A loan is an amount of money borrowed for a period of time with the promise of paying it back.

Préstamo Un préstamo es una cantidad de dinero pedido prestaddo por un espacio de tiempo con la promesa de pagarlo apoya.

Loan length Loan length is the period of time set to repay a loan.

Preste longitud La longitud del préstamo es el conjunto de espacio de tiempo de devolver un préstamo.

Loan term The term of a loan is the period of time set to repay the loan.

Preste término El término de un préstamo es el conjunto de espacio de tiempo de devolver el préstamo.

Locate To locate is to find or identify a value, usually on a number line or coordinate graph.

Ubicar Ubicar es hallar o identificar un valor, generalmente en una recta numérica o en una gráfica de coordenadas.

Loss When a business's expenses are greater than the business's income, there is a loss.

Pérdida Cuando los gastos de un negocio son más que los ingresos del negocio, hay una pérdida.

English/Spanish Glossary

M

Mapping diagram A mapping diagram describes a relation by linking the input values to the corresponding output values using arrows.

Diagrama de correspondencia Un diagrama de correspondencia describe una relación uniendo con flechas los valores de entrada con sus correspondientes valores de salida.

Markdown Markdown is the amount of decrease from the selling price to the sale price. The markdown as a percent decrease of the original selling price is called the percent markdown.

Rebaja La rebaja es la cantidad de disminución de un precio de venta a un precio rebajado. La rebaja como una disminución porcentual del precio de venta original se llama porcentaje de rebaja.

Markup Markup is the amount of increase from the cost to the selling price. The markup as a percent increase of the original cost is called the percent markup.

Margen de ganancia El margen de ganancia es la cantidad de aumento del costo al precio de venta. El margen de ganancia como un aumento porcentual del costo original se llama porcentaje del margen de ganancia.

Mean The mean represents the center of a numerical data set. To find the mean, sum the data values and then divide by the number of values in the data set.

Media La media representa el centro de un conjunto de datos numéricos. Para hallar la media, suma los valores y luego divide por el número de valores del conjunto de datos.

Mean absolute deviation The mean absolute deviation is a measure of variability that describes how much the data values are spread out from the mean of a data set. The mean absolute deviation is the average distance that the data values are spread around the mean.

$$\text{mean absolute deviation} = \frac{\text{sum of the absolute deviations of the data values}}{\text{total number of data values}}$$

Desviación absoluta media La desviación absoluta media es una medida de variabilidad que describe cuánto se alejan los valores de la media de un conjunto de datos. La desviación absoluta media es la distancia promedio que los valores se alejan de la media.

$$\text{desviación absoluta media} = \frac{\text{suma de las desviaciones absolutas de los valores}}{\text{número total de valores}}$$

English/Spanish Glossary

Measure of variability A measure of variability describes the spread of values in a data set. There may be more than one measure of variability for a data set.

Medida de variabilidad Una medida de variabilidad describe la distribución de los valores de un conjunto de datos. Puede haber más de una medida de variabilidad para un conjunto de datos.

Measurement data Measurement data consist of data that are measures.

Datos de mediciones Los datos de mediciones son datos que son medidas.

Measures of center A measure of center is a value that represents the middle of a data set. There may be more than one measure of center for a data set.

Medida de tendencia central Una medida de tendencia central es un valor que representa el centro de un conjunto de datos. Puede haber más de una medida de tendencia central para un conjunto de datos.

Median The median represents the center of a numerical data set. For an odd number of data values, the median is the middle value when the data values are arranged in numerical order. For an even number of data values, the median is the average of the two middle values when the data values are arranged in numerical order.

Mediana La mediana representa el centro de un conjunto de datos numéricos. Para un número impar de valores, la mediana es el valor del medio cuando los valores están organizados en orden numérico. Para un número par de valores, la mediana es el promedio de los dos valores del medio cuando los valores están organizados en orden numérico.

Median-median line The median-median line, or median trend line, is a method of finding a fit line for a scatter plot that suggests a linear association. This method involves dividing the data into three subgroups and using medians to find a summary point for each subgroup. The summary points are used to find the equation of the fit line.

Recta mediana-mediana La recta mediana-mediana es un método que se usa para hallar una línea de ajuste para un diagrama de dispersión que sugiere una asociación lineal. Este método implica dividir los datos en tres subgrupos y usar medianas para hallar un punto medio para cada subgrupo. Los puntos medios se usan para hallar la ecuación de la línea de ajuste.

Million Whole numbers in the millions have 7, 8, or 9 digits.

Millón Los números enteros no negativos que están en los millones tienen 7, 8 ó 9 dígitos.

English/Spanish Glossary

Mixed number A mixed number combines a whole number and a fraction.

Número mixto Un número mixto combina un número entero no negativo con una fracción.

Mode The item, or items, in a data set that occurs most frequently.

Modo El artículo, o los artículos, en un conjunto de datos que ocurre normalmente.

Model To model is to represent a situation using pictures, diagrams, or number sentences.

Demostrar Demostrar es usar ilustraciones, diagramas o enunciados numéricos para representar una situación.

Monetary incentive A monetary incentive is an offer that might encourage customers to buy a product.

Estímulo monetario Un estímulo monetario es una oferta que quizás favorezca a clientes para comprar un producto.

Multiple A multiple of a number is the product of the number and a whole number.

Múltiplo El múltiplo de un número es el producto del número y un número entero no negativo.

N

Natural numbers The natural numbers are the counting numbers.

Números naturales Los números naturales son los números que se usan para contar.

Negative exponent property For every nonzero number a and integer n, $a^{-n} = \frac{1}{a^n}$.

Propiedad del exponente negativo Para todo número distinto de cero a y entero n, $a^{-n} = \frac{1}{a^n}$.

Negative numbers Negative numbers are numbers less than zero.

Números negativos Los números negativos son números menores que cero.

English/Spanish Glossary

Net A net is a two-dimensional pattern that you can fold to form a three-dimensional figure. A net of a figure shows all of the surfaces of that figure in one view.

Modelo plano Un modelo plano es un diseño bidimensional que puedes doblar para formar una figura tridimensional. Un modelo plano de una figura muestra todas las superficies de la figura en una vista.

Net worth Net worth is the total value of all assets minus the total value of all liabilities.

Patrimonio neto El patrimonio neto es el valor total de todas las ventajas menos el valor total de todas las obligaciones.

Net worth statement Net worth is the total value of all assets minus the total value of all liabilities.

Declaración de patrimonio neto El patrimonio neto es el valor total de todas las ventajas menos el valor total de todas las obligaciones.

No solution A linear equation in one variable has no solution if no value of the variable makes the two sides of the equation equal.

Sin solución Una ecuación lineal en una variable no tiene solución si ningún valor de la variable hace que los dos lados de la ecuación sean iguales.

Nonlinear function A nonlinear function is a function that does not have a constant rate of change.

Función no lineal Una función no lineal es una función que no tiene una tasa de cambio constante.

Numerator The numerator is the number above the fraction bar in a fraction.

Numerador El numerador es el número que está arriba de la barra de fracción en una fracción.

Numerical expression A numerical expression is a mathematical phrase that consists of numbers and operation symbols.

Expresión numérica Una expresión numérica es una frase matemática que contiene números y símbolos de operaciones.

English/Spanish Glossary

O

Obtuse angle An obtuse angle is an angle with a measure greater than 90° and less than 180°.

Ángulo obtuso Un ángulo obtuso es un ángulo con una medida mayor que 90° y menor que 180°.

Obtuse triangle An obtuse triangle is a triangle with one obtuse angle.

Triángulo obtusángulo Un triángulo obtusángulo es un triángulo que tiene un ángulo obtuso.

Octagon An octagon is a polygon with eight sides.

Octágono Un octágono es un polígono de ocho lados.

Online payment system An online payment system allows money to be exchanged electronically between buyer and seller, usually using credit card or bank account information.

Sistema en línea de pago Un sistema en línea del pago permite dinero para ser cambiado electrónicamente entre comprador y vendedor, utilizando generalmente información de tarjeta de crédito o cuenta bancaria.

Open sentence An open sentence is an equation with one or more variables.

Enunciado abierto Un enunciado abierto es una ecuación con una o más variables.

Opposites Opposites are two numbers that are the same distance from 0 on a number line, but in opposite directions.

Opuestos Los opuestos son dos números que están a la misma distancia de 0 en la recta numérica, pero en direcciones opuestas.

Order of operations The order of operations is the order in which operations should be performed in an expression. Operations inside parentheses are done first, followed by exponents. Then, multiplication and division are done in order from left to right, and finally addition and subtraction are done in order from left to right.

Orden de las operaciones El orden de las operaciones es el orden en el que se deben resolver las operaciones de una expresión. Las operaciones que están entre paréntesis se resuelven primero, seguidas de los exponentes. Luego, se multiplica y se divide en orden de izquierda a derecha, y finalmente se suma y se resta en orden de izquierda a derecha.

English/Spanish Glossary

Ordered pair An ordered pair identifies the location of a point in the coordinate plane. The x-coordinate shows a point's position left or right of the y-axis. The y-coordinate shows a point's position up or down from the x-axis.

Par ordenado Un par ordenado identifica la ubicación de un punto en el plano de coordenadas. La coordenada x muestra la posición de un punto a la izquierda o a la derecha del eje de las y. La coordenada y muestra la posición de un punto arriba o abajo del eje de las x.

Origin The origin is the point of intersection of the x- and y-axes on a coordinate plane.

Origen El origen es el punto de intersección del eje de las x y el eje de las y en un plano de coordenadas.

Outcome An outcome is a possible result of an action.

Resultado Un resultado es un desenlace posible de una acción.

Outlier An outlier is a piece of data that doesn't seem to fit with the rest of a data set.

Valor extremo Un valor extremo es un valor que parece no ajustarse al resto de los datos de un conjunto.

P

Parallel lines Parallel lines are lines in the same plane that never intersect.

Rectas paralelas Las rectas paralelas son rectas que están en el mismo plano y nunca se intersecan.

Parallelogram A parallelogram is a quadrilateral with both pairs of opposite sides parallel.

Paralelogramo Un paralelogramo es un cuadrilátero en el cual los dos pares de lados opuestos son paralelos.

Partial product A partial product is part of the total product. A product is the sum of the partial products.

Producto parcial Un producto parcial es una parte del producto total. Un producto es la suma de los productos parciales.

English/Spanish Glossary

Pay period Wages for many jobs are paid at regular intervals, such a weekly, biweekly, semimonthly, or monthly. The interval of time is called a pay period.

Pague el período Los sueldos para muchos trabajos son pagados con regularidad, tal semanal, quincenal, quincenal, o mensual. El intervalo de tiempo es llamado un período de la paga.

Payroll deductions Your employer can deduct your income taxes from your wages before you receive your paycheck. The amounts deducted are called payroll deductions.

Deducciones de nómina Su empleador puede descontar sus impuestos de renta de sus sueldos antes que reciba su cheque de pago. Las cantidades descontadas son llamadas nómina deducciones.

Percent A percent is a ratio that compares a number to 100.

Porcentaje Un porcentaje es una razón que compara un número con 100.

Percent bar graph A percent bar graph is a bar graph that shows each category as a percent of the total number of data items.

Gráfico de barras de por ciento Un gráfico de barras del por ciento es un gráfico de barras que muestra cada categoría como un por ciento del número total de artículos de datos.

Percent decrease When a quantity decreases, the percent of change is called a percent decrease. percent decrease = $\frac{\text{amount of decrease}}{\text{original quantity}}$

Disminución porcentual Cuando una cantidad disminuye, el porcentaje de cambio se llama disminución porcentual. disminución porcentual = $\frac{\text{cantidad de disminución}}{\text{cantidad original}}$

Percent equation The percent equation describes the relationship between a part and a whole. You can use the percent equation to solve percent problems. part = percent · whole

Ecuación de porcentaje La ecuación de porcentaje describe la relación entre una parte y un todo. Puedes usar la ecuación de porcentaje para resolver problemas de porcentaje. parte = por ciento · todo

Percent error Percent error describes the accuracy of a measured or estimated value compared to an actual or accepted value.

Error porcentual El error porcentual describe la exactitud de un valor medido o estimado en comparación con un valor real o aceptado.

English/Spanish Glossary

Percent increase When a quantity increases, the percent of change is called a percent increase.

Aumento porcentual Cuando una cantidad aumenta, el porcentaje de cambio se llama aumento porcentual.

Percent of change Percent of change is the percent something increases or decreases from its original measure or amount. You can find the percent of change by using the equation: percent of change $= \dfrac{\text{amount of change}}{\text{original quantity}}$

Porcentaje de cambio El porcentaje de cambio es el porcentaje en que algo aumenta o disminuye en relación a la medida o cantidad original. Puedes hallar el porcentaje de cambio con la siguiente ecuación: porcentaje de cambio $= \dfrac{\text{cantidad de cambio}}{\text{cantidad original}}$

Perfect cube A perfect cube is the cube of an integer.

Cubo perfecto Un cubo perfecto es el cubo de un entero.

Perfect square A perfect square is a number that is the square of an integer.

Cuadrado perfecto Un cuadrado perfecto es un número que es el cuadrado de un entero.

Perimeter Perimeter is the distance around a figure.

Perímetro El perímetro es la distancia alrededor de una figura.

Period A period is a group of 3 digits in a number. Periods are separated by a comma and start from the right of a number.

Período Un período es un grupo de 3 dígitos en un número. Los períodos están separados por una coma y empiezan a la derecha del número.

Periodic savings plan A periodic savings plan is a method of saving that involves making deposits on a regular basis.

Plan de ahorros periódico Un plan de ahorros periódico es un método de guardar que implica depósitos que hace con regularidad.

Perpendicular lines Perpendicular lines intersect to form right angles.

Rectas perpendiculares Las rectas perpendiculares se intersecan para formar ángulos rectos.

English/Spanish Glossary

Pi Pi (π) is the ratio of a circle's circumference, C, to its diameter, d.

Pi Pi (π) es la razón de la circunferencia de un círculo, C, a su diámetro, d.

Place value Place value is the value given to an individual digit based on its position within a number.

Valor posicional El valor posicional es el valor asignado a determinado dígito según su posición en un número.

Plane A plane is a flat surface that extends indefinitely in all directions.

Plano Un plano es una superficie plana que se extiende indefinidamente en todas direcciones.

Polygon A polygon is a closed figure formed by three or more line segments that do not cross.

Polígono Un polígono es una figura cerrada compuesta por tres o más segmentos que no se cruzan.

Population A population is the complete set of items being studied.

Población Una población es todo el conjunto de elementos que se estudian.

Positive numbers Positive numbers are numbers greater than zero.

Números positivos Los números positivos son números mayores que cero.

Power A power is a number expressed using an exponent.

Potencia Una potencia es un número expresado con un exponente.

Predict To predict is to make an educated guess based on the analysis of real data.

Predecir Predecir es hacer una estimación informada según el análisis de datos reales.

Prime factorization The prime factorization of a composite number is the expression of the number as a product of its prime factors.

Descomposición en factores primos La descomposición en factores primos de un número compuesto es la expresión del número como un producto de sus factores primos.

English/Spanish Glossary

Prime number A prime number is a whole number greater than 1 with exactly two factors, 1 and the number itself.

Número primo Un número primo es un número entero mayor que 1 con exactamente dos factores, 1 y el número mismo.

Principal The original amount of money deposited or borrowed in an account.

Capital La cantidad original de dinero que se deposita o se pide prestada en una cuenta.

Prism A prism is a three-dimensional figure with two parallel polygonal faces that are the same size and shape.

Prisma Un prisma es una figura tridimensional con dos caras poligonales paralelas que tienen el mismo tamaño y la misma forma.

Probability model A probability model consists of an action, its sample space, and a list of events with their probabilities. The events and probabilities in the list have these characteristics: each outcome in the sample space is in exactly one event, and the sum of all of the probabilities must be 1.

Modelo de probabilidad Un modelo de probabilidad consiste en una acción, su espacio muestral y una lista de eventos con sus probabilidades. Los eventos y las probabilidades de la lista tienen estas características: cada resultado del espacio muestral está exactamente en un evento, y la suma de todas las probabilidades debe ser 1.

Probability of an event The probability of an event is a number from 0 to 1 that measures the likelihood that the event will occur. The closer the probability is to 0, the less likely it is that the event will happen. The closer the probability is to 1, the more likely it is that the event will happen. You can express probability as a fraction, decimal, or percent.

Probabilidad de un evento La probabilidad de un evento es un número de 0 a 1 que mide la probabilidad de que suceda el evento. Cuanto más se acerca la probabilidad a 0, menos probable es que suceda el evento. Cuanto más se acerca la probabilidad a 1, más probable es que suceda el evento. Puedes expresar la probabilidad como una fracción, un decimal o un porcentaje.

Product A product is the value of a multiplication or an expression showing multiplication.

Producto Un producto es el valor de una multiplicación o una expresión que representa la multiplicación.

English/Spanish Glossary

Profit When a business's expenses are less than the business's income, there is a profit.

Ganancia Cuando los gastos de un negocio son menos que los ingresos del negocio, hay una ganancia.

Proof A proof is a logical, deductive argument in which every statement of fact is supported by a reason.

Comprobación Una comprobación es un argumento lógico y deductivo en el que cada enunciado de un hecho está apoyado por una razón.

Proper fraction A proper fraction has a numerator that is less than its denominator.

Fracción propia Una fracción propia tiene un numerador que es menor que su denominador.

Proportion A proportion is an equation stating that two ratios are equal.

Proporción Una proporción es una ecuación que establece que dos razones son iguales.

Proportional relationship Two quantities *x* and *y* have a proportional relationship if *y* is always a constant multiple of *x*. A relationship is proportional if it can be described by equivalent ratios.

Relación de proporción Dos cantidades *x* y *y* tienen una relación de proporción si *y* es siempre un múltiplo constante de *x*. Una relación es de proporción si se puede describir con razones equivalentes.

Pyramid A pyramid is a three-dimensional figure with a base that is a polygon and triangular faces that meet at a vertex. A pyramid is named for the shape of its base.

Pirámide Una pirámide es una figura tridimensional con una base que es un polígono y caras triangulares que se unen en un vértice. El nombre de la pirámide depende de la forma de su base.

English/Spanish Glossary

Pythagorean Theorem In any right triangle, the sum of the squares of the lengths of the legs equals the square of the length of the hypotenuse. If a triangle is a right triangle, then $a^2 + b^2 = c^2$, where a and b represent the lengths of the legs, and c represents the length of the hypotenuse.

Teorema de Pitágoras En cualquier triángulo rectángulo, la suma del cuadrado de la longitud de los catetos es igual al cuadrado de la longitud de la hipotenusa. Si un triángulo es un triángulo rectángulo, entonces $a^2 + b^2 = c^2$, donde a y b representan la longitud de los catetos, y c representa la longitud de la hipotenusa.

Q

Quadrant The x- and y-axes divide the coordinate plane into four regions called quadrants.

Cuadrante Los ejes de las x y de las y dividen el plano de coordenadas en cuatro regiones llamadas cuadrantes.

Quadrilateral A quadrilateral is a polygon with four sides.

Cuadrilátero Un cuadrilátero es un polígono de cuatro lados.

Quarter circle A quarter circle is one fourth of a circle.

Círculo cuarto Un círculo cuarto es la cuarta parte de un círculo.

Quartile The quartiles of a data set divide the data set into four parts with the same number of data values in each part.

Cuartil Los cuartiles de un conjunto de datos dividen el conjunto de datos en cuatro partes que tienen el mismo número de valores cada una.

Quotient The quotient is the answer to a division problem. When there is a remainder, "quotient" sometimes refers to the whole-number portion of the answer.

Cociente El cociente es el resultado de una división. Cuando queda un residuo, "cociente" a veces se refiere a la parte de la solución que es un número entero.

English/Spanish Glossary

R

Radius A radius of a circle is a segment that has one endpoint at the center and the other endpoint on the circle. The term radius can also mean the length of this segment.

Radio Un radio de un círculo es un segmento que tiene un extremo en el centro y el otro extremo en el círculo. El término radio también puede referirse a la longitud de este segmento.

Radius of a sphere The radius of a sphere, r, is a segment that has one endpoint at the center and the other endpoint on the sphere.

Radio de una esfera El radio de una esfera, r, es un segmento que tiene un extremo en el centro y el otro extremo en la esfera.

Random sample In a random sample, each member in the population has an equal chance of being selected.

Muestra aleatoria En una muestra aleatoria, cada miembro en la población tiene una oportunidad igual de ser seleccionado.

Range The range is a measure of variability of a numerical data set. The range of a data set is the difference between the greatest and least values in a data set.

Rango El rango es una medida de la variabilidad de un conjunto de datos numéricos. El rango de un conjunto de datos es la diferencia que existe entre el mayor y el menor valor del conjunto.

Rate A rate is a ratio involving two quantities measured in different units.

Tasa Una tasa es una razón que relaciona dos cantidades medidas con unidades diferentes.

Rate of change The rate of change of a linear function is the ratio $\frac{\text{vertical change}}{\text{horizontal change}}$ between any two points on the graph of the function.

Tasa de cambio La tasa de cambio de una función lineal es la razón del $\frac{\text{cambio vertical}}{\text{cambio horizontal}}$ que existe entre dos puntos cualesquiera de la gráfica de la función.

Ratio A ratio is a relationship in which for every x units of one quantity there are y units of another quantity.

Razón Una razón es una relación en la cual por cada x unidades de una cantidad hay y unidades de otra cantidad.

English/Spanish Glossary

Rational numbers A rational number is a number that can be written in the form $\frac{a}{b}$ or $-\frac{a}{b}$, where a is a whole number and b is a positive whole number. The rational numbers include the integers.

Números racionales Un número racional es un número que se puede escribir como $\frac{a}{b}$ or $-\frac{a}{b}$, donde a es un número entero no negativo y b es un número entero positivo. Los números racionales incluyen los enteros.

Real numbers The real numbers are the set of rational and irrational numbers.

Números reales Los números reales son el conjunto de los números racionales e irracionales.

Reason To reason is to think through a problem using facts and information.

Razonar Razonar es usar hechos e información para estudiar detenidamente un problema.

Rebate A rebate returns part of the purchase price of an item after the buyer provides proof of purchase through a mail-in or online form.

Reembolso Un reembolso regresa la parte del precio de compra de un artículo después de que el comprador proporcione comprobante de compra por un correo-en o forma en línea.

Recall To recall is to remember a fact quickly.

Recordar Recordar es traer a la memoria un hecho rápidamente.

Reciprocals Two numbers are reciprocals if their product is 1. If a nonzero number is named as a fraction, , then its reciprocal is .

Recíprocos Dos números son recíprocos si su producto es 1. Si un número distinto de cero se expresa como una fracción, , entonces su recíproco es .

Rectangle A rectangle is a quadrilateral with four right angles.

Rectángulo Un rectángulo es un cuadrilátero que tiene cuatro ángulos rectos.

Rectangular prism A rectangular prism is a prism with bases in the shape of a rectangle.

Prisma rectangular Un prisma rectangular es un prisma cuyas bases tienen la forma de un rectángulo.

English/Spanish Glossary

Reduction A reduction is a dilation with a scale factor less than 1. After a reduction, the image is smaller than the original figure.

Reducción Una reducción es una dilatación con un factor de escala menor que 1. Después de una reducción, la imagen es más pequeña que la figura original.

Reflection A reflection, or flip, is a transformation that flips a figure across a line of reflection.

Reflexión Una reflexión, o inversión, es una transformación que invierte una figura a través de un eje de reflexión.

Regular polygon A regular polygon is a polygon with all sides of equal length and all angles of equal measure.

Polígono regular Un polígono regular es un polígono que tiene todos los lados de la misma longitud y todos los ángulos de la misma medida.

Relate To relate two different things, find a connection between them.

Relacionar Para relacionar dos cosas diferentes, halla una conexión entre ellas.

Relation Any set of ordered pairs is called a relation.

Relación Todo conjunto de pares ordenados se llama relación.

Relative frequency relative frequency

of an event $= \dfrac{\text{number of times event occurs}}{\text{total number of trials}}$

Frecuencia relativa frecuencia relativa de un evento $=$

$\dfrac{\text{número de veces que sucede el evento}}{\text{número total de pruebas}}$

Relative frequency table A relative frequency table shows the ratio of the number of data in each category to the total number of data items. The ratio can be expressed as a fraction, decimal, or percent.

Mesa relativa de frecuencia Una mesa relativa de la frecuencia muestra la proporción del número de datos en cada categoría al número total de artículos de datos. La proporción puede ser expresada como una fracción, el decimal, o el por ciento.

Remainder In division, the remainder is the number that is left after the division is complete.

Residuo En una división, el residuo es el número que queda después de terminar la operación.

English/Spanish Glossary

Remote interior angles Remote interior angles are the two nonadjacent interior angles corresponding to each exterior angle of a triangle.

Ángulos internos no adyacentes Los ángulos internos no adyacentes son los dos ángulos internos de un triángulo que se corresponden con el ángulo externo que está más alejado de ellos.

Repeating decimal A repeating decimal has a decimal expansion that repeats the same digit, or block of digits, without end.

Decimal periódico Un decimal periódico tiene una expansión decimal que repite el mismo dígito, o grupo de dígitos, sin fin.

Represent To represent is to stand for or take the place of something else. Symbols, equations, charts, and tables are often used to represent particular situations.

Representar Representar es sustituir u ocupar el lugar de otra cosa. A menudo se usan símbolos, ecuaciones y tablas para representar determinadas situaciones.

Representative sample A representative sample is a sample of a population in which the number of subjects in the sample with the trait that you are studying is proportional to the number of members in the population with that trait. A representative sample accurately represents the population and does not have bias.

Muestra representativa Una muestra representativa es una muestra de una población en la que el número de sujetos de la muestra que tiene la característica que se estudia es proporcional al número de miembros de la población que tienen esa característica. Una muestra representativa representa la población con exactitud y no está sesgada.

Rhombus A rhombus is a parallelogram whose sides are all the same length.

Rombo Un rombo es un paralelogramo que tiene todos sus lados de la misma longitud.

Right angle A right angle is an angle with a measure of 90°.

Ángulo recto Un ángulo recto es un ángulo que mide 90°.

Right cone A right cone is a cone in which the segment representing the height connects the vertex and the center of the base.

Cono recto Un cono recto es un cono en el que el segmento que representa la altura une el vértice y el centro de la base.

English/Spanish Glossary

Right cylinder A right cylinder is a cylinder in which the height joins the centers of the bases.

Cilindro recto Un cilindro recto es un cilindro en el que la altura une los centros de las bases.

Right prism In a right prism, all lateral faces are rectangles.

Prisma recto En un prisma recto, todas las caras laterales son rectángulos.

Right pyramid In a right pyramid, the segment that represents the height intersects the base at its center.

Pirámide recta En una pirámide recta, el segmento que representa la altura interseca la base en el centro.

Right triangle A right triangle is a triangle with one right angle.

Triángulo rectángulo Un triángulo rectángulo es un triángulo que tiene un ángulo recto.

Rigid motion A rigid motion is a transformation that changes only the position of a figure.

Movimiento rígido Un movimiento rígido es una transformación que sólo cambia la posición de una figura.

Rotation A rotation is a rigid motion that turns a figure around a fixed point, called the center of rotation.

Rotación Una rotación es un movimiento rígido que hace girar una figura alrededor de un punto fijo, llamado centro de rotación.

Rounding Rounding a number means replacing the number with a number that tells about how much or how many.

Redondear Redondear un número significa reemplazar ese número por un número que indica más o menos cuánto o cuántos.

S

Sale A sale is a discount offered by a store. A sale does not require the customer to have a coupon.

Venta Una venta es un descuento ofreció por una tienda. Una venta no requiere al cliente a tener un cupón.

English/Spanish Glossary

Sales tax A tax added to the price of goods and services.

Las ventas tasan Un impuesto añadió al precio de bienes y servicios.

Sample of a population A sample of a population is part of the population. A sample is useful when you want to find out about a population but you do not have the resources to study every member of the population.

Muestra de una población Una muestra de una población es una parte de la población. Una muestra es útil cuando quieres saber algo acerca de una población, pero no tienes los recursos para estudiar a cada miembro de esa población.

Sample space The sample space for an action is the set of all possible outcomes of that action.

Espacio muestral El espacio muestral de una acción es el conjunto de todos los resultados posibles de esa acción.

Sampling method A sampling method is the method by which you choose members of a population to sample.

Método de muestreo Un método de muestreo es el método por el cual escoges miembros de una población para muestrear.

Savings Savings is money that a person puts away for use at a later date.

Ahorros Los ahorros son dinero que una persona guarda para el uso en una fecha posterior.

Scale A scale is a ratio that compares a length in a scale drawing to the corresponding length in the actual object.

Escala Una escala es una razón que compara una longitud en un dibujo a escala con la longitud correspondiente en el objeto real.

Scale drawing A scale drawing is an enlarged or reduced drawing of an object that is proportional to the actual object.

Dibujo a escala Un dibujo a escala es un dibujo ampliado o reducido de un objeto que es proporcional al objeto real.

English/Spanish Glossary

Scale factor The scale factor is the ratio of a length in the image to the corresponding length in the original figure.

Factor de escala El factor de escala es la razón de una longitud de la imagen a la longitud correspondiente en la figura original.

Scalene triangle A scalene triangle is a triangle in which no sides have the same length.

Triángulo escaleno Un triángulo escaleno es un triángulo que no tiene lados de la misma longitud.

Scatter plot A scatter plot is a graph that uses points to display the relationship between two different sets of data. Each point can be represented by an ordered pair.

Diagrama de dispersión Un diagrama de dispersión es una gráfica que usa puntos para mostrar la relación entre dos conjuntos de datos diferentes. Cada punto se puede representar con un par ordenado.

Scholarship A type of monetary award a student can use to pay for his or her education. The student does not need to repay this money.

Beca Un tipo de premio monetario que un estudiante puede utilizar para pagar por su educación. El estudiante no debe devolver este dinero.

Scientific notation A number in scientific notation is written as the product of two factors, one greater than or equal to 1 and less than 10, and the other a power of 10.

Notación científica Un número en notación científica está escrito como el producto de dos factores, uno mayor que o igual a 1 y menor que 10, y el otro una potencia de 10.

Segment A segment is part of a line. It consists of two endpoints and all of the points on the line between the endpoints.

Segmento Un segmento es una parte de una recta. Está formado por dos extremos y todos los puntos de la recta que están entre los extremos.

Semicircle A semicircle is one half of a circle.

Semicírculo Un semicírculo es la mitad de un círculo.

English/Spanish Glossary

Similar figures A two-dimensional figure is similar to another two-dimensional figure if you can map one figure to the other by a sequence of rotations, reflections, translations, and dilations.

Figuras semejantes Una figura bidimensional es semejante a otra figura bidimensional si puedes hacer corresponder una figura con otra mediante una secuencia de rotaciones, reflexiones, traslaciones y dilataciones.

Simple interest Simple interest is interest paid only on an original deposit. To calculate simple interest, use the formula where I *is* the simple interest, p is the principal, r is the annual interest rate, and t is the number of years that the account earns interest.

Interés simple El interés simple es el interés que se paga sobre un depósito original solamente. Para calcular el interés simple, usa la fórmula donde I es el interés simple, c es el capital, r es la tasa de interés anual y t es el número de años en que la cuenta obtiene un interés.

Simple random sampling Simple random sampling is a sampling method in which every member of the population has an equal chance of being chosen for the sample.

Muestreo aleatorio simple El muestreo aleatorio simple es un método de muestreo en el que cada miembro de la población tiene la misma probabilidad de ser seleccionado para la muestra.

Simpler form A fraction is in simpler form when it is equivalent to a given fraction and has smaller numbers in the numerator and denominator.

Forma simplificada Una fracción está en su forma simplificada cuando es equivalente a otra fracción dada, pero tiene números más pequeños en el numerador y el denominador.

Simplest form A fraction is in simplest form when the only common factor of the numerator and denominator is one.

Mínima expresión Una fracción está en su mínima expresión cuando el único factor común del numerador y el denominador es 1.

Simplify an algebraic expression To simplify an algebraic expression, combine the like terms of the expression.

Simplificar una expresión algebraica Para simplificar una expresión algebraica, combina los términos semejantes de la expresión.

English/Spanish Glossary

Simulation A simulation is a model of a real-world situation that is used to find probabilities.

Simulación Una simulación es un modelo de una situación de la vida diaria que se usa para hallar probabilidades.

Sketch To sketch a figure, draw a rough outline. When a sketch is asked for, it means that a drawing needs to be included in your response.

Bosquejo Para hacer un bosquejo, dibuja un esquema simple. Si se pide un bosquejo, tu respuesta debe incluir un dibujo.

Slant height of a cone The slant height of a cone, ℓ, is the length of its lateral surface from base to vertex.

Altura inclinada de un cono La altura inclinada de un cono, ℓ, es la longitud de su superficie lateral desde la base hasta el vértice.

Slant height of a pyramid The slant height of a pyramid is the height of a lateral face.

Altura inclinada de una pirámide La altura inclinada de una pirámide es la altura de una cara lateral.

Slope Slope is a ratio that describes steepness.

$$\text{slope} = \frac{\text{vertical change}}{\text{horizontal change}} = \frac{\text{rise}}{\text{run}}$$

Pendiente La pendiente es una razón que describe la inclinación.

$$\text{pendiente} = \frac{\text{cambio vertical}}{\text{cambio horizontal}}$$

$$= \frac{\text{distancia vertical}}{\text{distancia horizontal}}$$

Slope of a line slope $=$

$$\frac{\text{change in } y\text{-coordinates}}{\text{change in } x\text{-coordinates}} = \frac{\text{rise}}{\text{run}}$$

Pendiente de una recta pendiente $=$

$$\frac{\text{cambio en las coordenadas } y}{\text{cambio en las coordenadas } x}$$

$$= \frac{\text{distancia vertical}}{\text{distancia horizontal}}$$

Slope-intercept form An equation written in the form $y = mx + b$ is in slope-intercept form. The graph is a line with slope m and y-intercept b.

Forma pendiente-intercepto Una ecuación escrita en la forma $y = mx + b$ está en forma de pendiente-intercepto. La gráfica es una línea recta con pendiente m e intercepto en y b.

English/Spanish Glossary

Solution of a system of linear equations A solution of a system of linear equations is any ordered pair that makes all the equations of that system true.

Solución de un sistema de ecuaciones lineales Una solución de un sistema de ecuaciones lineales es cualquier par ordenado que hace que todas las ecuaciones de ese sistema sean verdaderas.

Solution of an equation A solution of an equation is a value of the variable that makes the equation true.

Solución de una ecuación Una solución de una ecuación es un valor de la variable que hace que la ecuación sea verdadera.

Solution of an inequality The solutions of an inequality are the values of the variable that make the inequality true.

Solución de una desigualdad Las soluciones de una desigualdad son los valores de la variable que hacen que la desigualdad sea verdadera.

Solution set A solution set contains all of the numbers that satisfy an equation or inequality.

Conjunto solución Un conjunto solución contiene todos los números que satisfacen una ecuación o desigualdad.

Solve To solve a given statement, determine the value or values that make the statement true. Several methods and strategies can be used to solve a problem, including estimating, isolating the variable, drawing a graph, or using a table of values.

Resolver Para resolver un enunciado dado, determina el valor o los valores que hacen que ese enunciado sea verdadero. Para resolver un problema se pueden usar varios métodos y estrategias, como estimar, aislar la variable, dibujar una gráfica o usar una tabla de valores.

Sphere A sphere is the set of all points in space that are the same distance from a center point.

Esfera Una esfera es el conjunto de todos los puntos en el espacio que están a la misma distancia de un punto central.

Square A square is a quadrilateral with four right angles and all sides the same length.

Cuadrado Un cuadrado es un cuadrilátero que tiene cuatro ángulos rectos y todos los lados de la misma longitud.

English/Spanish Glossary

Square root A square root of a number is a number that, when multiplied by itself, equals the original number.

Raíz cuadrada La raíz cuadrada de un número es un número que, cuando se multiplica por sí mismo, es igual al número original.

Square unit A square unit is the area of a square that has sides that are 1 unit long.

Unidad cuadrada Una unidad cuadrada es el área de un cuadrado en el que cada lado mide 1 unidad de longitud.

Standard form A number written using digits and place value is in standard form.

Forma estándar Un número escrito con dígitos y valor posicional está escrito en forma estándar.

Statistical question A statistical question is a question that investigates an aspect of the real world and can have variety in the responses.

Pregunta estadística Una pregunta estadística es una pregunta que investiga un aspecto de la vida diaria y puede tener varias respuestas.

Statistics Statistics is the study of collecting, organizing, graphing, and analyzing data to draw conclusions about the real world.

Estadística La estadística es el estudio de la recolección, organización, representación gráfica y análisis de datos para sacar conclusiones sobre la vida diaria.

Stem-and-leaf plot A stem-and-leaf plot is a graph that uses the digits of each number to show the data distribution. Each data item is broken into a stem and into a leaf. The leaf is the last digit of the data value. The stem is the other digit or digits of the data value.

Complot de tallo y hoja Un complot del tallo y la hoja es un gráfico que utiliza los dígitos de cada número para mostrar la distribución de datos. Cada artículo de datos es roto en un tallo y en una hoja. La hoja es el último dígito de los datos valora. El tallo es el otro dígito o los dígitos de los datos valoran.

Stored-value card A stored-value card is a prepaid card electronically coded to be worth a specified amount of money.

Tarjeta de almacenado-valor Una tarjeta del almacenado-valor es una tarjeta pagada por adelantado codificó electrónicamente valer una cantidad especificado de dinero.

English/Spanish Glossary

Straight angle A straight angle is an angle with a measure of 180°.

Ángulo llano Un ángulo llano es un ángulo que mide 180°.

Student loan A student loan provides money to a student to pay for college. The student needs to repay the loan after leaving college. Often the student will need to pay interest on the amount of the loan.

Crédito personal para estudiantes Un crédito personal para estudiantes le proporciona dinero a un estudiante para pagar por el colegio. El estudiante debe devolver el préstamo después de dejar el colegio. A menudo el estudiante deberá pagar interés en la cantidad del préstamo.

Subject Each member in a sample is a subject.

Sujeto Cada miembro de una muestra es un sujeto.

Sum The sum is the answer to an addition problem.

Suma o total La suma o total es el resultado de una operación de suma.

Summarize To summarize an explanation or solution, go over or review the most important points.

Resumir Para resumir una explicación o solución, revisa o repasa los puntos más importantes.

Supplementary angles Two angles are supplementary angles if the sum of their measures is 180°. Supplementary angles that are adjacent form a straight angle.

Ángulos suplementarios Dos ángulos son suplementarios si la suma de sus medidas es 180°. Los ángulos suplementarios que son adyacentes forman un ángulo llano.

Surface area of a cone The surface area of a cone is the sum of the lateral area and the area of the base. The formula for the surface area of a cone is S.A. = L.A. + B.

Área total de un cono El área total de un cono es la suma del área lateral y el área de la base. La fórmula del área total de un cono es A.T. = A.L. + B.

English/Spanish Glossary

Surface area of a cube The surface area of a cube is the sum of the areas of the faces of the cube. The formula for the surface area, S.A., of a cube is S.A. , where s represents the length of an edge of the cube.

Área total de un cubo El área total de un cubo es la suma de las áreas de las caras del cubo. La fórmula del área total, A.T., de un cubo es A.T. , donde *s* representa la longitud de una arista del cubo.

Surface area of a cylinder The surface area of a cylinder is the sum of the lateral area and the areas of the two circular bases. The formula for the surface area of a cylinder is S.A. L.A. 2*B*, where L.A. represents the lateral area of the cylinder and *B* represents the area of a base of the cylinder.

Área total de un cilindro El área total de un cilindro es la suma del área lateral y las áreas de las dos bases circulares. La fórmula del área total de un cilindro es A.T. A.L. 2*B*, donde A.L. representa el área lateral del cilindro y *B* representa el área de una base del cilindro.

Surface area of a pyramid The surface area of a pyramid is the sum of the areas of the faces of the pyramid. The formula for the surface area, S.A., of a pyramid is S.A. = L.A. + *B*, where L.A. represents the lateral area of the pyramid and *B* represents the area of the base of the pyramid.

Área total de una pirámide El área total de una pirámide es la suma de las áreas de las caras de la pirámide. La fórmula del área total, A.T., de una pirámide es A.T. = A.L. + *B*, donde A.L. representa el área lateral de la pirámide y *B* representa el área de la base de la pirámide.

Surface area of a sphere The surface area of a sphere is equal to the lateral area of a cylinder that has the same radius, *r*, and height 2*r*. The formula for the surface area of a sphere is S.A. = $4\pi r^2$, where *r* represents the radius of the sphere.

Área total de una esfera El área total de una esfera es igual al área lateral de un cilindro que tiene el mismo radio, *r*, y una altura de 2*r*. La fórmula del área total de una esfera es A.T. = $4\pi r^2$, donde *r* representa el radio de la esfera.

Surface area of a three-dimensional figure The surface area of a three-dimensional figure is the sum of the areas of its faces. You can find the surface area by finding the area of the net of the three-dimensional figure.

Área total de una figura tridimensional El área total de una figura tridimensional es la suma de las áreas de sus caras. Puedes hallar el área total si hallas el área del modelo plano de la figura tridimensional.

English/Spanish Glossary

System of linear equations A system of linear equations is formed by two or more linear equations that use the same variables.

Sistema de ecuaciones lineales Un sistema de ecuaciones lineales está formado por dos o más ecuaciones lineales que usan las mismas variables.

Systematic sampling Systematic sampling is a sampling method in which you choose every nth member of the population, where n is a predetermined number. A systematic sample is useful when the researcher is able to approach the population in a systematic, or methodical, way.

Muestreo sistemático El muestreo sistemático es un método de muestreo en el que se escoge cada enésimo miembro de la población, donde n es un número predeterminado. Una muestra sistemática es útil cuando el investigador puede enfocarse en la población de manera sistemática o metódica.

T

Taxable wages For federal income tax purposes, your taxable wages are the difference between your earned wages and your withholding allowance. Your employer divides your withholding allowance equally among the pay periods of one year.

Sueldos imponibles Para propósitos federales de impuesto de renta, sus sueldos imponibles son la diferencia entre sus sueldos ganados y su concesión que retienen. Su empleador divide su concesión que retiene igualmente entre los períodos de paga de un año.

Tenths One tenth is one out of ten equal parts of a whole.

Décimas Una décima es 1 de 10 partes iguales de un todo.

Term A term is a number, a variable, or the product of a number and one or more variables.

Término Un término es un número, una variable o el producto de un número y una o más variables.

Terminating decimal A terminating decimal has a decimal expansion that terminates in 0.

Decimal finito Un decimal finito tiene una expansión decimal que termina en 0.

English/Spanish Glossary

Terms of a ratio The terms of a ratio are the quantities *x* and *y* in the ratio.

Términos de una razón Los términos de una razón son la cantidad *x* y la cantidad *y* de la razón.

Theorem A theorem is a conjecture that is proven.

Teorema Un teorema es una conjetura que se ha comprobado.

Theoretical probability When all outcomes of an action are equally likely,

$$P(\text{event}) = \frac{\text{number of favourable outcomes}}{\text{number of possible outcomes}}.$$

Probabilidad teórica Cuando todos los resultados de una acción son igualmente probables, $P(\text{evento}) =$

$$\frac{\text{número de resultados favorables}}{\text{número de resultados posibles}}.$$

Third quartile For an ordered set of data, the third quartile is the median of the upper half of the data set.

Tercer cuartil Para un conjunto de datos ordenados, el tercer cuartil es la mediana de la mitad superior del conjunto de datos.

Thousandths One thousandth is one part of 1,000 equal parts of a whole.

Milésimas Una milésima es 1 de 1,000 partes iguales de un todo.

Three-dimensional figure A three-dimensional (3-D) figure is a figure that does not lie in a plane.

Figura tridimensional Una figura tridimensional es una figura que no está en un plano.

Total cost of a loan The total cost of a loan is the total amount spent to repay the loan. Total cost includes the principal and all interest paid over the length of the loan. Total cost also includes any fees charged.

El coste total de un préstamo El coste total de un préstamo es el cantidad total que es gastado para devolver el préstamo. El coste total incluye al director y todo el interés pagó sobre la longitud del préstamo. El coste total también incluye cualquier honorario cargado.

Transaction A banking transaction moves money into or out of a bank account.

Transacción Una transacción bancaria mueve dinero en o fuera de una cuenta bancaria.

English/Spanish Glossary

Transfer A transaction that moves money from one bank account to another is a transfer. The balance of one account increases by the same amount the other account decreases.

Transferencia Una transacción que mueve dinero de una cuenta bancaria a otro es una transferencia. El equilibrio de un aumentos de cuenta por la misma cantidad que la otra cuenta disminuye.

Transformation A transformation is a change in position, shape, or size of a figure. Three types of transformations that change position only are translations, reflections, and rotations.

Transformación Una transformación es un cambio en la posición, la forma o el tamaño de una figura. Tres tipos de transformaciones que cambian sólo la posicion son las traslaciones, las reflexiones y las rotaciones.

Translation A translation, or slide, is a rigid motion that moves every point of a figure the same distance and in the same direction.

Traslación Una traslación, o deslizamiento, es un movimiento rígido que mueve cada punto de una figura a la misma distancia y en la misma dirección.

Transversal A transversal is a line that intersects two or more lines at different points.

Transversal o secante Una transversal o secante es una línea que interseca dos o más líneas en distintos puntos.

Trapezoid A trapezoid is a quadrilateral with exactly one pair of parallel sides.

Trapecio Un trapecio es un cuadrilátero que tiene exactamente un par de lados paralelos.

Trend line A trend line is a line on a scatter plot, drawn near the points, that approximates the association between the data sets.

Línea de tendencia Una línea de tendencia es una línea en un diagrama de dispersión, trazada cerca de los puntos, que se aproxima a la relación entre los conjuntos de datos.

Trial In a probability experiment, you carry out or observe an action repeatedly. Each observation of the action is a trial.

Prueba En un experimento de probabilidad, realizas u observas una acción varias veces. Cada observación de la acción es una prueba.

Triangle A triangle is a polygon with three sides.

Triángulo Un triángulo es un polígono de tres lados.

English/Spanish Glossary

Triangular prism A triangular prism is a prism with bases in the shape of a triangle.

Prisma triangular Un prisma triangular es un prisma cuyas bases tienen la forma de un triángulo.

True equation A true equation has equal values on each side of the equals sign.

Ecuación verdadera En una ecuación verdadera, los valores a ambos lados del signo igual son iguales.

Two-way frequency table A two-way frequency table displays the counts of the data in each group.

Tabla de frecuencia con dos variables Una tabla de frecuencia con dos variables muestra el conteo de los datos de cada grupo.

Two-way relative frequency table A two-way relative frequency table shows the ratio of the number of data in each group to the size of the population. The relative frequencies can be calculated with respect to the entire population, the row populations, or the column populations. The relative frequencies can be expressed as fractions, decimals, or percents.

Tabla de frecuencias relativas con dos variables Una tabla de frecuencias relativas con dos variables muestra la razón del número de datos de cada grupo al tamaño de la población. Las frecuencias relativas se pueden calcular respecto de la población entera, las poblaciones de las filas o las poblaciones de las columnas. Las frecuencias relativas se pueden expresar como fracciones, decimales o porcentajes.

Two-way table A two-way table shows bivariate categorical data for a population.

Tabla con dos variables Una tabla con dos variables muestra datos bivariados por categorías de una población.

U

Uniform probability model A uniform probability model is a probability model based on using the theoretical probability of equally likely outcomes.

Modelo de probabilidad uniforme Un modelo de probabilidad uniforme es un modelo de probabilidad que se basa en el uso de la probabilidad teórica de resultados igualmente probables.

English/Spanish Glossary

Unit fraction A unit fraction is a fraction with a numerator of 1 and a denominator that is a whole number greater than 1.

Fracción unitaria Una fracción unitaria es una fracción con un numerador 1 y un denominador que es un número entero mayor que 1.

Unit price A unit price is a unit rate that gives the price of one item.

Precio por unidad El precio por unidad es una tasa por unidad que muestra el precio de un artículo.

Unit rate The rate for one unit of a given quantity is called the unit rate.

Tasa por unidad Se llama tasa por unidad a la tasa que corresponde a 1 unidad de una cantidad dada.

Use To use given information, draw on it to help you determine something else.

Usar Para usar una información dada, apóyate en ella para determinar otra cosa.

V

Valid inference A valid inference is an inference that is true about the population. Valid inferences can be made when they are based on data from a representative sample.

Inferencia válida Una inferencia válida es una inferencia verdadera acerca de una población. Se pueden hacer inferencias válidas si están basadas en los datos de una muestra representativa.

Variability Variability describes how much the items in a data set differ (or vary) from each other. On a data display, variability is shown by how much the data on the horizontal scale are spread out.

Variabilidad La variabilidad describe qué diferencia (o variación) existe entre los elementos de un conjunto de datos. Al exhibir datos, la variabilidad queda representada por la distancia que separa los datos en la escala horizontal.

Variable A variable is a letter that represents an unknown value.

Variable Una variable es una letra que representa un valor desconocido.

Variable expenses Variable expenses are expenses that change from one budget period to the next.

Gastos variables Los gastos variables son los gastos que cambian de un período económico al próximo.

English/Spanish Glossary

Vertex of a cone The vertex of a cone is the point farthest from the base.

Vértice de un cono El vértice de un cono es el punto más alejado de la base.

Vertex of a polygon The vertex of a polygon is any point where two sides of a polygon meet.

Vértice de un polígono El vértice de un polígono es cualquier punto donde se encuentran dos lados de un polígono.

Vertex of a three-dimensional figure A vertex of a three-dimensional figure is a point where three or more edges meet.

Vértice de una figura tridimensional El vértice de una figura tridimensional es un punto donde se unen tres o más aristas.

Vertex of an angle The vertex of an angle is the point of intersection of the rays that make up the sides of the angle.

Vértice de un ángulo El vértice de un ángulo es el punto de intersección de las semirrectas que forman los lados del ángulo.

Vertical angles Vertical angles are formed by two intersecting lines and are opposite each other. Vertical angles have equal measures.

Ángulos opuestos por el vértice Los ángulos opuestos por el vértice están formados por dos rectas secantes y están uno frente a otro. Los ángulos opuestos por el vértice tienen la misma medida.

Vertical-line test The vertical-line test is a method used to determine if a relation is a function or not. If a vertical line passes through a graph more than once, the graph is not the graph of a function.

Prueba de recta vertical La prueba de recta vertical es un método que se usa para determinar si una relación es una función o no. Si una recta vertical atraviesa la gráfica más de una vez, la gráfica no es la gráfica de una función.

Volume Volume is the number of cubic units needed to fill a solid figure.

Volumen El volumen es el número de unidades cúbicas que se necesitan para llenar un cuerpo geométrico.

English/Spanish Glossary

Volume of a cone The volume of a cone is the number of unit cubes, or cubic units, needed to fill the cone. The formula for the volume of a cone is $V = \frac{1}{3}Bh$, where B represents the area of the base and h represents the height of the cone.

Volumen de un cono El volumen de un cono es el número de bloques de unidades, o unidades cúbicas, que se necesitan para llenar el cono. La fórmula del volumen de un cono $V = \frac{1}{3}Bh$, donde B representa el área de la base y h representa la altura del cono.

Volume of a cube The volume of a cube is the number of unit cubes, or cubic units, needed to fill the cube. The formula for the volume V of a cube is $V = s^3$, where s represents the length of an edge of the cube.

Volumen de un cubo El volumen de un cubo es el número de bloques de unidades, o unidades cúbicas, que se necesitan para llenar el cubo. La fórmula del volumen, V, de un cubo es $V = s^3$, donde s representa la longitud de una arista del cubo.

Volume of a cylinder The volume of a cylinder is the number of unit cubes, or cubic units, needed to fill the cylinder. The formula for the volume of a cylinder is $V = \pi r^2 h$, where r represents the radius of a base and h represents the height of the cylinder.

Volumen de un cilindro El volumen de un cilindro es el número de bloques de unidades, o unidades cúbicas, que se necesitan para llenar el cilindro. La fórmula del volumen de un cilindro es $V = \pi r^2 h$, donde r representa el radio de una base y h representa la altura del cilindro.

Volume of a prism The volume of a prism is the number of unit cubes, or cubic units, needed to fill the prism. The formula for the volume V of a prism is $V = Bh$, where B represents the area of a base and h represents the height of the prism.

Volumen de un prisma El volumen de un prisma es el número de bloques de unidades, o unidades cúbicas, que se necesitan para llenar el prisma. La fórmula del volumen, V, de un prisma $V = Bh$, donde B representa el área de una base y h representa la altura del prisma.

Volume of a pyramid The volume of a pyramid is the number of unit cubes needed to fill the pyramid. The formula for the volume V of a pyramid is $V = \frac{1}{3}Bh$, where B represents the area of the base and h represents the height of the pyramid.

Volumen de una pirámide El volumen de una pirámide es el número de bloques de unidades, o unidades cúbicas, que se necesitan para llenar la pirámide. La fórmula del volumen, V, de una pirámide es $V = \frac{1}{3}Bh$, donde B representa el área de la base y h representa la altura de la pirámide.

English/Spanish Glossary

Volume of a sphere The volume of a sphere is the number of unit cubes, or cubic units, needed to fill the sphere. The formula for the volume of a sphere is $V = \frac{4}{3}\pi r^3$.

Volumen de una esfera El volumen de una esfera es el número de bloques de unidades, o unidades cúbicas, que se necesitan para llenar la esfera. La fórmula del volumen de una esfera es $V = \frac{4}{3}\pi r^3$.

W

Whole numbers The whole numbers consist of the number 0 and all of the natural numbers.

Números enteros no negativos Los números enteros no negativos son el número 0 y todos los números naturales.

Withdrawal A transaction that takes money out of a bank account is a withdrawal.

Retirada Una transacción que toma dinero fuera de una cuenta bancaria es una retirada.

Withholding allowance You can exclude a portion of your earned wages, called a withholding allowance, from federal income tax. You can claim one withholding allowance for yourself and one for each person dependent upon your income.

Retener concesión Puede excluir una porción de sus sueldos ganados, llamó una concesión que retiene, del impuesto de renta federal. Puede reclamar una concesión que retiene para usted mismo y para uno para cada dependiente de persona sobre sus ingresos.

Word form of a number The word form of a number is the number written in words.

Número en palabras Un número en palabras es un número escrito con palabras en lugar de dígitos.

Work-Study Work-study is a type of need-based aid that schools might offer to a student. A student must earn work-study money by working certain jobs.

Práctica estudiantil La práctica estudiantil es un tipo de ayuda necesidad-basado que escuelas quizás ofrezcan a un estudiante. Un estudiante debe ganar dinero de práctica estudiantil por ciertos trabajos de trabajo.

English/Spanish Glossary

X

x-axis The x-axis is the horizontal number line that, together with the y-axis, forms the coordinate plane.

Eje de las x El eje de las x es la recta numérica horizontal que, junto con el eje de las y, forma el plano de coordenadas.

x-coordinate The x-coordinate is the first number in an ordered pair. It tells the number of horizontal units a point is from 0.

Coordenada x La coordenada x (abscisa) es el primer número de un par ordenado. Indica cuántas unidades horizontales hay entre un punto y 0.

Y

y-axis The y-axis is the vertical number line that, together with the x-axis, forms the coordinate plane.

Eje de las y El eje de las y es la recta numérica vertical que, junto con el eje de las x, forma el plano de coordenadas.

y-coordinate The y-coordinate is the second number in an ordered pair. It tells the number of vertical units a point is from 0.

Coordenada y La coordenada y (ordenada) es el segundo número de un par ordenado. Indica cuántas unidades verticales hay entre un punto y 0.

y-intercept The y-intercept of a line is the y-coordinate of the point where the line crosses the y-axis.

Intercepto en y El intercepto en y de una recta es la coordenada y del punto por donde la recta cruza el eje de las y.

Z

Zero exponent property For any nonzero number a, $a^0 = 1$.

Propiedad del exponente cero Para cualquier número distinto de cero a, $a^0 = 1$.

Zero Property of Multiplication The product of 0 and any number is 0. For any number n, $n \cdot 0 = 0$ and $0 \cdot n = 0$.

Propiedad del cero en la multiplicación El producto de 0 y cualquier número es 0. Para cualquier número n, $n \cdot 0 = 0$ and $0 \cdot n = 0$.

Formulas

$P = 2b + 2h$

$A = bh$

Rectangle

$P = 4s$

$A = s^2$

Square

$A = \frac{1}{2}bh$

Triangle

$A = bh$

Parallelogram

$A = \frac{1}{2}h(b_1 + b_2)$

Trapezoid

$C = 2\pi r$ or $C = \pi d$

$A = \pi r^2$

Circle

S.A. $= 6s^2$

$V = s^3$

Cube

$V = Bh$

L.A. $= ph$

S.A. $=$ L.A. $+ 2B$

Rectangular Prism

Formulas

$V = \frac{1}{3}Bh$

L.A. $= 2b\ell$

S.A. $=$ L.A. $+ B$

Square Pyramid

$V = Bh$

L.A. $= 2\pi rh$

S.A. $=$ L.A. $+ 2B$

Cylinder

$V = \frac{1}{3}Bh$

L.A. $= \pi r\ell$

S.A. $=$ L.A. $+ B$

Cone

$V = \frac{4}{3}\pi r^3$

S.A. $= 4\pi r^2$

Sphere

$a^2 + b^2 = c^2$

Pythagorean Theorem

$y = mx + b$, where
$m =$ slope and
$b = y$-intercept

Equation of Line

Math Symbols

$+$	plus (addition)		r	radius		
$-$	minus (subtraction)		S.A.	surface area		
\times , \cdot	times (multiplication)		B	area of base		
\div , $\sqrt{}$, $\frac{a}{b}$	divide (division)		L.A.	lateral area		
$=$	is equal to		ℓ	slant height		
$<$	is less than		V	volume		
$>$	is greater than		a^n	nth power of a		
\leq	is less than or equal to		\sqrt{x}	nonnegative square root of x		
\geq	is greater than or equal to		π	pi, an irrational number approximately equal to 3.14		
\neq	is not equal to					
()	parentheses for grouping		(a, b)	ordered pair with x-coordinate a and y-coordinate b		
[]	brackets for grouping					
$-a$	opposite of a		\overline{AB}	segment AB		
\ldots	and so on		A'	image of A, A prime		
\circ	degrees		$\triangle ABC$	triangle with vertices A, B, and C		
$	a	$	absolute value of a			
$\overset{?}{=}, \overset{?}{<}, \overset{?}{>}$	Is the statement true?		\rightarrow	arrow notation		
\approx	is approximately equal to		$a : b, \frac{a}{b}$	ratio of a to b		
$\frac{b}{a}$	reciprocal of $\frac{a}{b}$		\cong	is congruent to		
A	area		\sim	is similar to		
ℓ	length		$\angle A$	angle with vertex A		
w	width		AB	length of segment \overline{AB}		
h	height		\overrightarrow{AB}	ray AB		
d	distance		$\angle ABC$	angle formed by \overrightarrow{BA} and \overrightarrow{BC}		
r	rate		$m\angle ABC$	measure of angle ABC		
t	time		\perp	is perpendicular to		
P	perimeter		\overleftrightarrow{AB}	line AB		
b	base length		\parallel	is parallel to		
C	circumference		%	percent		
d	diameter		P (event)	probability of an event		

Measures

Customary	Metric
Length	**Length**
1 foot (ft) = 12 inches (in.) 1 yard (yd) = 36 in. 1 yd = 3 ft 1 mile (mi) = 5,280 ft 1 mi = 1,760 yd	1 centimeter (cm) = 10 millimeters (mm) 1 meter (m) = 100 cm 1 kilometer (km) = 1,000 m 1 mm = 0.001 m
Area	**Area**
1 square foot (ft^2) = 144 square inches ($in.^2$) 1 square yard (yd^2) = 9 ft^2 1 square mile (mi^2) = 640 acres	1 square centimeter (cm^2) = 100 square millimeters (mm^2) 1 square meter (m^2) = 10,000 cm^2
Volume	**Volume**
1 cubic foot (ft^3) = 1,728 cubic inches ($in.^3$) 1 cubic yard (yd^3) = 27 ft^3	1 cubic centimeter (cm^3) = 1,000 cubic millimeters (mm^3) 1 cubic meter (m^3) = 1,000,000 cm^3
Mass	**Mass**
1 pound (lb) = 16 ounces (oz) 1 ton (t) = 2,000 lb	1 gram (g) = 1,000 milligrams (mg) 1 kilogram (kg) = 1,000 g
Capacity	**Capacity**
1 cup (c) = 8 fluid ounces (fl oz) 1 pint (pt) = 2 c 1 quart (qt) = 2 pt 1 gallon (gal) = 4 qt	1 liter (L) = 1,000 milliliters (mL) 1000 liters = 1 kiloliter (kL)

Customary Units and Metric Units	
Length	1 in. = 2.54 cm 1 mi \approx 1.61 km 1 ft \approx 0.3 m
Capacity	1 qt \approx 0.94 L
Weight and Mass	1 oz \approx 28.3 g 1 lb \approx 0.45 kg

Properties

Unless otherwise stated, the variables a, b, c, m, and n used in these properties can be replaced with any number represented on a number line.

Identity Properties
Addition $\quad n + 0 = n$ and $0 + n = n$
Multiplication $\quad n \cdot 1 = n$ and $1 \cdot n = n$

Commutative Properties
Addition $\quad a + b = b + a$
Multiplication $\quad a \cdot b = b \cdot a$

Associative Properties
Addition $\quad (a + b) + c = a + (b + c)$
Multiplication $\quad (a \cdot b) \cdot c = a \cdot (b \cdot c)$

Inverse Properties
Addition
$a + (-a) = 0$ and $-a + a = 0$
Multiplication
$a \cdot \frac{1}{a} = 1$ and $\frac{1}{a} \cdot a = 1$, $(a \neq 0)$

Distributive Properties
$a(b + c) = ab + ac \quad (b + c)a = ba + ca$
$a(b - c) = ab - ac \quad (b - c)a = ba - ca$

Properties of Equality
Addition \quad If $a = b$,
$\qquad\qquad$ then $a + c = b + c$.
Subtraction \quad If $a = b$,
$\qquad\qquad$ then $a - c = b - c$.
Multiplication If $a = b$,
$\qquad\qquad$ then $a \cdot c = b \cdot c$.
Division \quad If $a = b$, and $c \neq 0$,
$\qquad\qquad$ then $\frac{a}{c} = \frac{b}{c}$.
Substitution \quad If $a = b$, then b can
$\qquad\qquad$ replace a in any
$\qquad\qquad$ expression.

Zero Property
$a \cdot 0 = 0$ and $0 \cdot a = 0$.

Properties of Inequality
Addition \quad If $a > b$,
$\qquad\qquad$ then $a + c > b + c$.
$\qquad\qquad$ If $a < b$,
$\qquad\qquad$ then $a + c < b + c$.
Subtraction \quad If $a > b$,
$\qquad\qquad$ then $a - c > b - c$.
$\qquad\qquad$ If $a < b$,
$\qquad\qquad$ then $a - c < b - c$.
Multiplication
If $a > b$ and $c > 0$, then $ac > bc$.
If $a < b$ and $c > 0$, then $ac < bc$.
If $a > b$ and $c < 0$, then $ac < bc$.
If $a < b$ and $c < 0$, then $ac > bc$.
Division
If $a > b$ and $c > 0$, then $\frac{a}{c} > \frac{b}{c}$.
If $a < b$ and $c > 0$, then $\frac{a}{c} < \frac{b}{c}$.
If $a > b$ and $c < 0$, then $\frac{a}{c} < \frac{b}{c}$.
If $a < b$ and $c < 0$, then $\frac{a}{c} > \frac{b}{c}$.

Properties of Exponents
For any nonzero number n and any integers m and n:

Zero Exponent $\qquad a^0 = 1$
Negative Exponent $\quad a^{-n} = \frac{1}{a^n}$
Product of Powers $\quad a^m \cdot a^n = a^{m+n}$
Power of a Product $\quad (ab)^n = a^n b^n$
Quotient of Powers $\quad \frac{a^m}{a^n} = a^{m-n}$
Power of a Quotient $\quad \left(\frac{a}{b}\right)^n = \frac{a^n}{b^n}$
Power of a Power $\qquad (a^m)^n = a^{mn}$